AMAZING
THEATRES
OF THE WORLD

AMAZING THEATRES
OF THE WORLD

DOMINIC CONNOLLY

with an introduction by

SIR TIM RICE

amber
BOOKS

This Amber Book published in 2022

Published by
Amber Books Ltd
United House
North Road
London N7 9DP
United Kingdom
www.amberbooks.co.uk
Instagram: amberbooksltd
Facebook: amberbooks
Twitter: @amberbooks
Pinterest: Amberbooksltd

978-1-83886-207-7

Project Editor: Michael Spilling
Designer: Keren Harragan
Picture Research: Justin Willsdon

Printed in Malaysia

Contents

Introduction

Sir Tim Rice

I've been fortunate to have had the privilege of my lyrics being performed at some of the world's most astounding theatres (thanks largely to the outstanding tunes that have accompanied them), from the iconic Sydney Opera House to the bucolic Open Air Theatre in London's Regent's Park, from the striking Esplanade in Singapore to the landmark Auditorium Opera House on Tenerife. And over the years I've been lucky enough to have seen my musicals performed at many Broadway and West End theatres, and at literally dozens of venues around

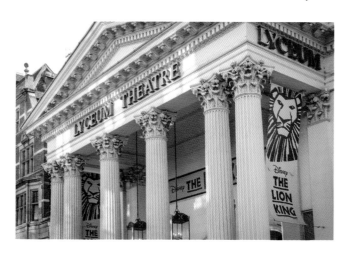

the world. I try not to forget that my words are merely one aspect of each production and that they are only there because of the contributions of many others – not least the building or space in which they are heard.

The love of theatre spans cultures – every society cherishes performance in a communal setting. And it also spans time. The earliest civilizations built phenomenal structures where people could gather together and be entertained, auditoria that often still survive as working theatres. And today the most hi-tech and ambitious methods are being employed to create theatrical spaces for the present and the future.

ABOVE:
Disney's *The Lion King* has been staged at the Lyceum Theatre in London since 1999 – and is also the fifth longest running musical ever on Broadway.

But theatres do not just reflect how people have always loved performance the world over; they can also be agents for change. Through cutting-edge design they can push the boundaries of architecture, economically they can put somewhere previously neglected on the map, and socially they can bring disparate people together… starting conversations that may never have happened before.

Dominic Connolly, in this striking and original work, has superbly demonstrated the power and magic of theatre, which transcends the performance on stage, no matter how brilliant that may be, through the fourth wall and beyond.

– Tim Rice, November 2021

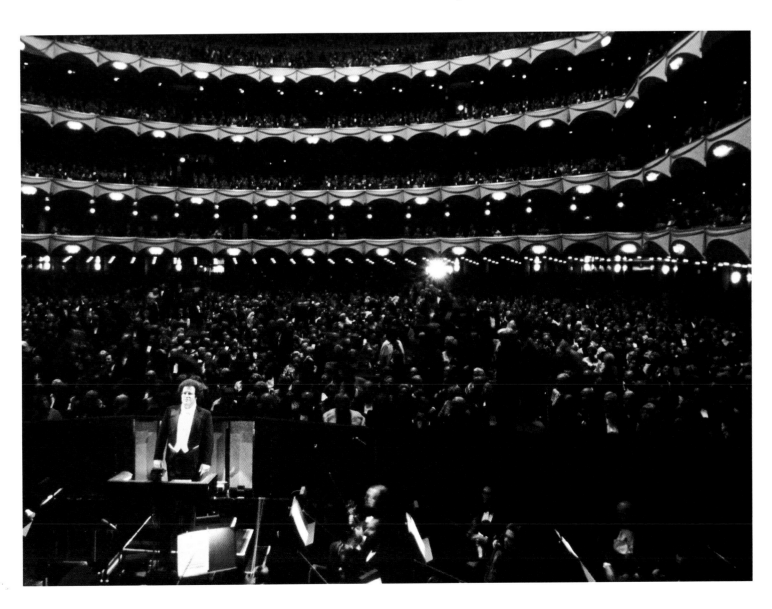

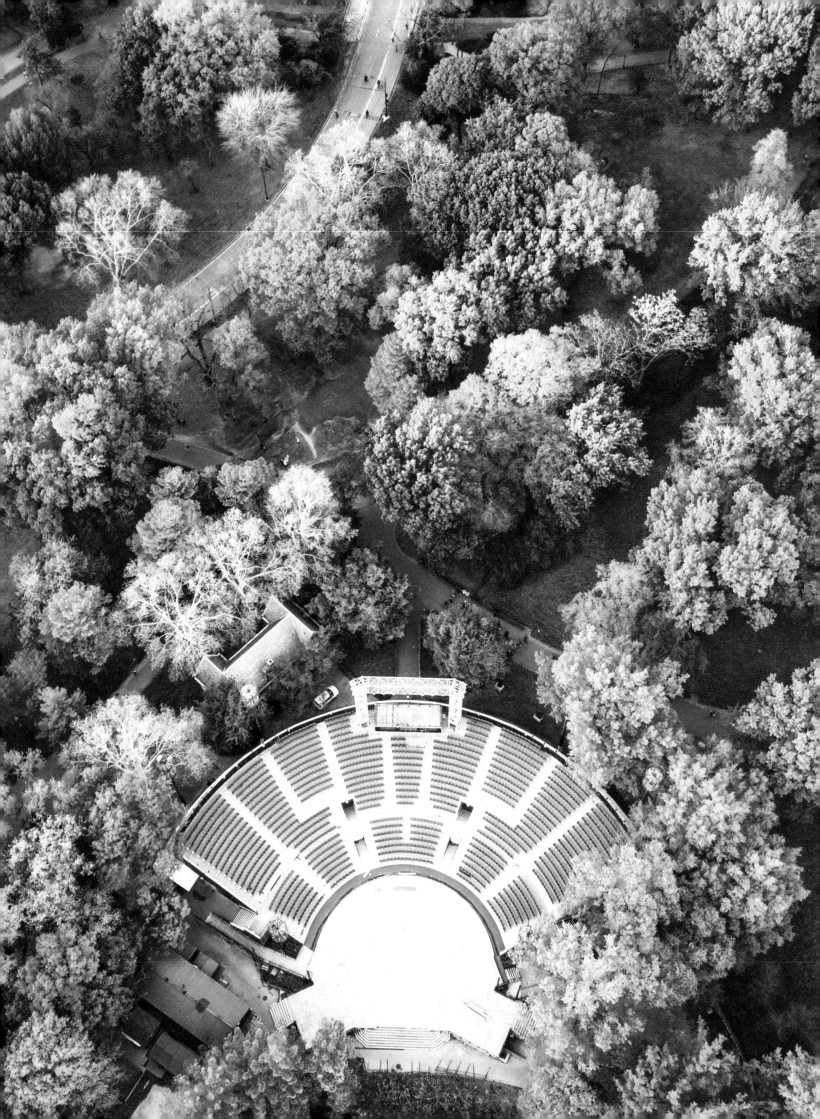

New York and London

Broadway, the West End and beyond

Mention 'Broadway' or 'the West End' and no further explanation is needed as to where – or what – is being discussed. Those two terms are synonymous with theatre in New York and London, and for more than a century those cities have been the world's ongoing twin epicentres of onstage – and backstage – talent. The West End and Broadway set the pace with the theatre explosion that progressed through the 19th and early 20th centuries, erecting playhouse after playhouse to keep up with the burgeoning demand from their respective growing cities – and to replace the constant numbers destroyed by fire, particularly in London.

Many architectural gems were thrown up in this golden period, and the influence of New York's 'Great White Way' and London's 'Theatreland' extended into the further reaches of each city, too. But although this was a distinct boom time for New York and London theatres, the amazing theatres present in those two cities are still diverse. New York's Central Park has the open-air Delacorte, while London's South Bank the brutalist National Theatre. In Brooklyn's Dumbo neighbourhood there is the converted industrial building of St Ann's Warehouse, while in London's East End there is the renewed vaudevillian splendour of Wilton's Music Hall. Latterly, restoration has been the name of the game for many theatres, as renewed interest in theatre in recent decades has brought back the glory days to the dual homes of theatre – so they can maintain their pre-eminent status for years to come.

OPPOSITE:

Delacorte Theater, New York City
This open-air venue in Central Park staged its first play in 1962
– *The Merchant of Venice*, with George C. Scott and James Earl
Jones. Established with money from magazine publisher George
T. Delacorte Jr and his wife Valerie, the theatre is best known for
its free productions of Shakespeare plays, a summer tradition in
the Big Apple.

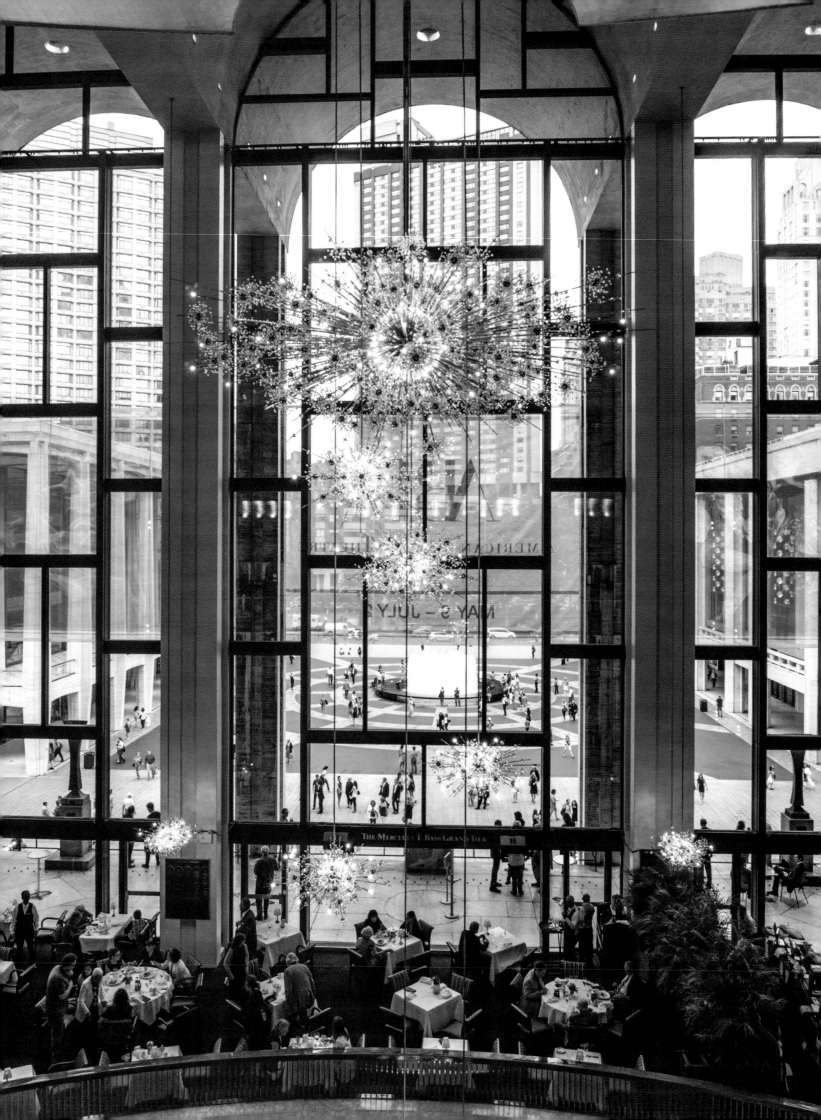

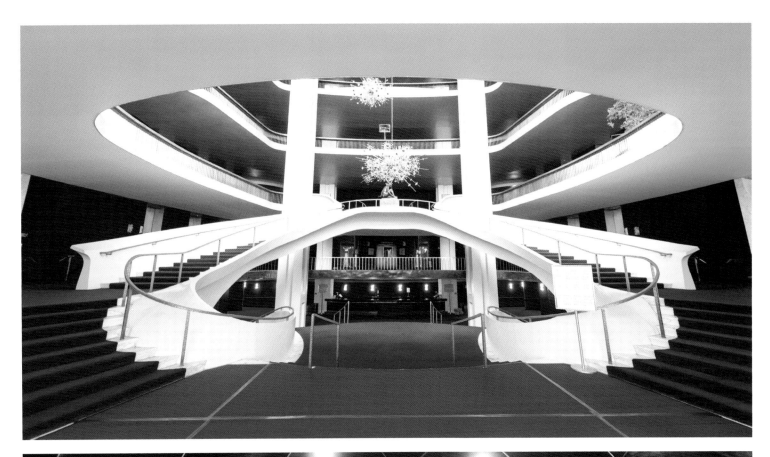

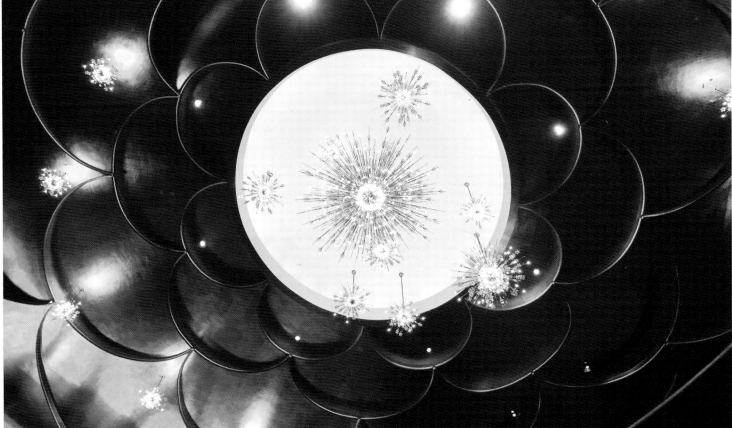

ALL PHOTOGRAPHS:

Metropolitan Opera House, New York City

The Lincoln Center opened in the 1960s and one of its institutions was
this one, which had already existed for almost a century. The 'Met',
founded in 1883, had previously been housed in a theatre at the junction
of Broadway and 39th Street. When the Lincoln Center was built, it was
on the area that was the setting for *West Side Story*.

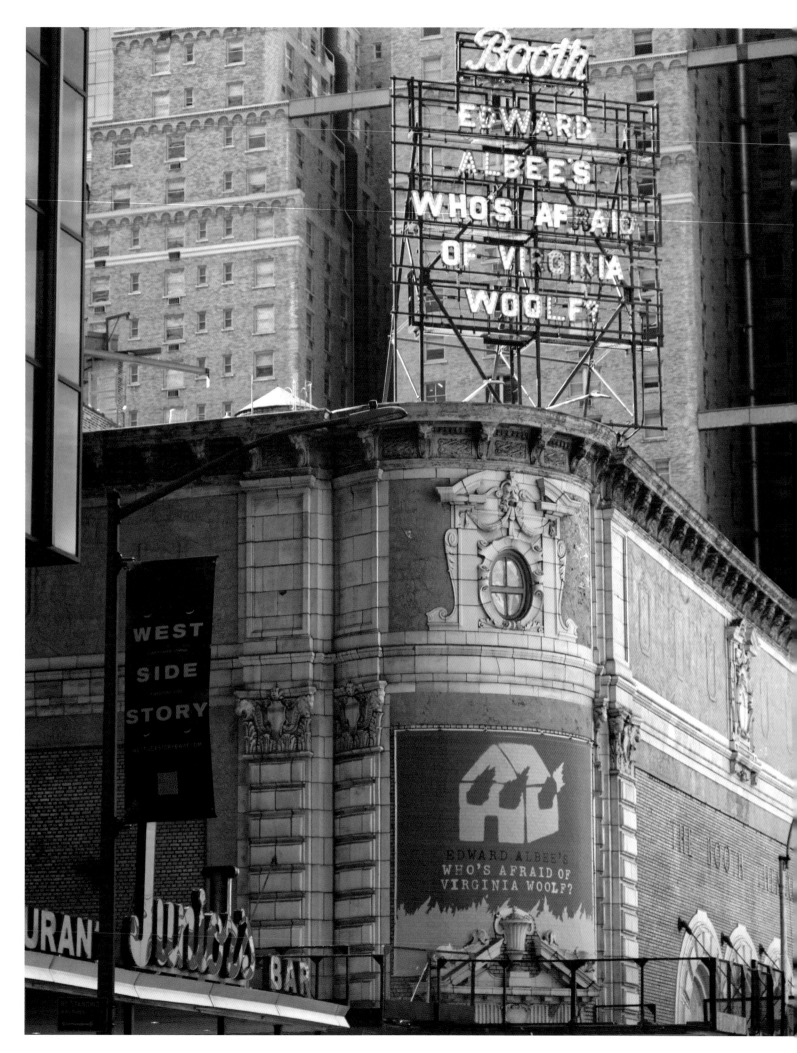

LEFT:

Booth Theater, New York City

This Broadway playhouse was built with its companion, the Shubert, so that both could sit within one seamless unit. It opened in 1913 and was named after actor Edwin Booth, who had already had a New York theatre named after him. The actor was the brother of John Wilkes Booth, who assassinated Abraham Lincoln – in a theatre.

BELOW:

Lyceum Theater, New York City

Built by producer-manager David Frohman in 1903, this Broadway venue boasts six Corinthian columns. Frohman built an apartment for himself in the venue, including a small door offering a bird's eye view of the stage below. Legend has it that he would wave a white handkerchief from it to tell his wife, actress Margaret Illington, when she was over-acting.

Shubert Theatre, New York City
The Booth's larger companion, this playhouse rose from the ashes of a failed 'art' venue on Central Park West. The Shubert shares a private road with the Booth – known as Shubert Alley – and, like the Lyceum (also owned by the Shubert Organization), there is an apartment above the theatre, which acts as the business's offices.

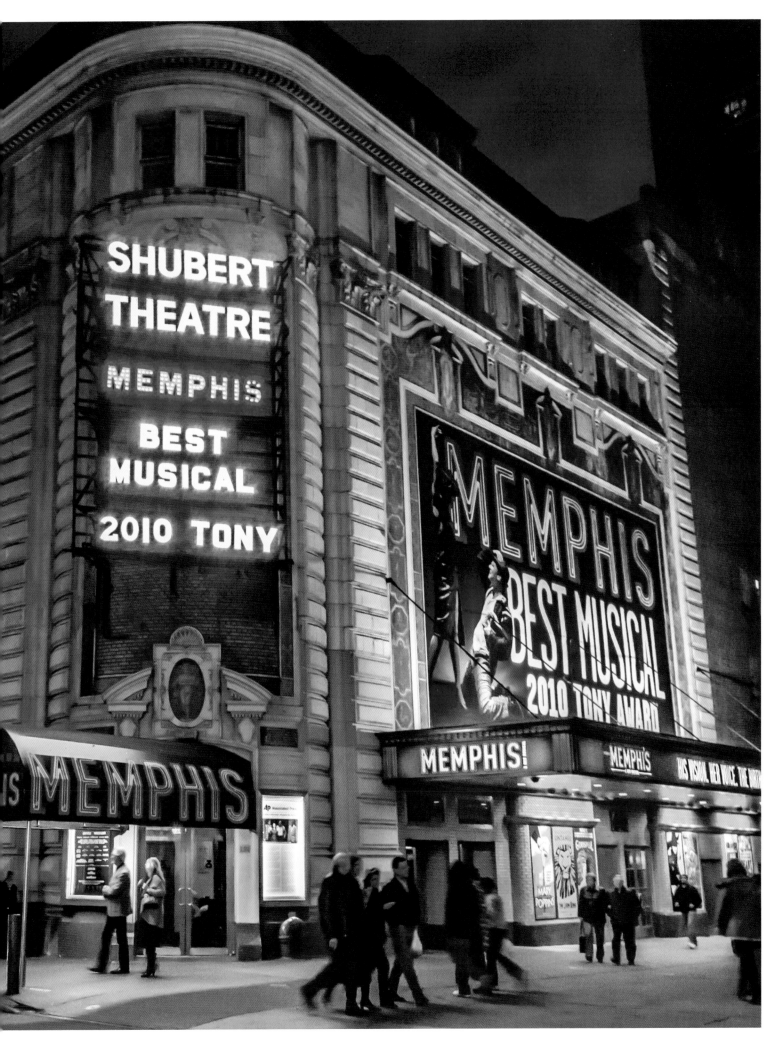

LEFT:
Richard Rodgers Theatre, New York City
This Broadway venue was built by Irwin Chanin in 1925 and was the first to feature a 'democratic' seating plan, in which there were no separate doors for the posh seats. It was renamed in 1990 after composer Richard Rodgers. Hamilton broke its box office record after it opened in 2015.

BELOW:
Walter Kerr Theatre, New York City
Opening as the Ritz in 1921, this playhouse was a radio and then television studio between 1943 and 1965, and was then vacant until 1971. It eventually reopened as a children's theatre, named in honour of Robert F. Kennedy. In 1990 it was renamed after theatre critic Walter Kerr.

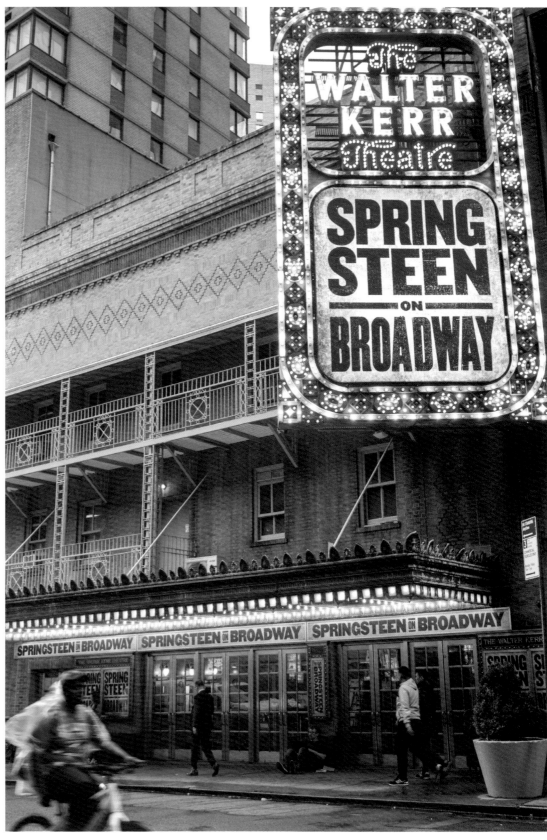

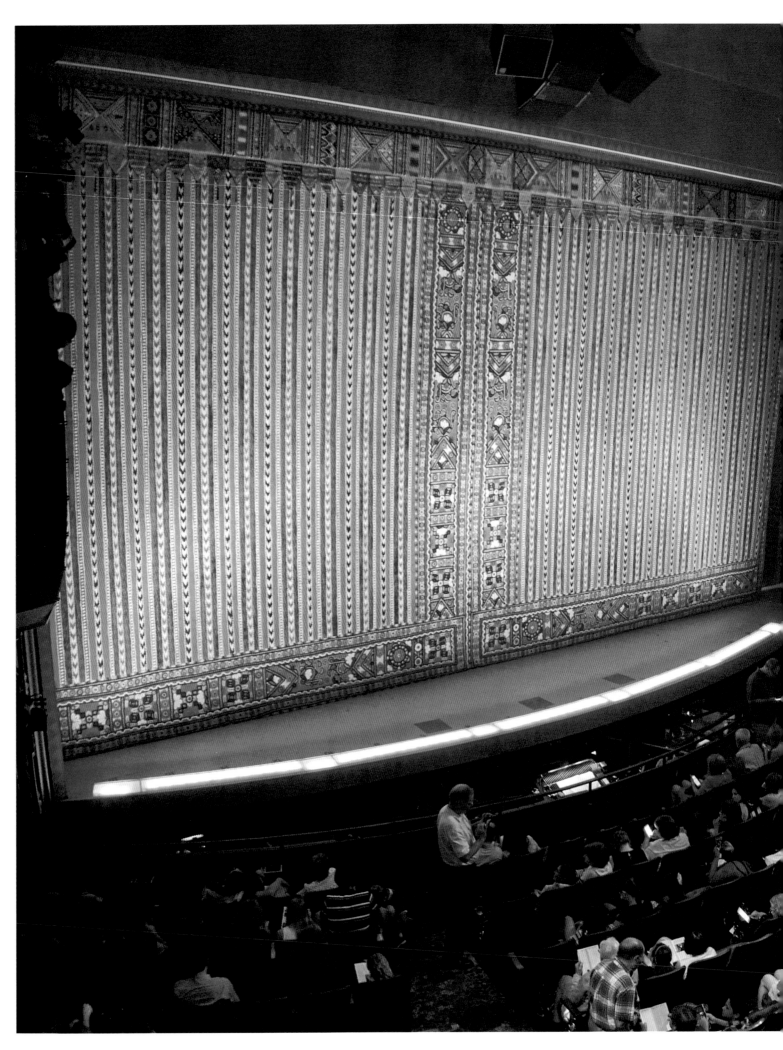

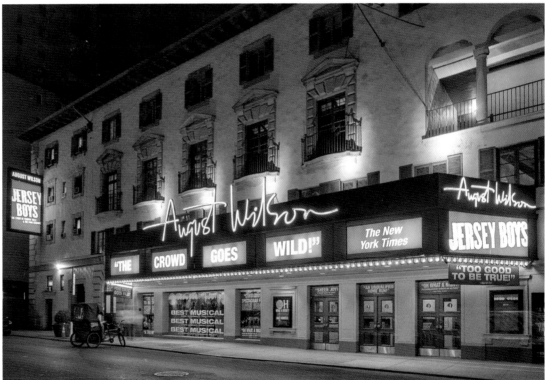

LEFT:

New Amsterdam Theatre, New York City

Nicknamed the 'House Beautiful' when it opened in 1903, this venue was home to the dance-led spectacular Ziegfeld Follies for 14 years from 1918. The 1929 Great Depression started five decades of decline for the theatre, and it was a cinema for a time. It is said to be haunted by a Ziegfeld Follies chorus girl who died from mercury poisoning.

ABOVE TOP:

Al Hirschfeld Theatre, New York City

Architect G. Albert Landsburgh designed this playhouse in the Byzantine and Moorish styles, with its dome being in the latter fashion. It was called the Martin Beck Theatre, after its owner, until 2003, when it was given its current name, in honour of illustrator Al Hirschfeld, who had a regular seat. Sadly, he died before the renaming ceremony.

ABOVE BOTTOM:

August Wilson Theater, New York City

This venue was given the name of the Pulitzer prize-winning playwright only 14 days after his death, in 2005. Until then, it had been called the Guild Theater, as it had been constructed by the Theater Guild in 1925, then the ANTA (American National Theater and Academy) Theater, and then the Virginia Theatre.

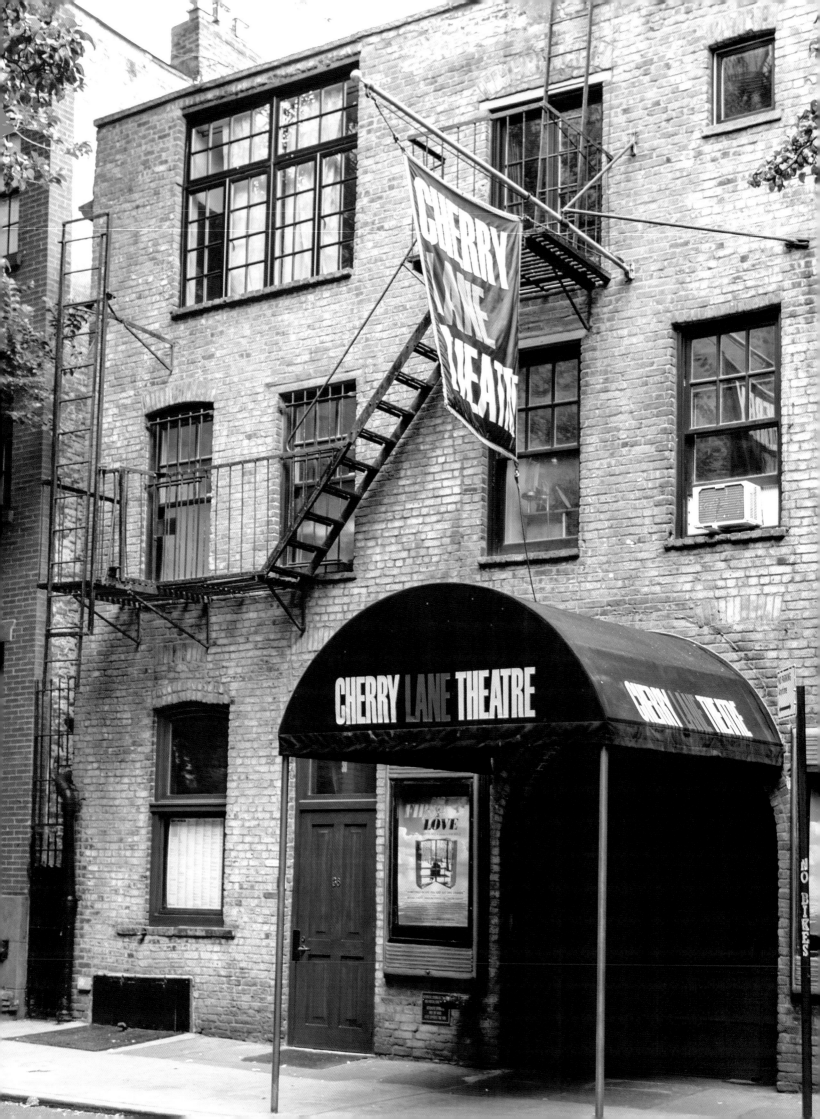

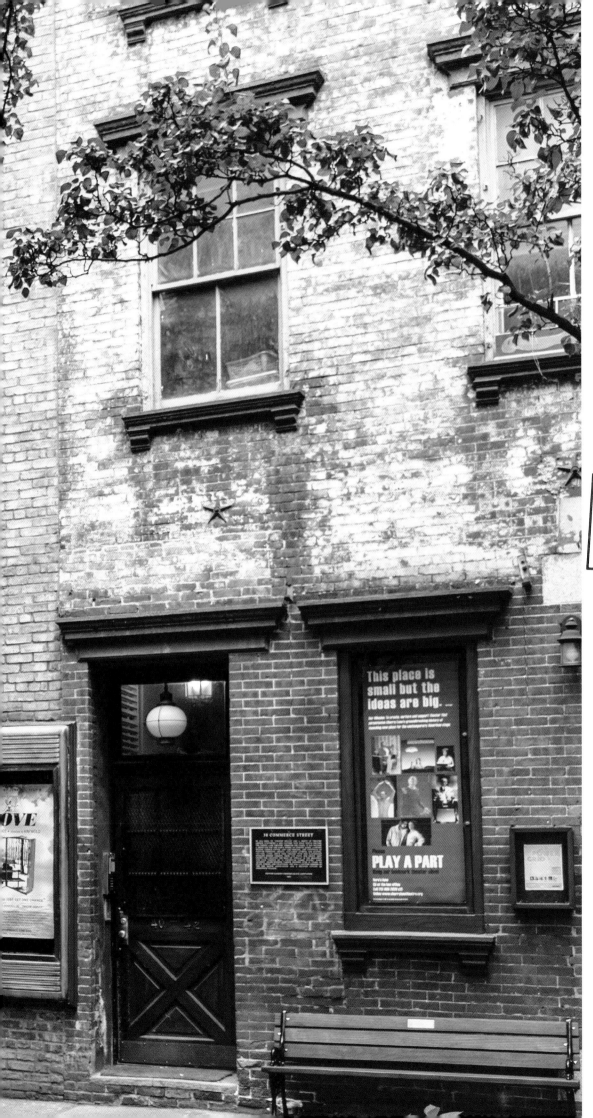

**Cherry Lane Theatre,
New York City**
This building was first erected as
a brewery in 1836, then a tobacco
warehouse and then a box factory.
Before all that there had been a
silo, when this Greenwich Village
gem had been part of a farm.
In 1923 it was converted into
a playhouse and works by the
likes of F. Scott Fitzgerald, T.S.
Eliot and Joe Orton have been
performed there.

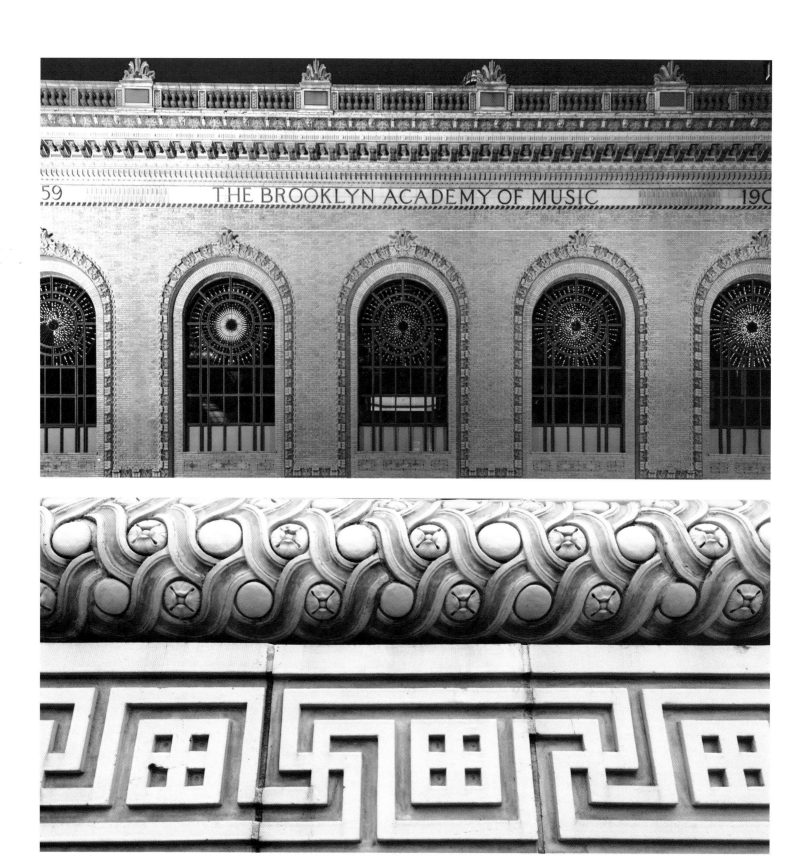

ABOVE TOP AND BOTTOM:

Brooklyn Academy, Brooklyn, New York City

This institution's 1861 building on Montague Street burned down in 1903, which precipitated the construction of the Layfayette Street base. The principal space here is the grand Opera House, and Brooklyn Academy was the first American venue to stage a performance from ballet dancer Rudolf Nureyev after he defected from the Soviet Union in 1961.

OPPOSITE:

The Public Theater, New York City

'Of, by, and for all people' is the motto of this non-profit organisation. It was founded by producer and director Joe Papp, who also established Shakespeare in the Park at the Delacorte. But, for the Public, he chose the old Astor Library in Lower Manhattan, moving there in 1967 and reportedly renting it from the City for $1 (about 75p) a year.

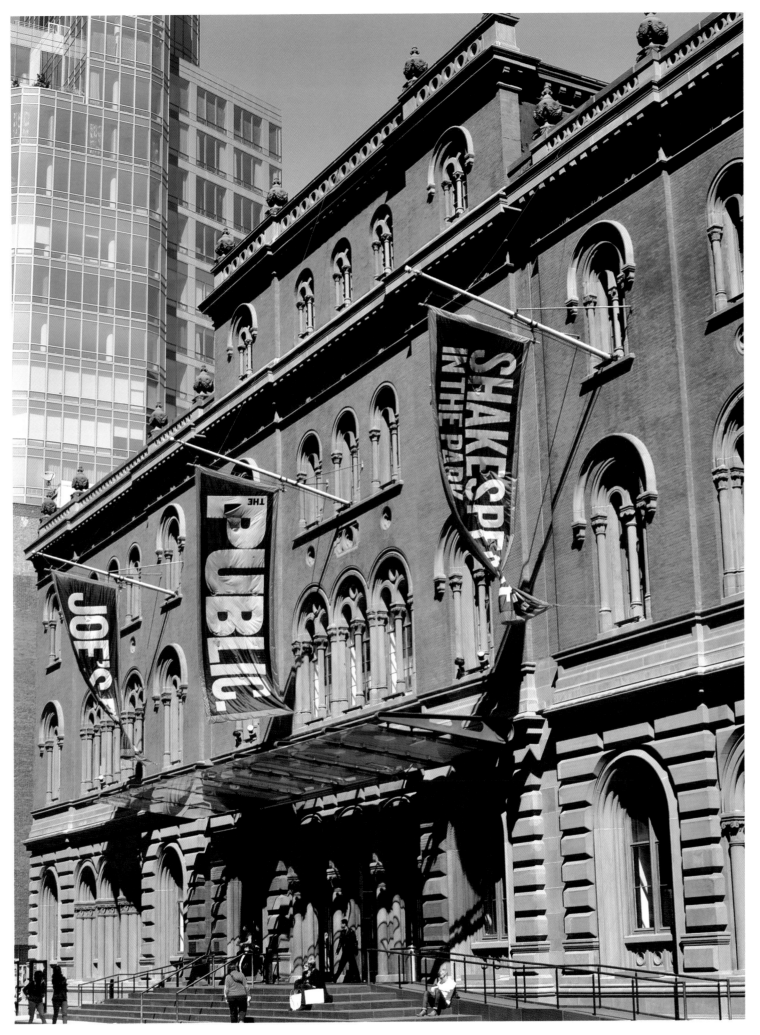

23

**St Ann's Warehouse,
Brooklyn, New York City**
This theatre, in the Dumbo (Down
Under the Manhattan Bridge
Overpass) area, is in an 1860
industrial building that stored
tobacco. Before that, the company
was in an old spice-milling factory
nearby, and before that, where it all
started back in 1980, the Church
of St Ann and the Holy Trinity in
Brooklyn Heights.

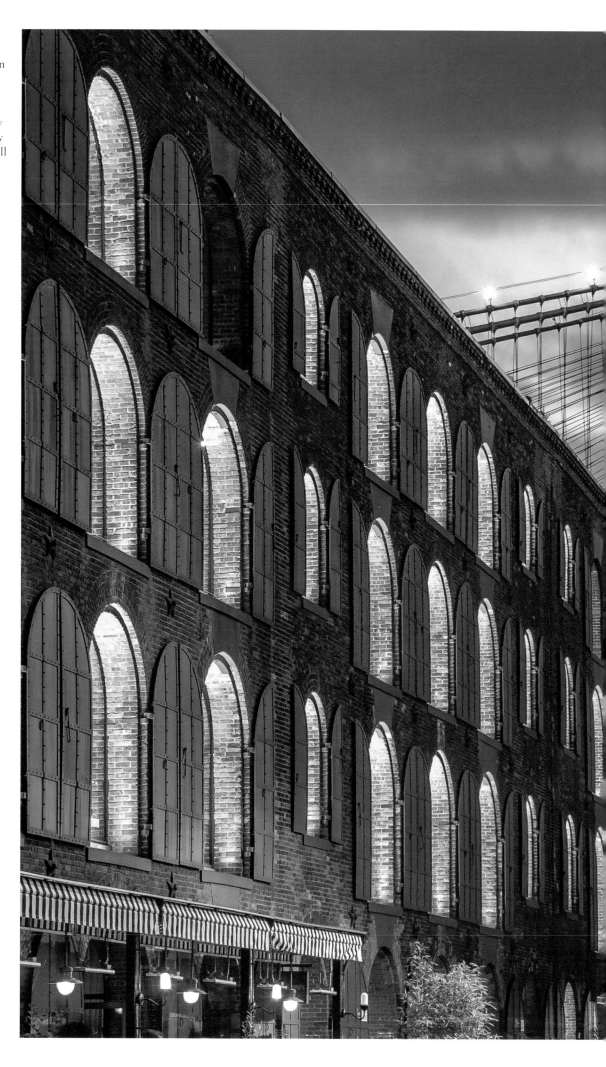

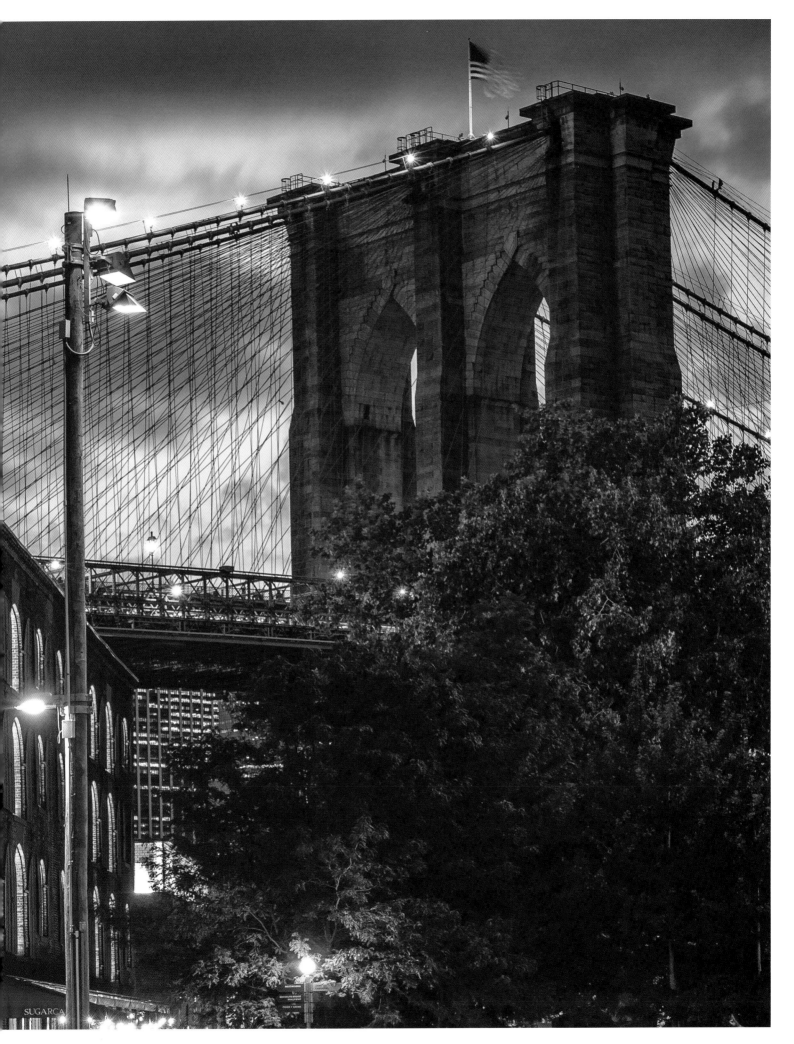

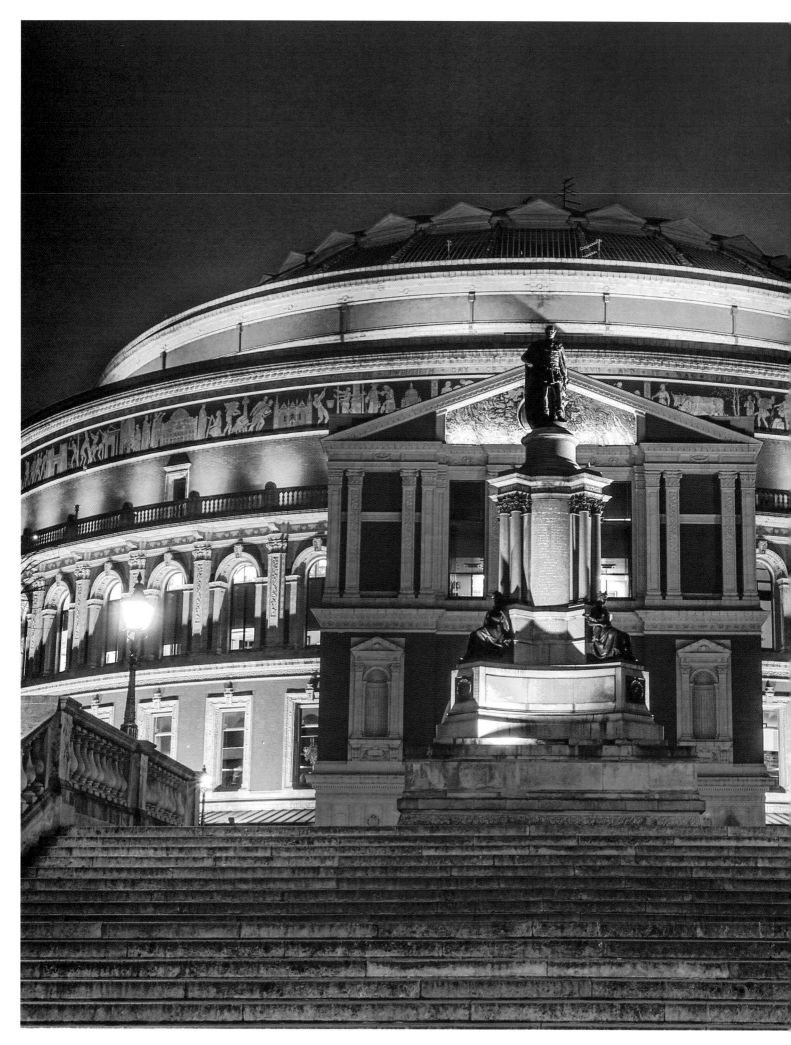

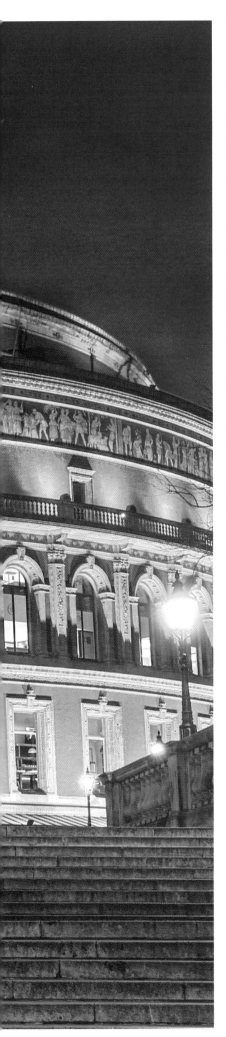

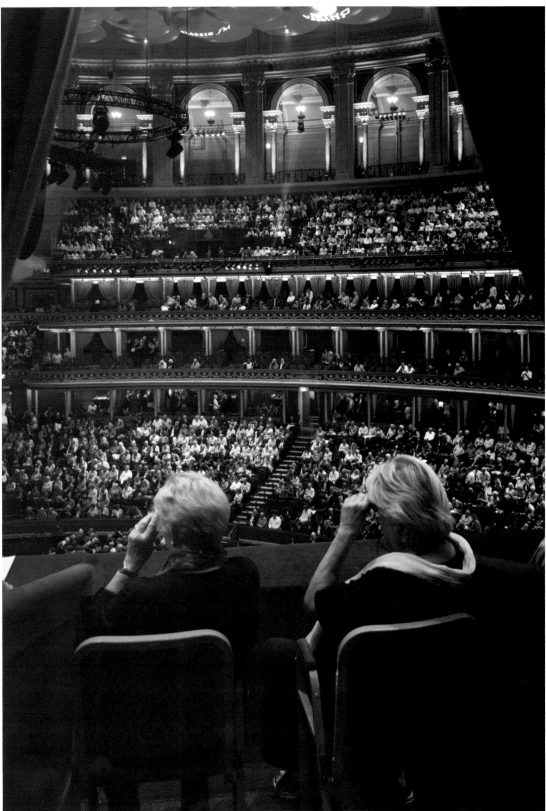

LEFT AND ABOVE:
Royal Albert Hall, London
This iconic London venue was built as part of a whole cultural quarter in South Kensington that was the pet project of Queen Victoria's husband Prince Albert. The distinctive circular design is based on Roman amphitheatres, and the red Aberdeen granite foundation stone, laid by Victoria herself, can still be found under seat 87, in row 11 of the K stalls.

ALL PHOTOGRAPHS:

Coliseum (English National Opera), London

Designed by theatre architect Frank Matcham, on opening in 1904 the London Coliseum was intended to be the largest and finest variety hall there was. Its giant stage was the first in Britain to have three 'revolves', and the theatre was the first in Europe to have public lifts to upper levels. In 1908 it even attempted a cricket match, between Middlesex and Surrey.

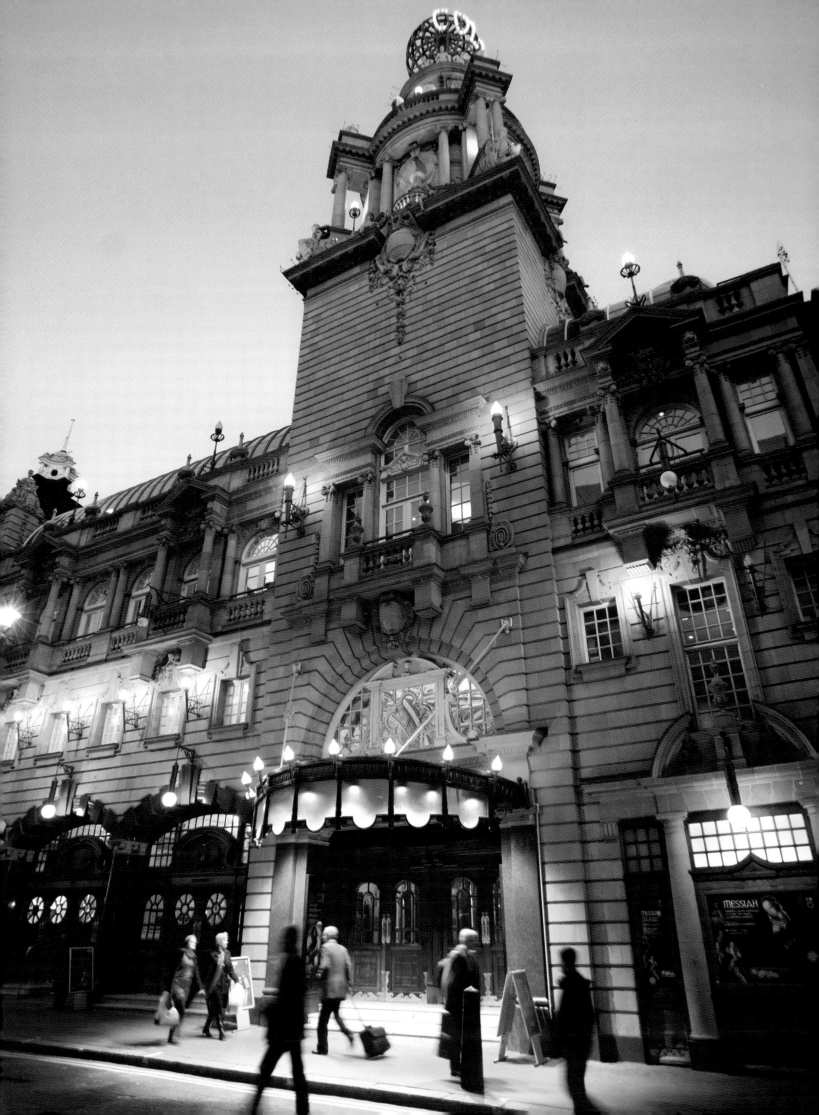

Lyceum Theatre, London
The rococo-style auditorium of this Covent Garden landmark spent much of the 20th century either under threat, earmarked for demolition, or used just for concerts. In the 19th century, Dracula author Bram Stoker was the theatre's business manager, writing the work there and being inspired for his lead character by his employer, actor and manager Henry Irving.

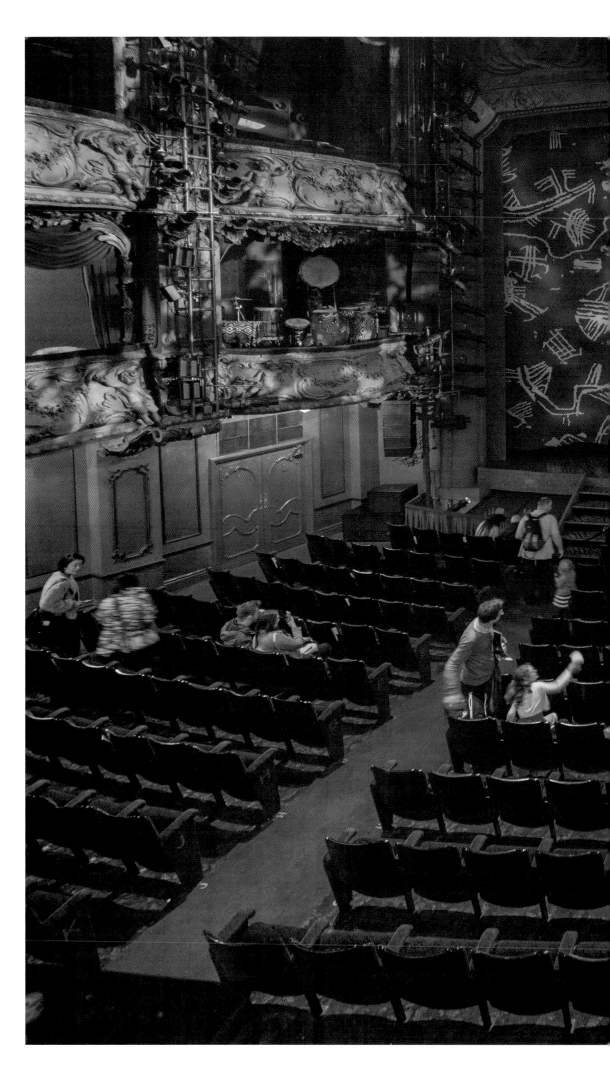

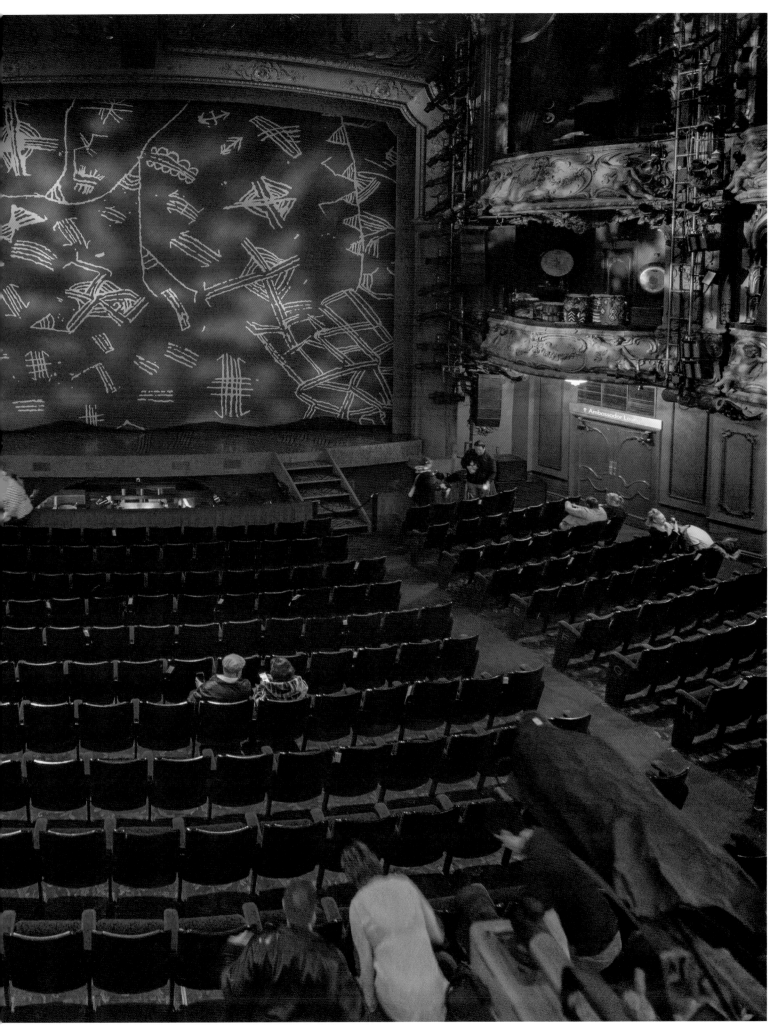

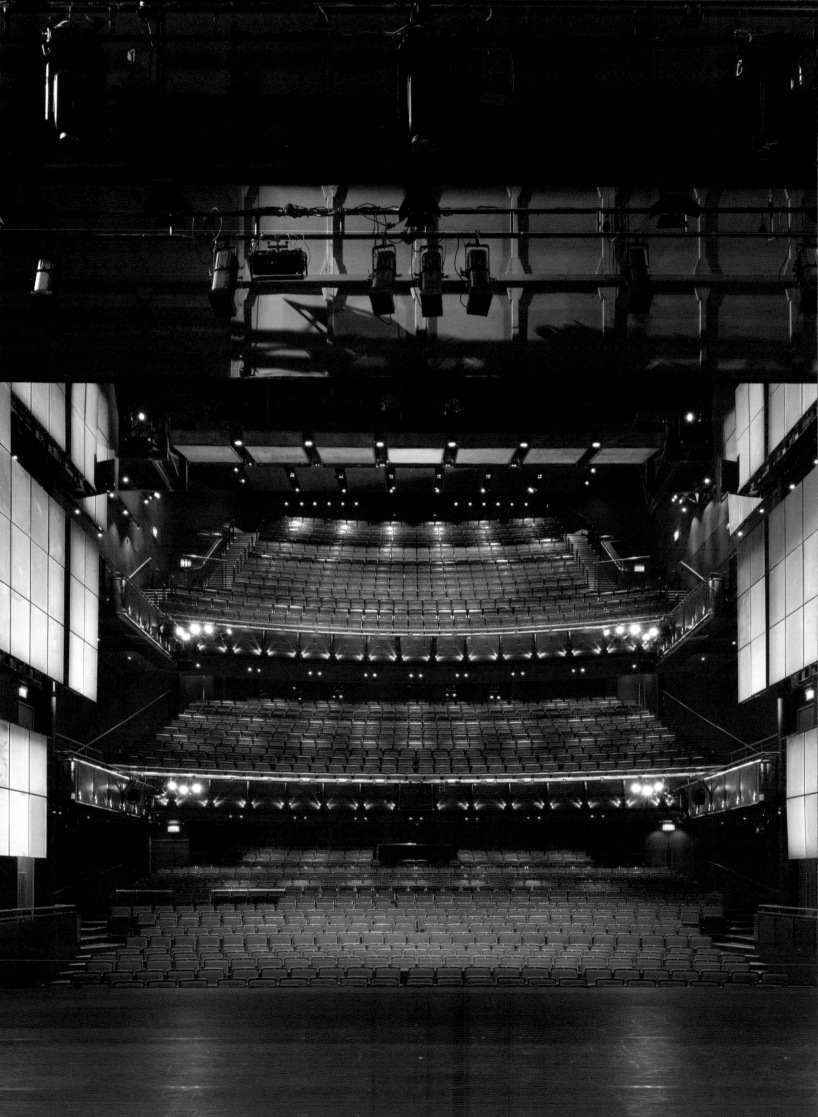

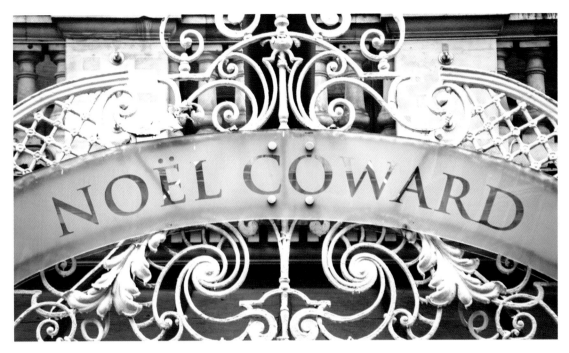

OPPOSITE:

Sadler's Wells, London
There has been a theatre on this Islington site since 1683, when Richard Sadler opened his 'Musick House' next to the terminus of the New River, which brought fresh water from Hertfordshire into London. The current 1998 theatre – one of the world's premier dance venues – is the sixth. Beneath it, there is still access to area's historic wells.

LEFT AND BELOW:

Noël Coward Theatre, London
This playhouse opened in 1903 and 30 years later was where John Gielgud made his name. It was originally called The New Theatre, then the Albery. Noël Coward's debut was in 1920 and the theatre was renamed after him in 2006.

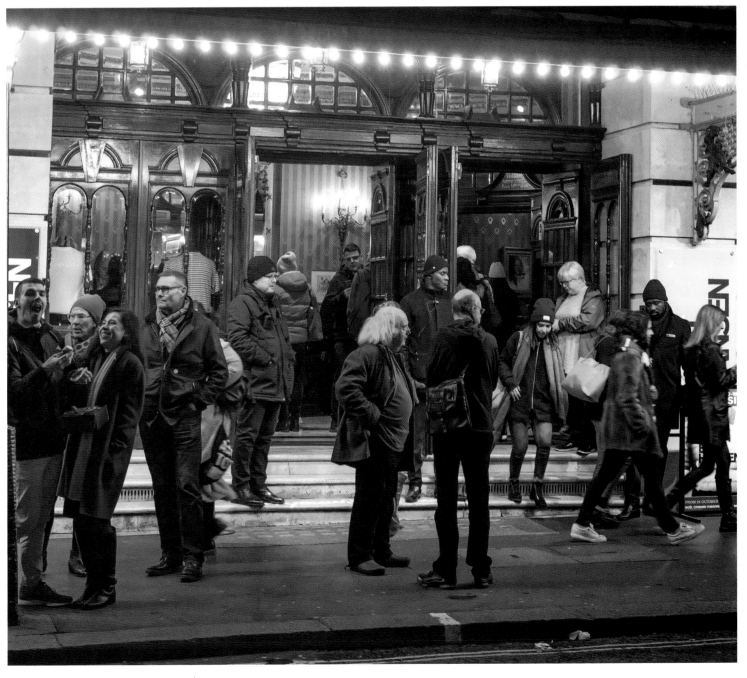

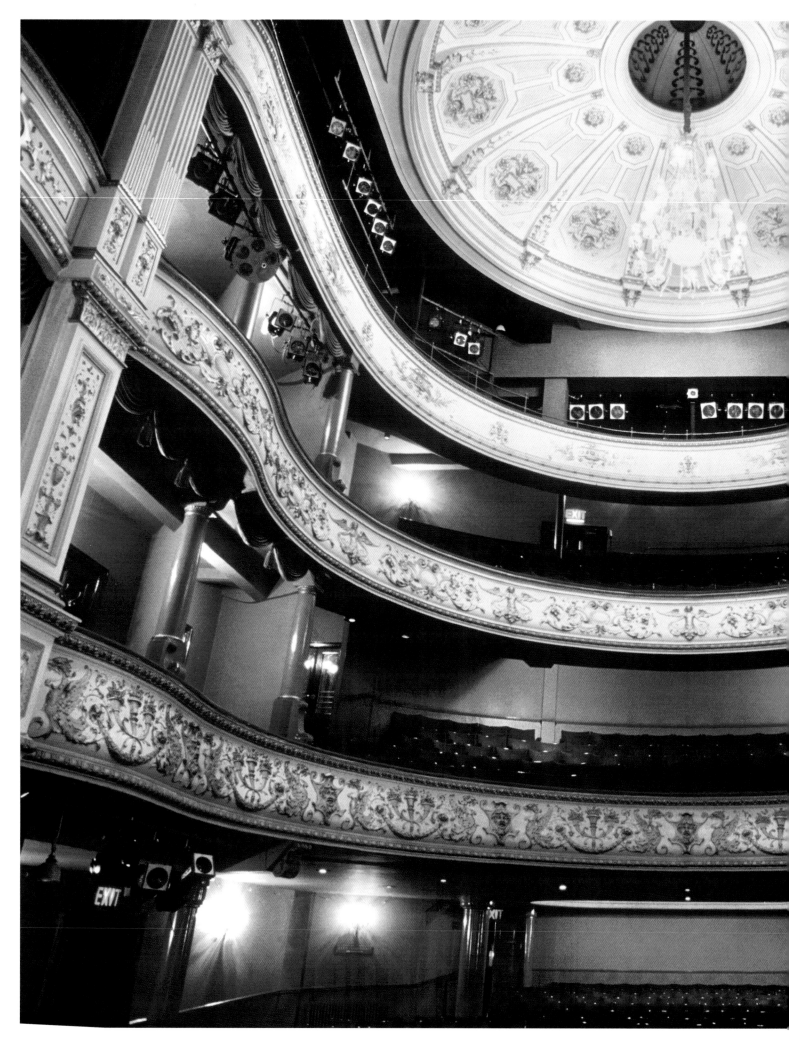

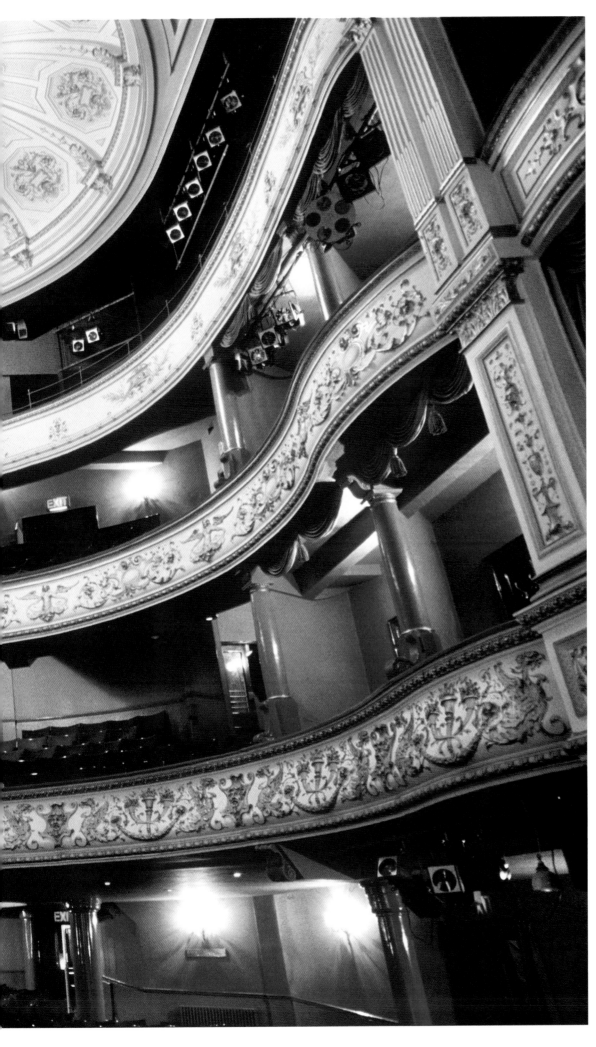

Duke of York's Theatre, London
When this venue opened in 1892, it did so as the Trafalgar Square Theatre, later given its current name in honour of the future King George V, who commented: 'It is a right royal building with a theatrical tradition fit for a King.' Charlie Chaplin's only West End performance was here, at 14, in *Sherlock Holmes* in 1905.

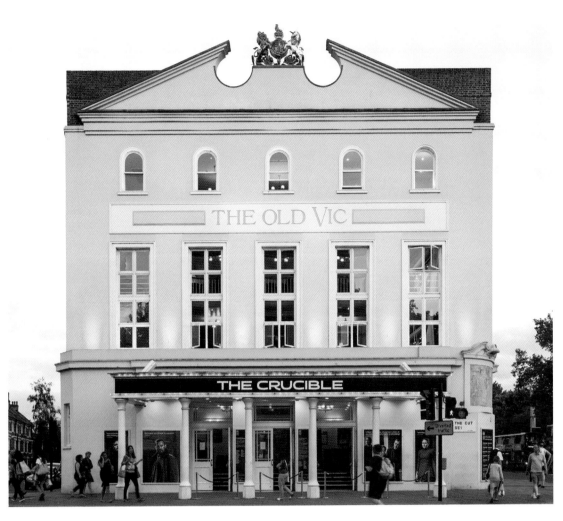

ALL PHOTOGRAPHS:

The Old Vic, London
Across the Thames from the West End stands a theatre that has become known by its nickname, rather than its original 1833 title, the Royal Victoria Theatre. When Shakespearean actor Edmund Kean ventured 'south of the river' to play The Old Vic, he said: 'I have never acted to such a set of ignorant, unmitigated brutes as I see before me.'

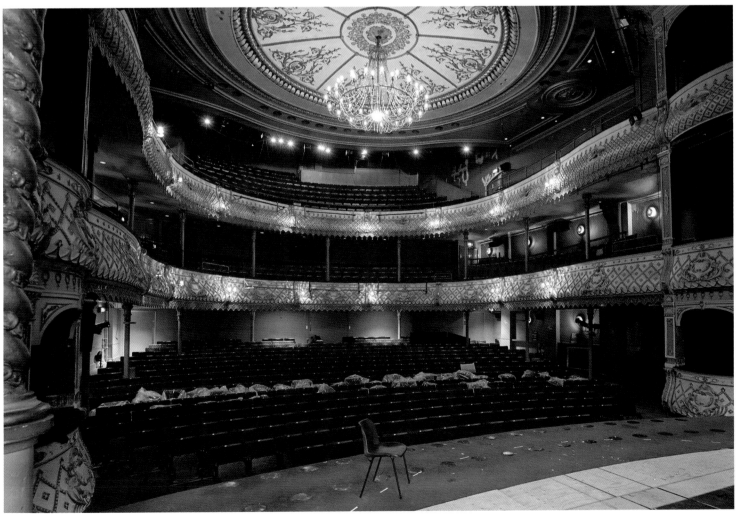

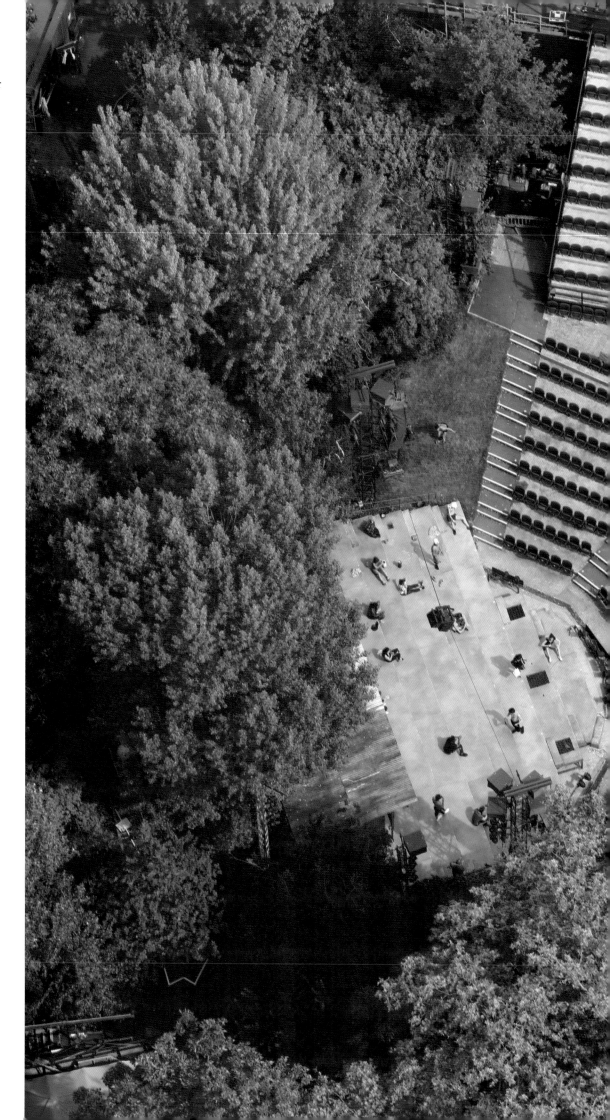

Regent's Park Theatre, London
Established in 1932, this open-air
'playhouse in the park' was one
of only two London theatres to
remain open throughout World
War II. Its first production was
Twelfth Night, which suited the
makeshift venue as it had been
hastily put together to plug a
gap in the West End after a play
on Napoleon by Italian dictator
Benito Mussolini had flopped.

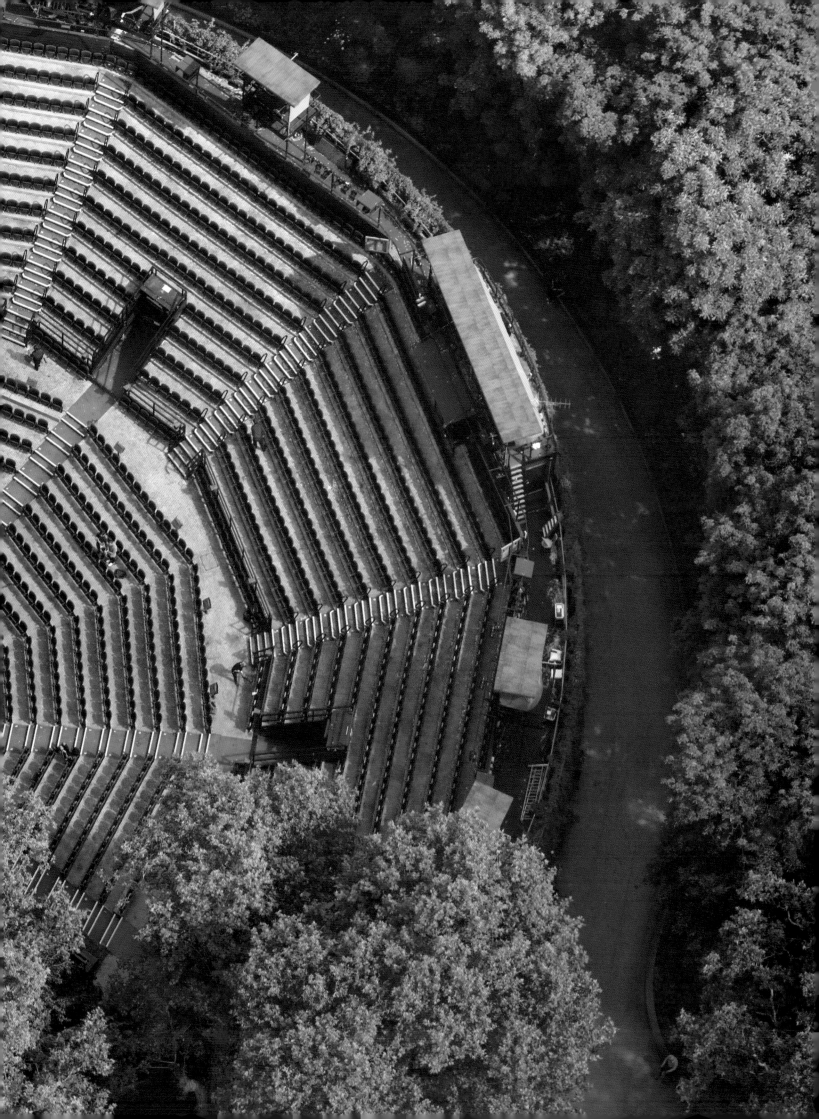

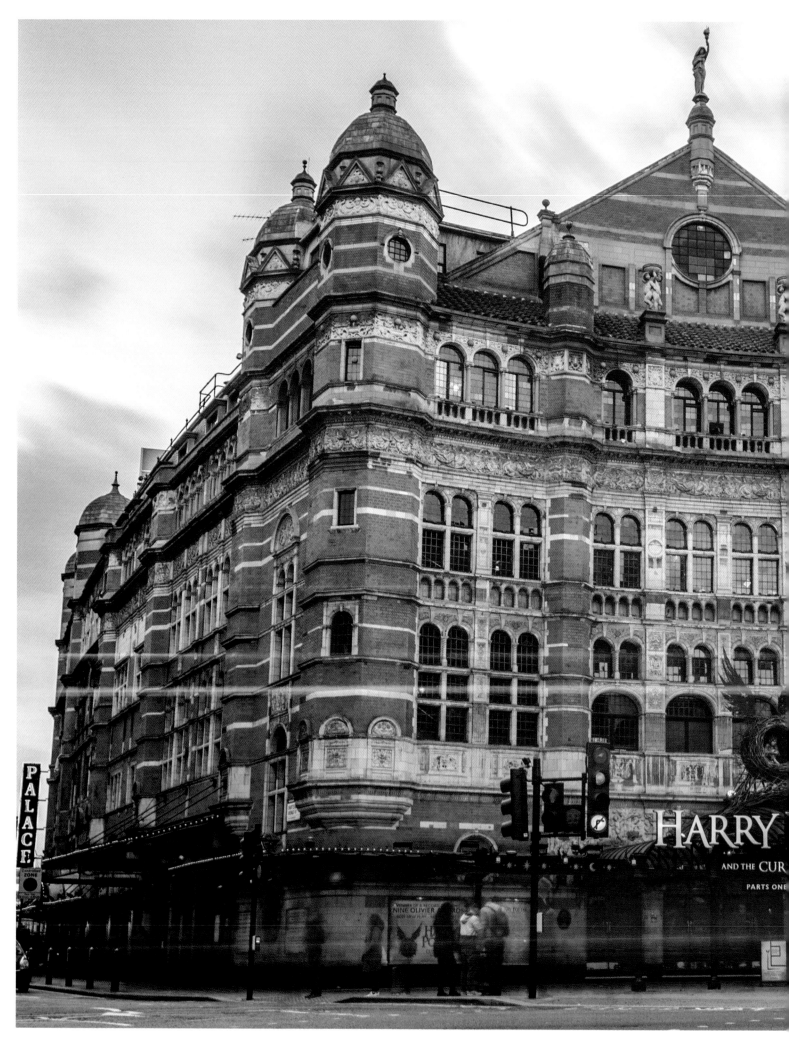

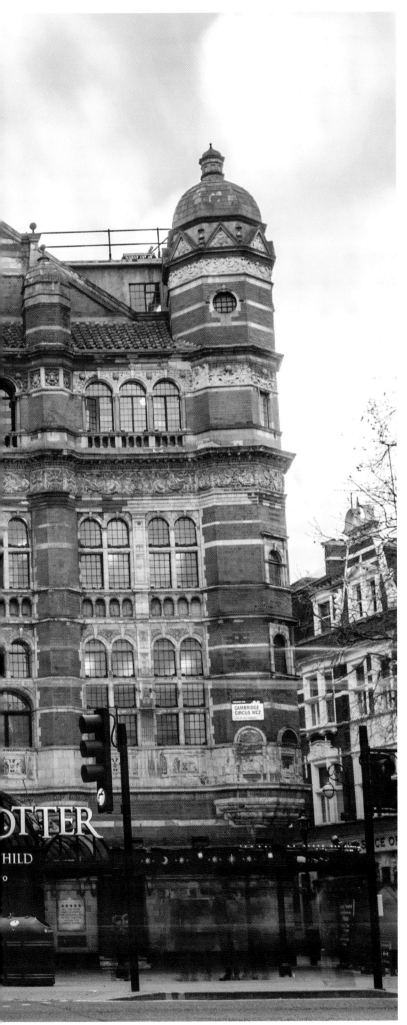

Palace Theatre, London

For almost 20 years, *Les Misérables* played at this Cambridge Circus landmark, becoming synonymous with the West End venue. Yet when it opened, in 1891, it was an opera house. Unfortunately, its owner, Richard d'Oyly Carte, had no operas to fill it so, within a year, it was converted into a music hall and renamed the Palace.

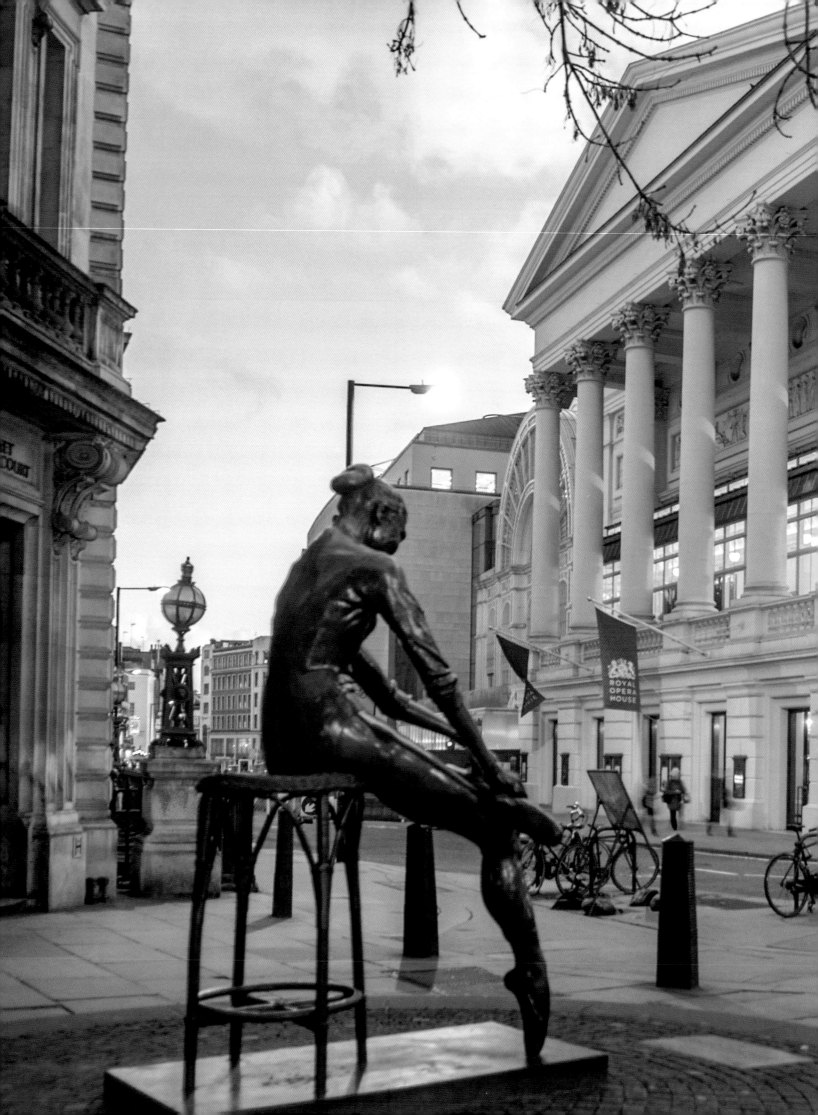

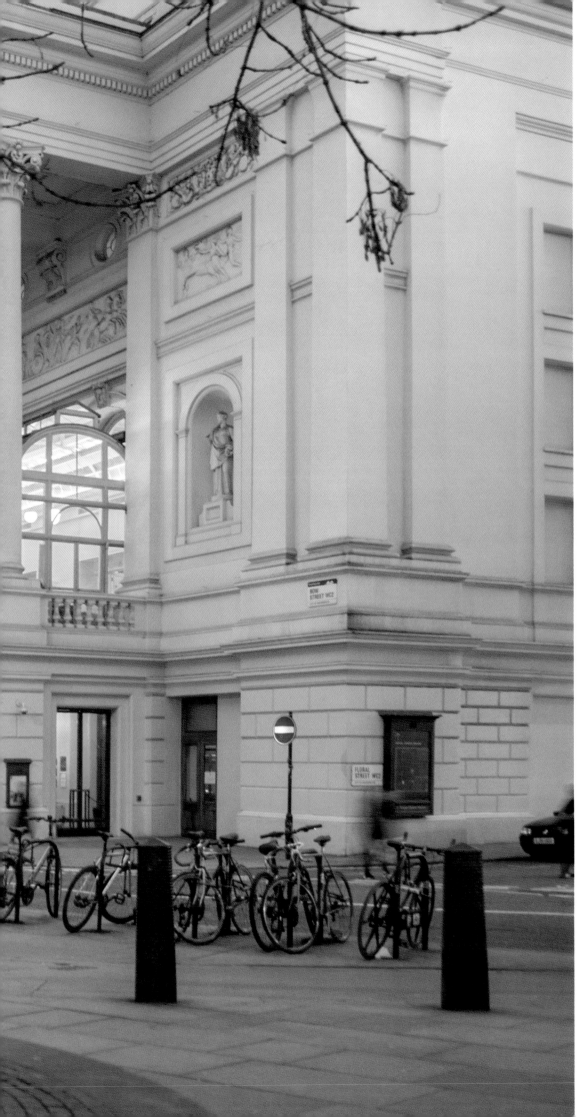

Royal Opera House, London
The current theatre, from 1858, is actually the site's third, the first two being destroyed by fire. The first was the Theatre Royal, Covent Garden, built in 1732 with the fortune that actor-manager John Rich made, appropriately, from *The Beggar's Opera*. In World War I, the building was a furniture repository and in World War II, a Mecca dance hall.

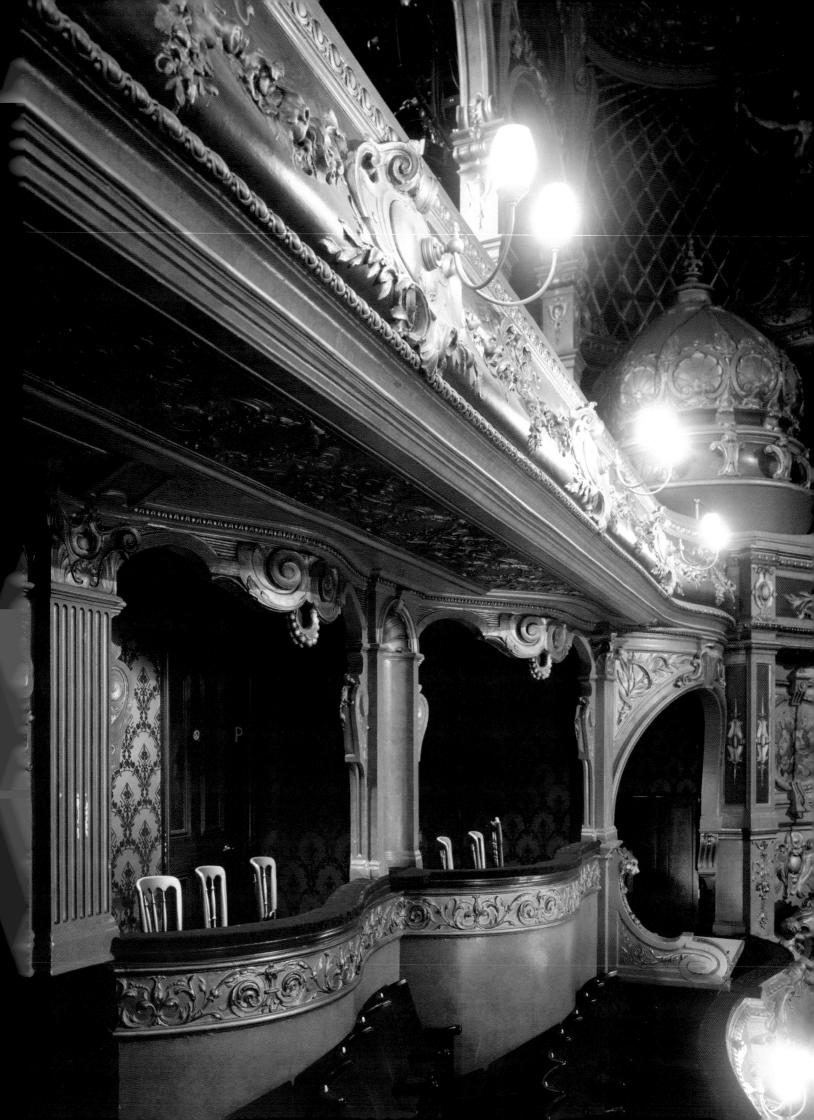

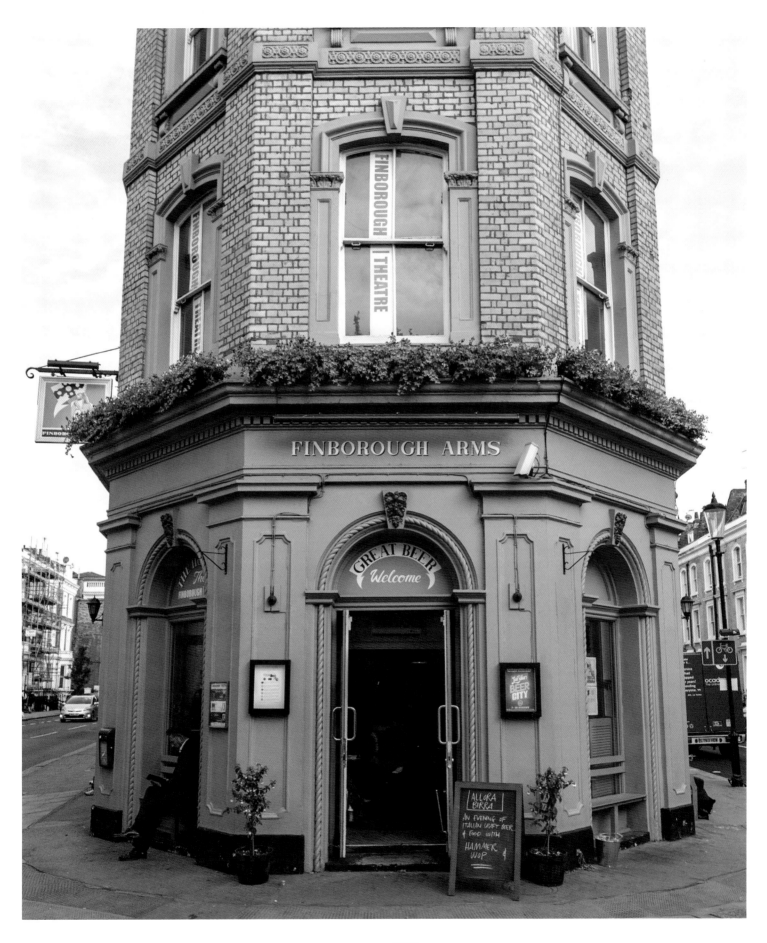

OPPOSITE:

Hackney Empire, London

The 1901 East End theatre was built as a music hall but spent most of the second-half of the 20th century as television studios, a bingo hall and a venue for alternative comedy, before being restored as a theatre. Charlie Chaplin, Stan Laurel and Julie Andrews all performed at the Frank Matcham-designed building when it was a music hall.

ABOVE:

Finborough Theatre, London

This gem in Earl's Court – which prides itself on putting on new or little-known works – sits above a pub, designed in 1868 by two brothers, one of whom, George Godwin, was also a playwright. However, the first floor was not a theatre until 1980, having previously been used as a Masonic Lodge, a billiards hall and a sitting room for the pub staff.

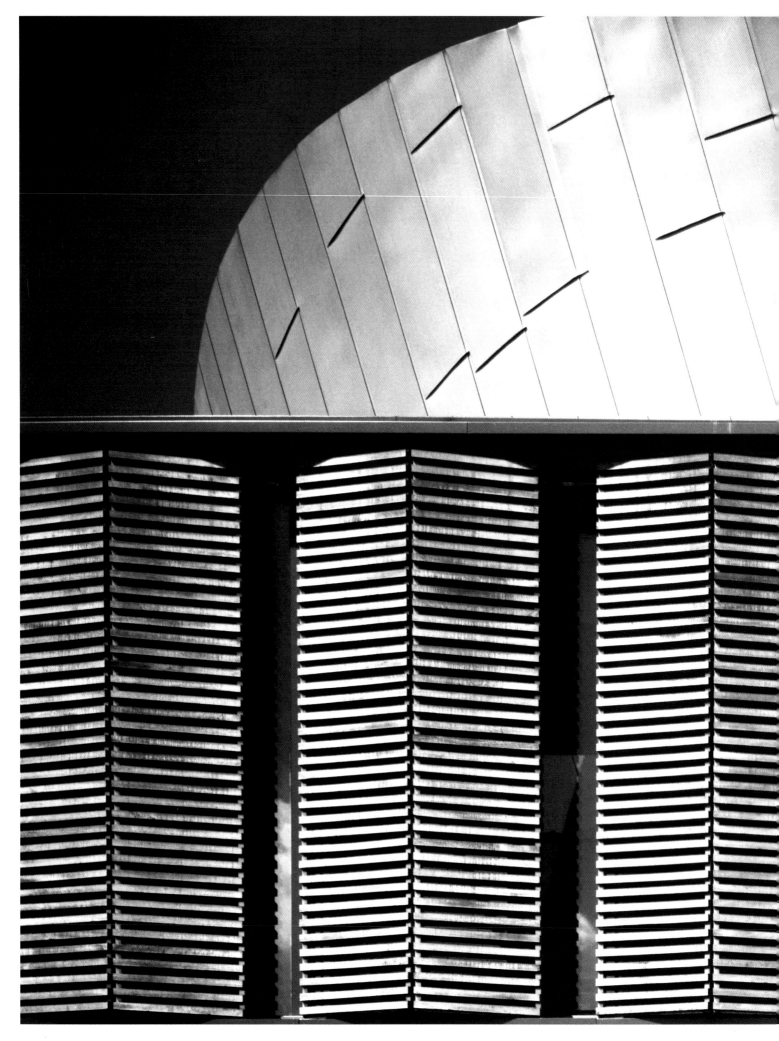

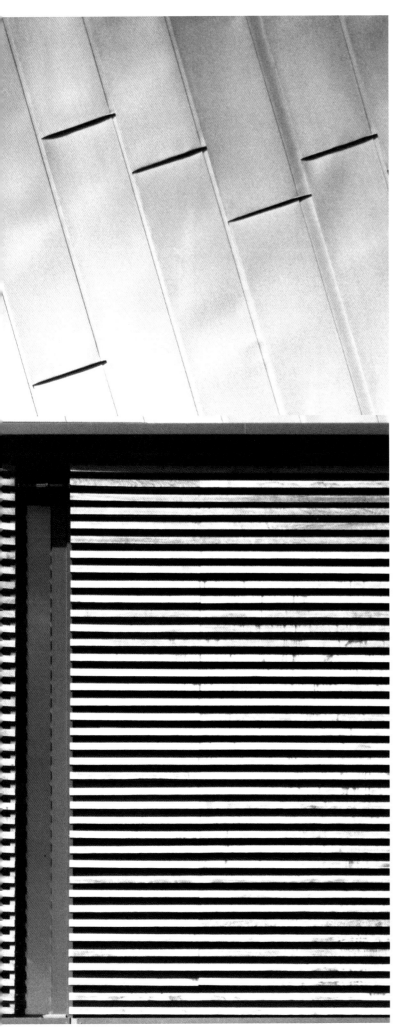

LEFT AND ABOVE:

Hampstead Theatre, London
This purpose-built 2003 building in Swiss Cottage is home to what originally started in 1959 in a school hall in Hampstead's Holly Bush Vale. In those days, Harold Pinter regularly tried out plays there. Since then, Hampstead Theatre has put on works by the likes of Mike Leigh, Michael Frayn and Brian Friel when they were emerging talents.

OVERLEAF:

Alexandra Palace Theatre, London
Looking down over the capital, this 1875 North London landmark was closed to the public for more than 80 years after it failed to compete with the West End. In the intervening years, it had various uses, including a chapel, a cinema, and BBC props store and workshop. The theatre was officially reopened in 2018.

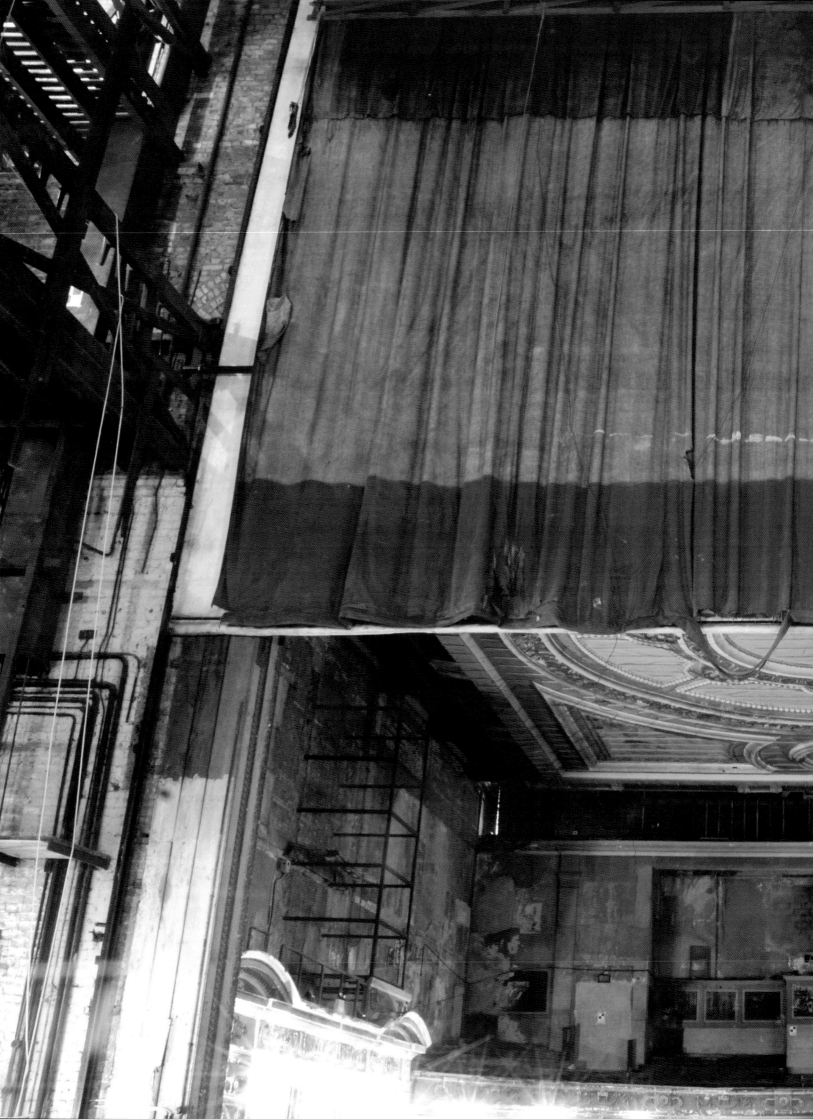

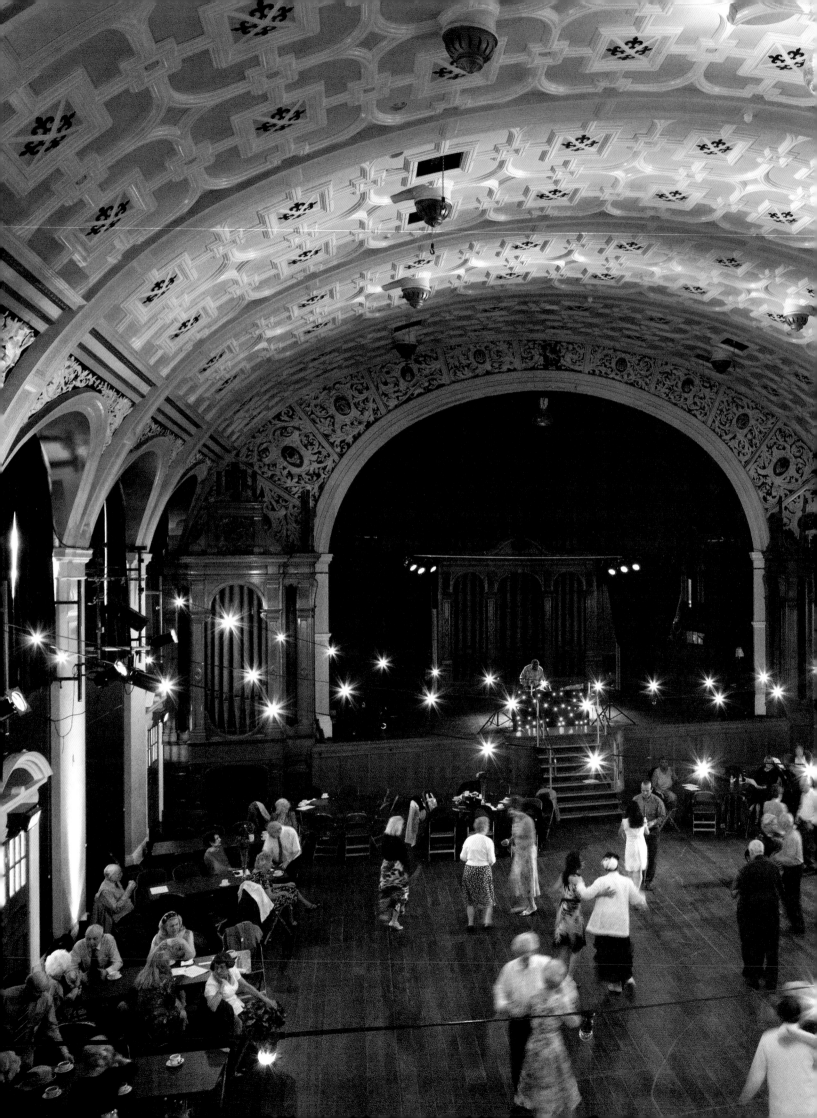

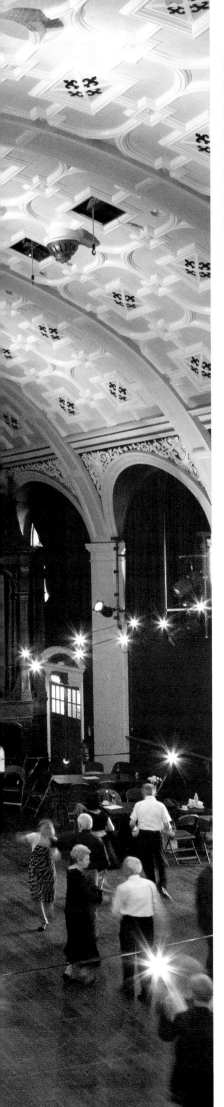

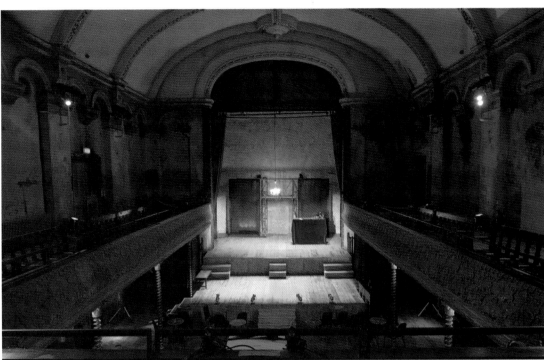

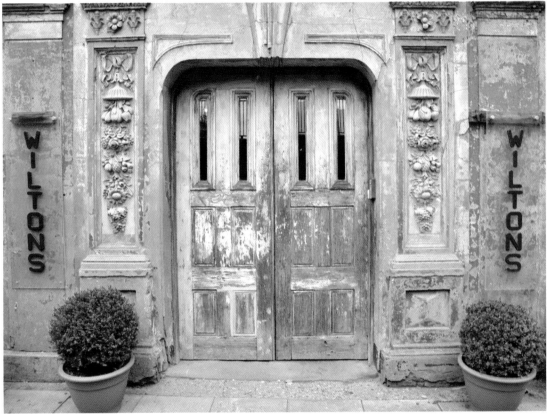

LEFT:

BAC (Battersea Arts Centre), London

The 1893 building is the area's former town hall, which was mothballed in 1965 when power was transferred a neighbouring council. It reopened as an arts centre in 1974, with one of its great successes being developing *Jerry Springer: the Opera*, which one four Olivier awards – and provoked 55,000 complaints.

ABOVE TOP AND BOTTOM:

Wilton's Music Hall, London

This space began life in the 1690s as houses, shops and a pub, which were combined in the 1850s to bring West End glamour to the East End. But then, in 1868, John Wilton sold his new music hall in order to open a West End restaurant. Throughout most of the 20th century, the theatre was a Methodist mission, before holding performances again from 1997.

OVERLEAF:

Globe Theatre, London

The open-air venue that stands today is a 1997 recreation of the 1599 playhouse built by the Lord Chamberlain's Men, the company Shakespeare wrote for and part-owned. It is the brainchild of American actor and director Sam Wanamaker, who spent more than two decades trying to resurrect 'Shakespeare's theatre' but died before it opened.

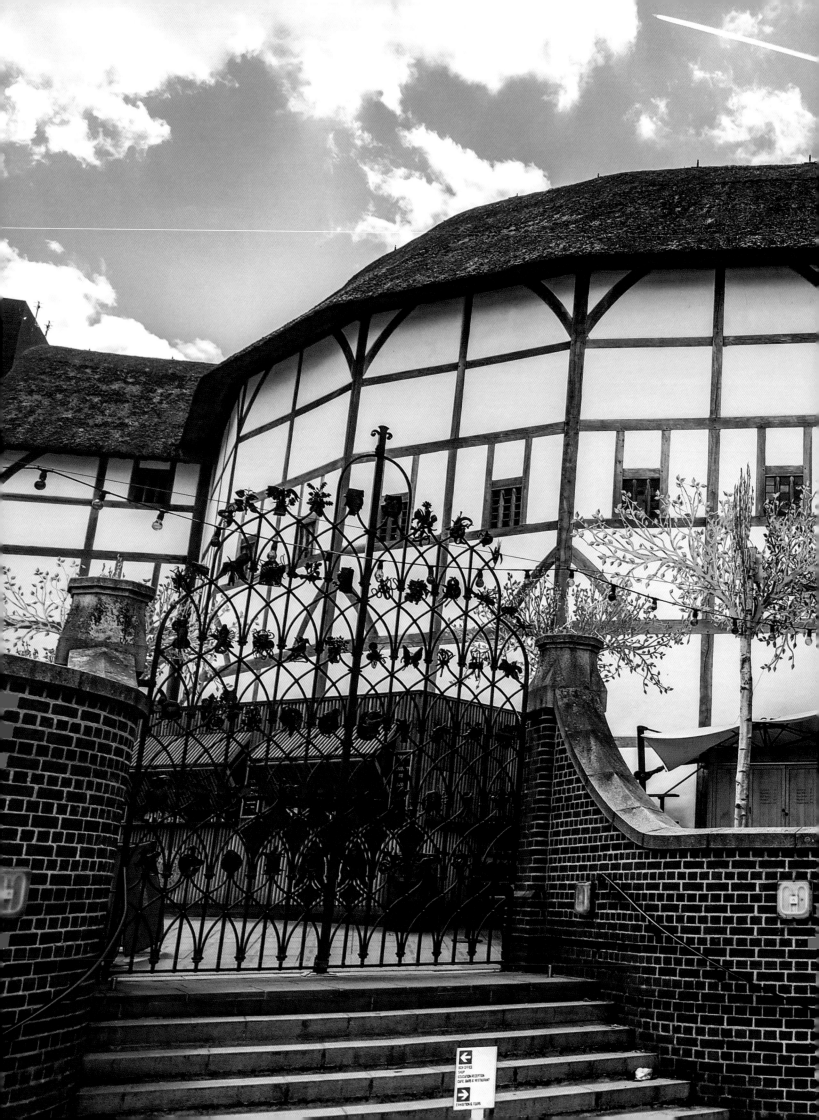

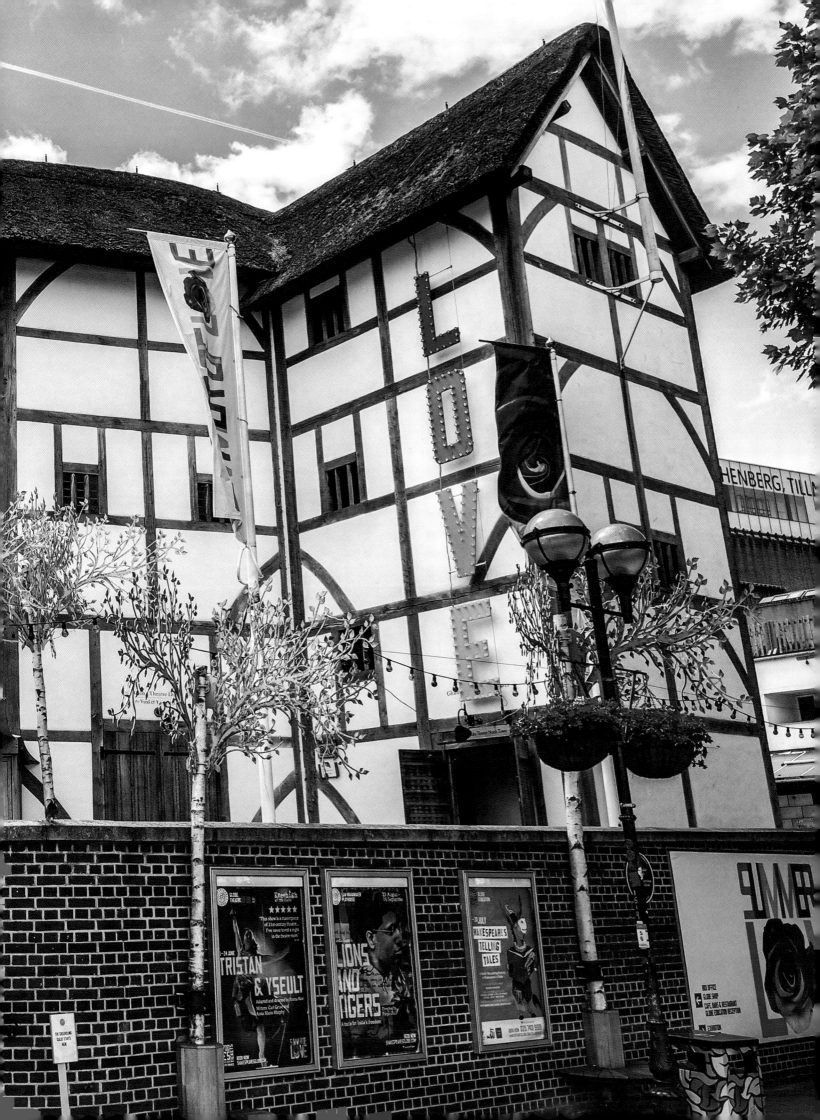

National Theatre, London
This iconic building on the South Bank opened in 1976, with Albert Finney playing Hamlet on the Lyttelton stage, one of the three venues in the complex. *Hamlet* had also been the launch play 13 years earlier, with Peter O'Toole in the title role, when the National Theatre Company was founded at The Old Vic, while the new venue was in gestation.

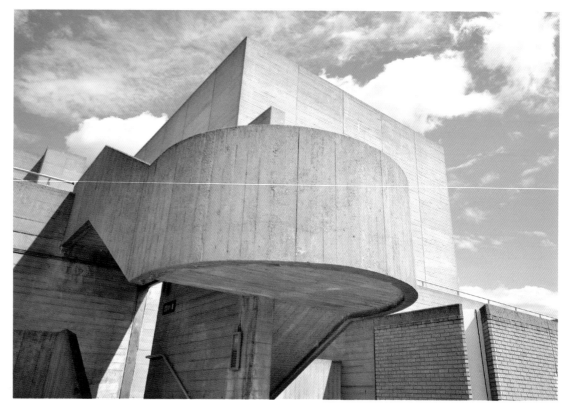

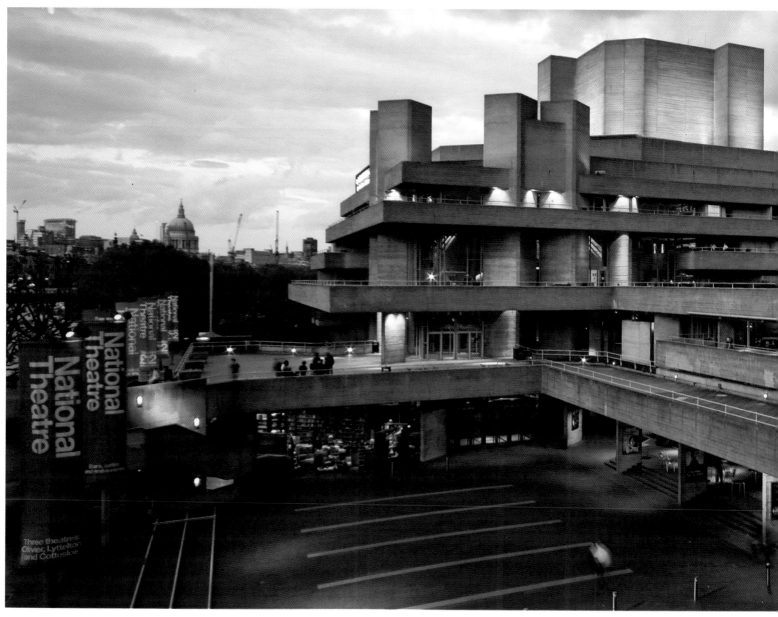

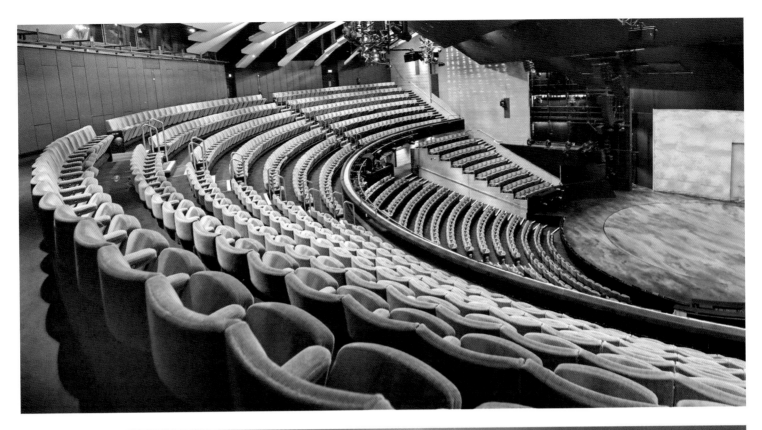

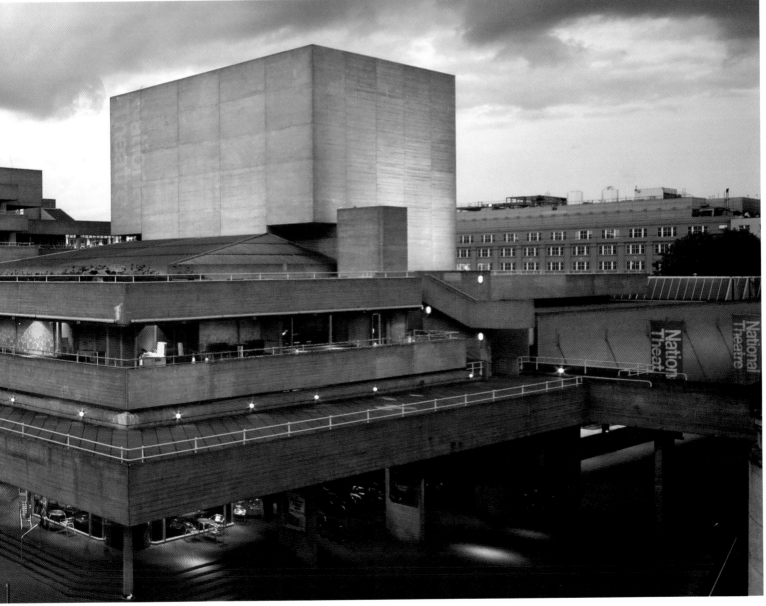

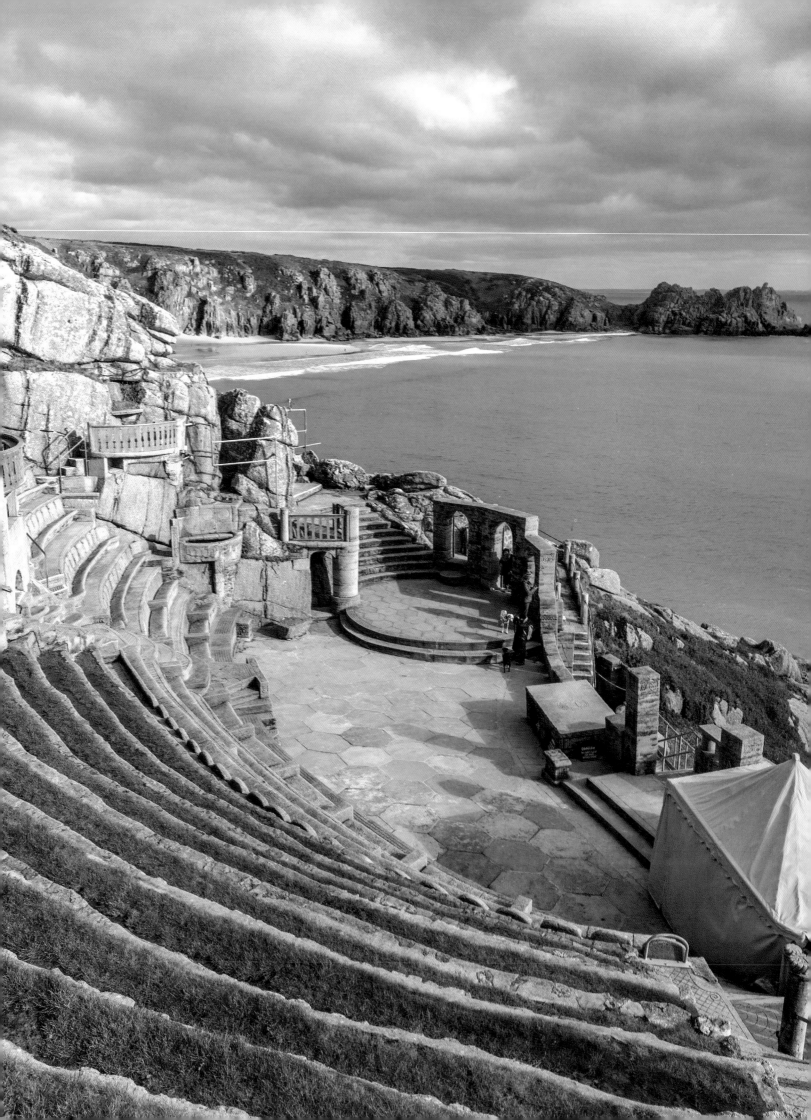

Europe

T When it comes to grandeur, there's no beating the 19th-century opera houses and national theatres of Europe. The scale and attention to detail knew no bounds, with many of the projects taking years and years to construct, as the ever-ambitious nations and cities sought to outdo each other with more and more opulent buildings, often by Royal decree. But then, what would have been expected of a continent that built the world's first surviving grand theatres, more than 2,000 years ago?

This chapter traces the roots of the stage all the way back to the open-air Greek and Roman amphitheatres, which extended across the continent and set the tone for playhouses in centuries to come, but arguably with better acoustics then. This chapter also delves into the variety of venues that Europe has to offer, from the converted slaughterhouse in Madrid that is now an arts centre, to the puppet theatre in Georgia that has recreated the Battle of Stalingrad; from the outdoor theatre hewn into a cliffside in Cornwall, to the theatre in Oslo that appears to be rising out of a fjord.

The basis for all these amazing theatres is creativity – either on a national or regional level. Europe is a continent that can create a theatre out of a cave in the Rock of Gibraltar or a quarry in Hungary, while at the same time put together the jaw-dropping splendour of Paris's Opera Garnier or Moscow's Bolshoi. And, with 21st-century additions coming in forms such as the Tenerife Opera House and Parco della Musica in Rome, it is creativity that remains unbounded.

OPPOSITE:
The Minack Theatre, Cornwall, England
This amphitheatre-style space is cut into the rock of a Cornish cliff and was built almost entirely by hand. It is the brainchild of one woman, Rowena Cade, who bought the Minack headland for £100 in the early 1920s to live there. The concrete used was mixed with sand from the beach, which Rowena carried up in sacks herself.

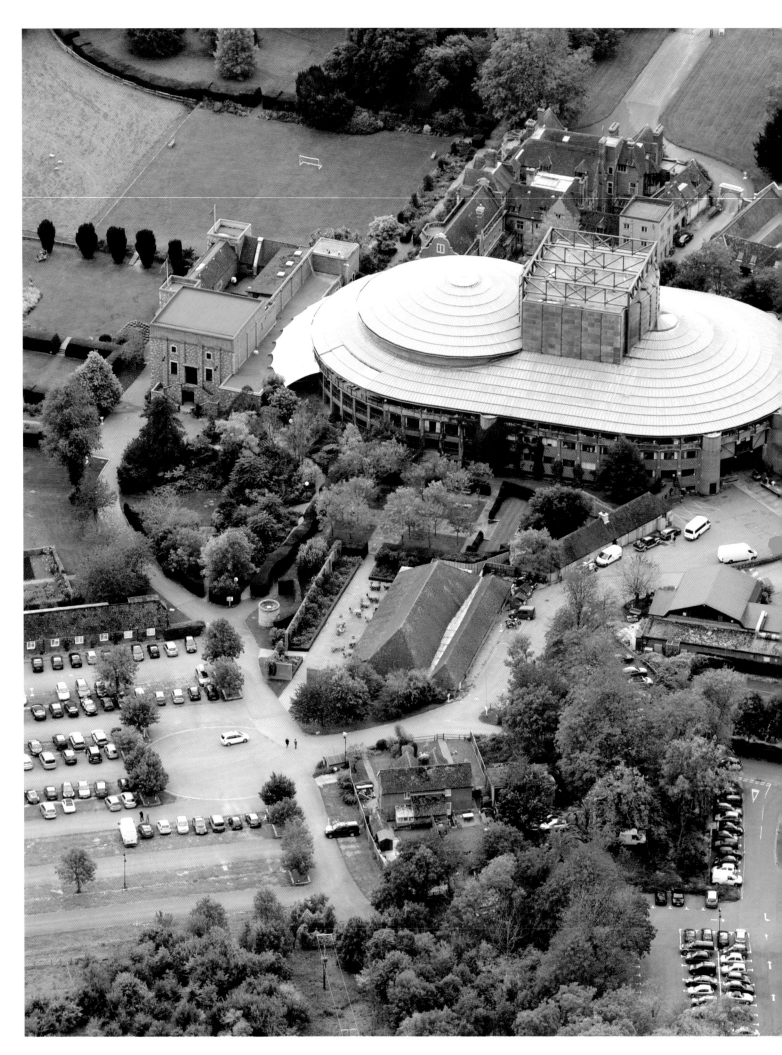

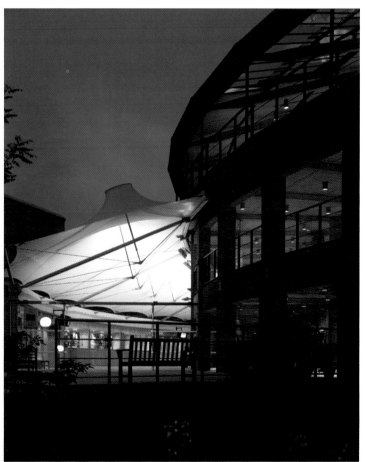

ALL PHOTOGRAPHS:
Glyndebourne, East Sussex, England
This set-up in the hills of the South Downs started in 1934 with a 300-seat annex built at the Christie family's manor house. Today, the house is dwarfed by a 1,200-seat auditorium, as the popularity of 'country house' opera – where shows have 90-minute intervals so the audience can dine in on-site restaurants – has grown.

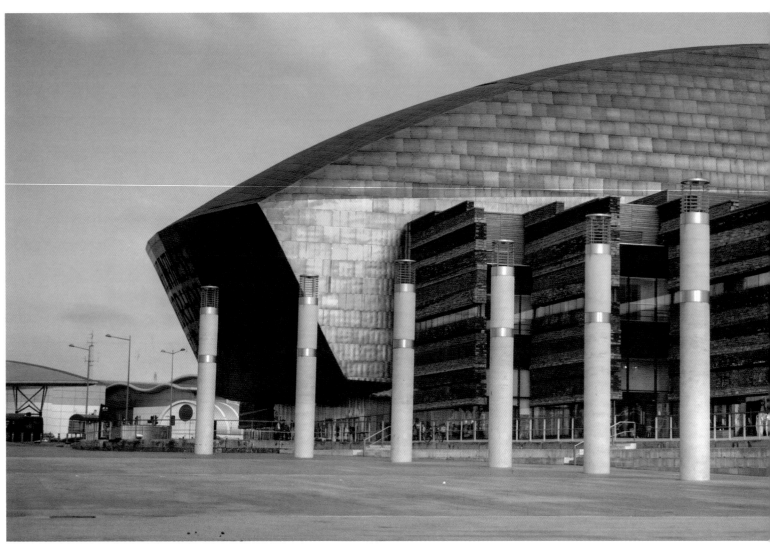

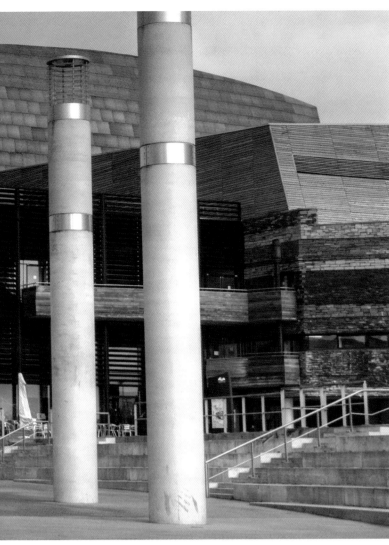

LEFT AND OPPOSITE BOTTOM:
Millenium Centre, Cardiff, Wales
Queen Elizabeth II opened this national centre in 2004 by using an ornate steel key – that had travelled across five continents – to unlock the front door. Affectionately known as the 'armadillo' because of its shape, the centre bears Celtic lettering on its side – in Welsh and English – proclaiming, 'In these stones, horizons sing.'

BELOW:
Sherman Theatre, Cardiff, Wales
The original 1973 red-brick building on the city's University College campus is now hidden behind a 2012 façade by Jonathan Adams, who also worked on the Millennium Centre. The theatre is named after Harry Sherman, of Sherman's Football Pools – once one of the largest employers in Cardiff – as he financed its construction.

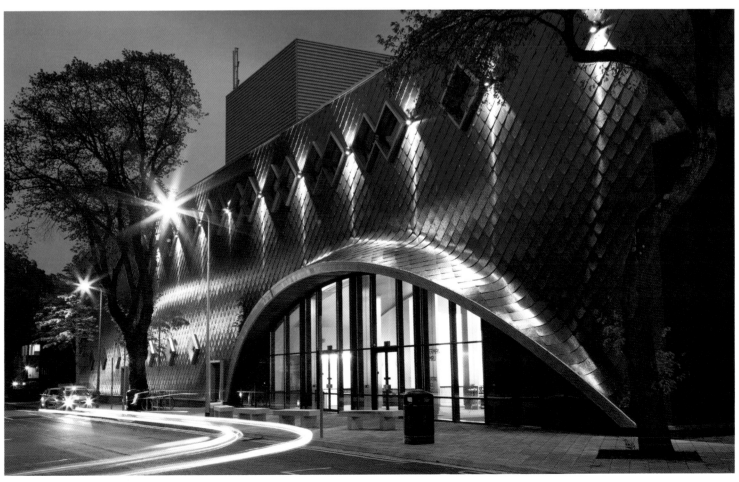

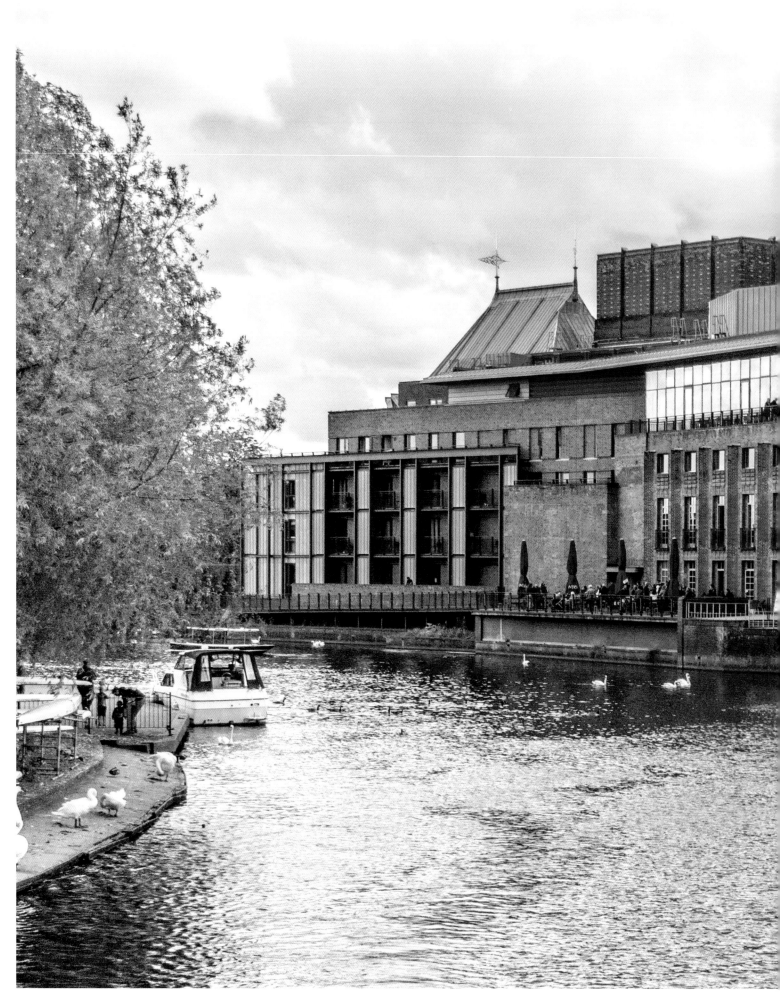

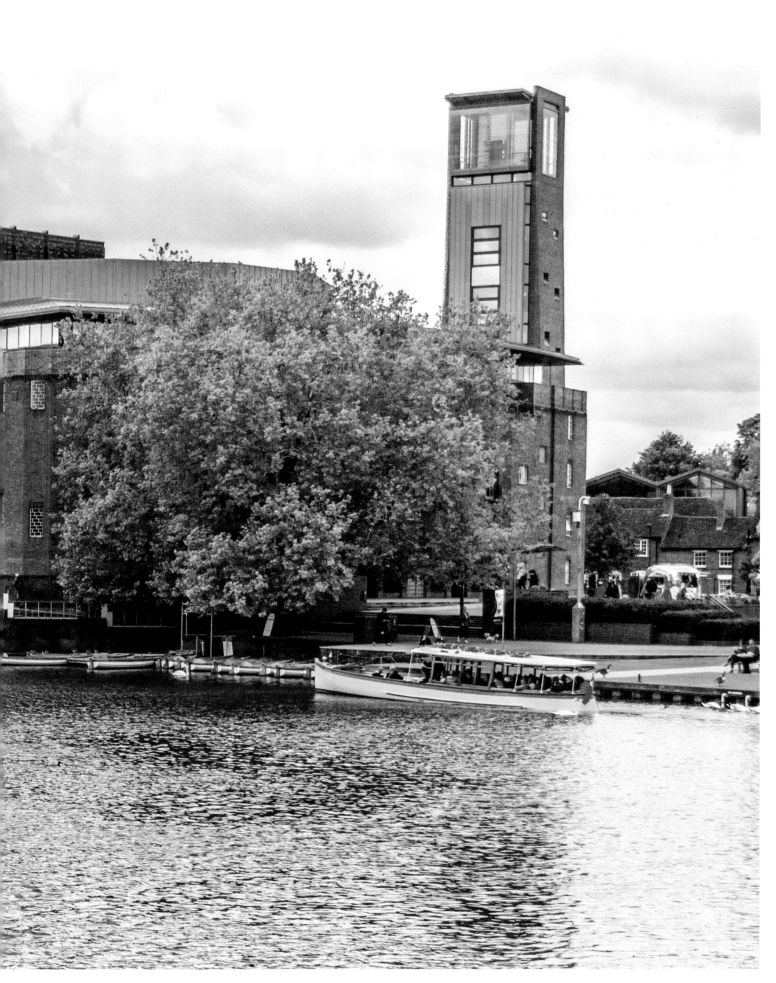

LEFT AND PREVIOUS PAGE:
RSC, Stratford-upon-Avon, England
The Royal Shakespeare Company was founded in 1961 and took over a theatre that had been built on the banks of the Avon in the town of the Bard's birth to celebrate his legacy. But in 2007, the existing 1932 theatre was demolished so it could be transformed, and the complex that exists today was opened by Queen Elizabeth II in 2011.

Royal Exchange, Manchester, England
The in-the-round theatre is housed in the building that, until 1968, was a world centre for the cotton trade, and there even exists a board on display with closing figures. At 150 tons, the seven-sided theatre itself is too heavy to sit on the floor of the Royal Exchange so it is suspended from four of its enormous columns.

Tower Ballroom, Blackpool, England

Frank Matcham designed the ornate dance hall in the complex beneath the Lancashire resort's 1894 landmark tower. The Tower Ballroom, which stands alongside a circus, is a destination for dance aficionados because of its unique spung floor. Among the ballroom's one-time strict rules were: 'Gentlemen may not dance unless with a lady.'

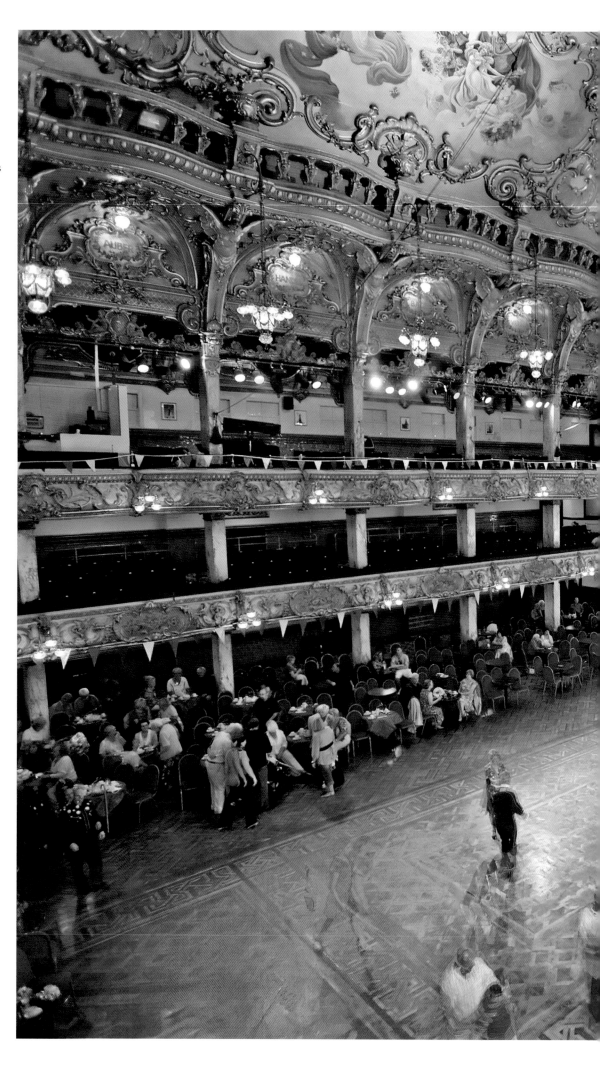

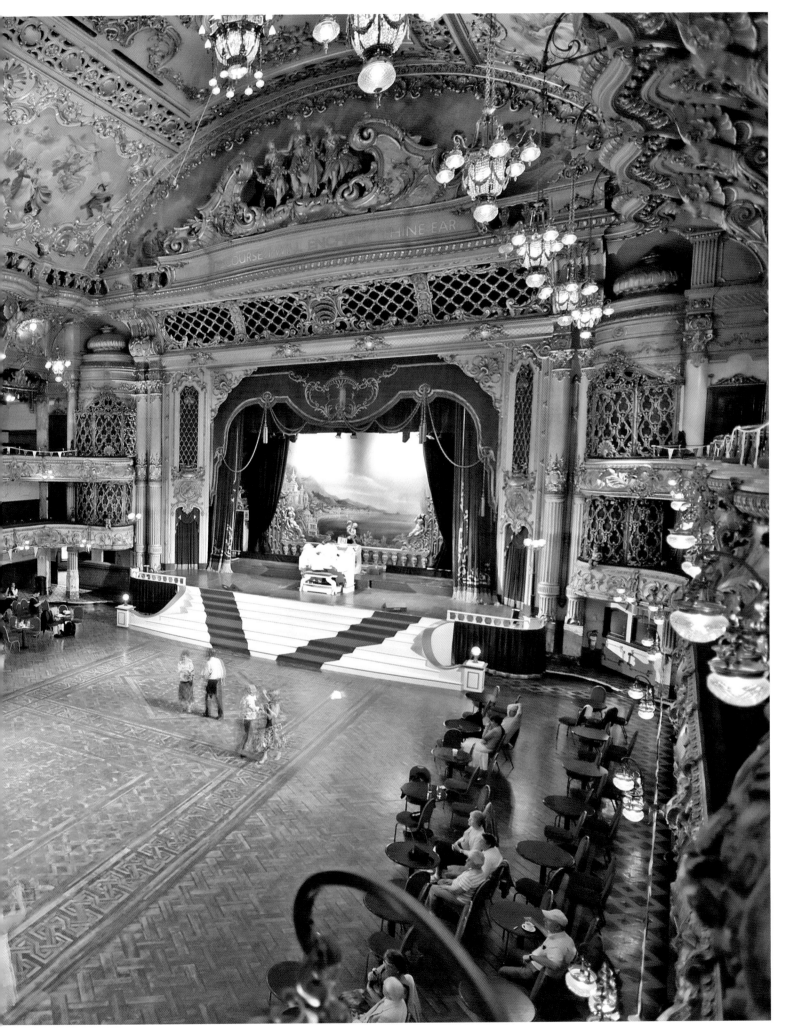

Theatre Royal, Newcastle, England

Architects Richard Grainger and John Dobson's plan for the city had this 1837 Grey Street landmark as one of its flagship buildings. However, its auditorium – designed by Frank Matcham – dates from 1901, after the original one was destroyed in a fire during a performance of Shakespeare's 'unlucky' play, *Macbeth*.

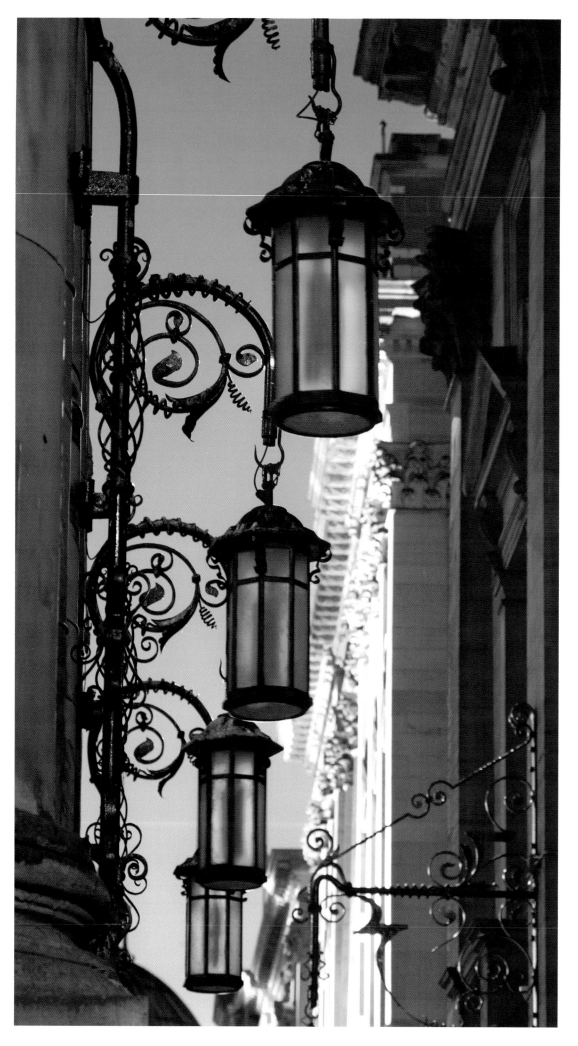

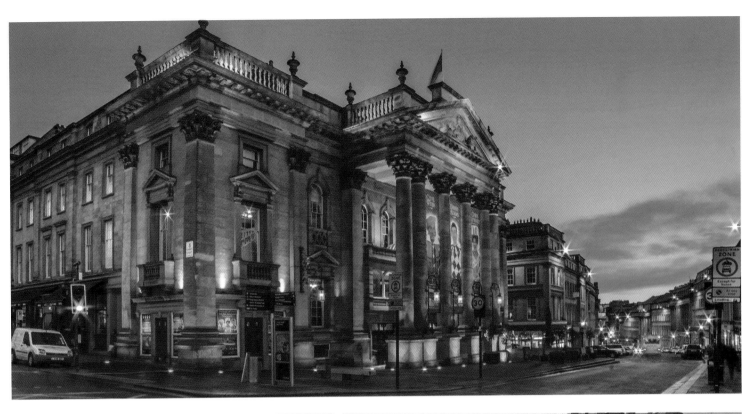

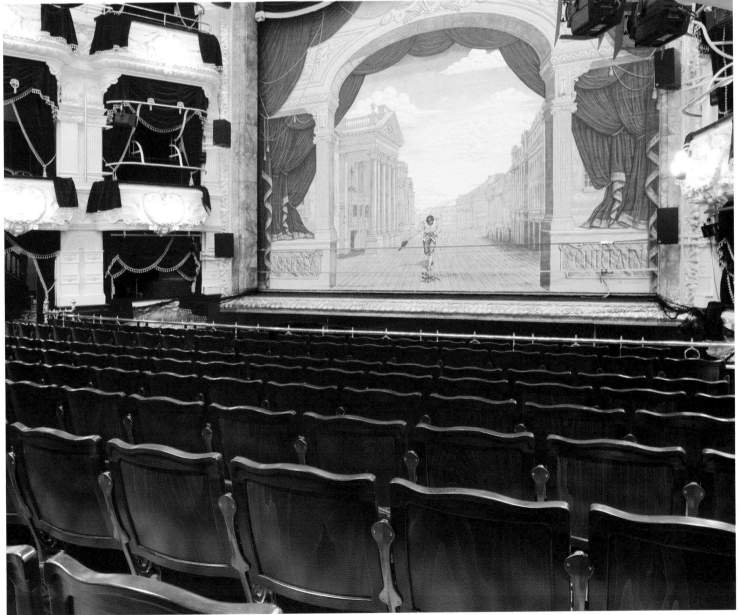

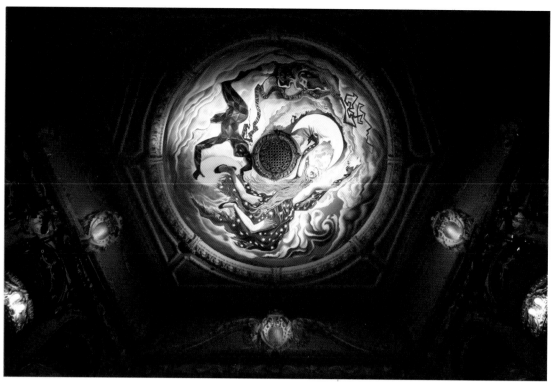

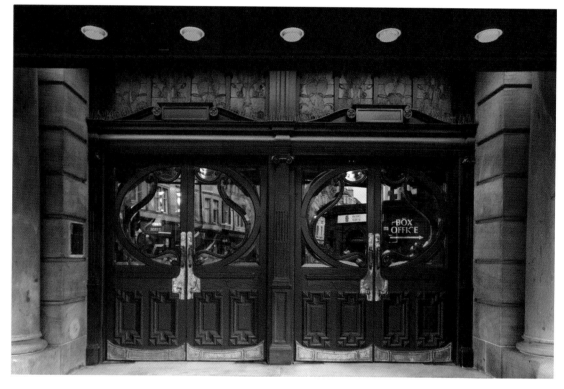

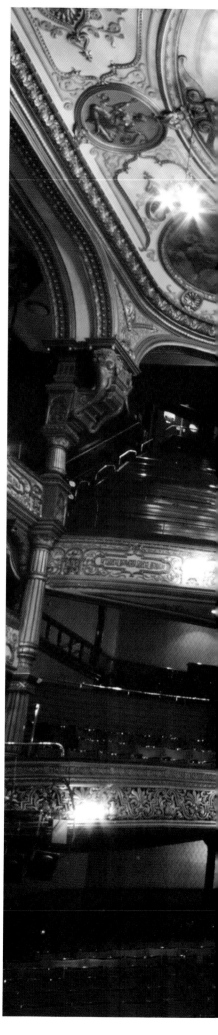

King's Theatre, Edinburgh, Scotland

Scottish-American industrialist and philanthropist Andrew Carnegie – who built New York venue Carnegie Hall – laid the foundation stone for this 1905 playhouse in the city's Tollcross area. Its painted dome, redesigned by Scottish playwright and artist John Byrne in 2013, appropriately features the words 'All the world's a stage', from *As You Like It*.

Opera House, Belfast, Northern Ireland

This 1895 venue has been damaged several times by bomb blasts, usually when the nearby Europa Hotel – often said to be 'the most bombed hotel in the world' – has been targeted. It was designed by the prolific Frank Matcham and the Theatres Trust describes the auditorium as 'probably the best surviving example in the UK of the Oriental style'.

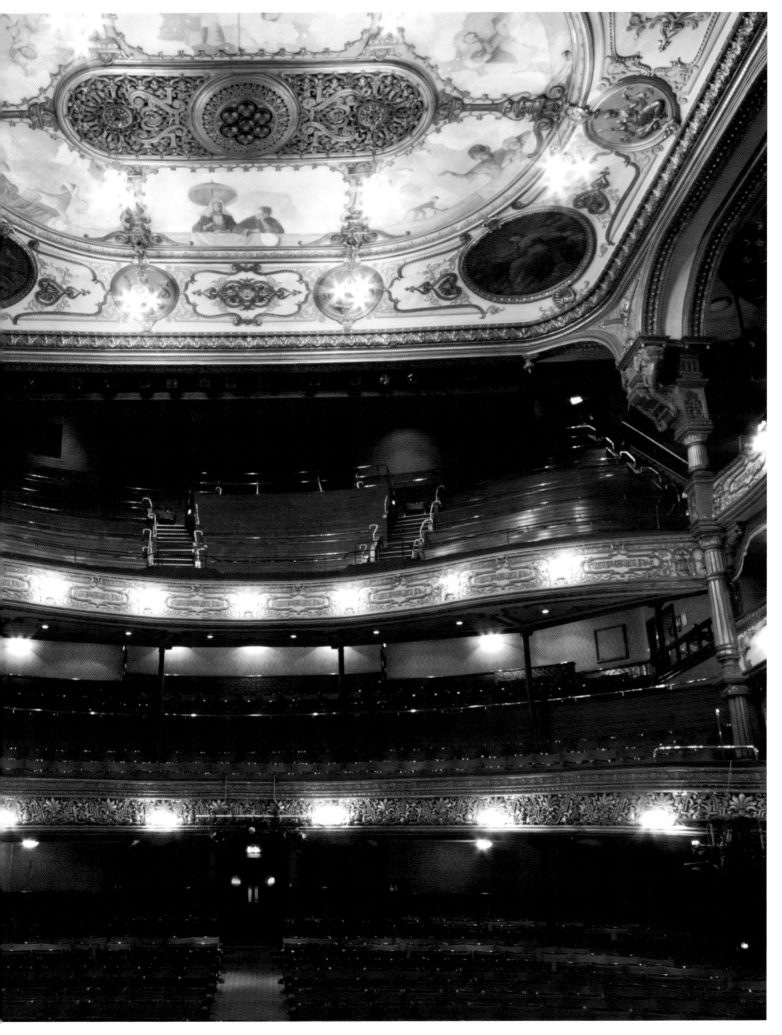

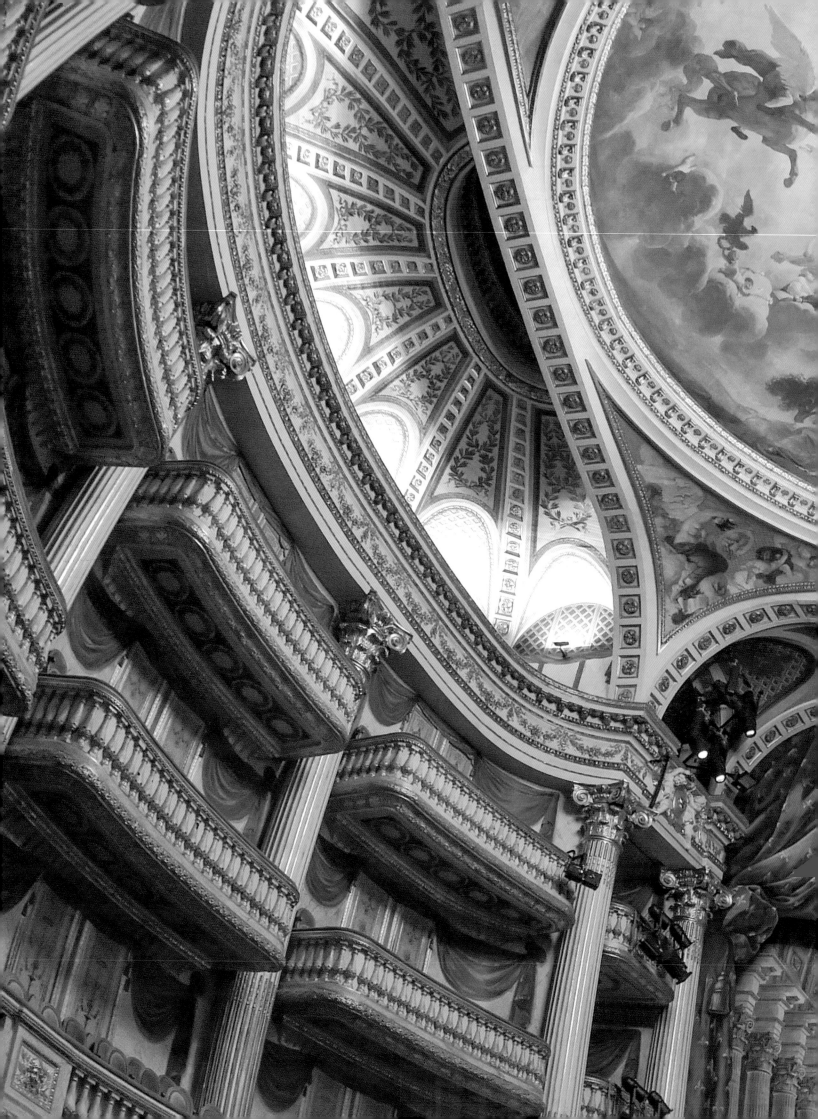

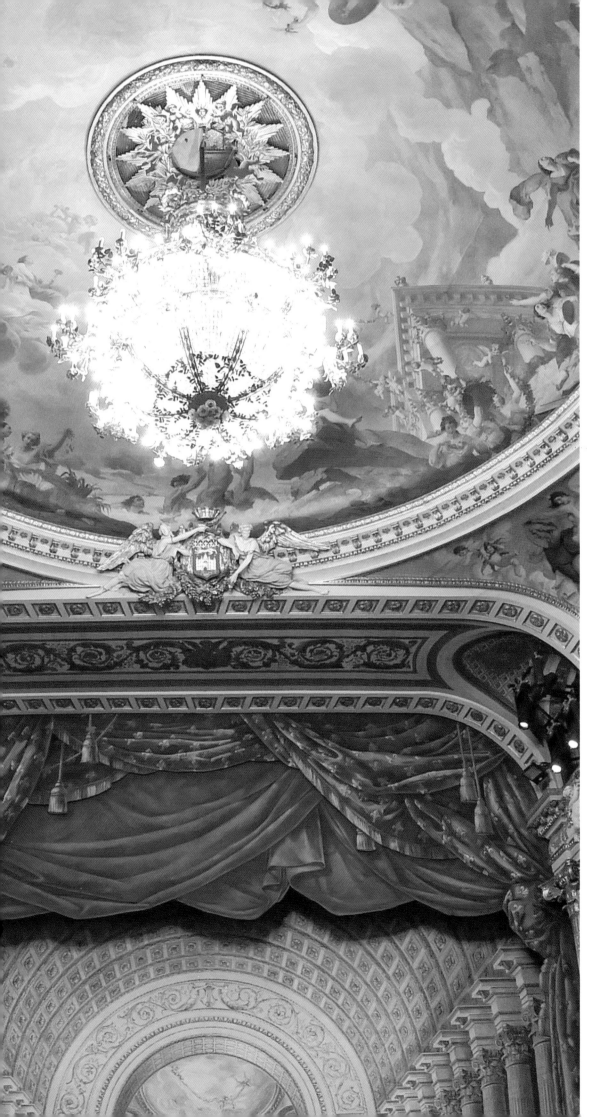

Grand Theatre de Bordeaux, Paris, France
Resplendent in the colours of royalty – blue, white and gold – this 18th-century marvel is home to the French city's national opera company. Designed by Victor Louis, it was inaugurated in 1780, and nearly a century later, Charles Garnier drew inspiration from the grand staircase for his design at the Opera de Paris.

OVERLEAF:
Comedie Francaise: Salle Richelieu, Paris, France
This theatre houses the oldest active theatre company in the world, founded in 1680. Since 1799, the company has been housed at Salle Richelieu, which had to be rebuilt in 1900 after a fire in which there was only one casualty, the actress Jane Henriot, a former model for Renoir who perished in the flames trying to save her dog.

75

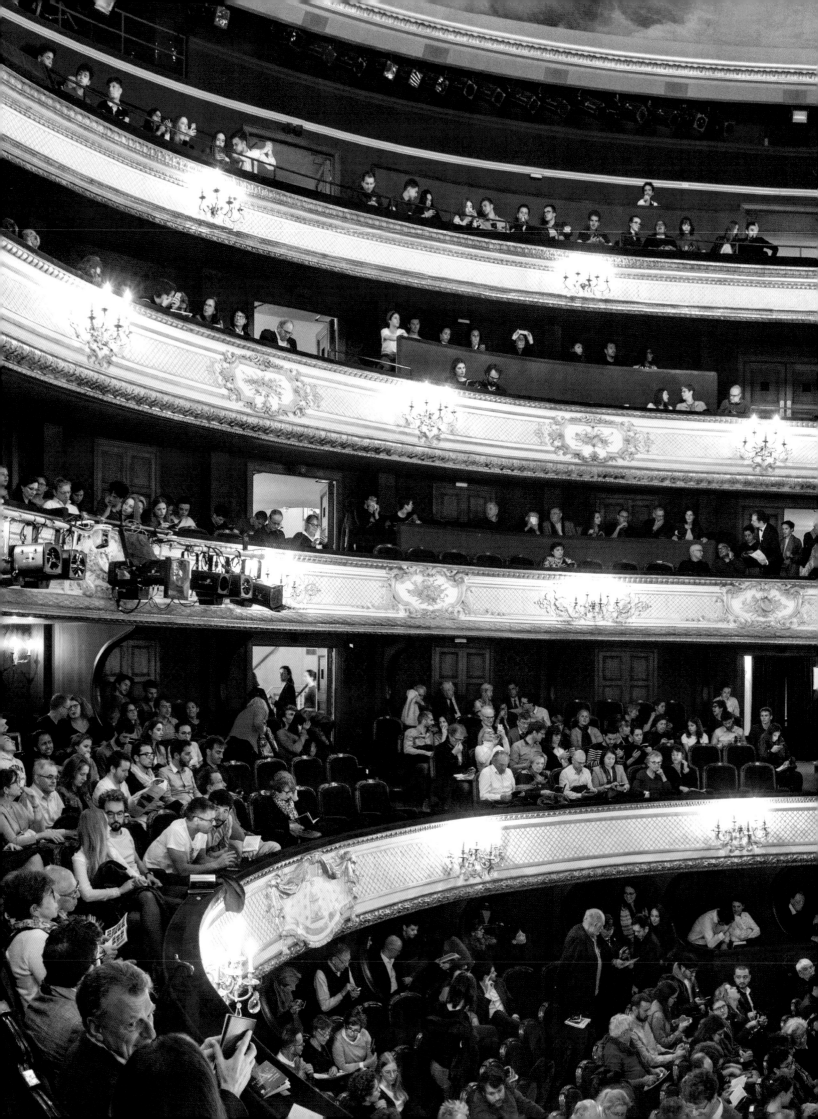

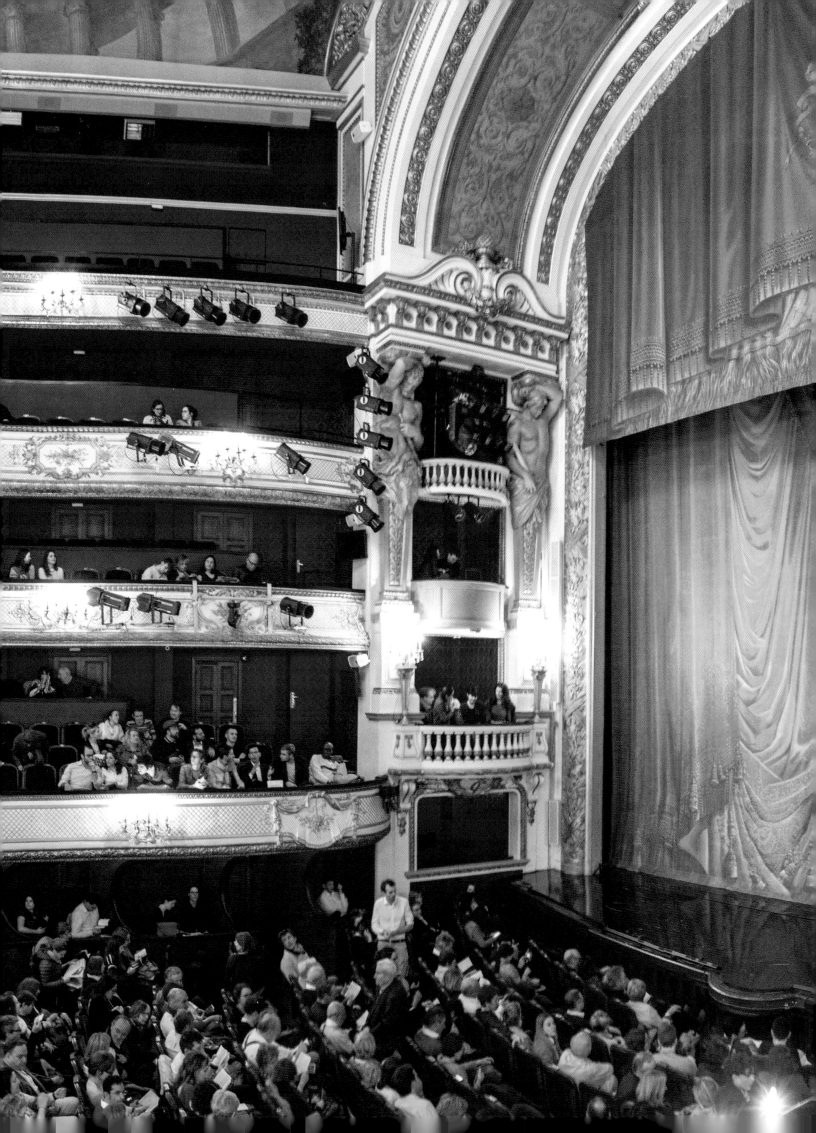

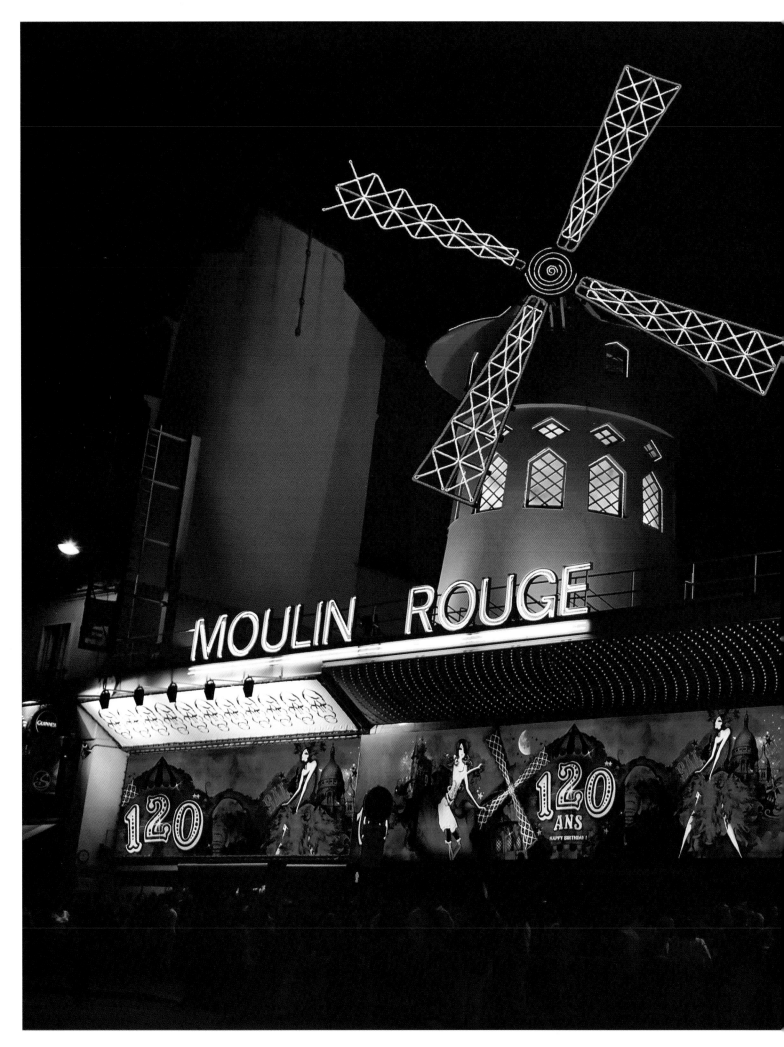

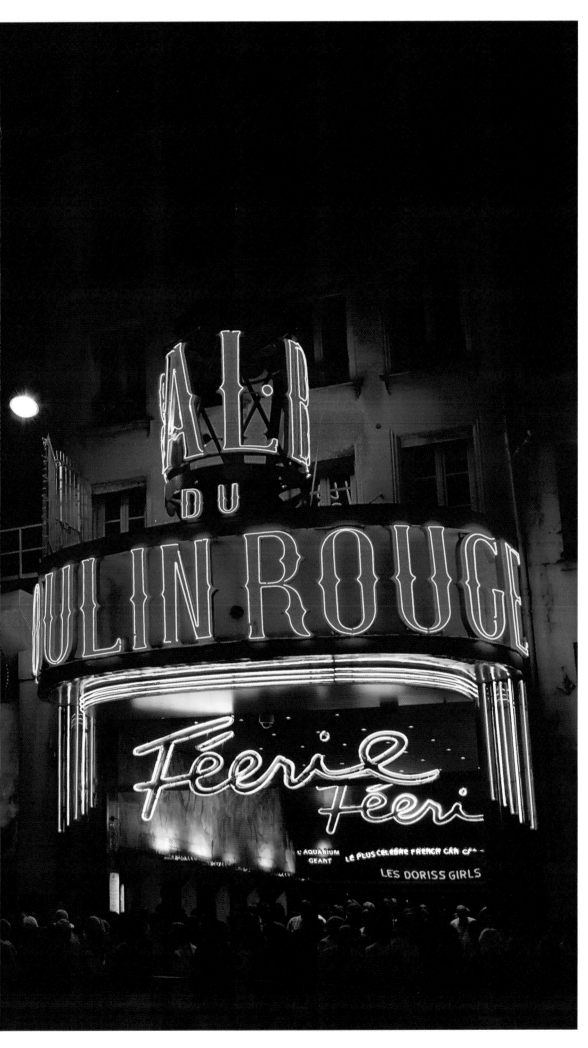

Moulin Rouge, Paris, France
The original cabaret theatre, which opened in 1889 at the foot of Montmartre hill, was destroyed by fire in 1915, and the current one – now a tourist attraction – dates from 1921. In its early days the Moulin Rouge became synonymous with the can-can dance, and the artist Henri de Toulouse-Lautrec became well-known for painting its practitioners.

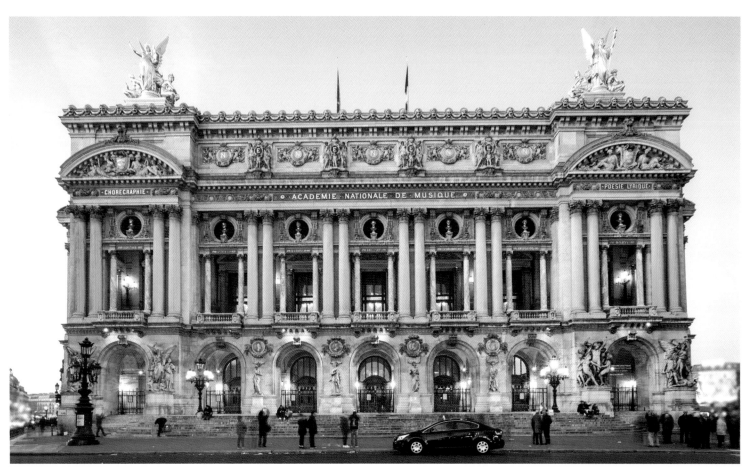

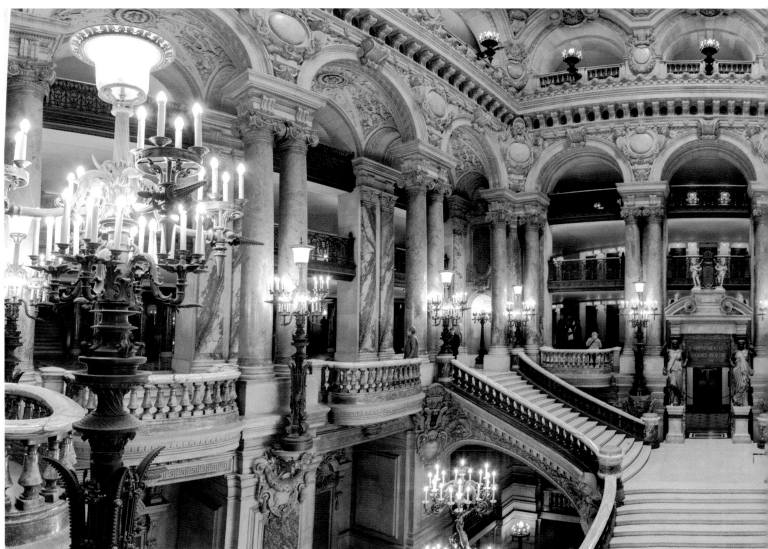

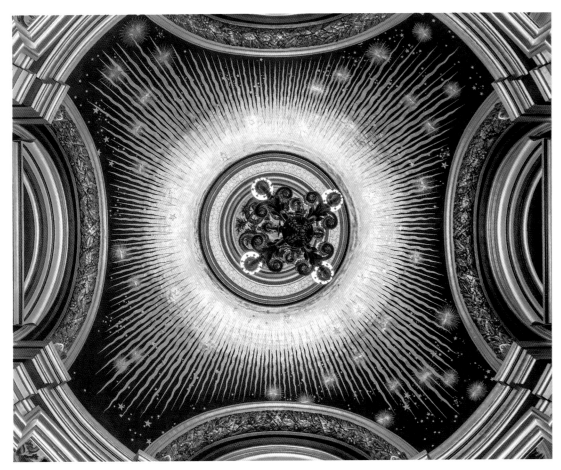

ALL PHOTOGRAPHS:

Opera Garnier, Paris, France
This grand theatre is the ultimate in opulence and was built between 1862 and 1875 at the behest of Emperor Napoleon III. The auditorium – which features 20th-century ceiling designs by Marc Chagall – was constructed in a horseshoe shape so the audience could see and be seen. Opera Garnier is also the setting for *The Phantom of the Opera.*

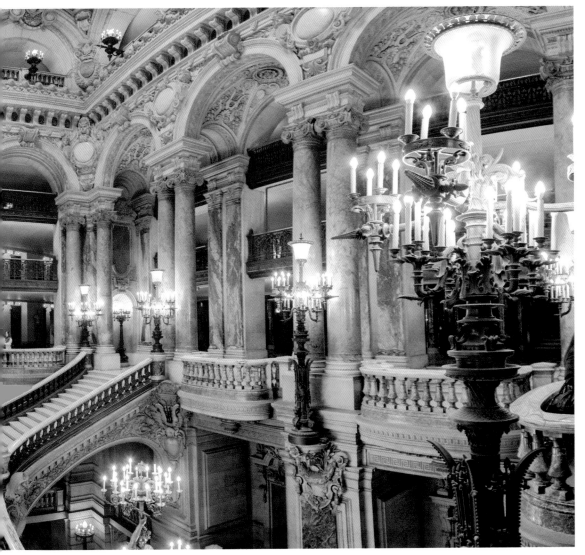

OVERLEAF:

Royal Opera, Versailles Palace, Paris, France
When this building was inaugurated in 1770 it was the largest concert hall in Europe. It survived the French Revolution but was relieved of all its furniture, mirrors, lighting and décor, until restoration in the 19th century under King Louis Philippe. But it had to be restored again after World War II, which had left it virtually in ruins.

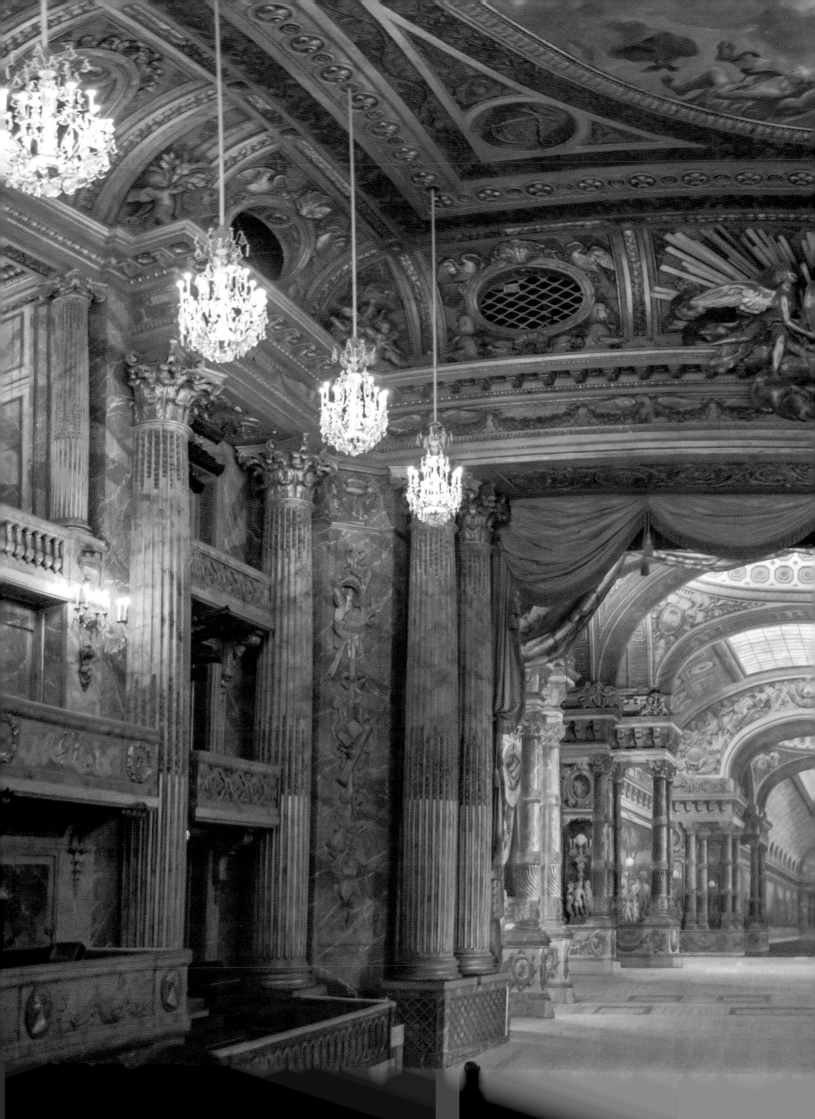

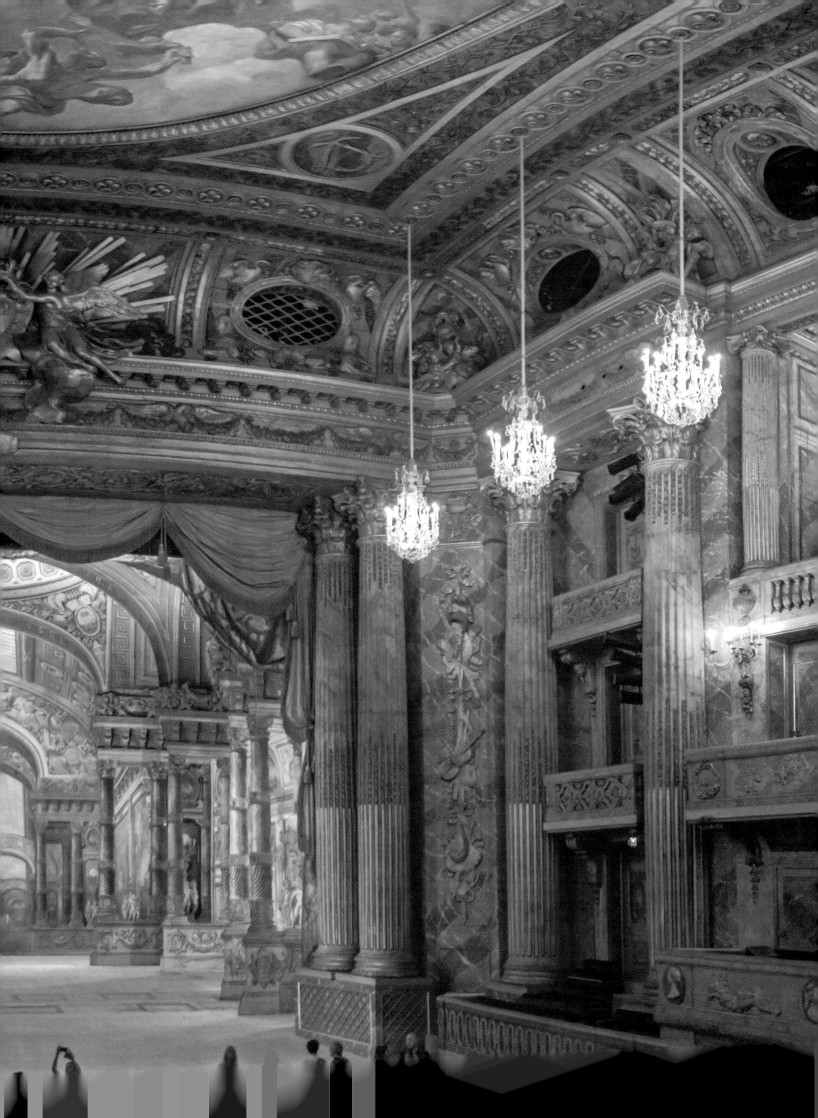

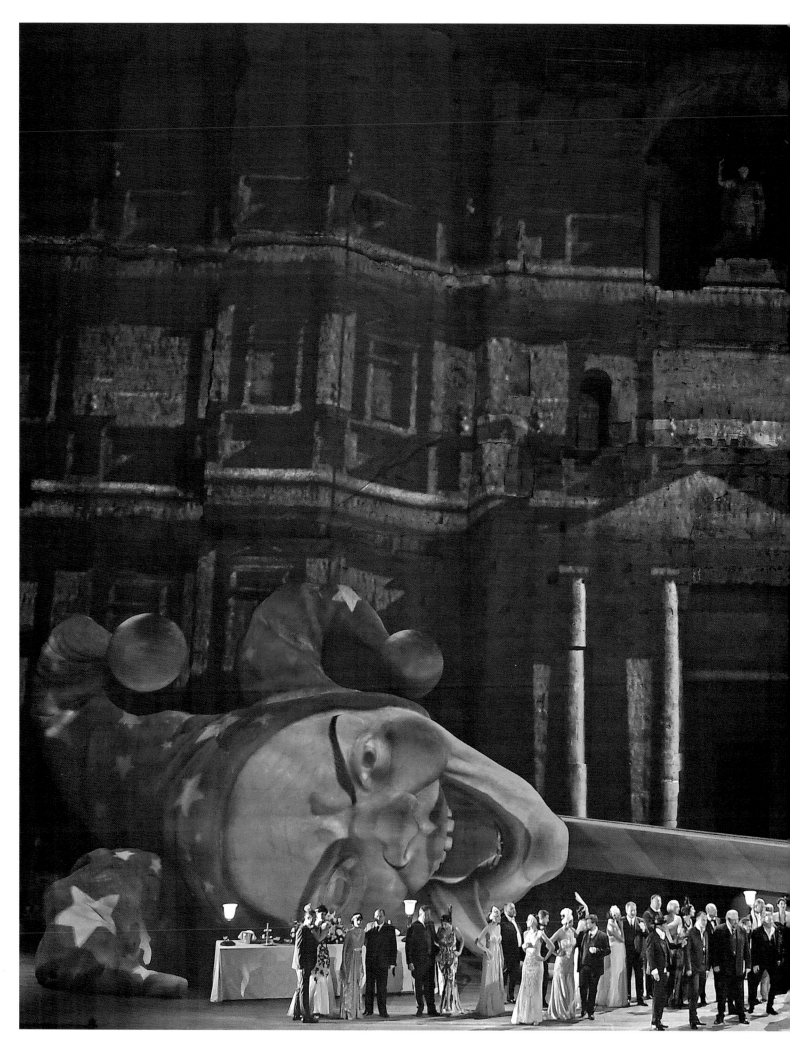

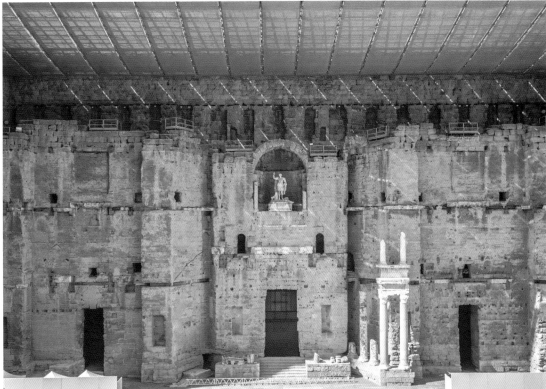

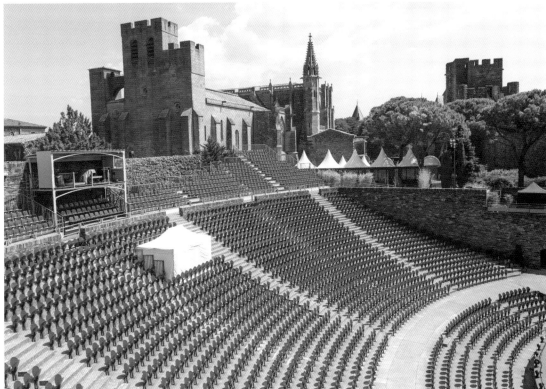

ABOVE TOP AND LEFT:
Roman Theatre, Orange, France
It was under Emperor Augustus that this structure was built in the 1st century, and its imposing façade was so awe-inspiring that King Louis XIV called it 'the most beautiful wall in my entire kingdom'. After neglect, the venue – widely seen as the best preserved of Roman theatres – was restored in 1825, and today opera is performed there in summer.

ABOVE BOTTOM:
Carcassonne, France
The medieval fortified city in southern France hosts a festival each summer in which the ancient buildings themselves become the backdrop to opera, theatre, dance and concerts. However, in 1849 the city had fallen into such disrepair that it was decreed by the government that it should be demolished. An uproar ensued and the city was promptly renovated.

Matadero, Madrid, Spain
The Centre for Contemporary
Creation in the country's capital
is housed in the city's former
slaughterhouse and cattle market,
with the 1911 building being
used for its original purpose
until 1996. The complex now has
wide-ranging arts facilities, as
well as various spaces devoted to
the performing arts. *Matadero*
translates into English as
'abattoir'.

BELOW:
Corral de Comedias, Madrid
This open-air theatre was built in
1601 and continued in use until
the mid-20th century, when it
was used as a cinema and then
fell into disrepair. The venue, in
the town of Alcala de Henares,
just outside Madrid, was restored
in the 1980s, and now resembles
carpenter Francisco Sanchez's
original creation.

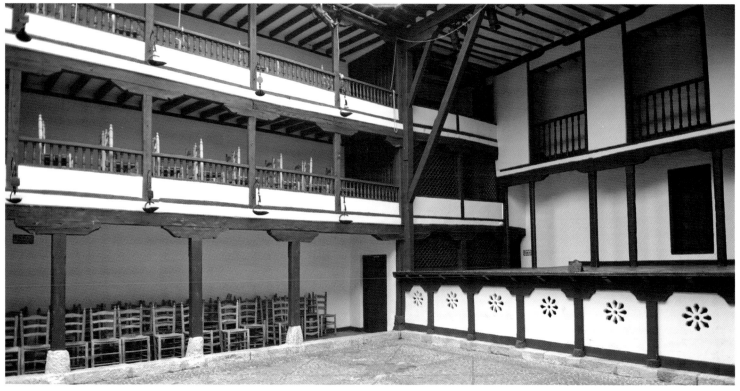

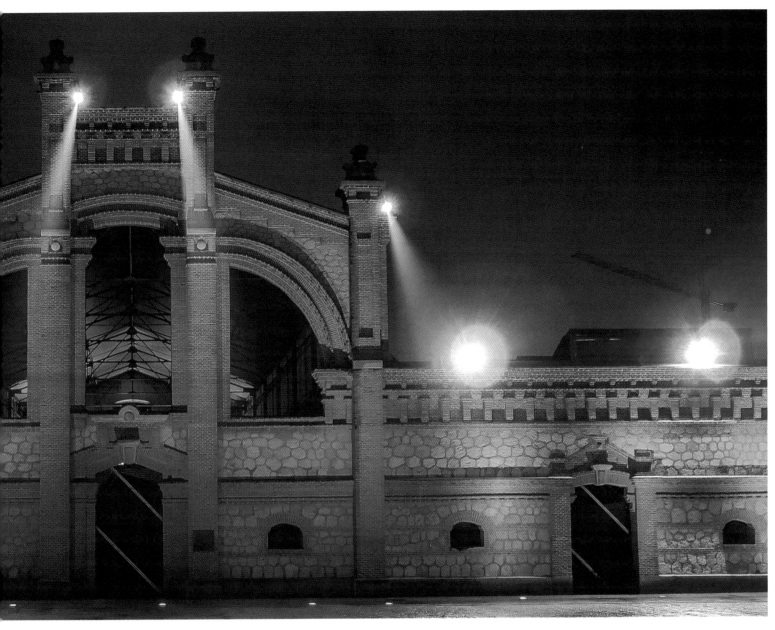

Teatro Real, Madrid, Spain
When it was built in 1850, this theatre was at the hub of the 19th-century remodelling of Madrid, next to the classy Austrias district and facing the Royal Palace. Inside, it has been redesigned several times, used for purposes other than theatre, and also closed for periods. *Teatro Real* translates into English as 'Royal Theatre'.

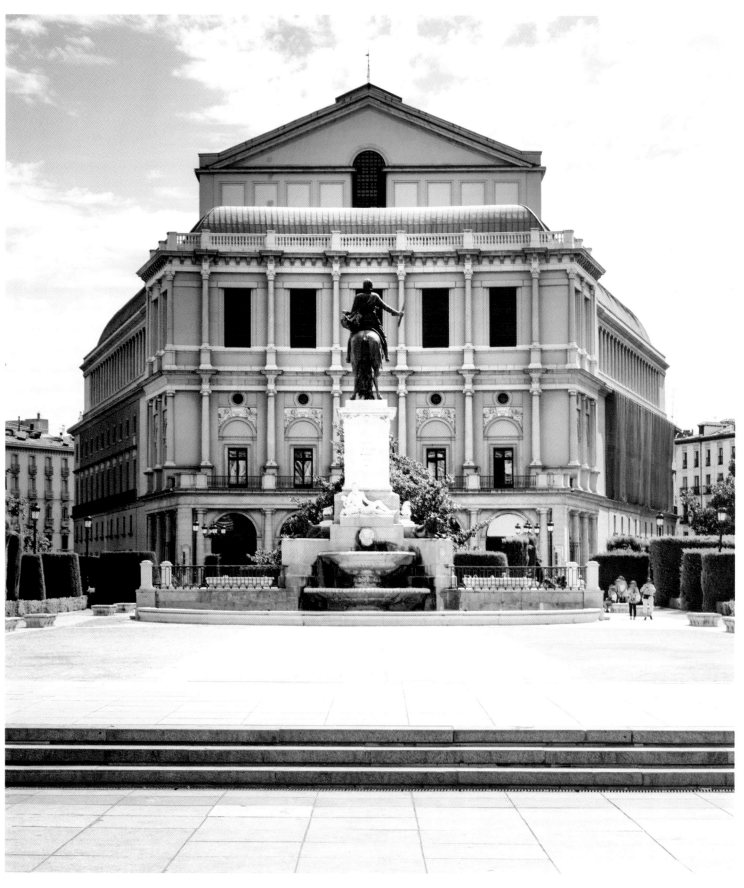

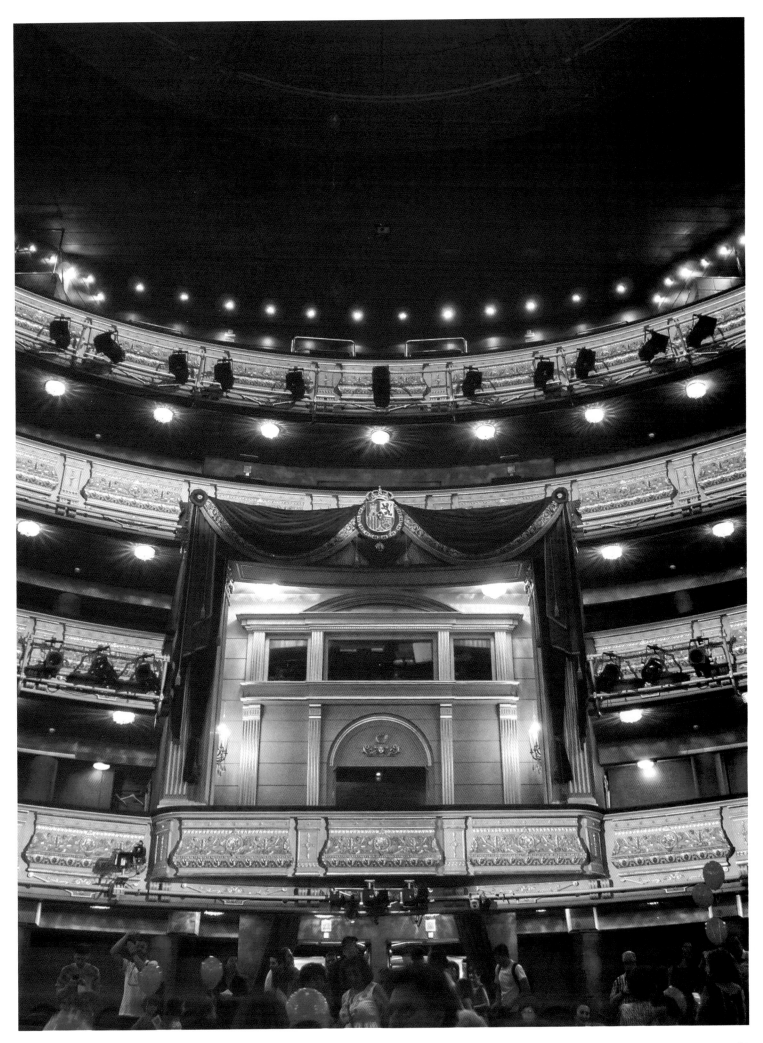

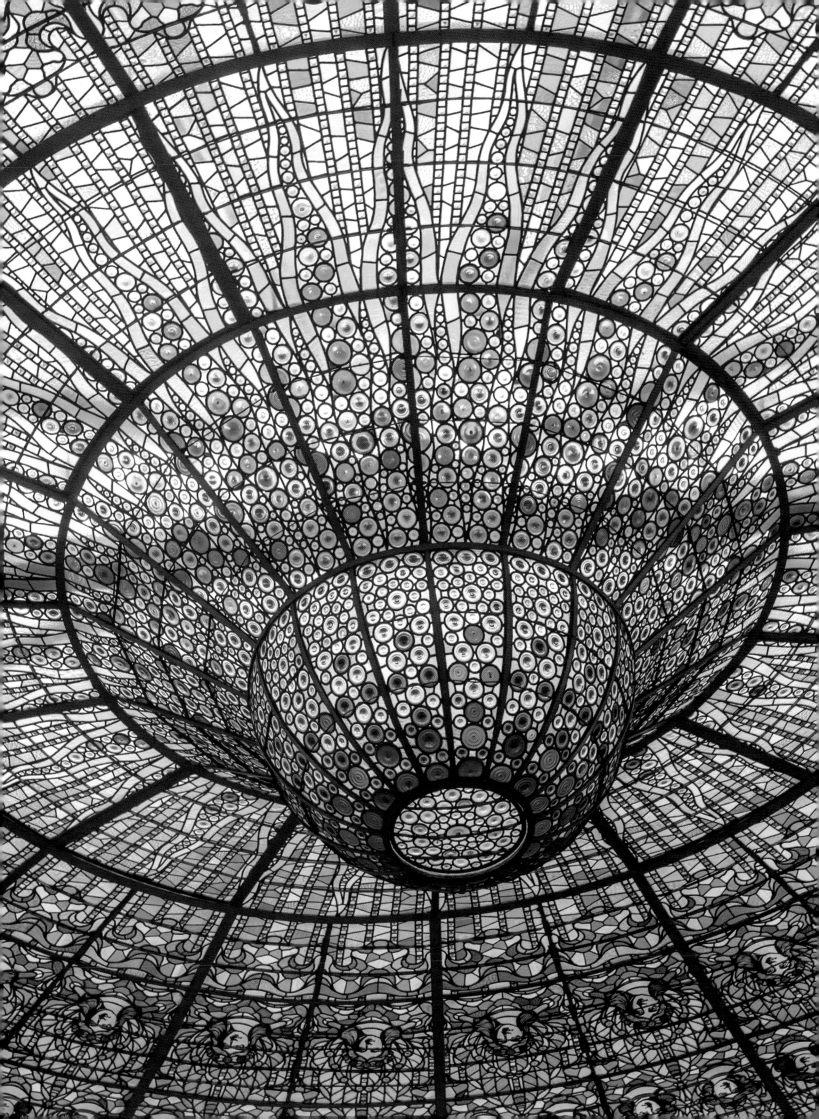

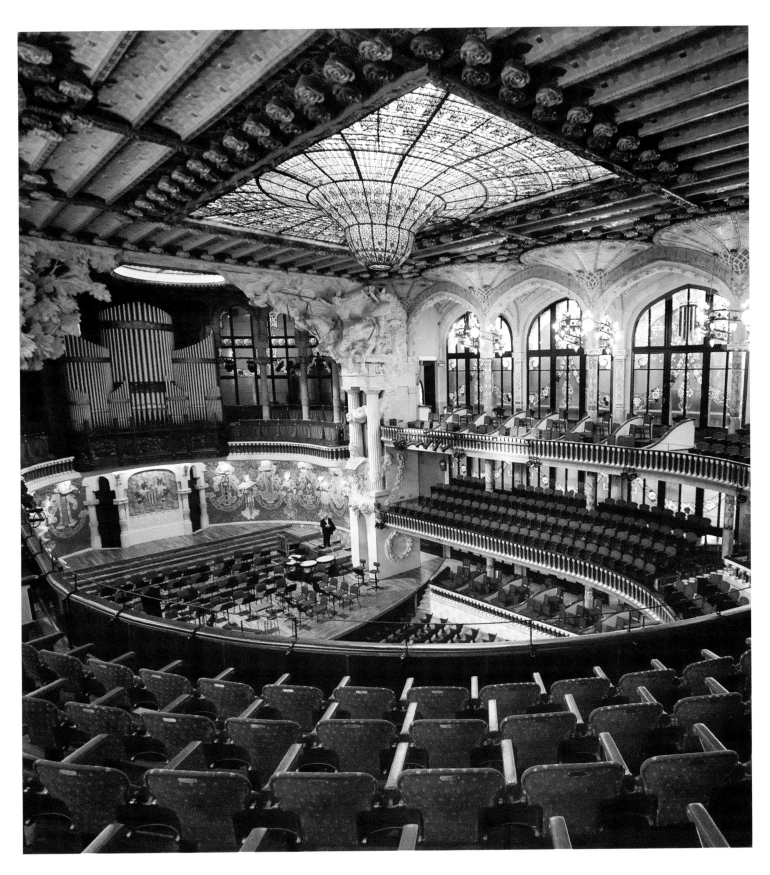

ALL PHOTOGRAPHS:

Palau de la Musica Catalana, Barcelona

This art nouveau concert hall was constructed by modernist architect Lluis Domenech I Montaner between 1905 and 1908. The auditorium is the only one in Europe that is completely lit by natural light in the daytime, being made up on two sides by stained glass windows. And above, the gold and blue of the glass dome suggests, appropriately, the sun and sky.

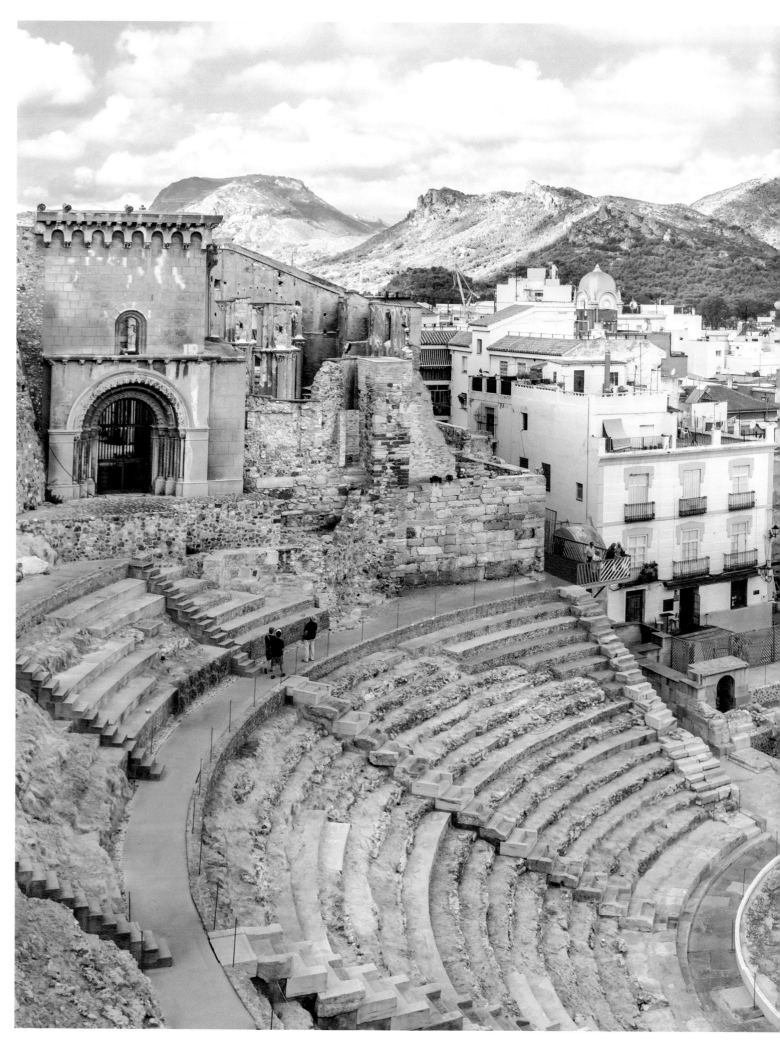

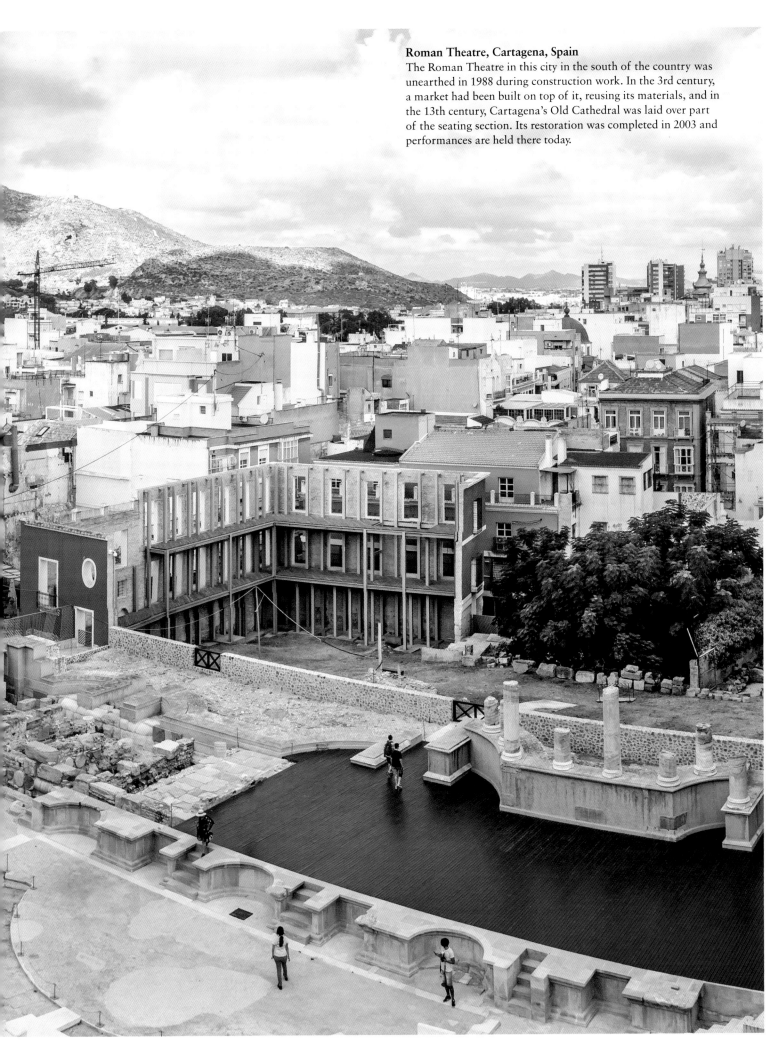

Roman Theatre, Cartagena, Spain
The Roman Theatre in this city in the south of the country was unearthed in 1988 during construction work. In the 3rd century, a market had been built on top of it, reusing its materials, and in the 13th century, Cartagena's Old Cathedral was laid over part of the seating section. Its restoration was completed in 2003 and performances are held there today.

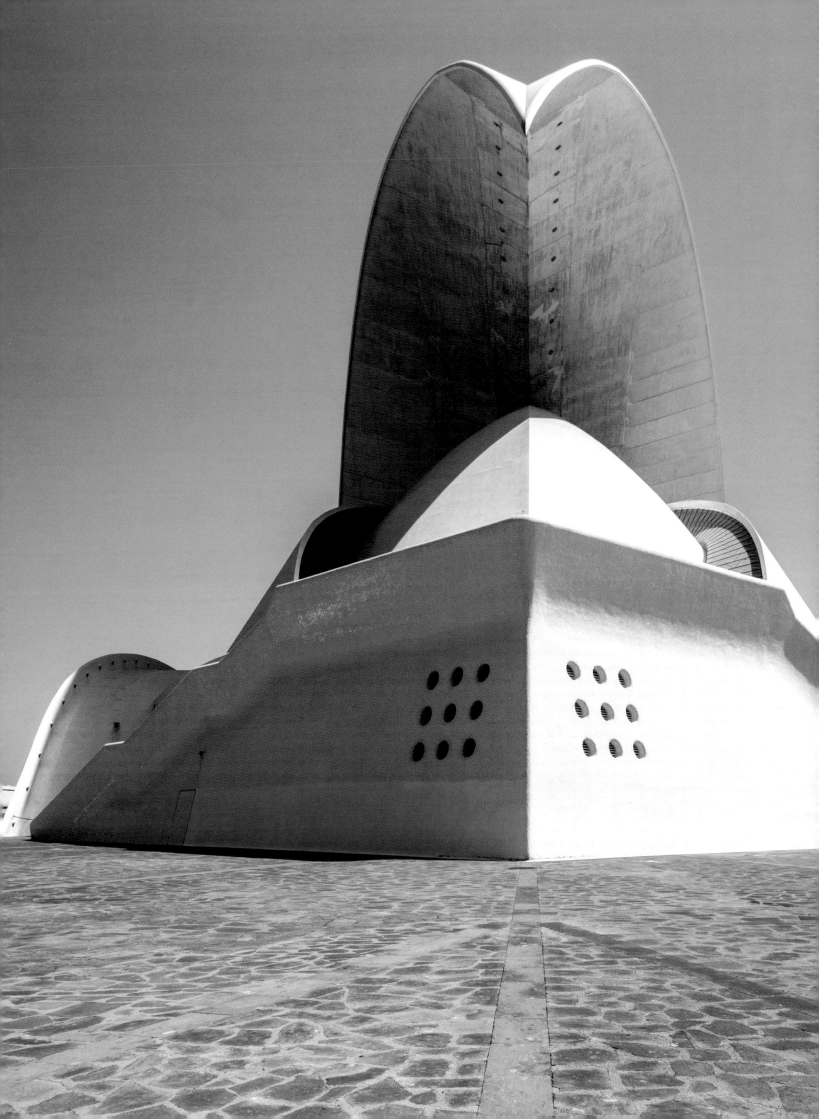

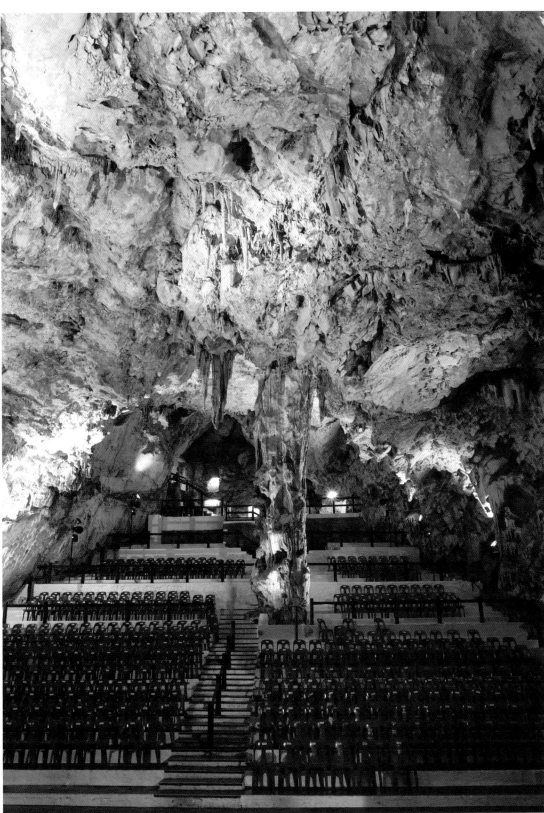

Auditorium Opera House, Tenerife, Spain
This Santiago Calatrava-designed building in Santa Cruz was inaugurated in 2003. In 2008, it was commemorated on one of a set of six Spanish stamps marking the most emblematic examples of the country's architecture. In 2011 it appeared on one of a set of commemorative coins portraying symbols of Spanish cities.

ABOVE:

St Michael's Cave, Gibraltar
Four hundred people can be seated in the auditorium that has been created in this natural limestone grotto. Above it is the top of the Rock of Gibraltar, and the Rock's caves have been used for parties, weddings, picnics and even duels since the Victorian era. In St Michael's Cave itself, Miss Gibraltar beauty pageants are among events that have been held.

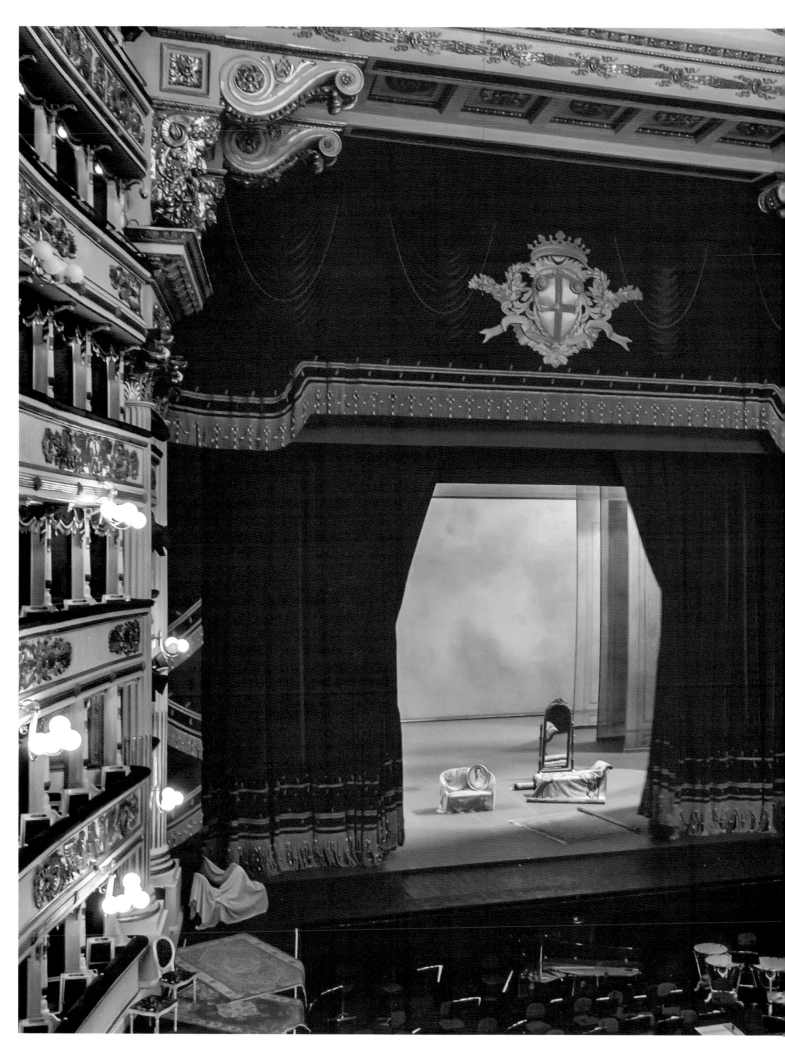

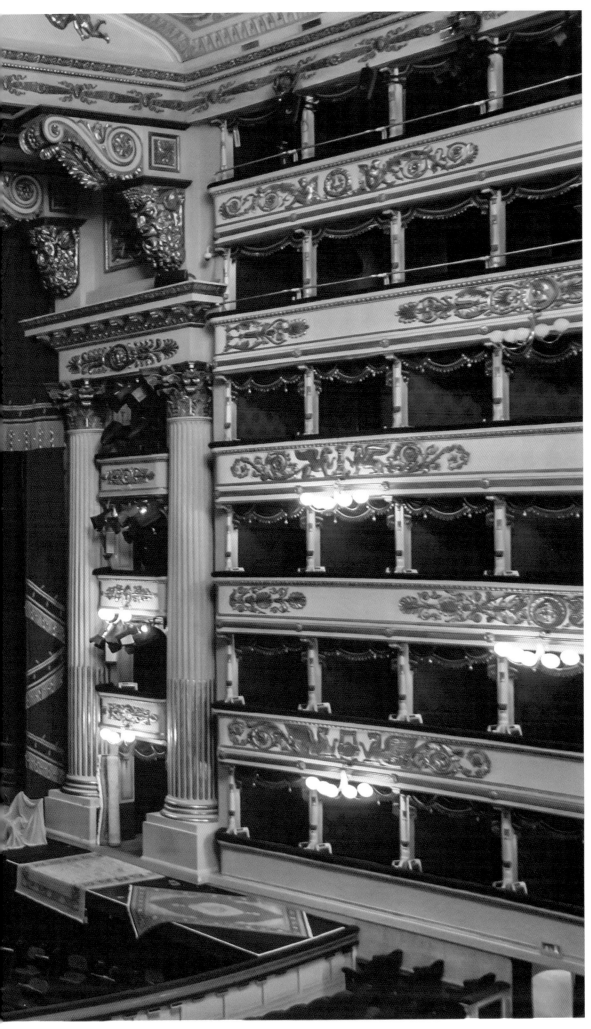

La Scala, Milan, Italy
When this opera house was commissioned in 1776, Milan was under Austrian control, and it was Empress Maria Theresa who approved the plans. As with most theatres at the time, La Scala was also a casino, with gamblers sitting in the foyer. The opera that opened it was *L'Europa riconosciuta* by Antonio Salieri, Mozart's great rival.

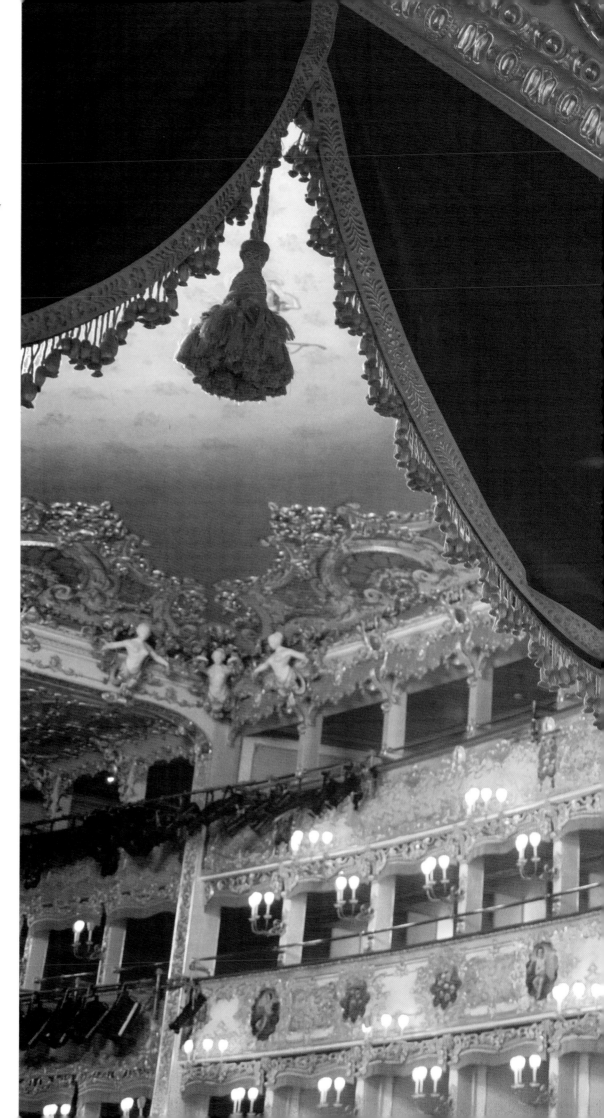

La Fenice, Venice, Italy
This opera house – which translates as 'the phoenix' in English – opened in 1792 but burned down in 1836. It was rebuilt, but fire destroyed it again 160 years later, only for it to be reconstructed 'as it was, where it was' by architect Aldo Rossi, reopening in 2003. Its name originally symbolised the recovery from troubled times of the company that built it.

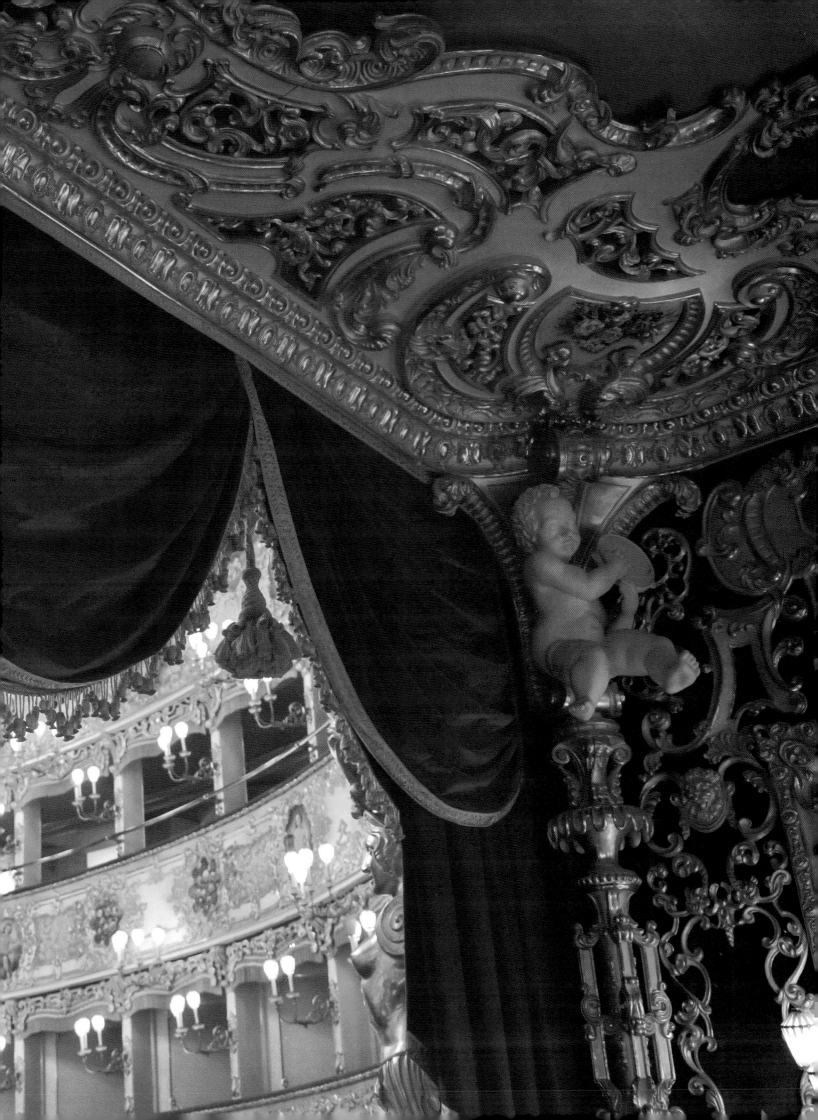

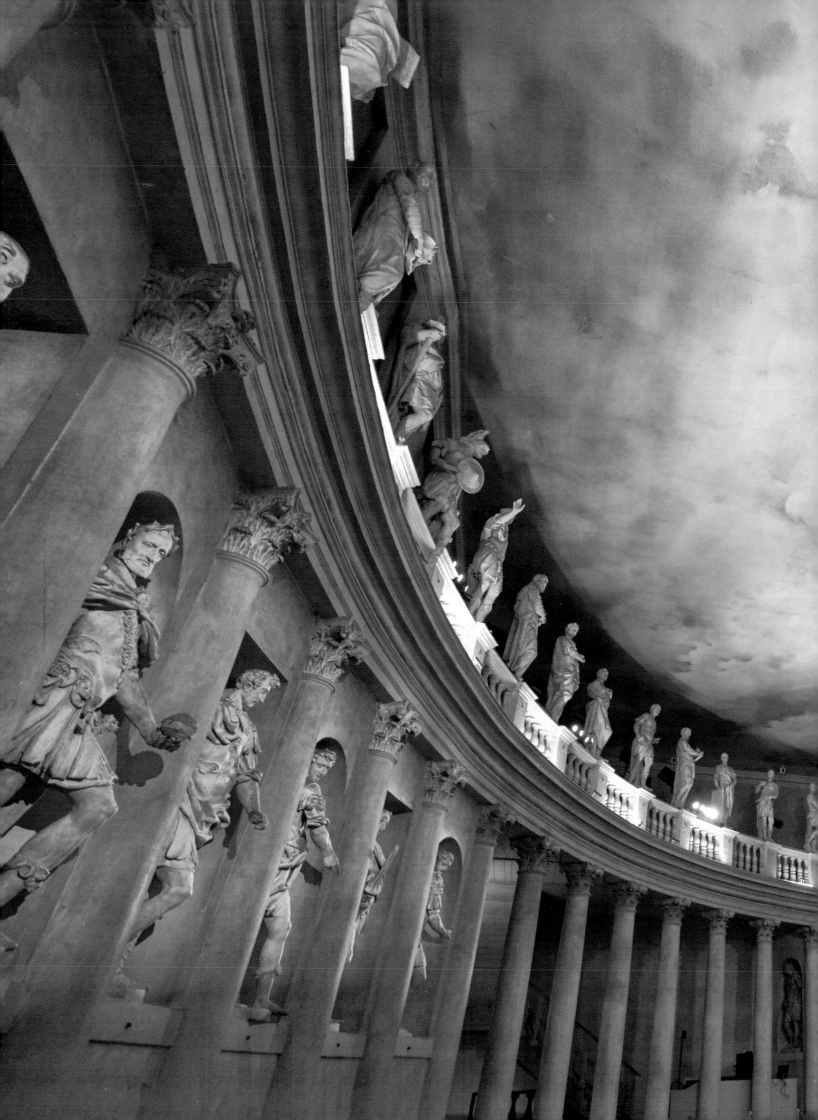

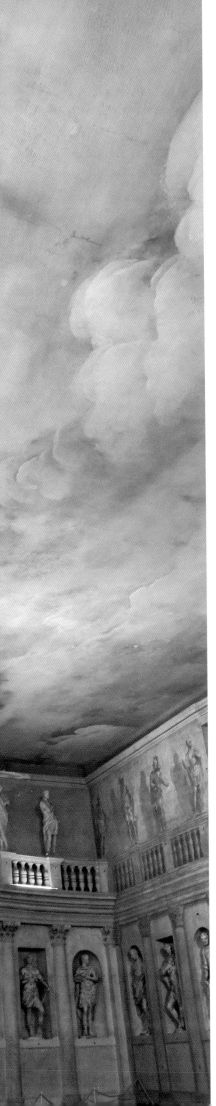

ALL PHOTOGRAPHS:

Teatro Olimpico, Vicenza, Italy
This was the first indoor playhouse made of masonry in the world, designed by Andrea Palladio between 1580 and 1585. However, Palladio died six months into the work schedule. The architect – who trained as a stonecutter and who was heavily influenced by Ancient Roman buildings – is now best known for his 'Palladian' villas of northern Italy.

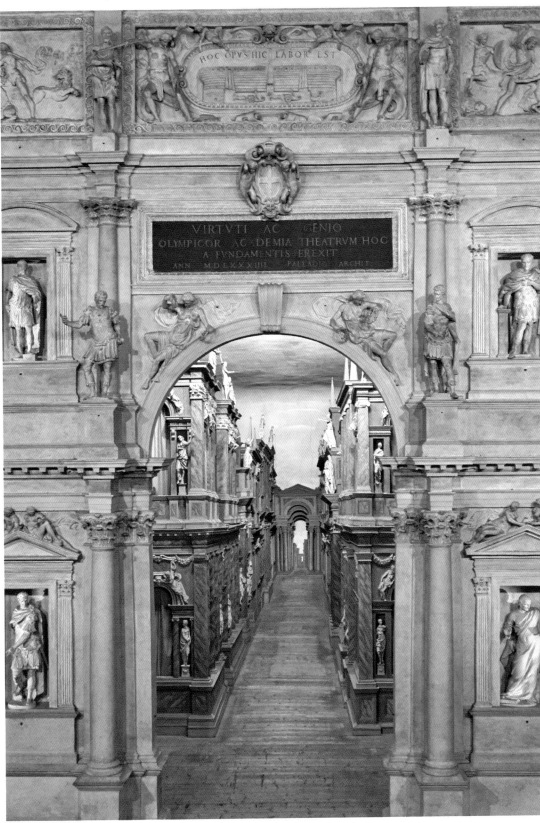

RIGHT:

Roman amphitheatre, Verona, Italy

Since 1913 – apart from breaks for the two world wars – the Roman amphitheatre in the Northern Italian city has held a summer opera festival every year. In ancient times, it could hold 30,000 people, reduced to 15,000 today. The structure is made from white and pink limestone from the wine region, Valpolicella.

OVERLEAF:

Farnese theatre, Parma, Italy

This wooden playhouse, which was built between 1618 and 1628, is the first surviving theatre with a permanent proscenium arch. It was renovated in the 1700s and then rebuilt after being destroyed in World War II. The large, U-shaped, open area was originally used for dancing, royal processions and was even flooded for water spectacles.

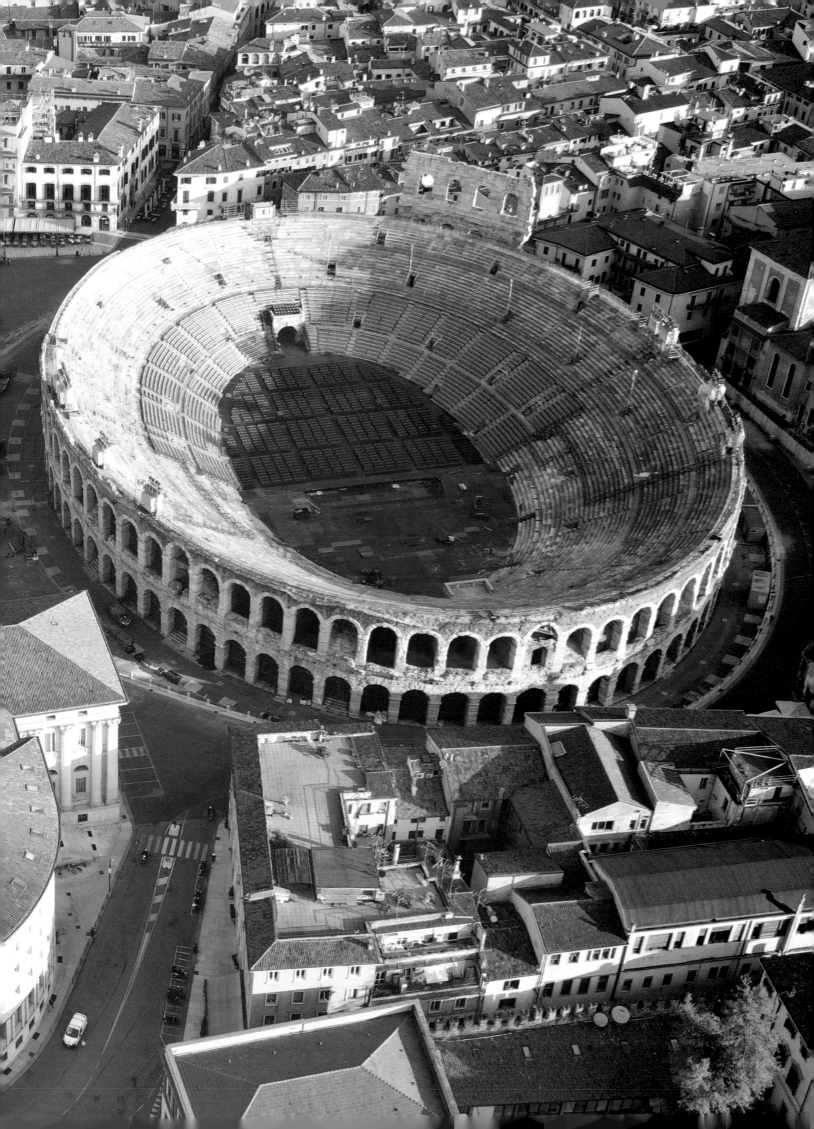

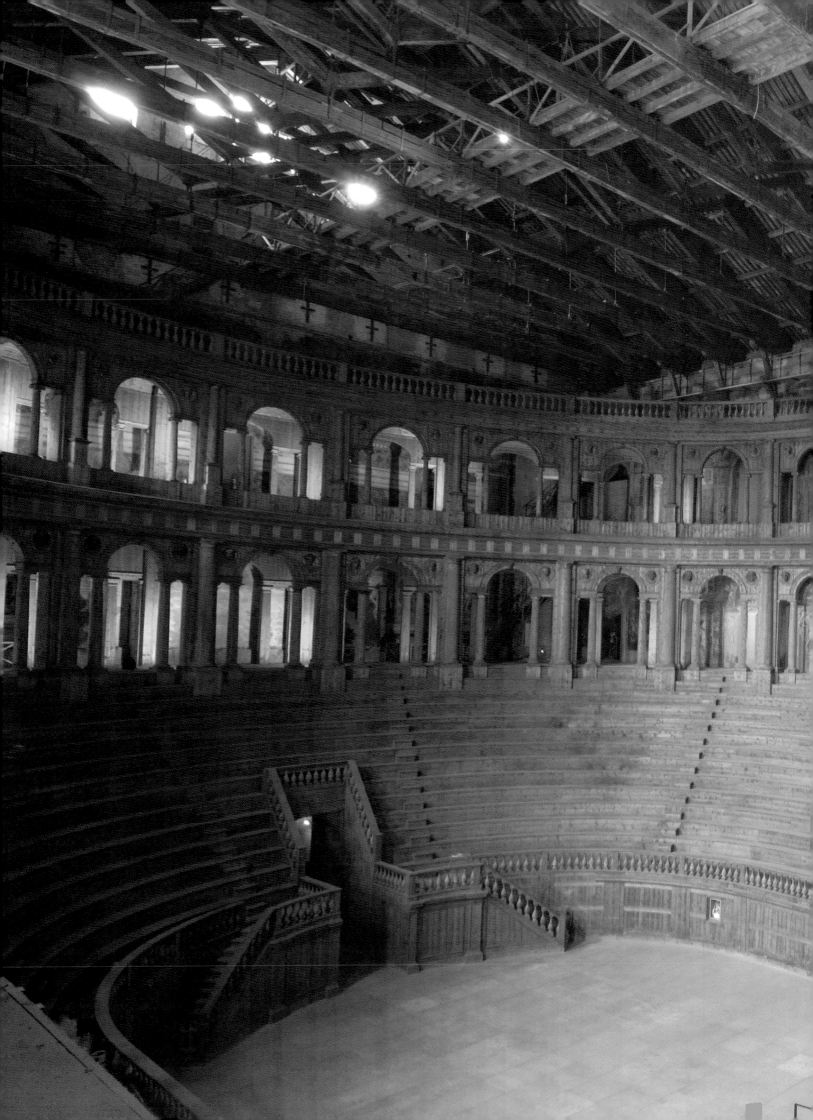

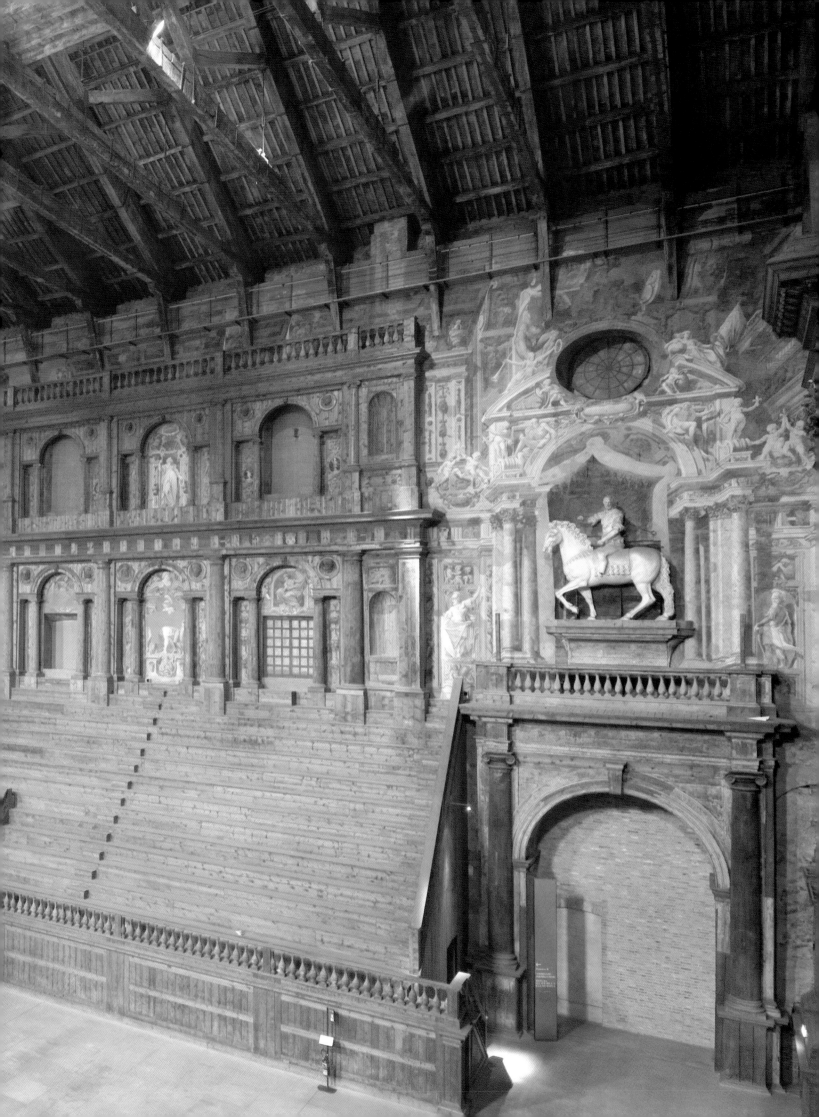

Auditorium Parco della Musica, Rome, Italy

In 1993, a call went out for a home to be built for the Accademia Nazionale de Santa Cecilia, which had been deprived of one since Mussolini demolished its concert hall. The result is this auditorium, which opened in 2002, in a park consisting of indoor and outdoor spaces for performances. The site is where the 1960 Summer Olympics was held.

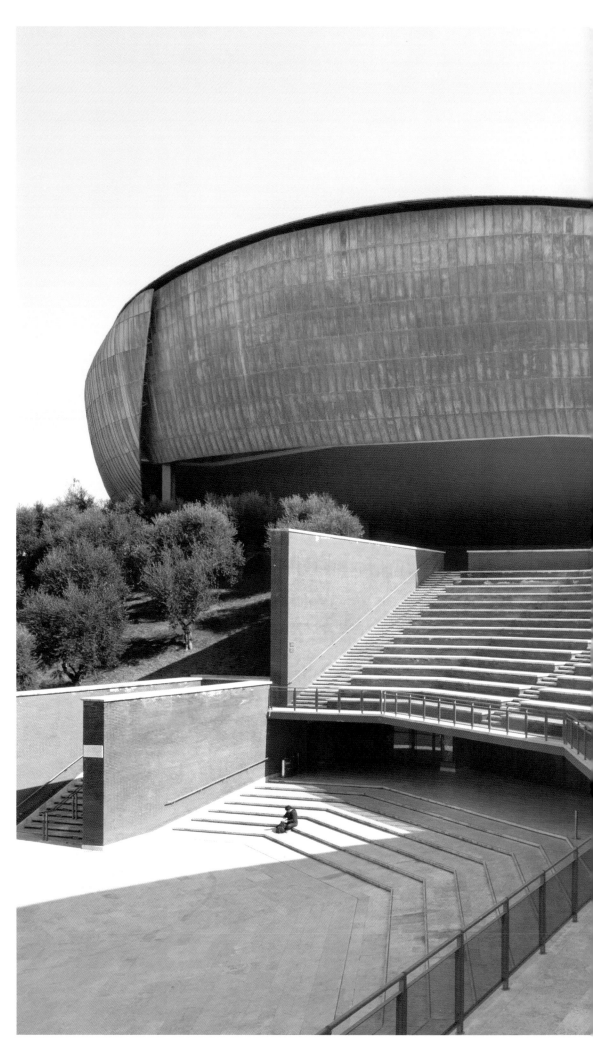

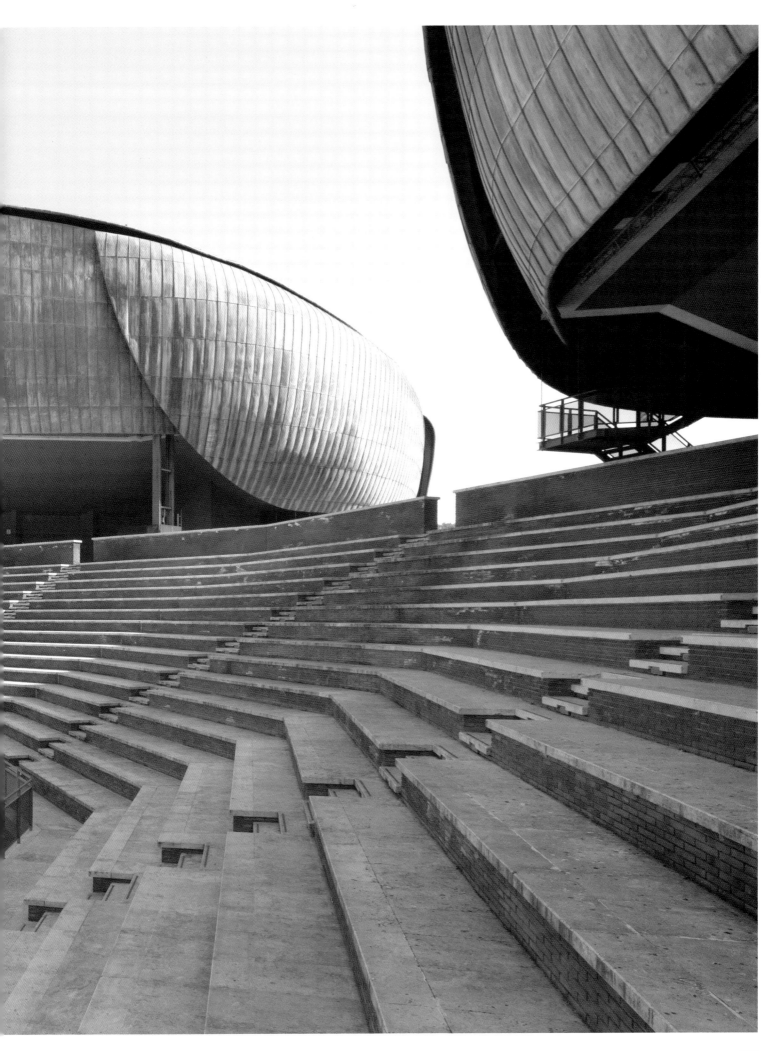

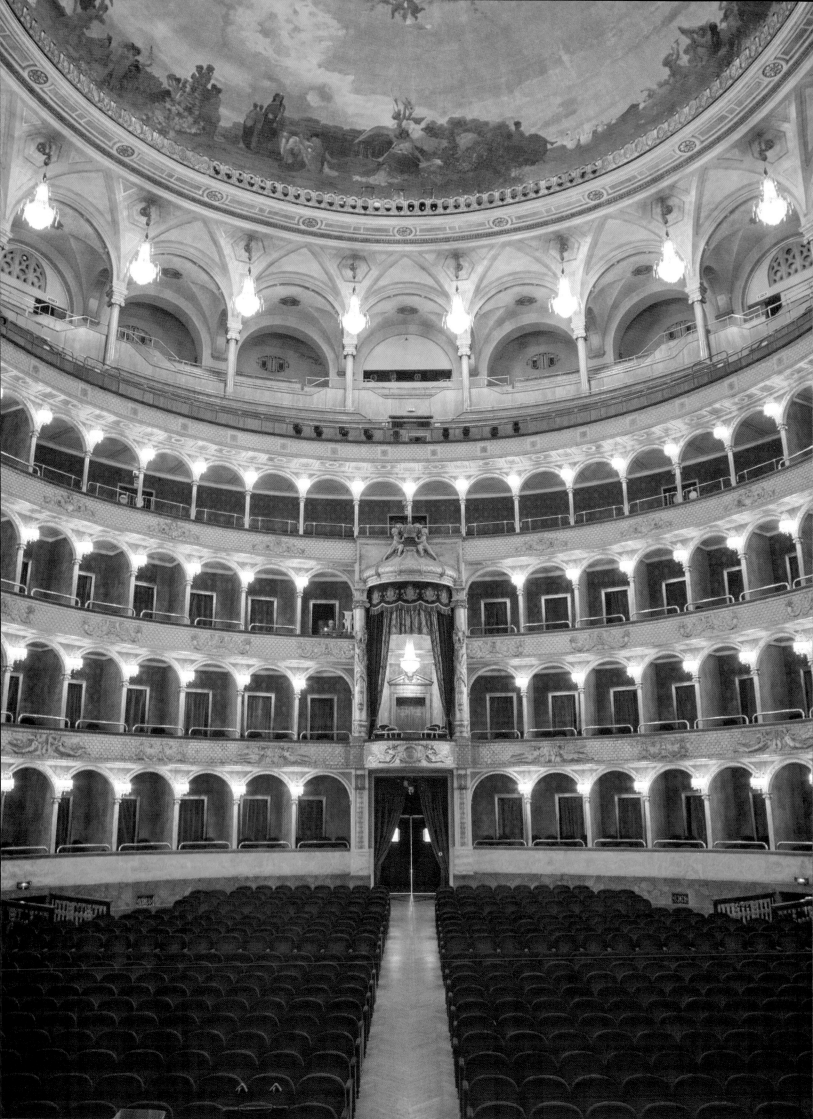

OPPOSITE:

Teatro dell'Opera di Roma, Rome, Italy

This venue, which opened in 1880, has been renamed a number of times, starting life as Teatro Costanzi, after Domenico Costanzi, who financed it. In 1926, Rome city council renamed it Teatro Reale dell'Opera, but in 1946, after the monarchy ended, 'Reale' was dropped. Both Mascagni's *Cavalleria rusticana* and Puccini's *Tosca* premiered there.

ABOVE TOP AND BOTTOM:

San Carlo Theatre, Naples, Italy

Having opened in 1737, this is the oldest continuously active venue for opera in the world. The orchestra pit was created at the suggestion of Giuseppe Verdi, and many of the great names of opera have performed there. One who didn't return for the last 20 years of his life was Enrico Caruso – he vowed never to return after being booed there in 1901.

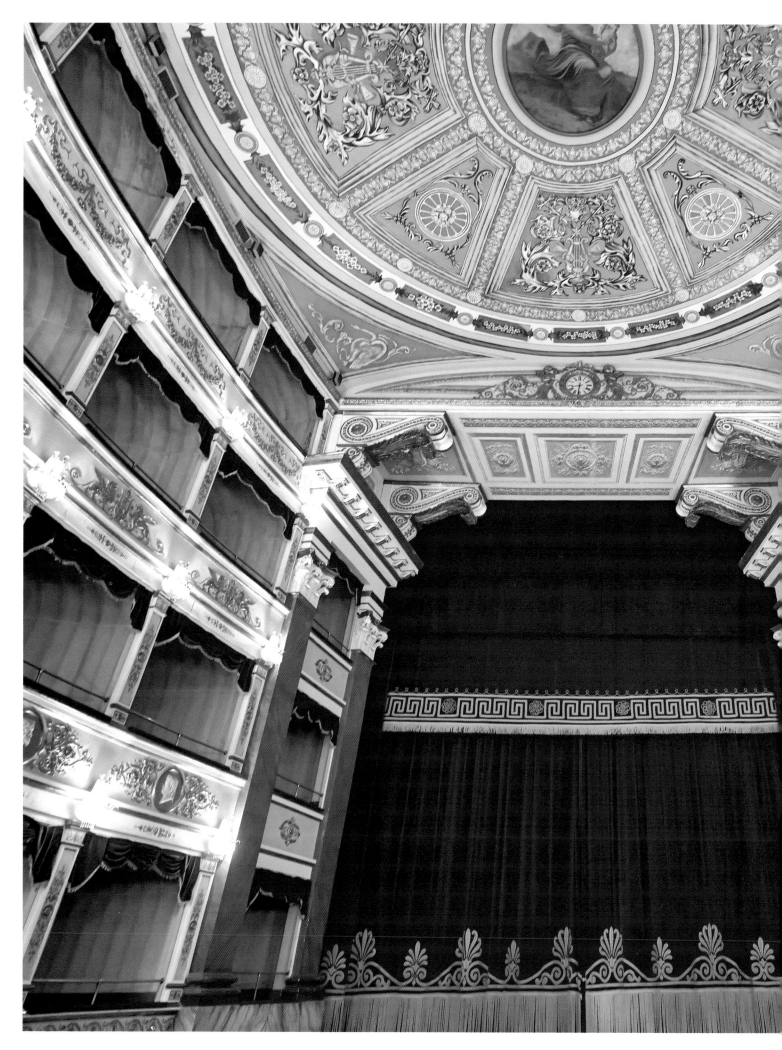

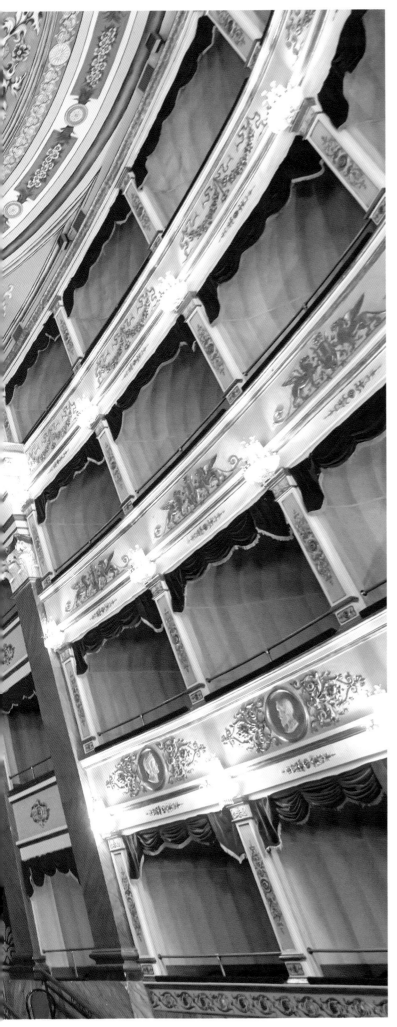

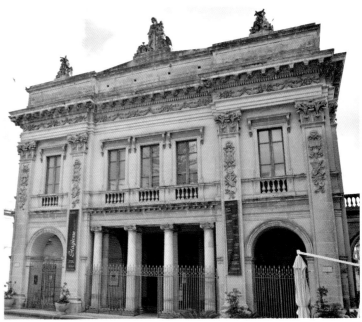

Teatro Tina di Lorenzo, Noto, Sicily
This playhouse, inaugurated in 1870, was previously named after King Vittorio Emanuele III. But the early 20th century his name was replaced by that of actress Tina di Lorenzo, who was raised in Noto, in the south of Sicily, in the 1870s and 1880s. The theatre is called a 'mini La Scala' because of its sumptuous interiors.

The Seebuhne, Lake Constance, Austria

Each summer, the Bregenz Festival presents al fresco opera on the water opposite the city. Structures on the 'floating stage' have included a tower for Wagner's *The Flying Dutchman* and a giant eye for Puccini's *Tosca*, which featured in the James Bond film *Quantum of Solace*. Audiences for the shows number 7,000.

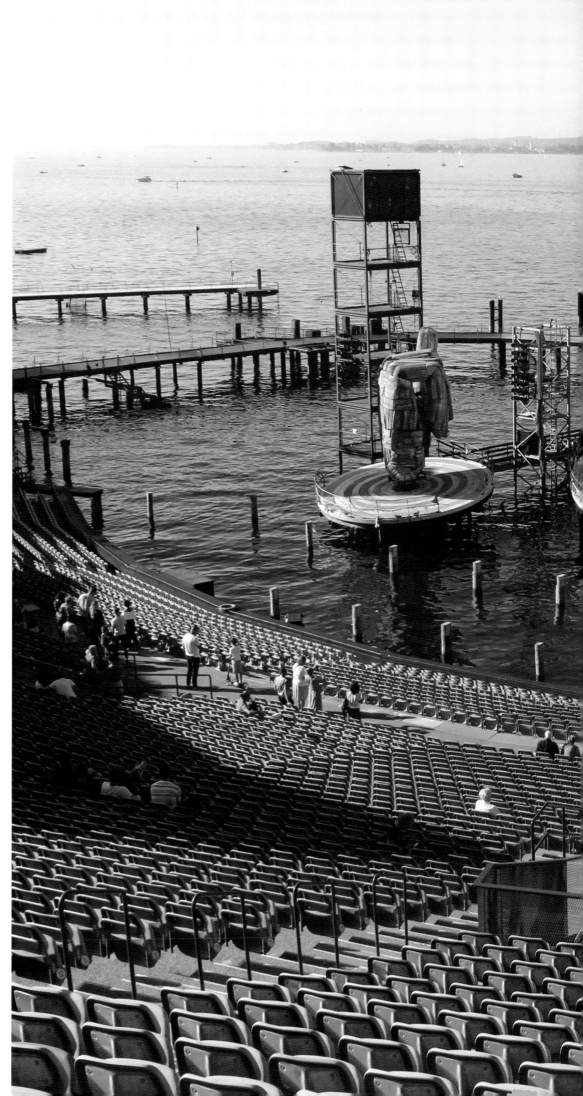

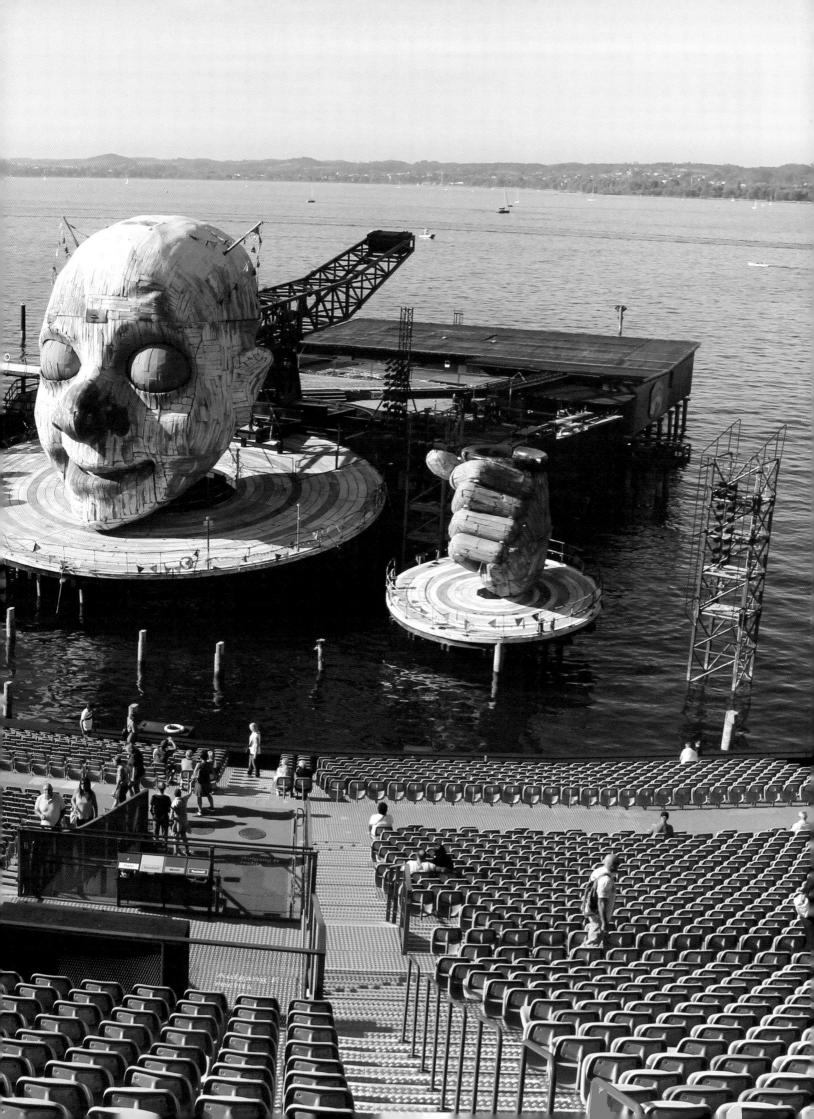

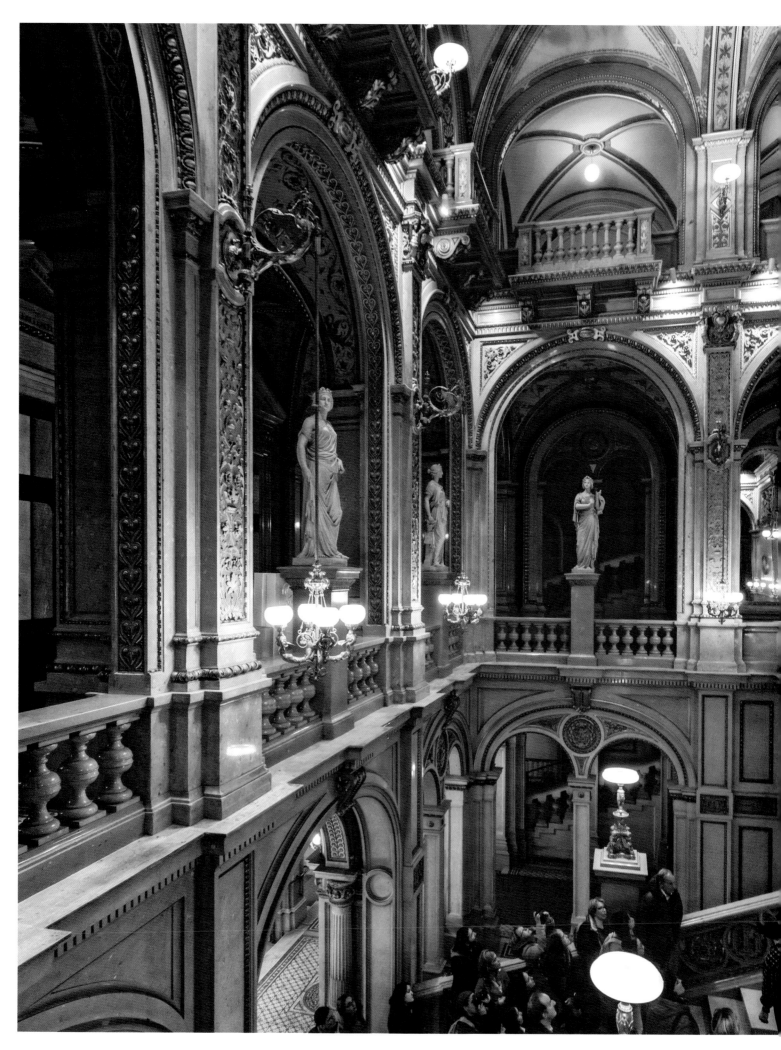

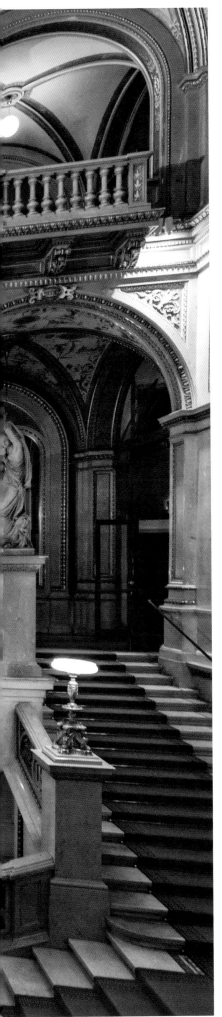

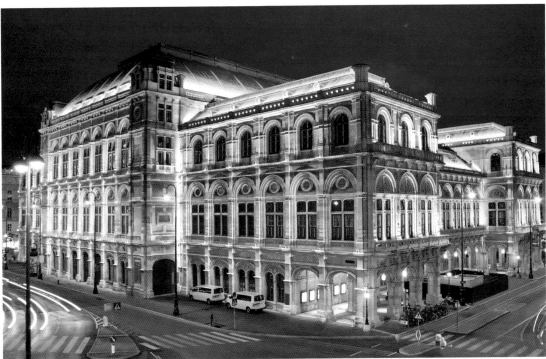

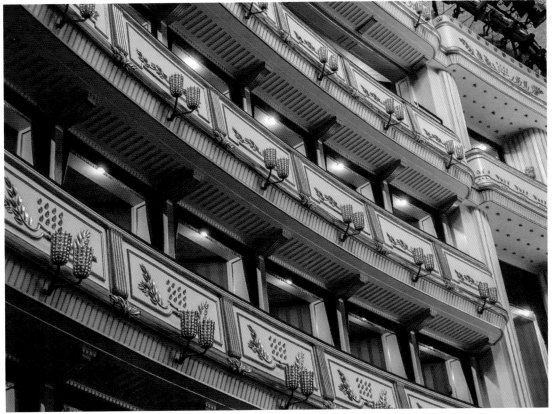

ALL PHOTOGRAPHS:

Vienna State Opera, Vienna, Austria

This monumental edifice opened in 1869, yet neither the architect nor interior designer were alive to be there. August Sicard von Sicardsburg, who designed the structure, had taken his own life, and his colleague, Eduard van der Nüll, was killed by a stroke. But today this lasting institution has the largest repertoire of any opera house in the world.

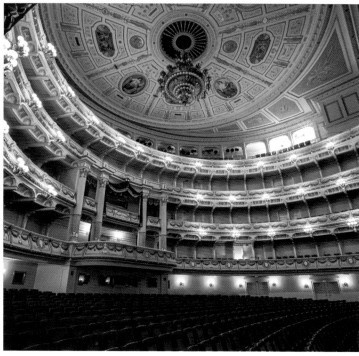

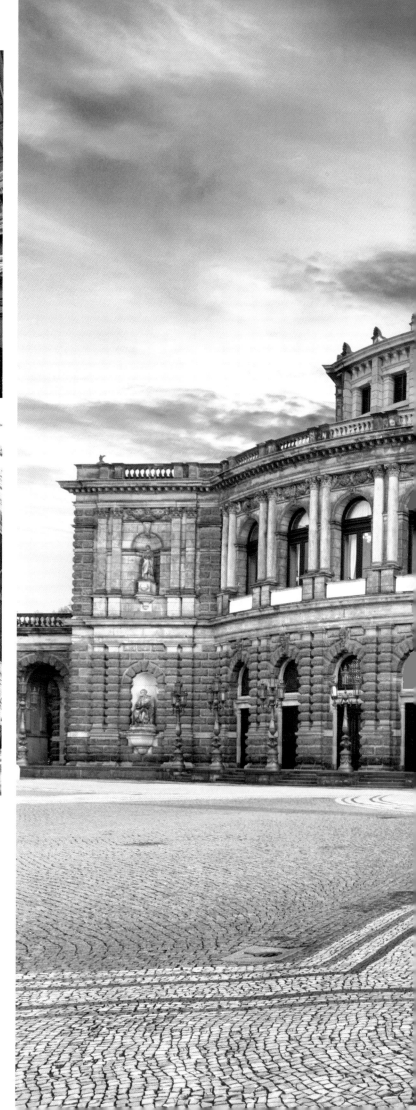

ALL PHOTOGRAPHS:

Semperoper, Dresden, Germany
On 13 February 1985, exactly 40 years after its predecessor's destruction in an Allied bombing raid, this grand recreation was officially unveiled. Before that, architect Gottfried Semper's opera house had stood since 1878. But even that was not the first 'Semperoper' – that one was built in 1841, then burned down in 1869.

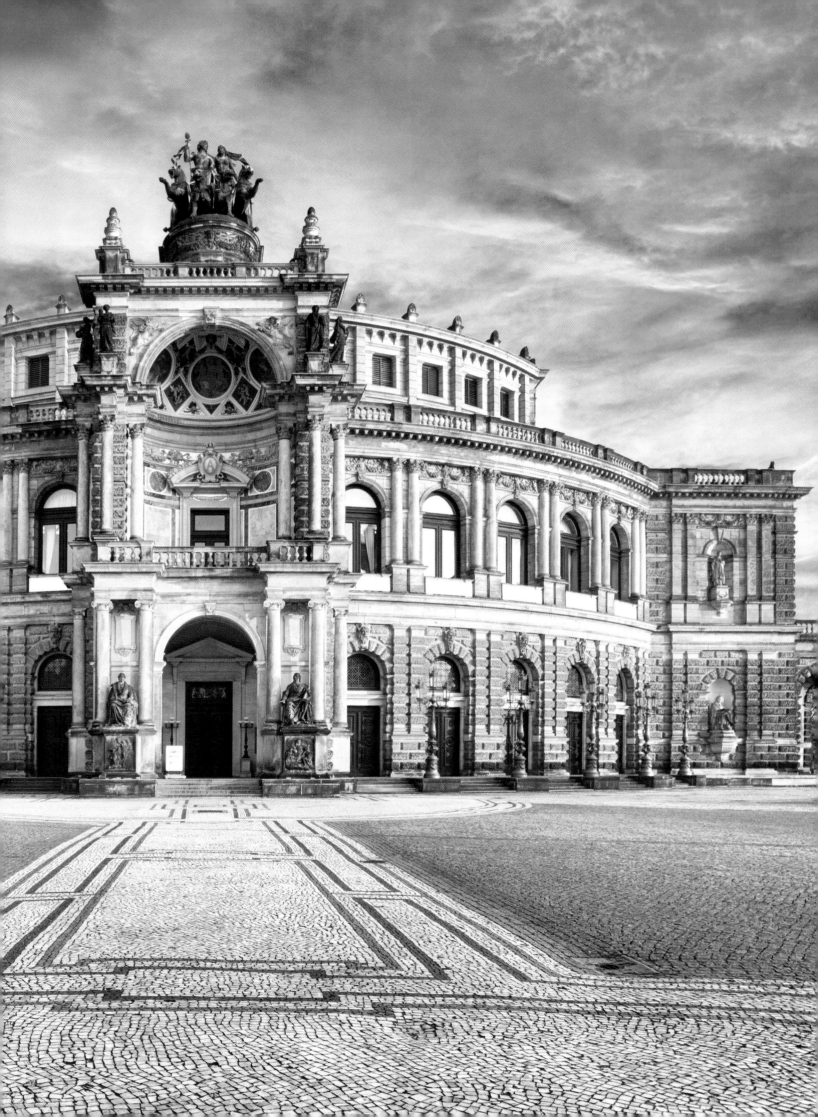

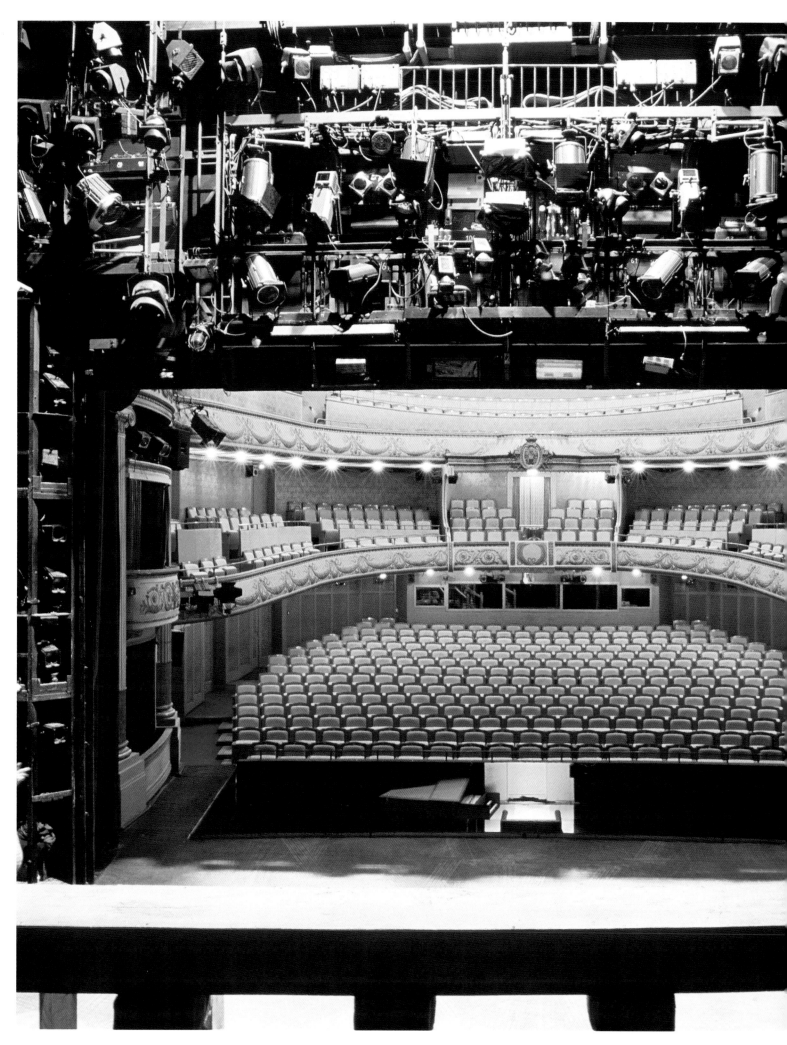

LEFT:
Meiningen Theatre, Meiningen, Germany
The company that started in this town in 1866 was one of the first in the world in which the role of the director was stressed. It was started by George II, Duke of Saxe-Meiningen, and its focus on authenticity heavily influenced the thinking of pioneering Russian director Konstantin Stanislavsky. The company's current theatre dates from 1909.

BELOW:
Margrave Theatre, Bayreuth, Germany
This baroque opera house, from 1748, was built by Margravine Wilhelmine of Brandenburg-Bayreuth, daughter of Frederick William I of Prussia, for the marriage of her only daughter. She modelled it on the grandest houses of the time and the outstanding theatre is the reason Wagner adopted Bayreuth for his annual festival.

OVERLEAF:
Berliner Philharmonie, Berlin, Germany
This building, inaugurated in 1963, is the current hall for its resident orchestra, which has had various homes. The Berlin Philharmonic started out in 1882 in Kreuzberg in an old skating rink and this, and its following venue, were both destroyed in the war. In the 1940s the orchestra also played in a disused cinema.

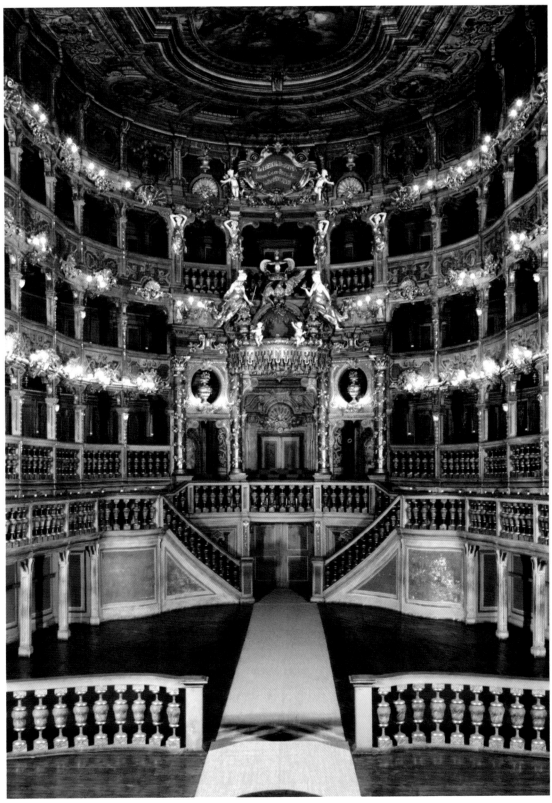

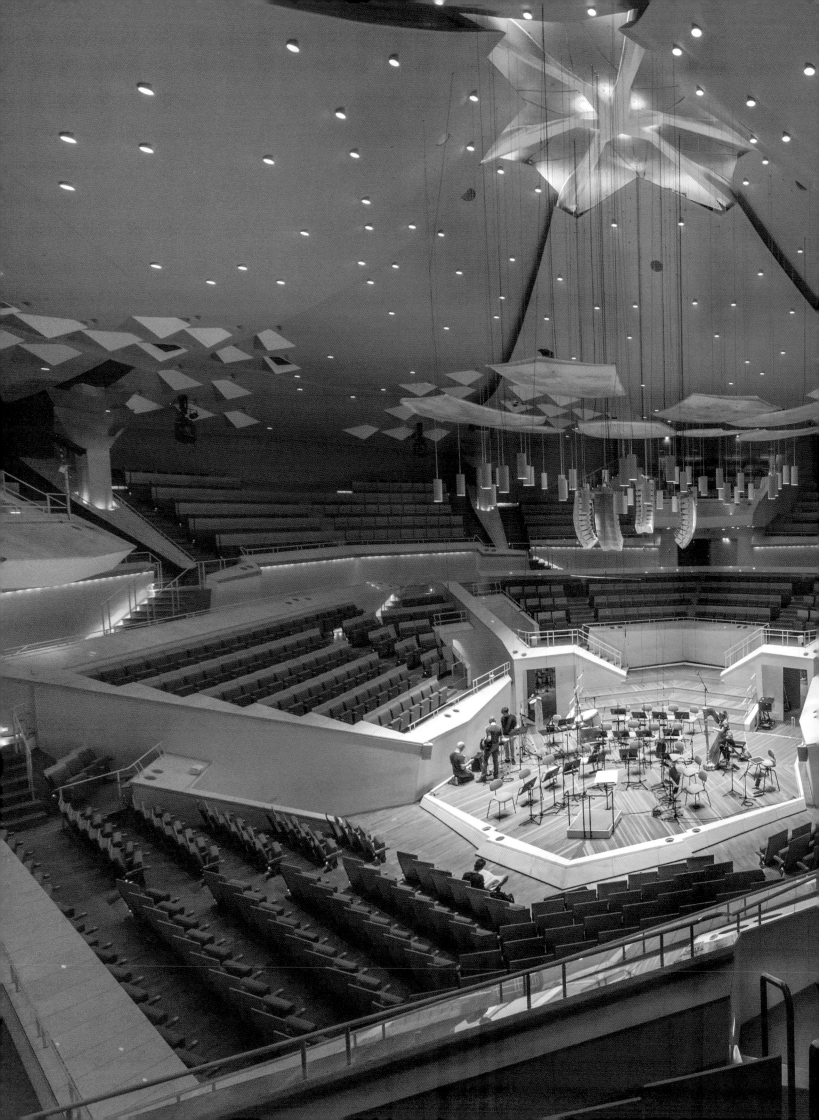

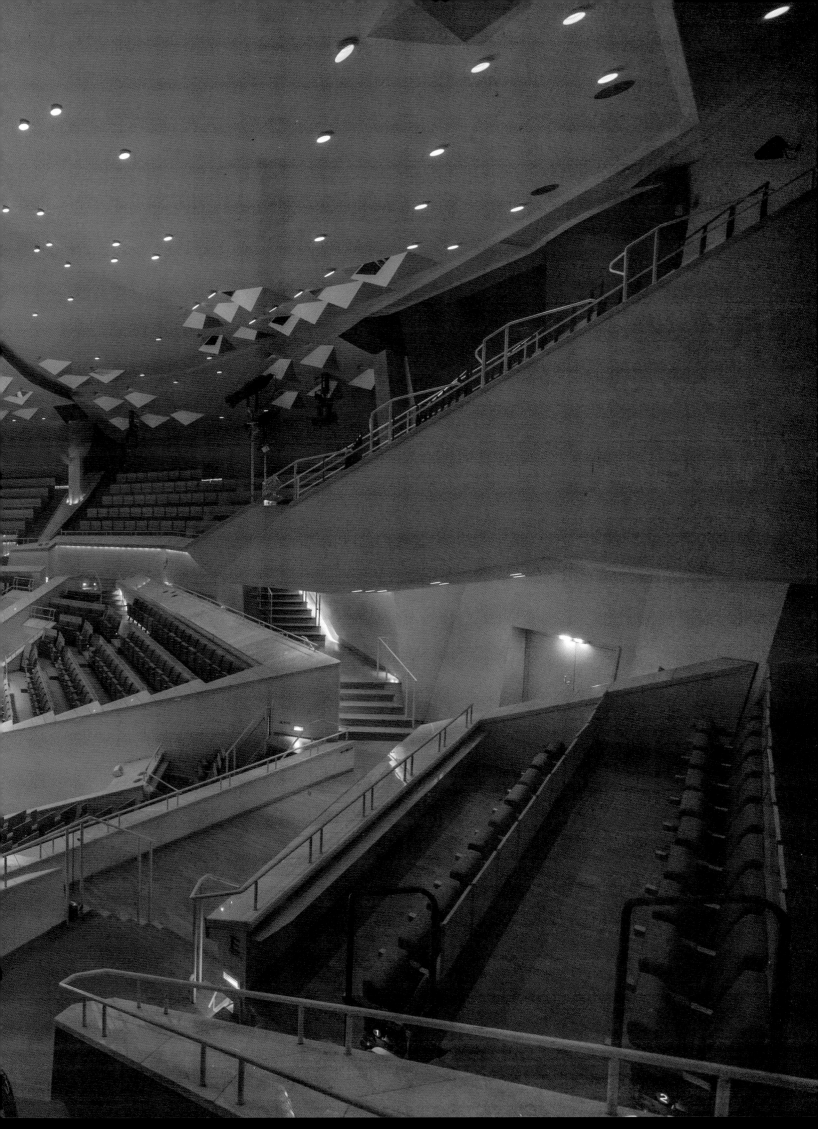

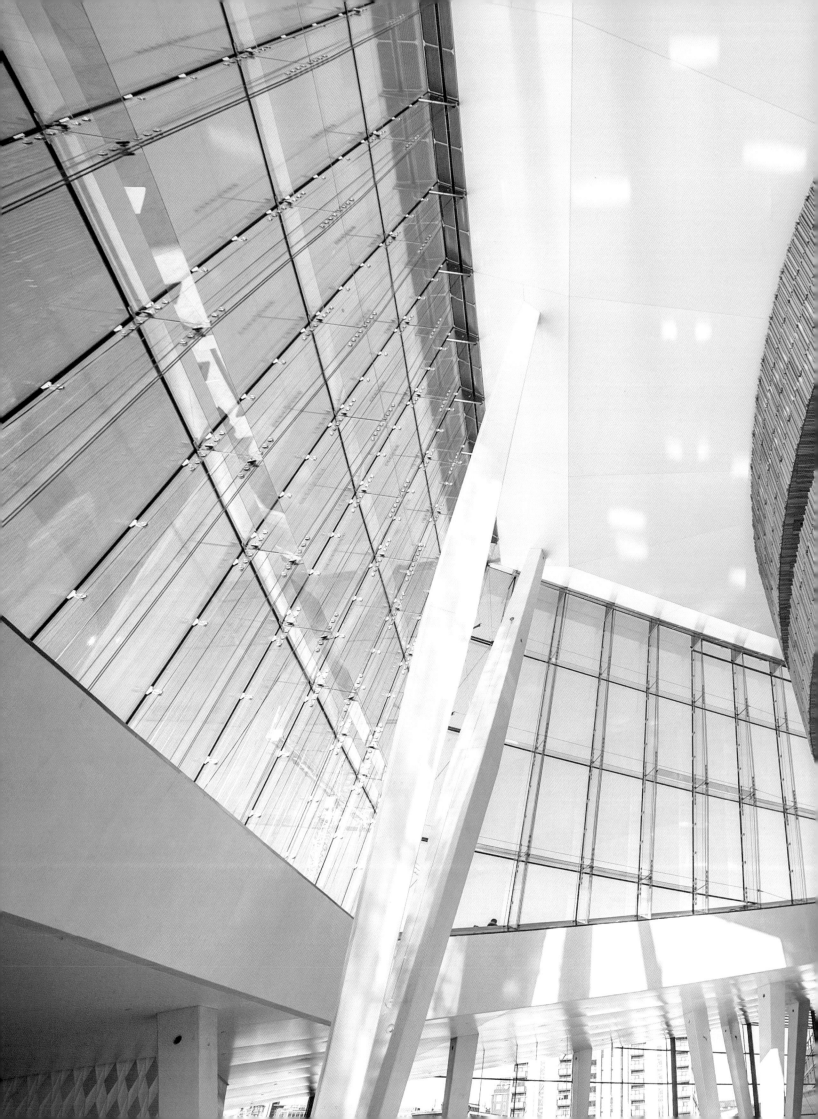

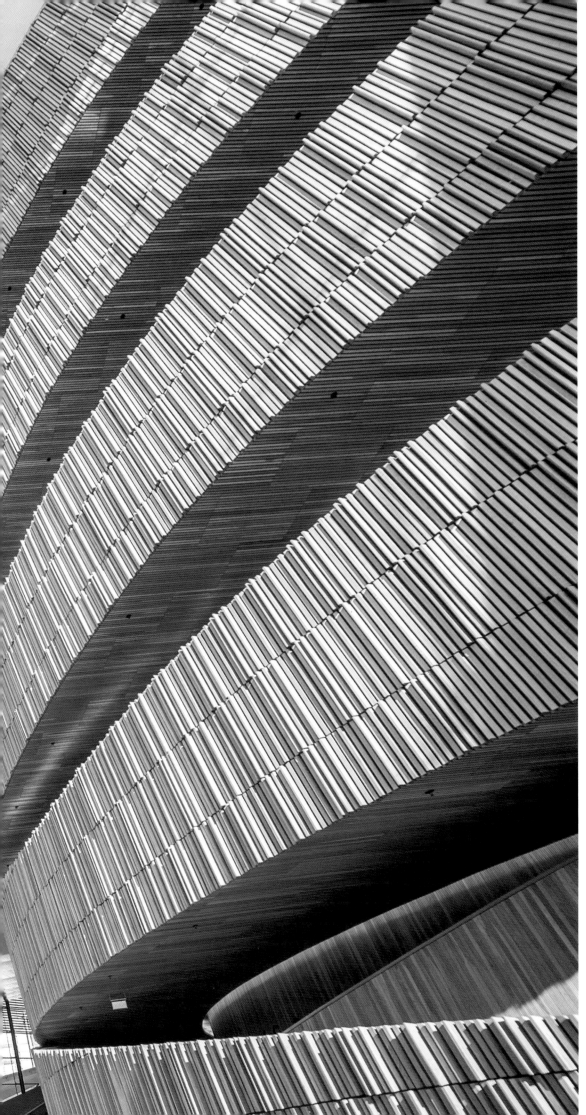

Oslo Opera House, Norway
The oakwood, glass, marble and aluminium of the interior of this arts complex is contained within a structure that looks like it is emerging from the city's fjord, and has a roof designed to be walked on. The building, which opened in 2008 in the Bordia area of the city, is inspired by Norwegian nature, rather than other opera houses.

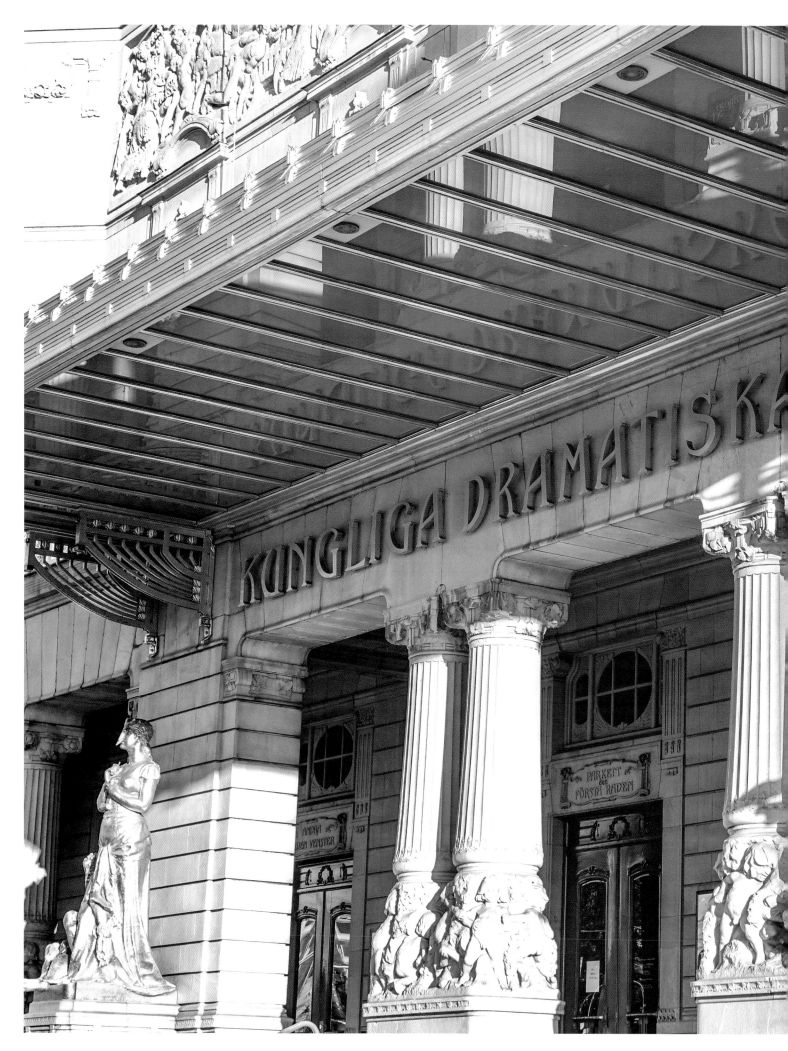

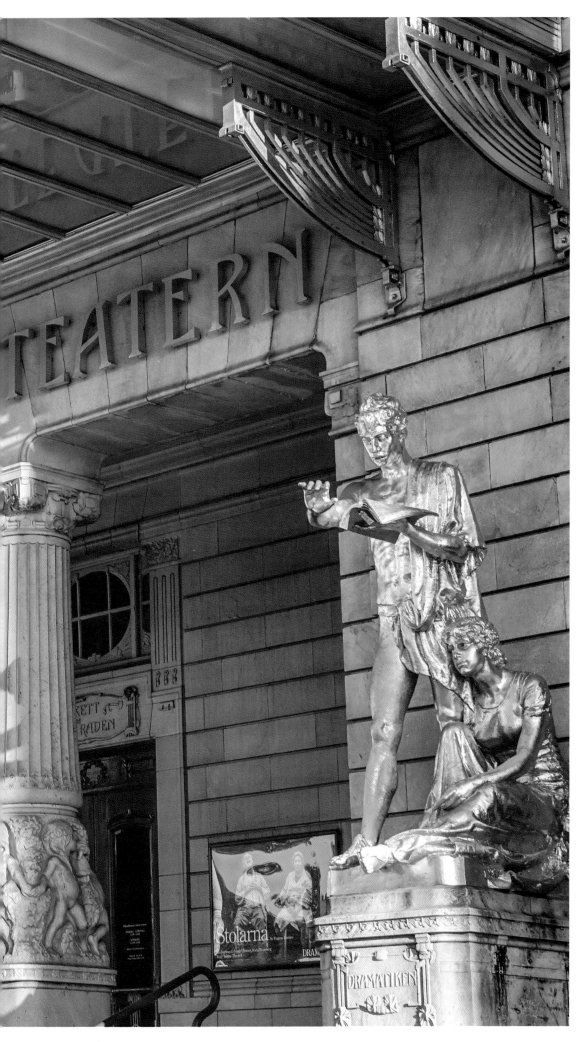

Royal Dramatic Theatre, Stockholm, Sweden
The country's national playhouse was founded in 1788 but took 120 years to find its current grand, city-centre home. King Gustaf III set up the institution next to the royal palace and in subsequent decades it moved to a building that burned down, then to the city's opera house and then to Stockholm's 'Smaller Theatre'.

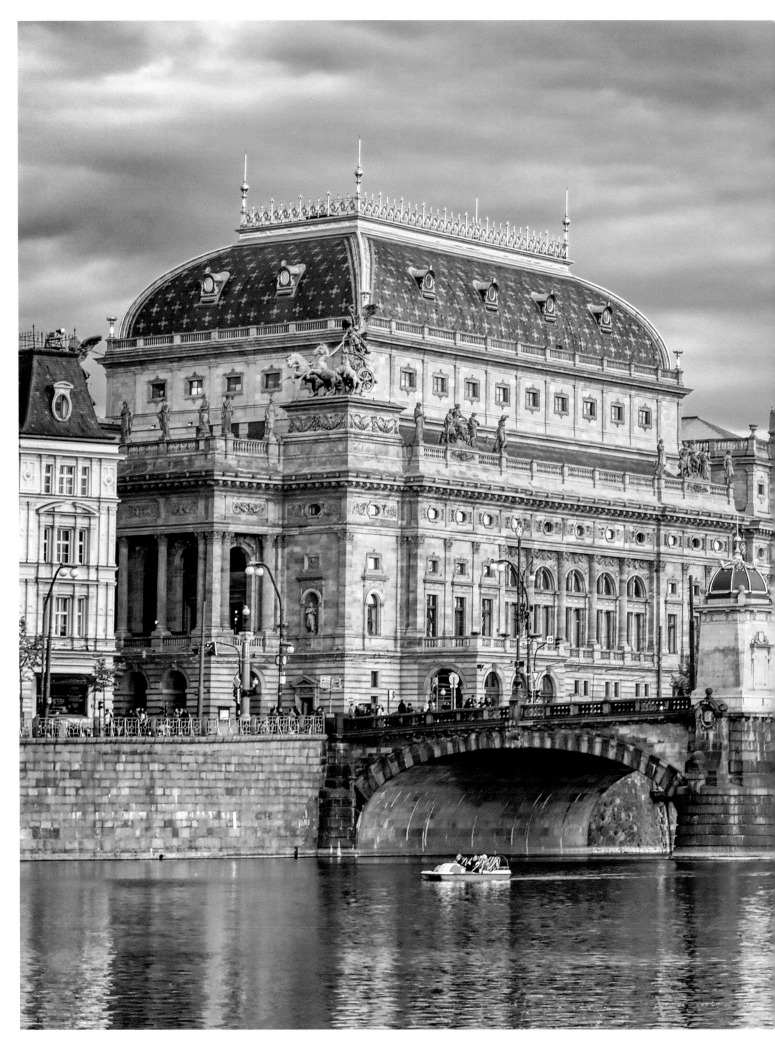

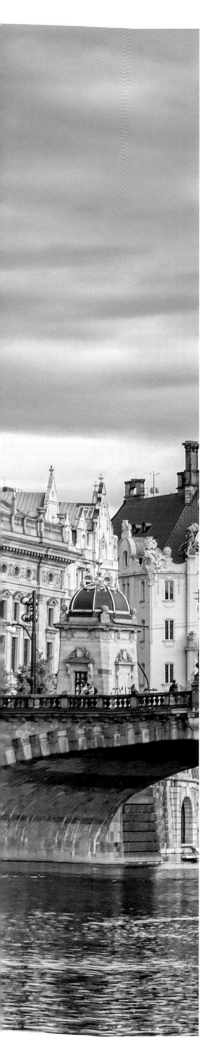

ALL PHOTOGRAPHS:

Prague National Theatre, Prague, Czech Republic
The site for this ornate edifice is a former salt works on the banks of the
River Vltava. The land was purchased by a group of patriotic Czechs
in 1852, after they had spent eight years raising funds. Another three
decades passed before it opened in the form we see today, after a fire in
1881 hampered its progress by another two years.

Hungarian State Opera, Budapest, Hungary

This ornate neo-Renaissance and baroque house was partly funded by Emperor Franz Joseph of Austria-Hungary and took nine years to build, opening in 1884. Its richly decorated interiors and beautifully hewn exteriors extend to gilded boxes, statues of Hungarian composers Franz Liszt and Ferenc Erkel, and a monumental circular ceiling fresco.

Quarry Cave Theatre, Fertorakos, Hungary

Fossilised shark teeth can be found in the walls of this space. The rock was formed 10 million years ago, it has been mined since the 1500s. It was in 1937 that pianist, composer and conductor Erno Dohnanyi recognised the potential of one of the quarry's caves, which now hosts up to 760 people and even has heated seats.

National Academic Theatre, Odessa, Ukraine

When the original 1810 building was gutted by fire in 1873, fundraising began for a replacement, and the 1878 Dresden Semperoper was the template chosen for the new design. The current building opened in 1887. In those days, summer audiences were kept cool by wagonloads of ice and straw unloaded into a basement under the hall.

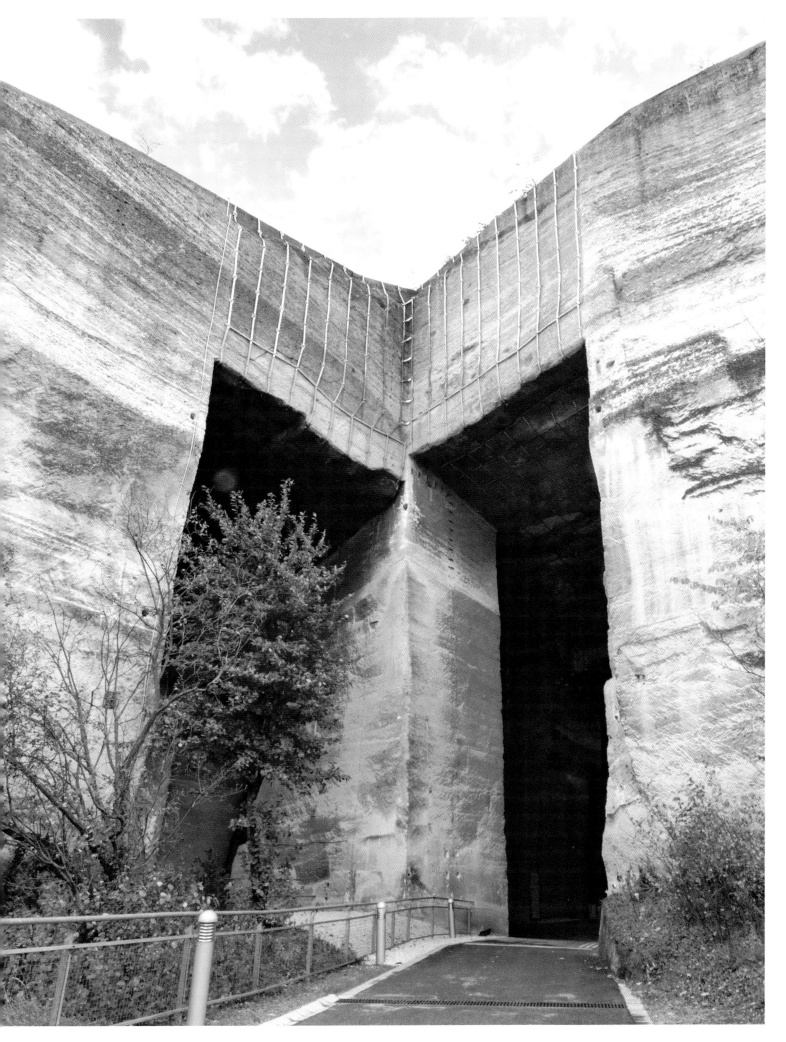

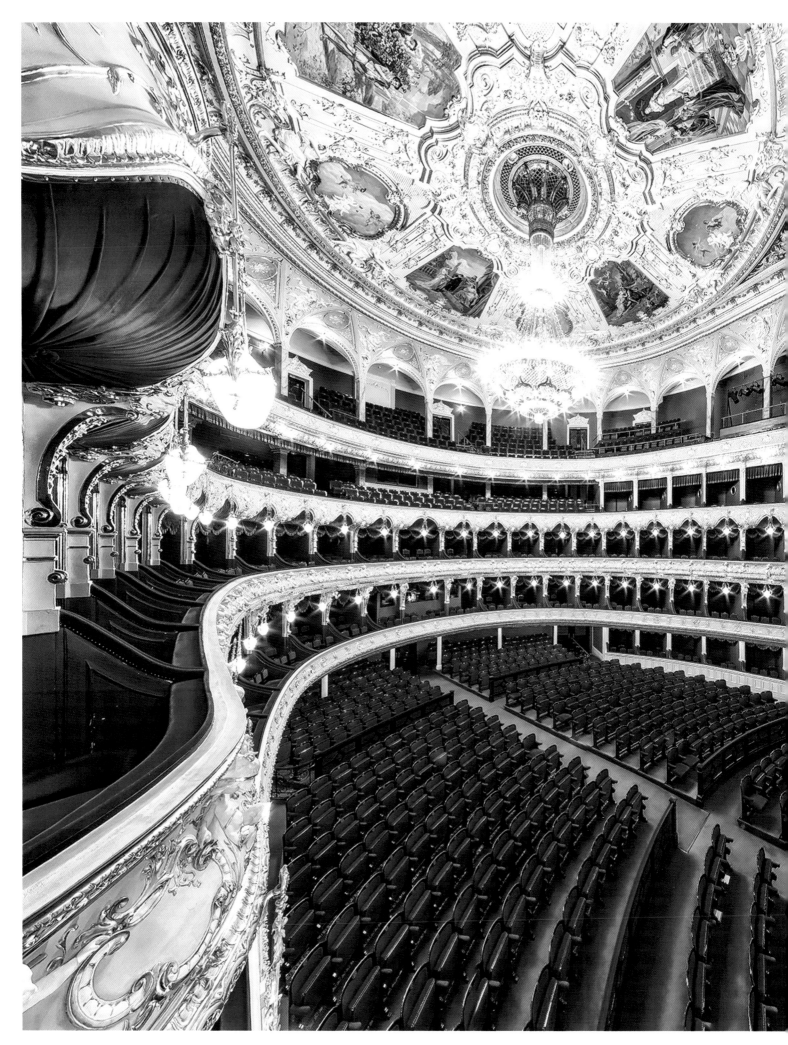

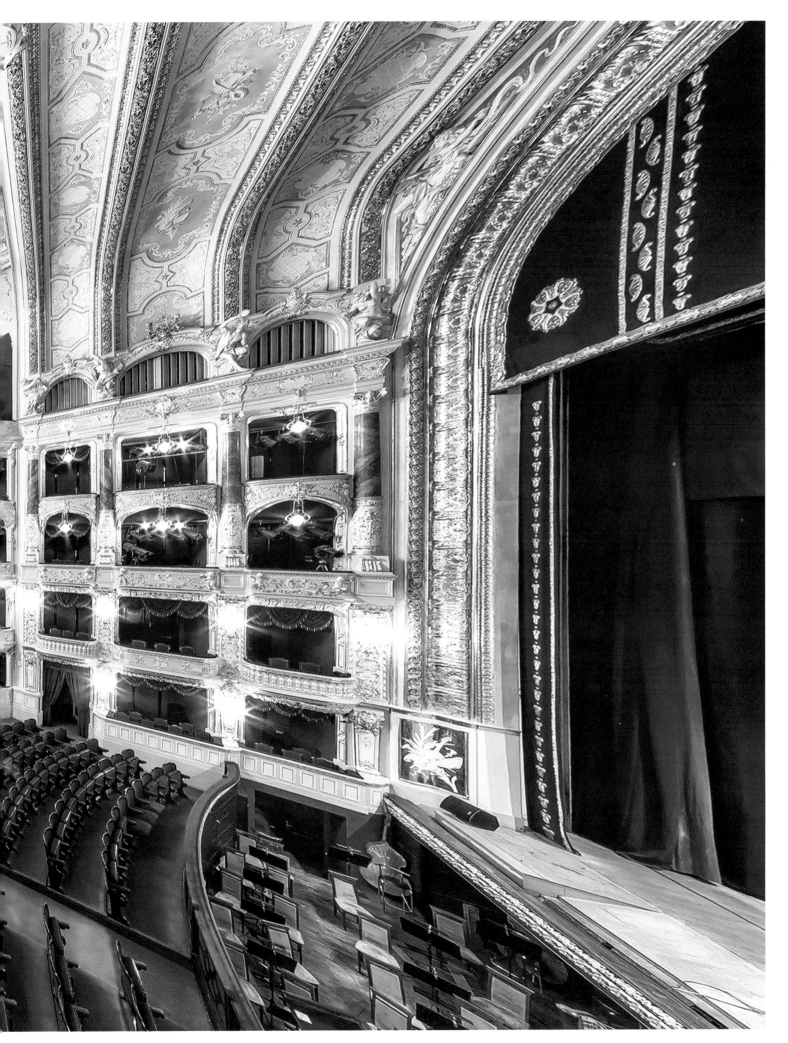

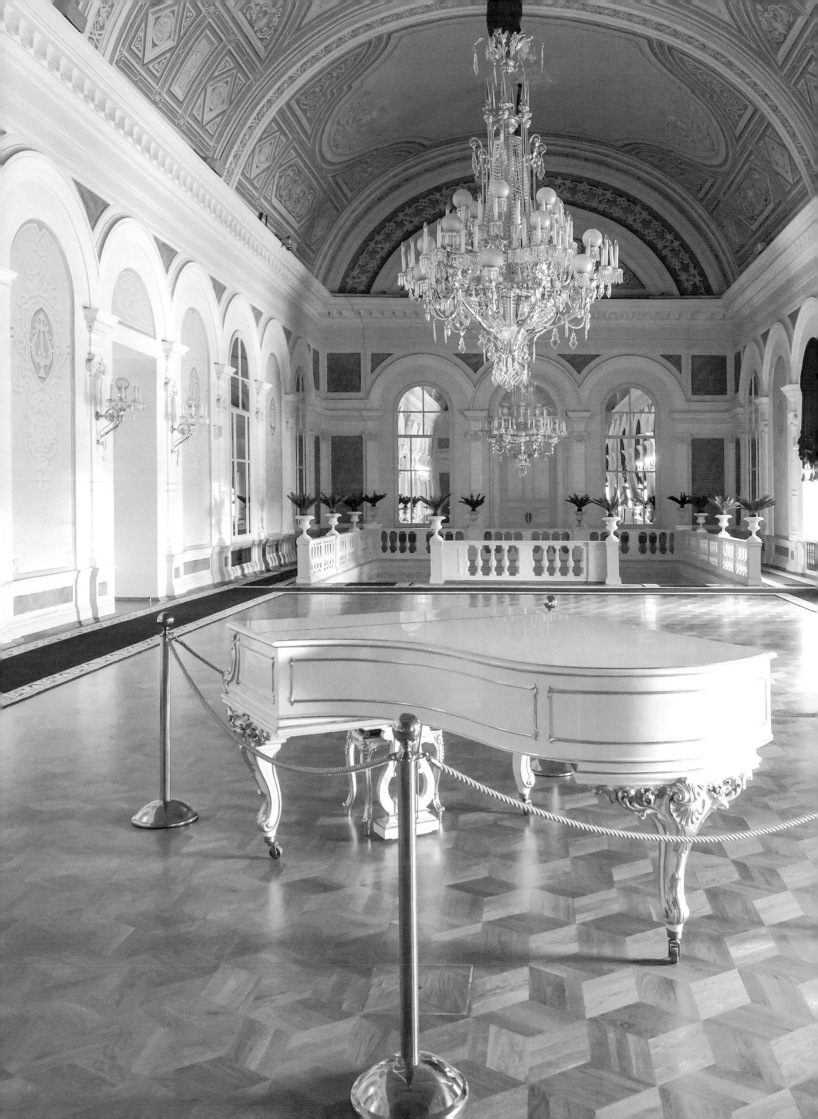

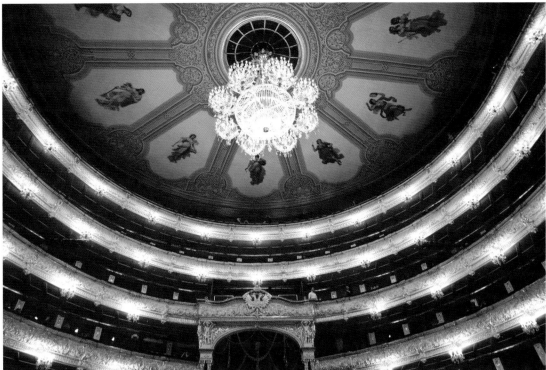

ALL PHOTOGRAPHS:
Bolshoi, Moscow, Russia
It was Tsar Alexander II's
coronation day in 1856 when this
landmark was opened. 'I tried
to decorate the auditorium as
extravagantly but at the same
time as lightly as possible, in
Renaissance taste but mixed
with Byzantine style,' architect
Alberto Cavos said. Less than 70
years later, the formation of the
USSR was proclaimed from the
Bolshoi's stage.

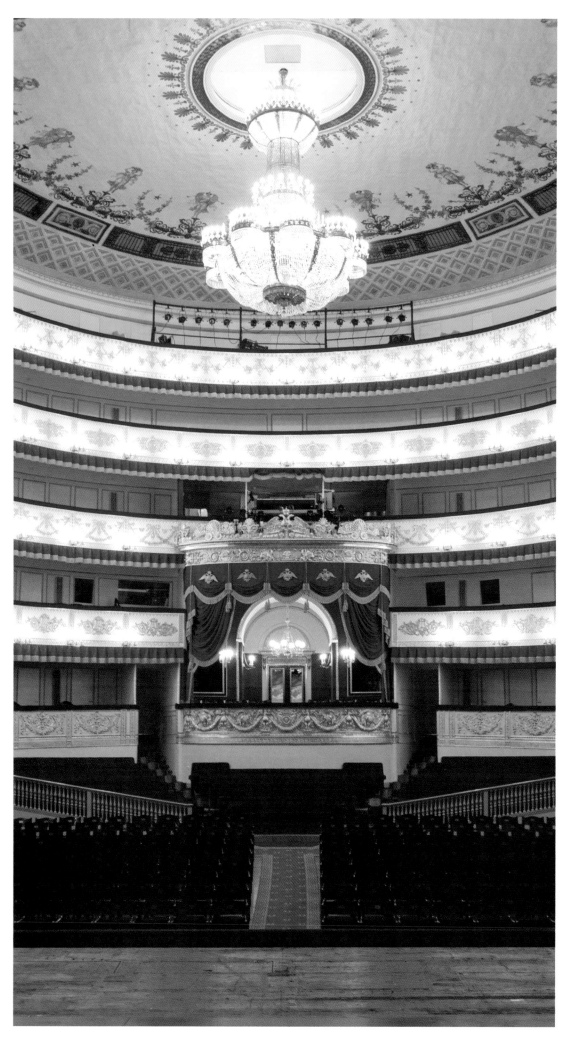

**Alexandrinsky Theatre,
St Petersburg, Russia**
A special order of the Senate,
signed by Peter the Great's
daughter Empress Elizabeth in
1756, established this institution.
Officially called the National
Drama Theatre of Russia,
it has become known as the
Alexandrinsky when it moved to
its current building, in 1834, in
honour of the wife of Emperor
Nikolai I, Alexandra Fyodorovna.

**Rezo Gabriadze Puppet Theatre,
Tblisi, Georgia**
The Battle of Stalingrad – with
mini tanks advancing to the strains
of Shostakovich – is one of the
feats attempted by this 'marionette
house'. The theatre, located in the
old town of the Georgian capital,
is the brainchild of artist Rezo
Gabriadze, who turned to puppets
to express himself under the
strictures of the Soviet Union.

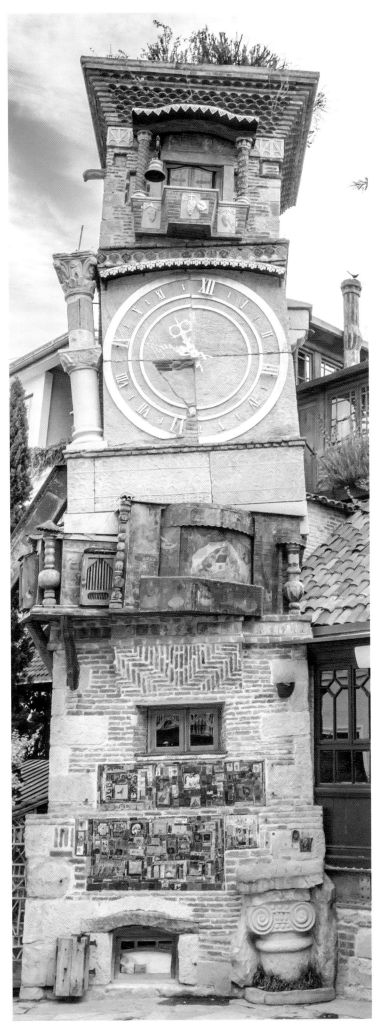

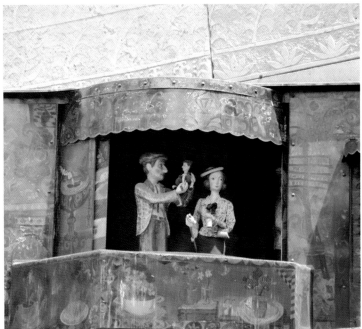

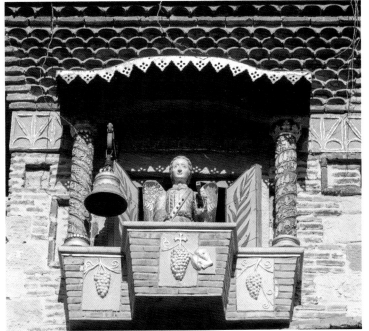

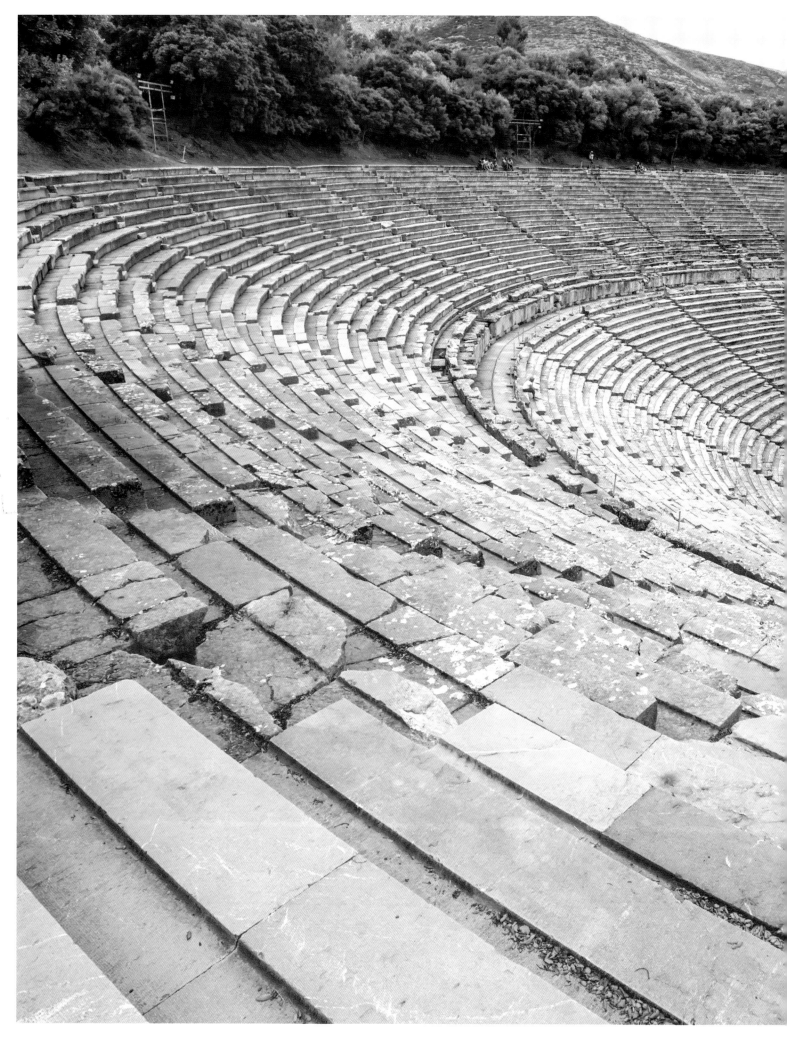

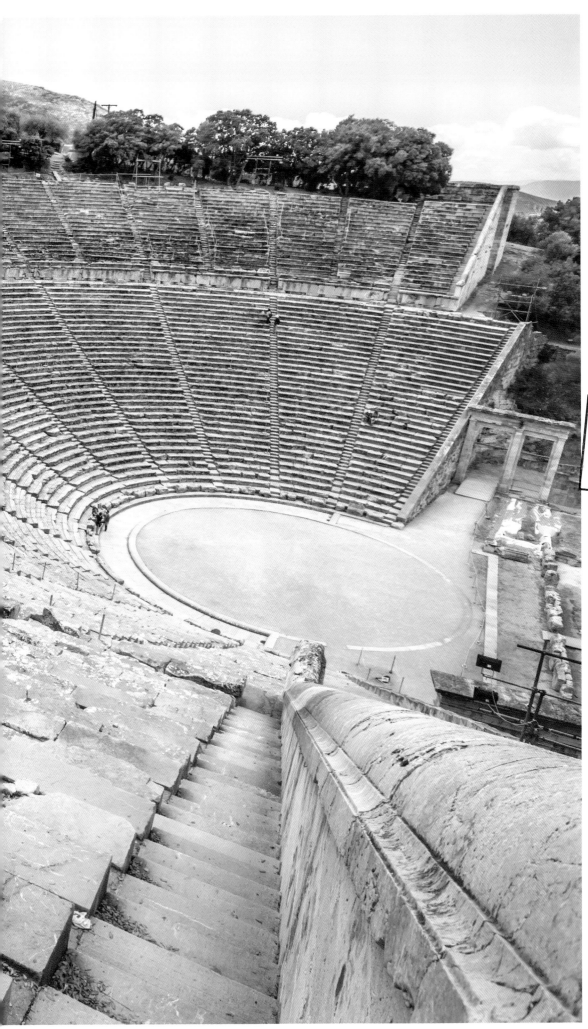

Epidaurus, Greece
This outdoor theatre dates from the 4th century BCE. It is particularly noted for its excellent acoustics and tour guides demonstrate this by striking a match centre stage that can be heard from anywhere within the theatre, where up to 14,000 people once sat. The original 34 rows were expanded by 21 in Roman times.

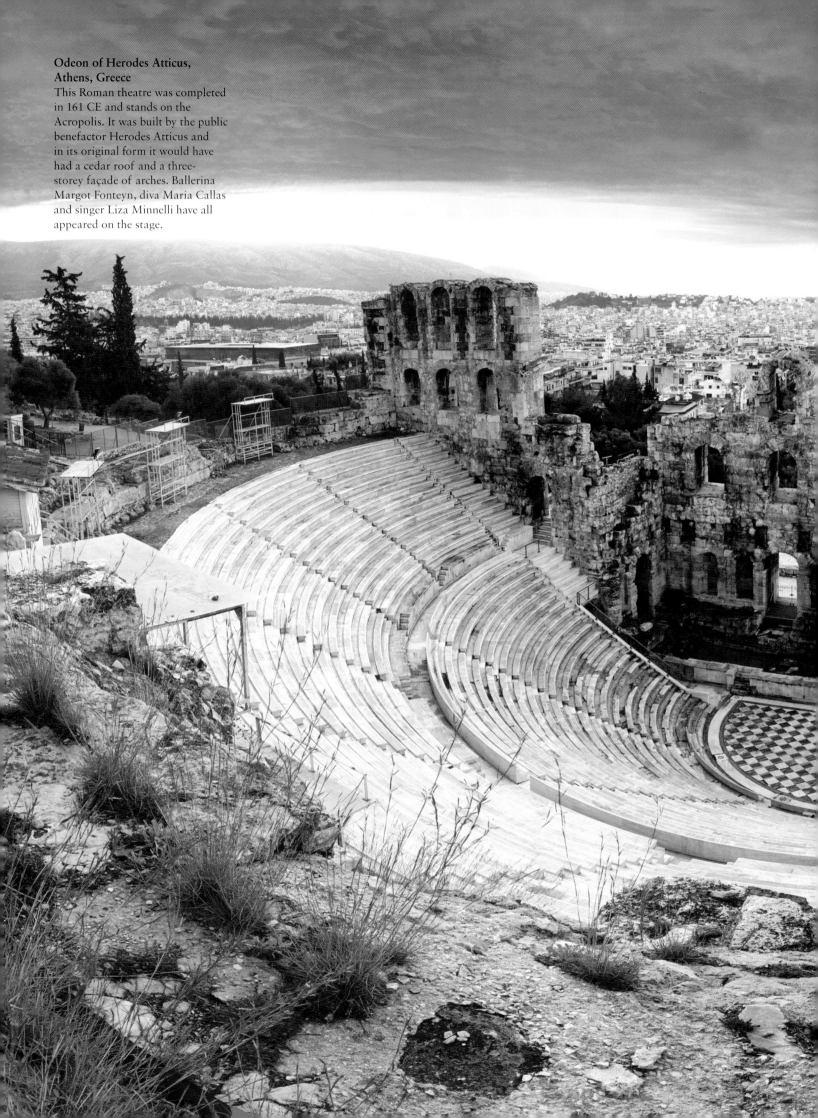

Odeon of Herodes Atticus, Athens, Greece
This Roman theatre was completed in 161 CE and stands on the Acropolis. It was built by the public benefactor Herodes Atticus and in its original form it would have had a cedar roof and a three-storey façade of arches. Ballerina Margot Fonteyn, diva Maria Callas and singer Liza Minnelli have all appeared on the stage.

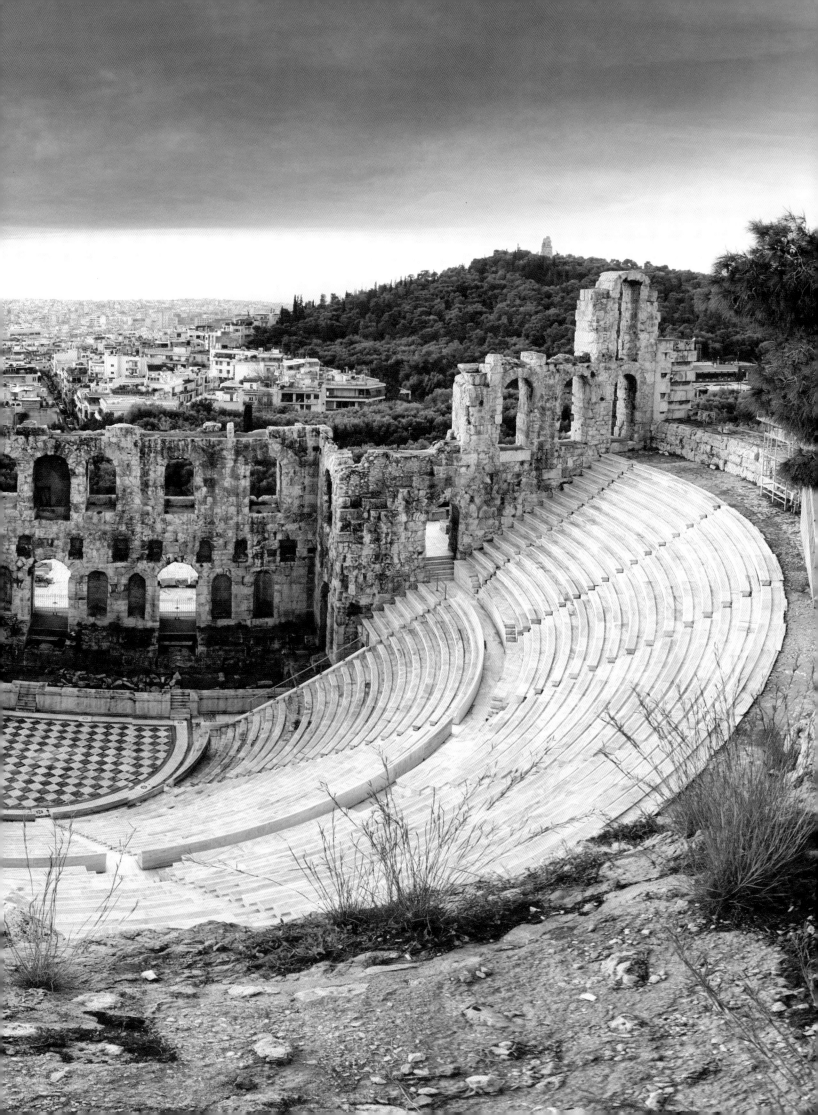

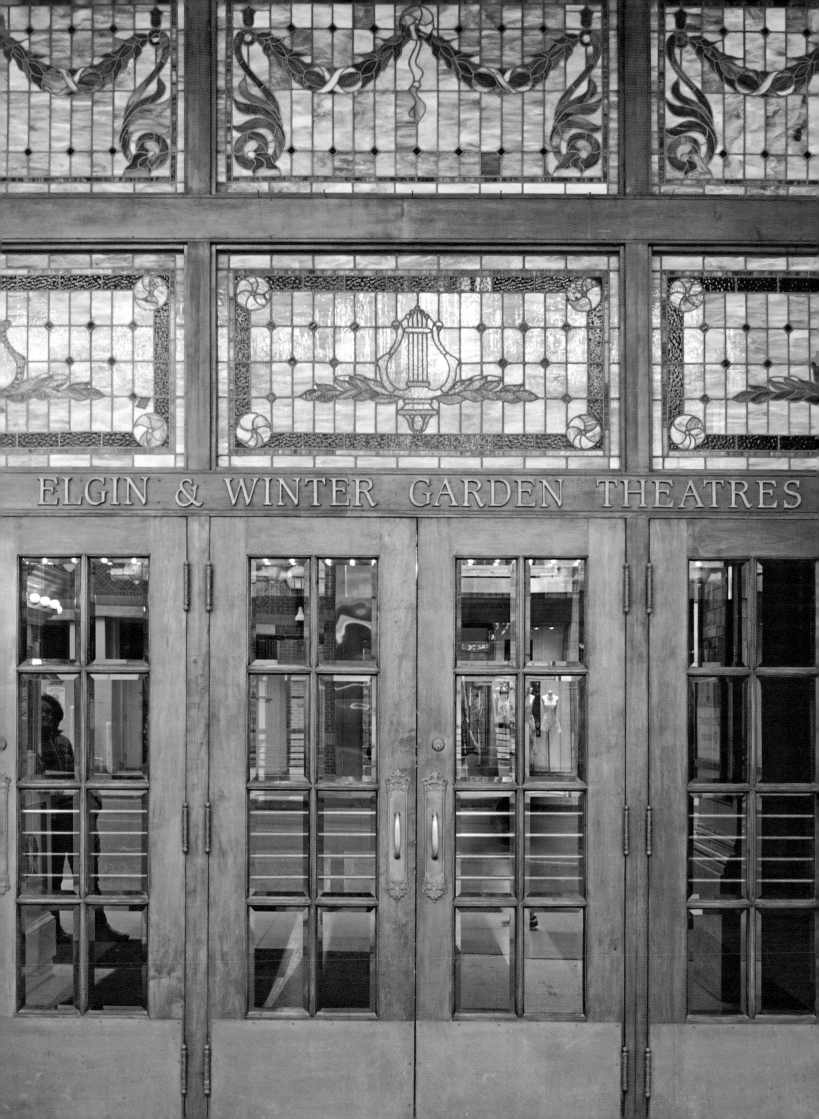

The Americas

Beyond Broadway, there is a huge amount of variety in the theatres of the USA and Canada. The time range spans from the first playhouse in America to be constructed exclusively for theatrical performance (the Dock Street Theatre in Charleston, dating from 1736) to one whose exterior consists of glass, pre-cast concrete and bead-blasted stainless steel (the Kauffman Center for the Performing Arts in Kansas City, which opened in 2011). In addition to that are the quirks of the 'double-decker' venue of the Elgin & Winter Garden Theatres in Toronto, and The Egg (named after what it resembles) in the New York state capital, Albany. And, of course, there is the theatre where Abraham Lincoln was assassinated, Ford's, in Washington, D.C. Latin America is equally as rich in notable theatrical buildings, with the grandeur of those built in the late 19th and early 20th centuries excellently preserved. Perhaps the greatest achievement is the Teatro Amazonas, in Manaus, in the heart of the Brazilian rainforest. It's location didn't stop its Belle Epoque splendour from being built, more than a century ago, even if many of its materials had to be shipped from Europe. But the oddest theatre building in Latin America must be the Ateneo Grand Splendid Theatre in Buenos Aires, Argentina. It is now a bookshop, albeit one with the auditorium and crimson curtains of its theatrical past.

OPPOSITE:
Elgin & Winter Garden Theatres, Toronto, Canada
These two playhouses make up a 'double-decker' complex, with the former sitting underneath the latter. When they were built in 1913, the Elgin was all gold leaf and rich fabrics, while the Winter Garden's walls were hand-painted to resemble a garden. After a decline, they were restored in the late 20th century.

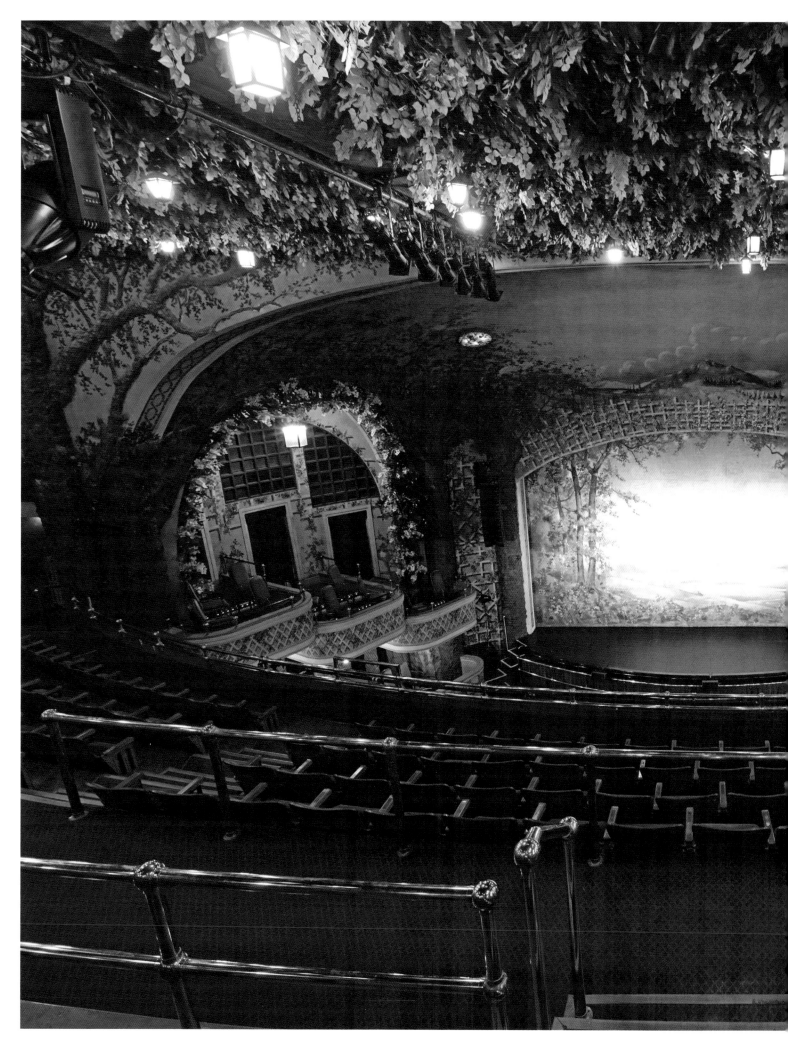

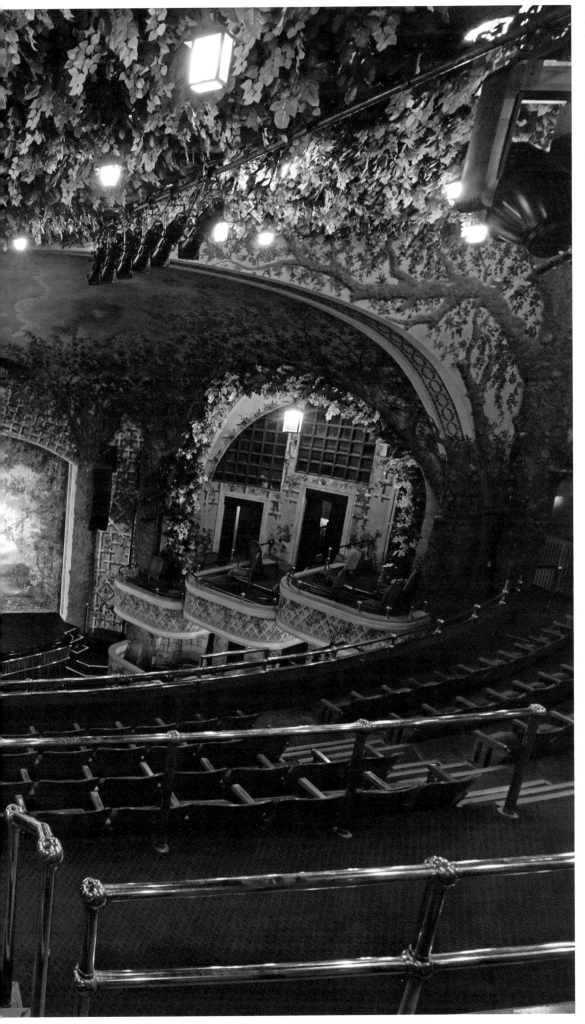

LEFT:

The Winter Garden Theatre, Toronto, Canada

This botanical fantasy originally had real beech boughs lining it. Refurbishment in the 1980s – requiring cleaning with hundreds of pounds of raw bread dough to avoid damaging the original hand-painted watercolour artwork – brought the theatre back to life.

OVERLEAF:

Orpheum Theatre, Vancouver, Canada

Debuting in 1927 as the city's biggest vaudeville house, this space later transitioned into a cinema and then a concert hall. It is the home of the Vancouver Symphony Orchestra and its interior featured prominently in the 2004 reboot of *Battlestar Galactica*, in which it was dressed to portray a heavenly opera house.

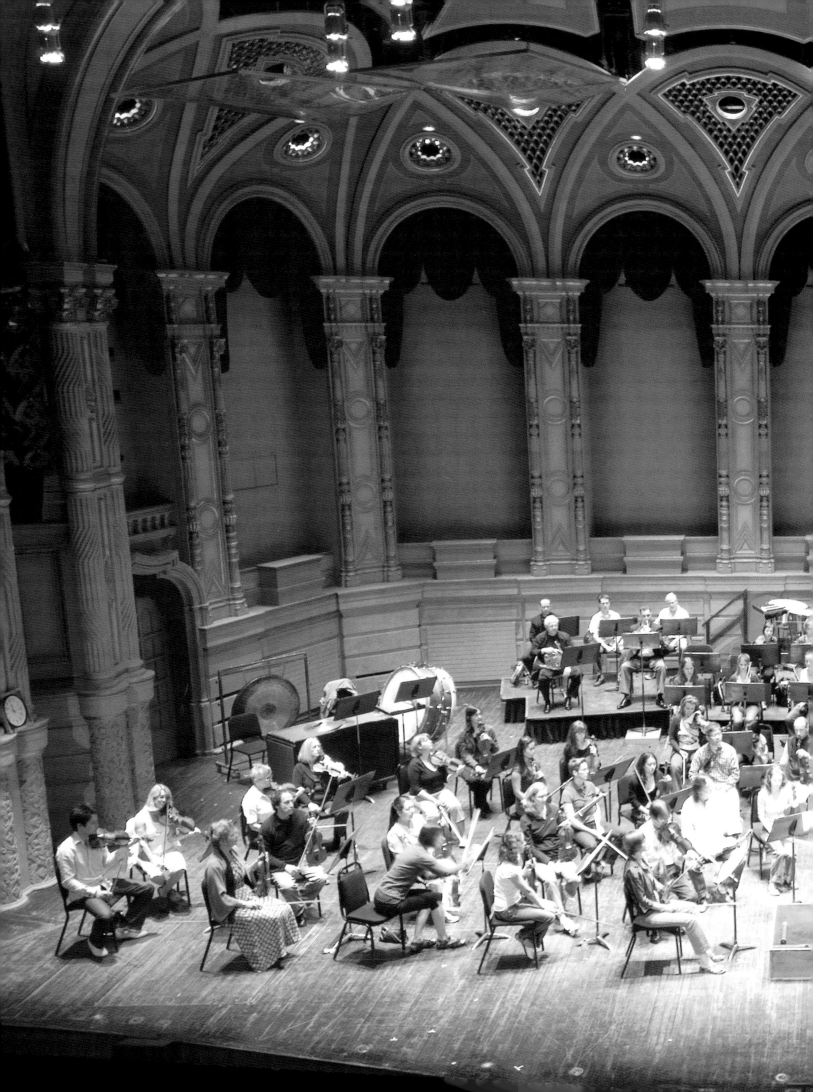

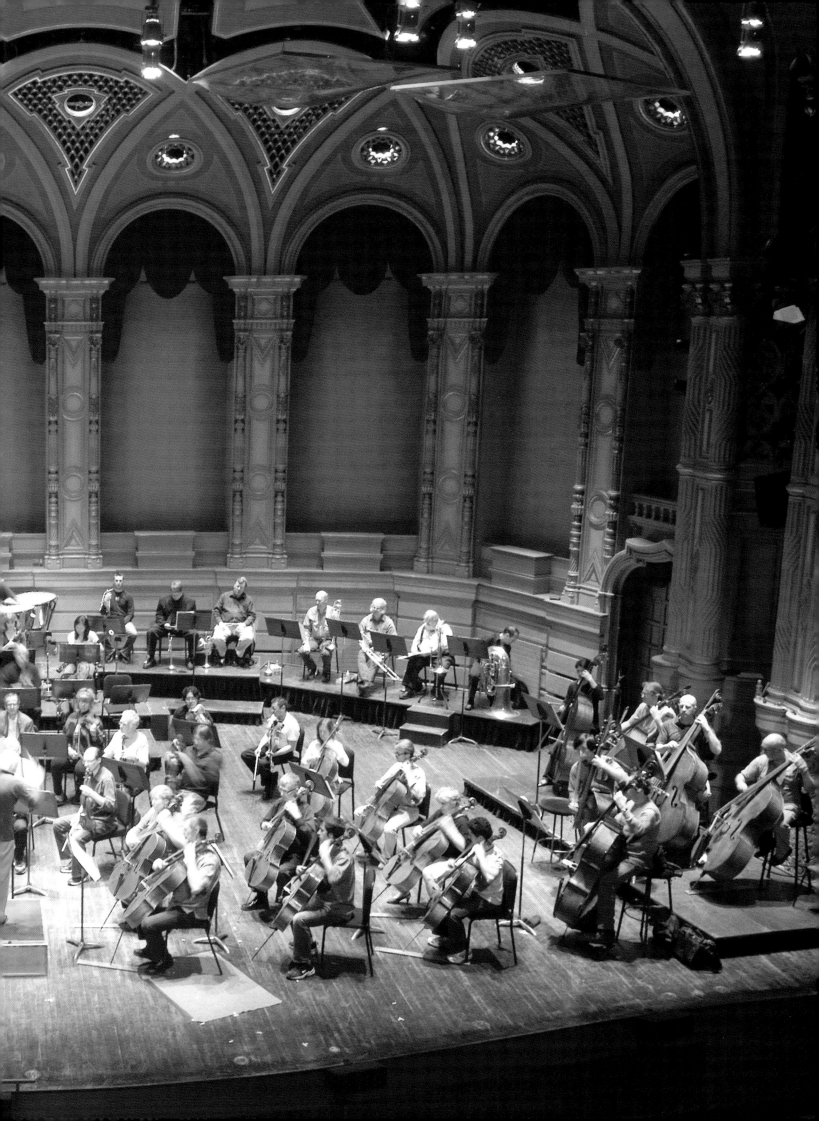

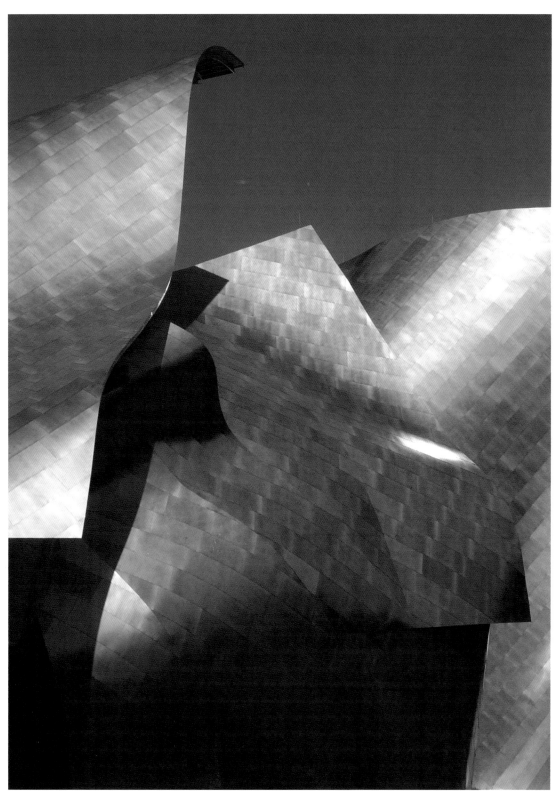

ABOVE:

**Fisher Center,
Annandale-on-Hudson, USA**
This upstate New York arts
institution was designed by
Frank Gehry, architect of the
Guggenheim Museum in Bilbao.
'The front façade of the building
can be interpreted as a theatrical
mask that covers the raw face
of the performance space,' he
said. It opened in 2003 at cost
$62 million.

RIGHT:

The Egg, Albany, USA
This form – which was opened in
the New York State capital in 1978
and took 12 years to construct –
contains two theatres, one seating
450 people and the other 982. Its
'stem' extends down six storeys
into the city's Empire State Plaza.
As well as being a venue for
concerts and dance events, yoga
classes are held there.

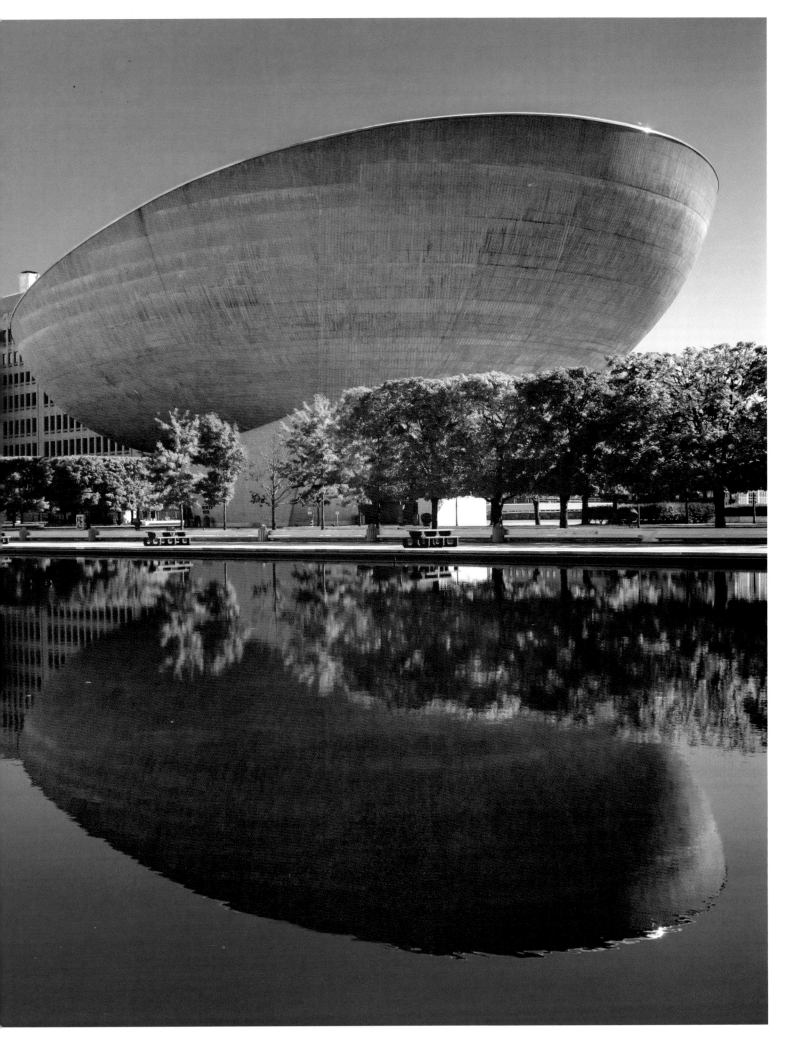

Ford's Theatre, Washington, D.C., USA

This playhouse had not started its third year of performances when President Lincoln was assassinated in it in 1865. It had been built in 1862 by theatre manager John T. Ford, but, after Lincoln's death, it was converted into government office buildings until 1932, when the Lincoln Museum moved there. Theatrical performances restarted in 1968.

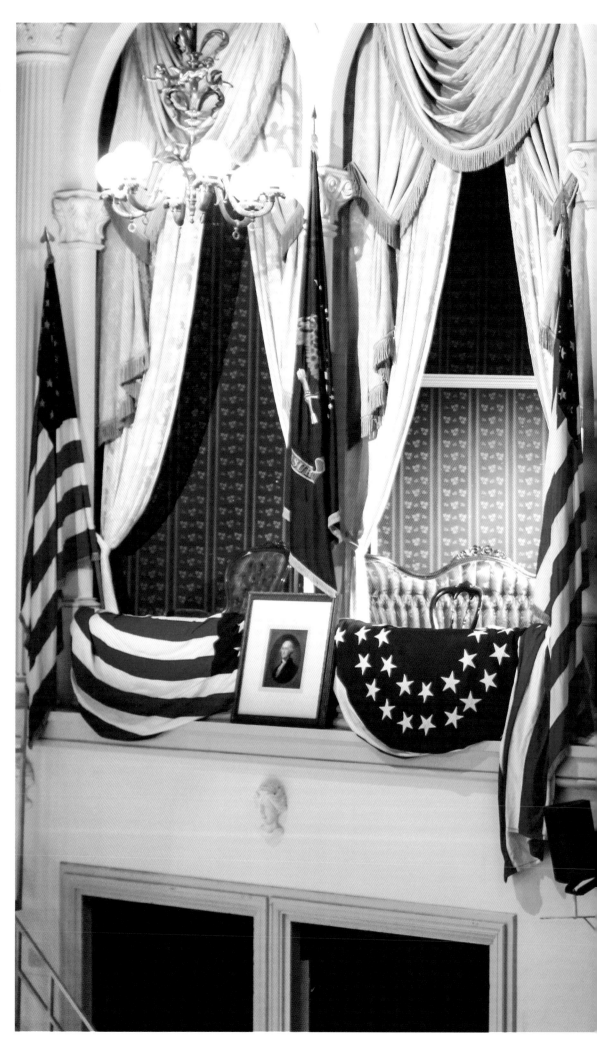

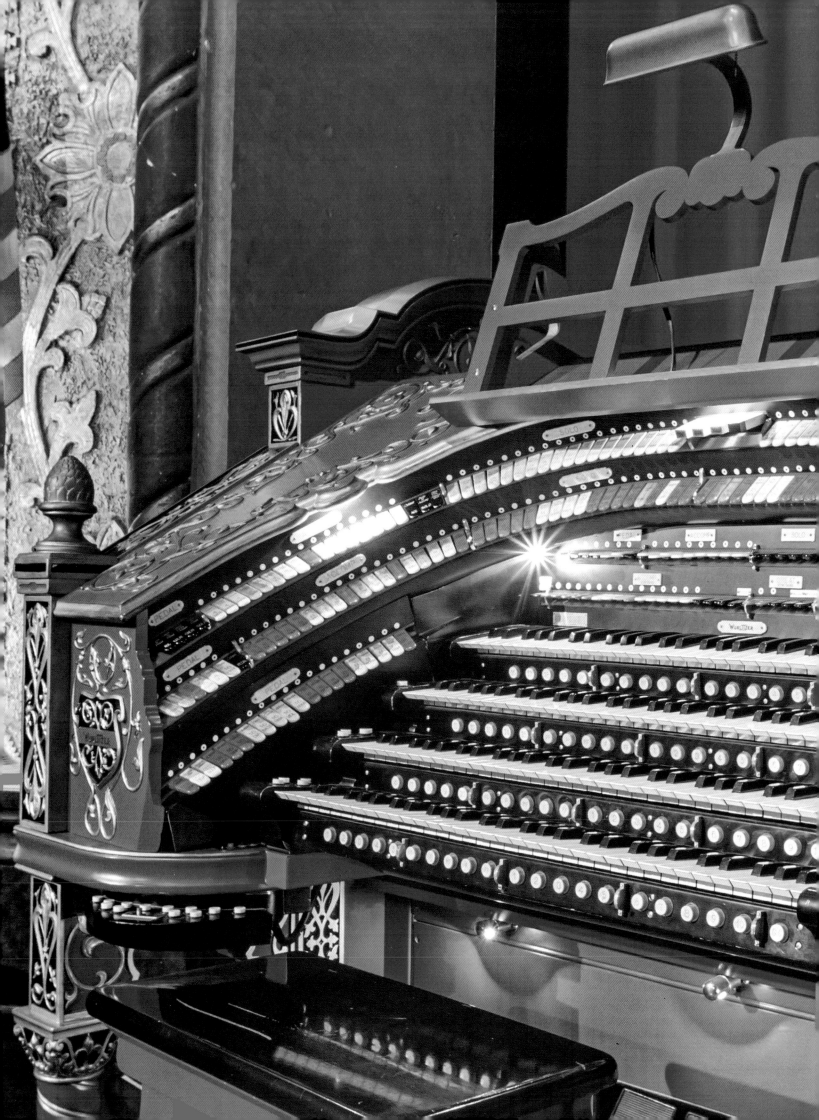

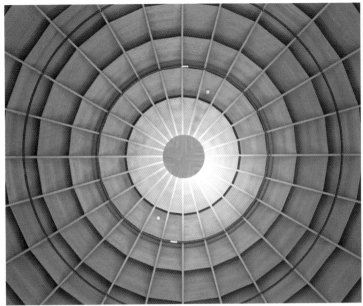

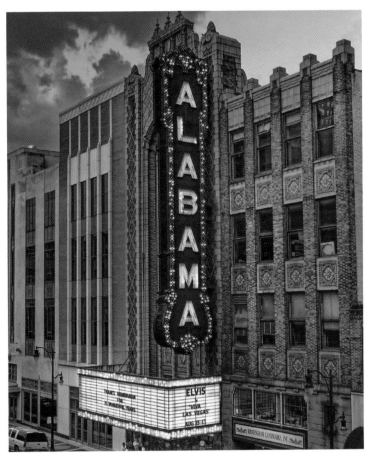

ALL PHOTOGRAPHS:

**The Alabama Theatre,
Birmingham, USA**
This ornate palace was constructed
by Paramount Studios as a home
in 1927 in which to showcase
its films. A Wurlitzer organ was
installed and the building ran as a
cinema – apart from annual Miss
Alabama pageants and a weekly
Mickey Mouse Club – until 1987.
It has now been restored and hosts
live events as well as films.

RIGHT TOP:

Saenger Theater, New Orleans, USA

The original was destroyed by Hurricane Katrina in 2005. It had been built in 1927 and advertisements described it as 'an acre of seats in a garden of Florentine splendor'. It was rebuilt and reopened in 2013 with an auditorium that still creates the sense of being in a 15th century Italian courtyard, with statues lining the walls.

RIGHT BOTTOM:

Dock Street Theatre, Charleston, USA

This playhouse was the first in America to be constructed exclusively for theatrical performance. It opened in 1736 but fire ripped through Charleston in 1740, whereupon a hotel was built on the site, with its wrought iron balcony added in 1835. The current Dock Street Theatre was built in the hotel's courtyard and opened in 2010.

OPPOSITE TOP AND BOTTOM:

Kauffman Center for the Performing Arts, Kansas City, USA

Architect Moshe Safdie built this but the driving force behind it is chairman Julia Irene Kauffman, who, when it opened in 2011, realised her philanthropist mother Muriel McBrien Kauffman's dream of there being a performing arts centre in Kansas City. Its exterior consists of glass, pre-cast concrete and bead-blasted stainless steel.

OVERLEAF, ALL PHOTOGRAPHS:

Fox Theatre, St Louis, USA

The Siamese-Byzantine splendour of this former cinema was restored in the early 1980s, after it had closed in 1978. It first opened in 1929 as one of the crown jewels in William Fox's motion picture empire, where people could listen to two organs, watch Fox Movietone News and, of course, see a 'talkie'. Today it caters for 200 live events each year.

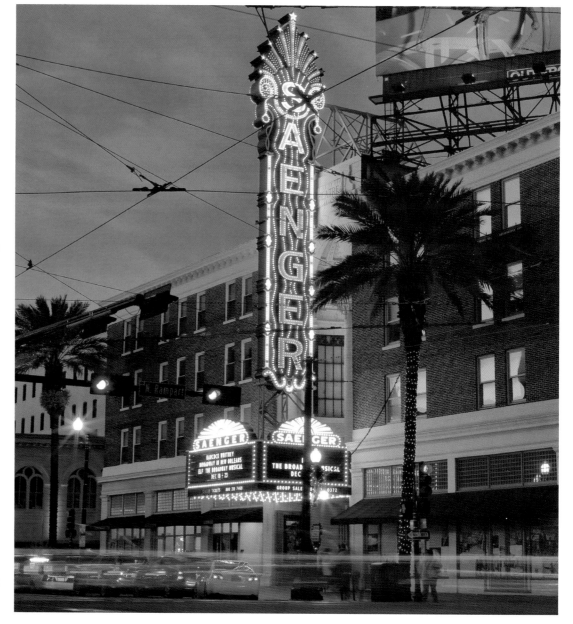

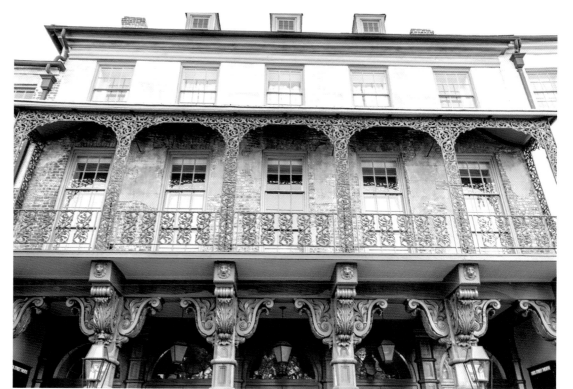

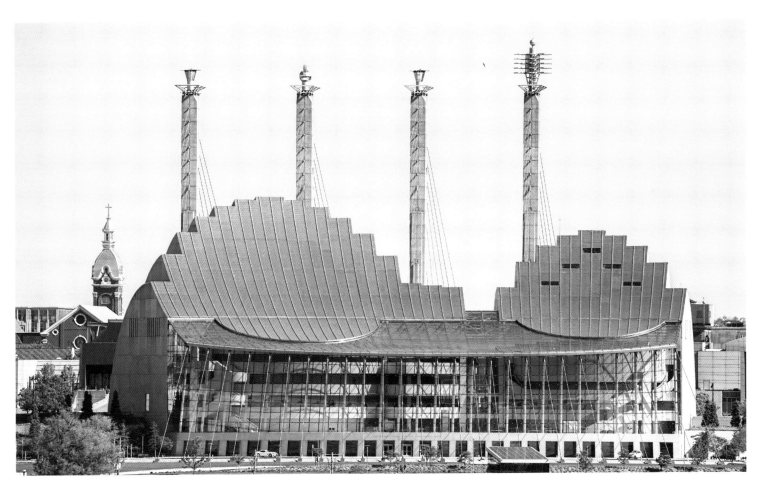

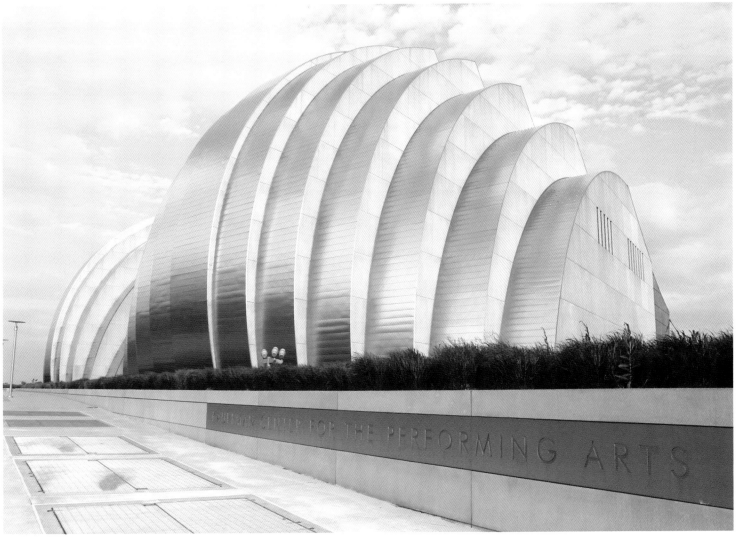

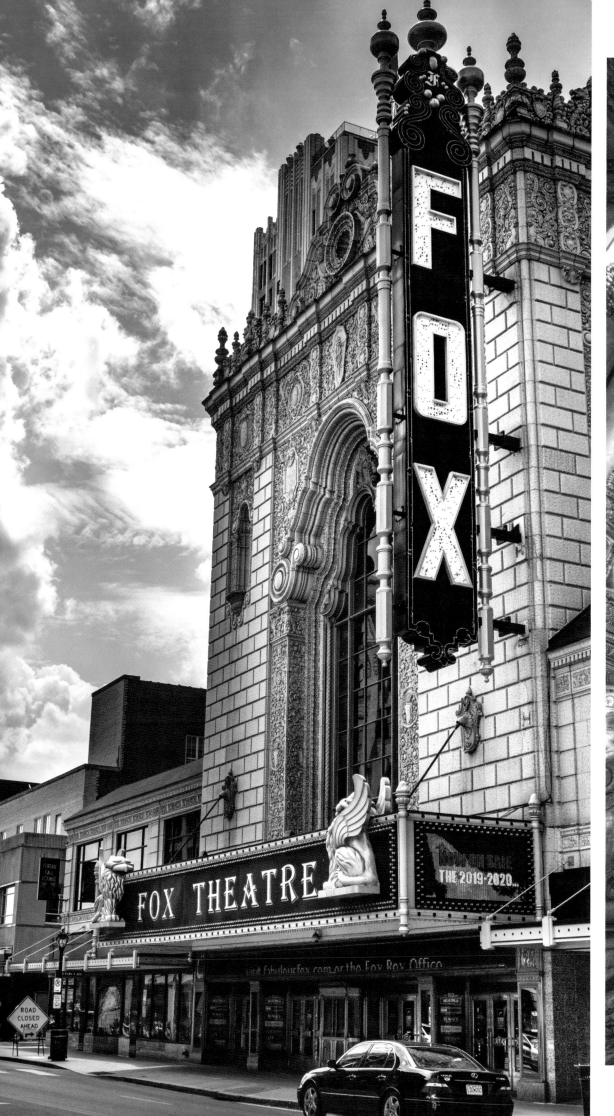

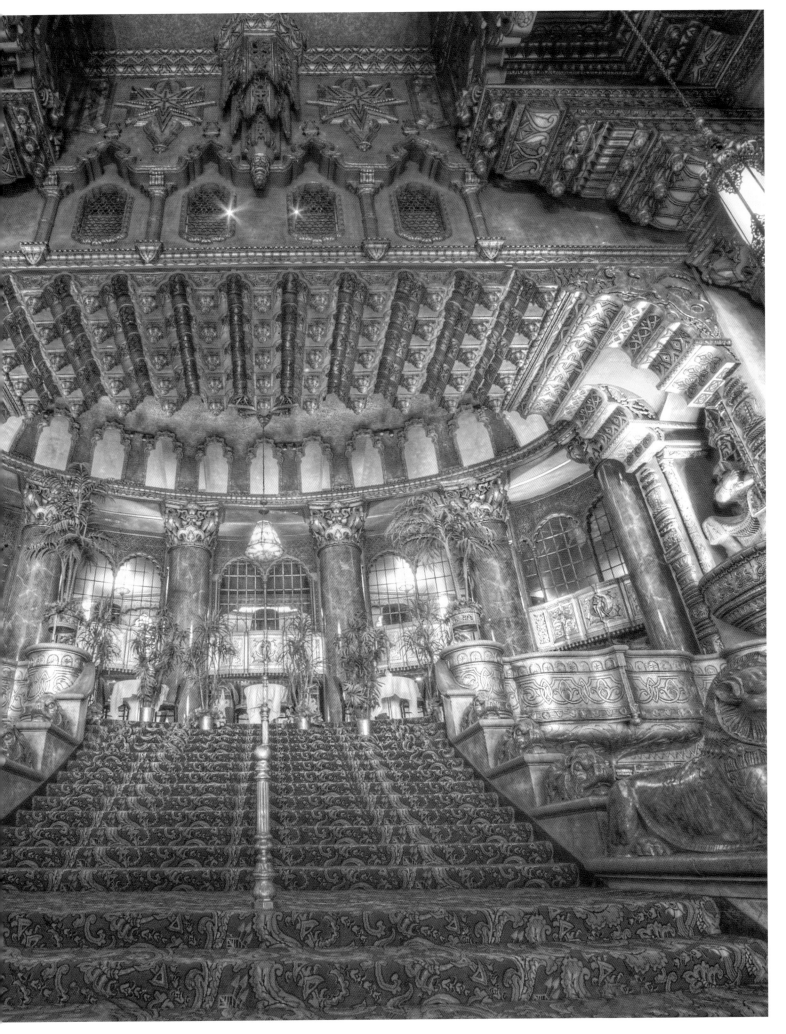

ALL PHOTOGRAPHS:

Walt Disney Concert Hall, Los Angeles, USA

Designed by Frank Gehry and completed in 2003, the style of the auditorium here is called a 'vineyard' and allows the audience to sit on four sides of the stage. The building is home to the Los Angeles Philharmonic. The project began in 1987 when Walt Disney's widow Lillian donated $50 million (about £38 million) for the project.

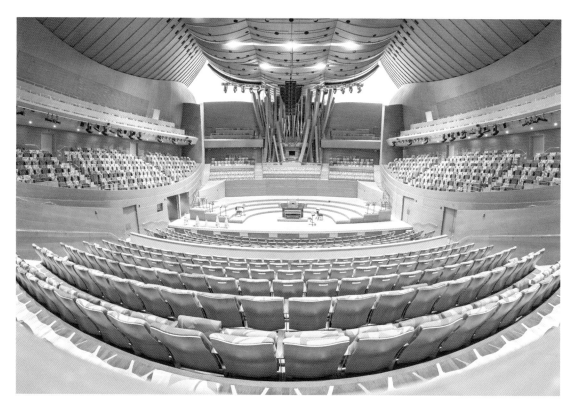

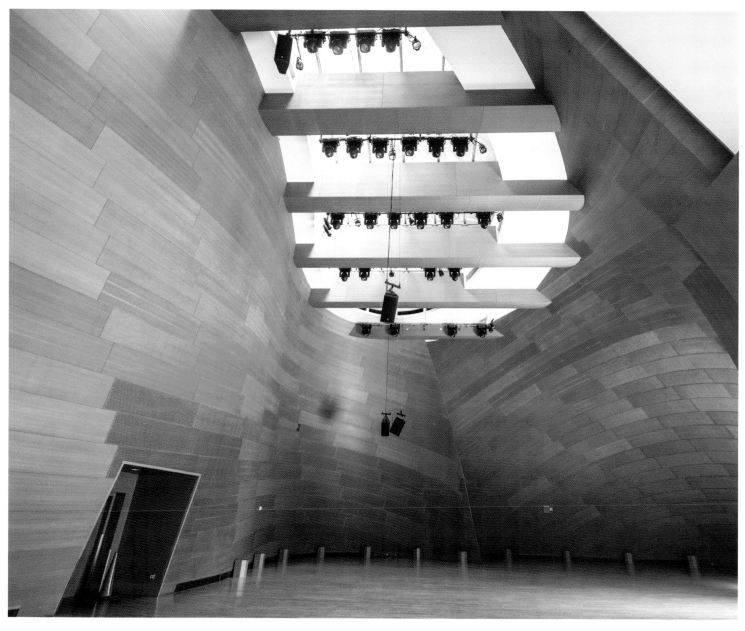

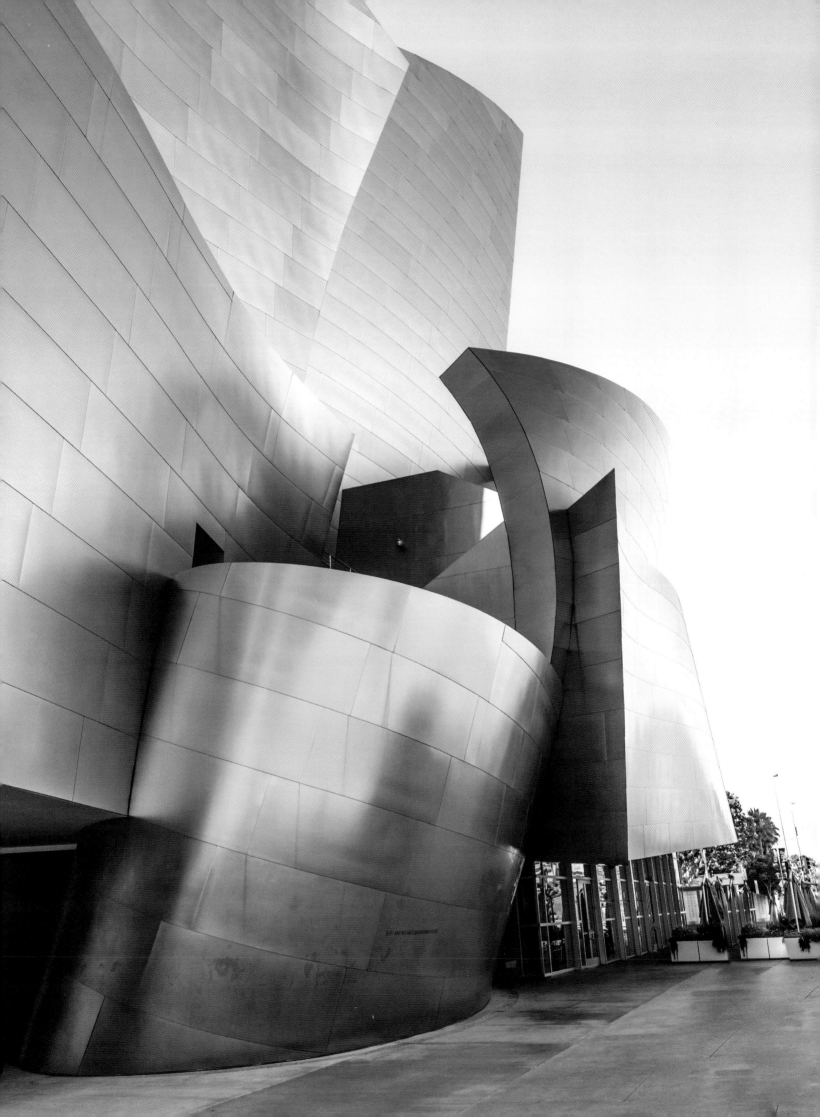

Palacio de Bellas Artes, Mexico City, Mexico
This landmark contains not just the country's National Theatre but its National Museum of Architecture, halls for sculpture and paintings, and murals by the likes of Diego Rivera. It was completed in 1934 having been commissioned in 1910 to celebrate the centenary of Mexico's independence from Spain, missing its deadline by 13 years.

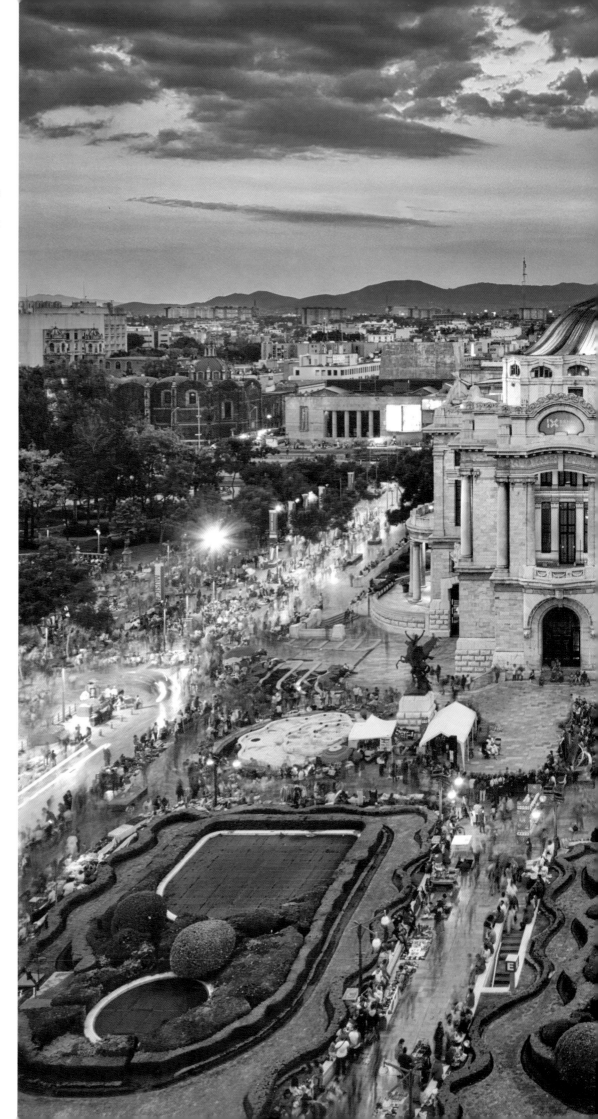

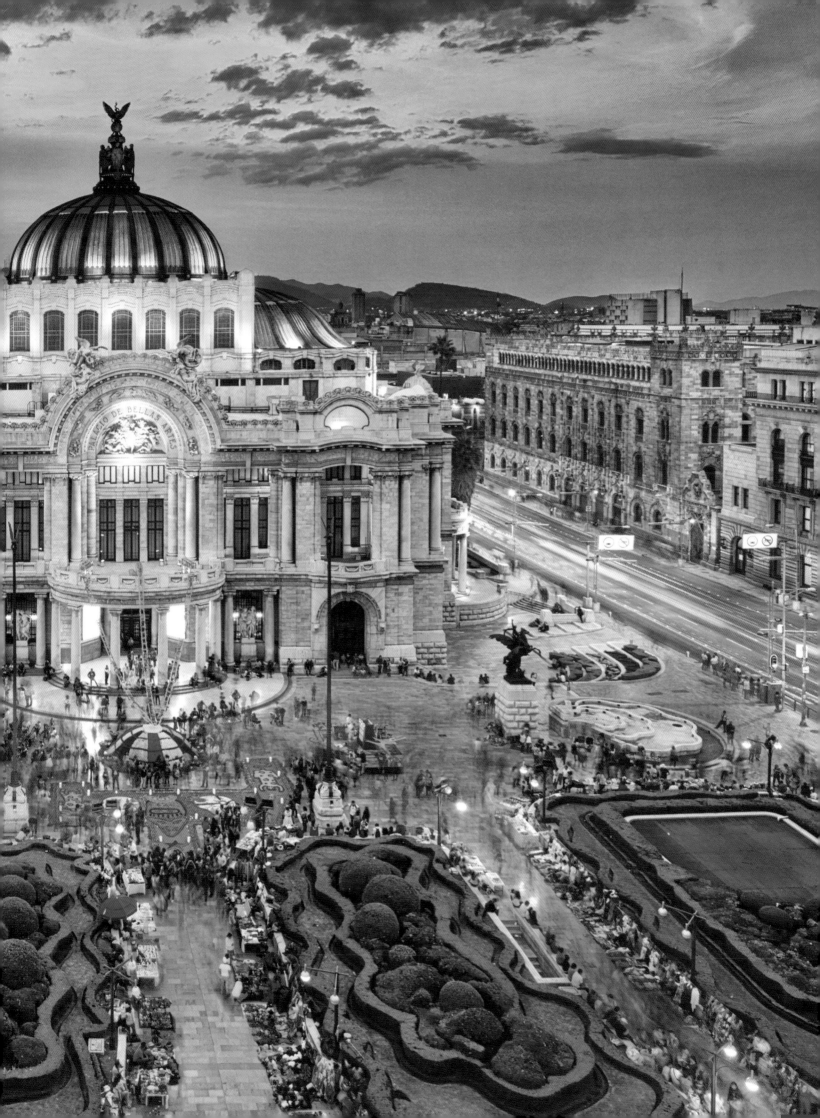

Gran Teatro de la Habana, Havana, Cuba

Home to the Cuban National Ballet, this institution was paid for by immigrants to Havana from the Galician region of northwest Spain. The building houses other arts venues and there are four sculptures on its front by Giuseppe Moretti, representing charity, education, music and theatre. Fidel Castro himself was of Galician descent.

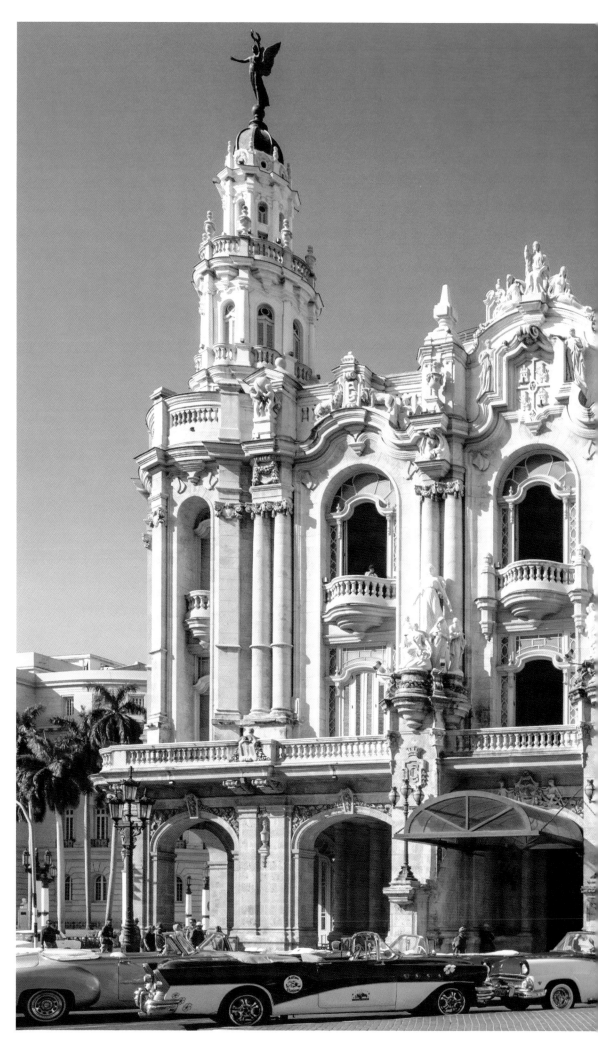

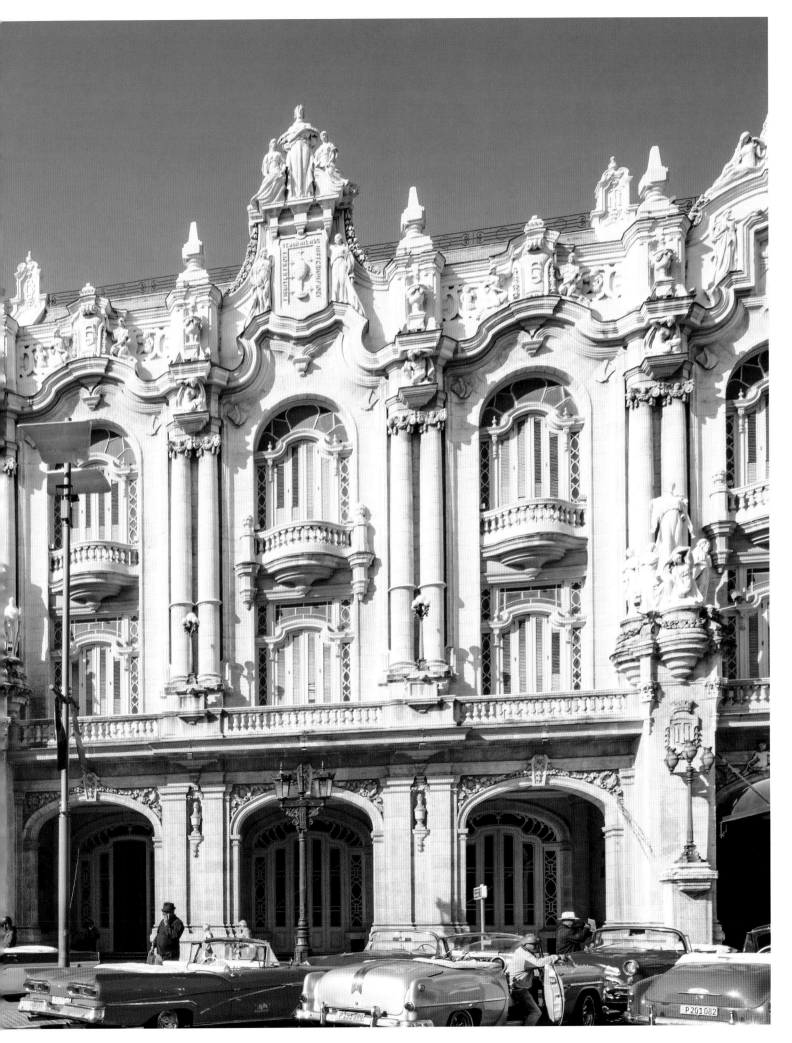

RIGHT:
Teatro Amazonas, Manaus, Brazil
This Belle Epoque masterpiece was built at the peak of the rubber boom in South America, its first performance coming in 1897. Situated in the heart of the Brazilian rainforest, it is home to the Amazonas Philharmonic Orchestra. The roofing tiles were imported from Alsace, the steel walls from Glasgow and the marble from Italy.

RIGHT BELOW AND OPPOSITE:
Municipal Theatre, Rio de Janeiro, Brazil
Inspired architecturally by the Paris Opera, this theatre was inaugurated in 1909. But its origins lie in another French theatre. In 1894 playwright Arthur Azevedo launched a campaign for the building of a new theatre to host a company created along the lines of the Comédie Française.

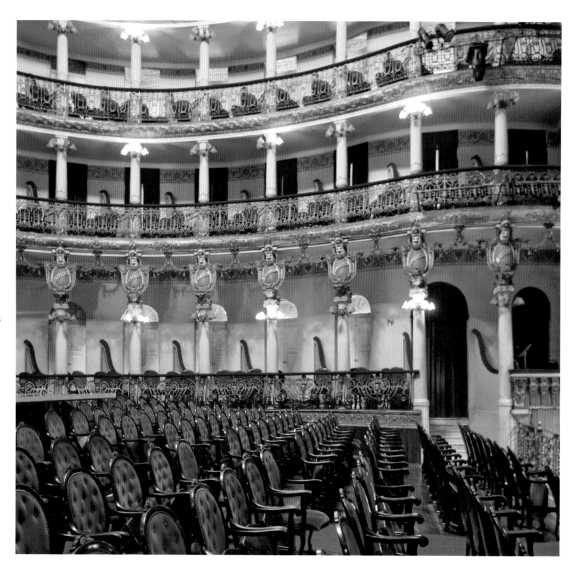

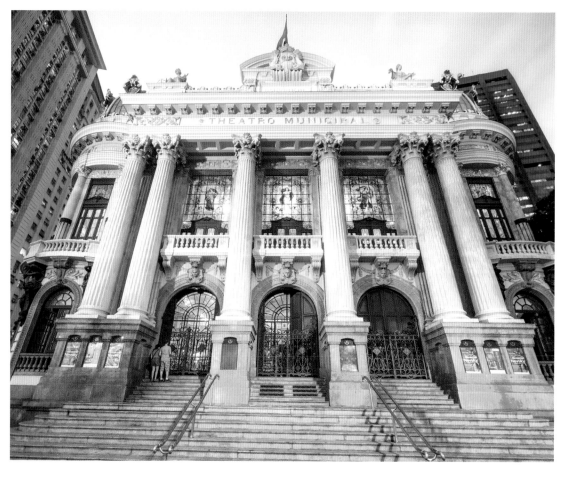

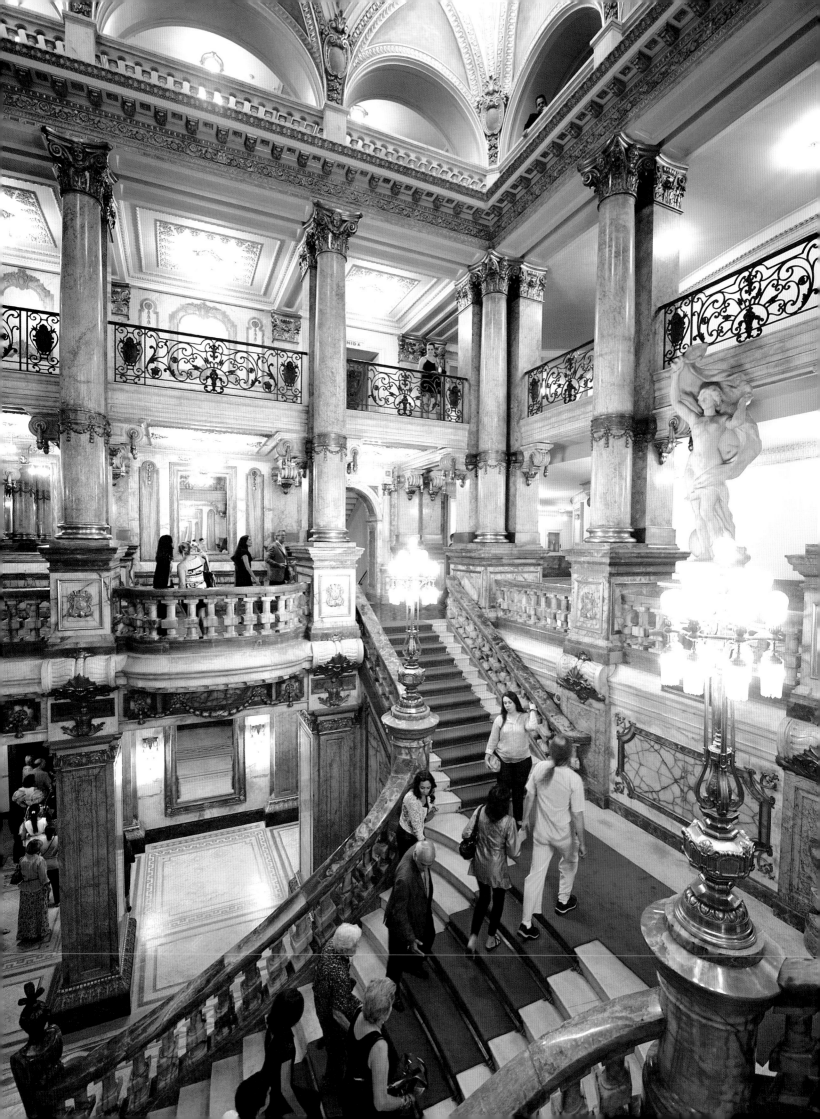

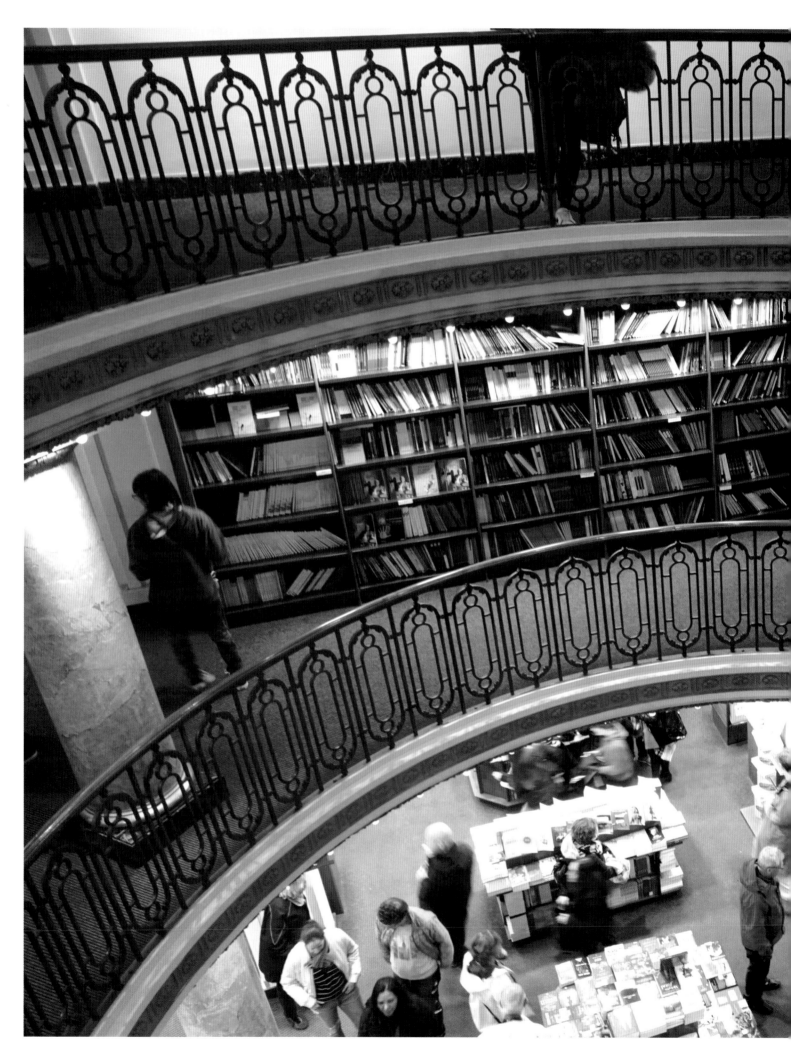

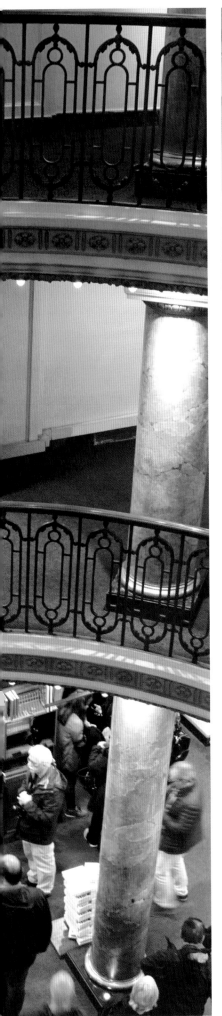

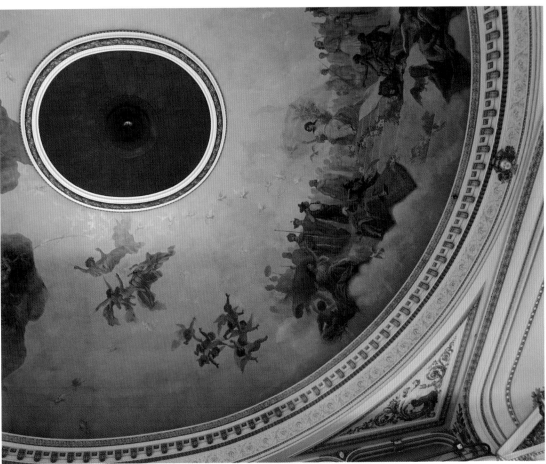

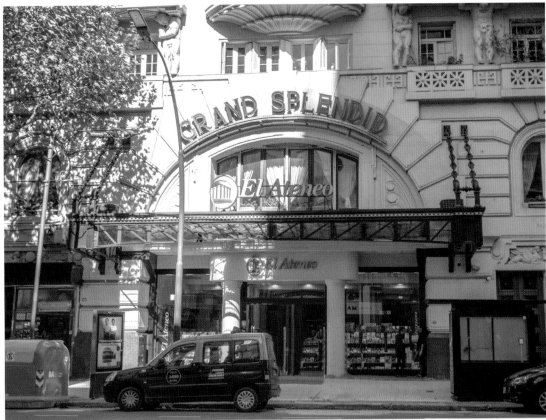

ALL PHOTOGRAPHS:

Ateneo Grand Splendid Theatre, Buenos Aires, Argentina
This is now a bookshop but opened as a playhouse in 1919. In the 1920s it started hosting radio shows and it was then converted into a cinema, showing the first 'talkies' in Argentina. In 2000, it became a bookshop, but it still retains the frescoes, seating and crimson curtains from its days as a theatre, with the old boxes now small reading rooms.

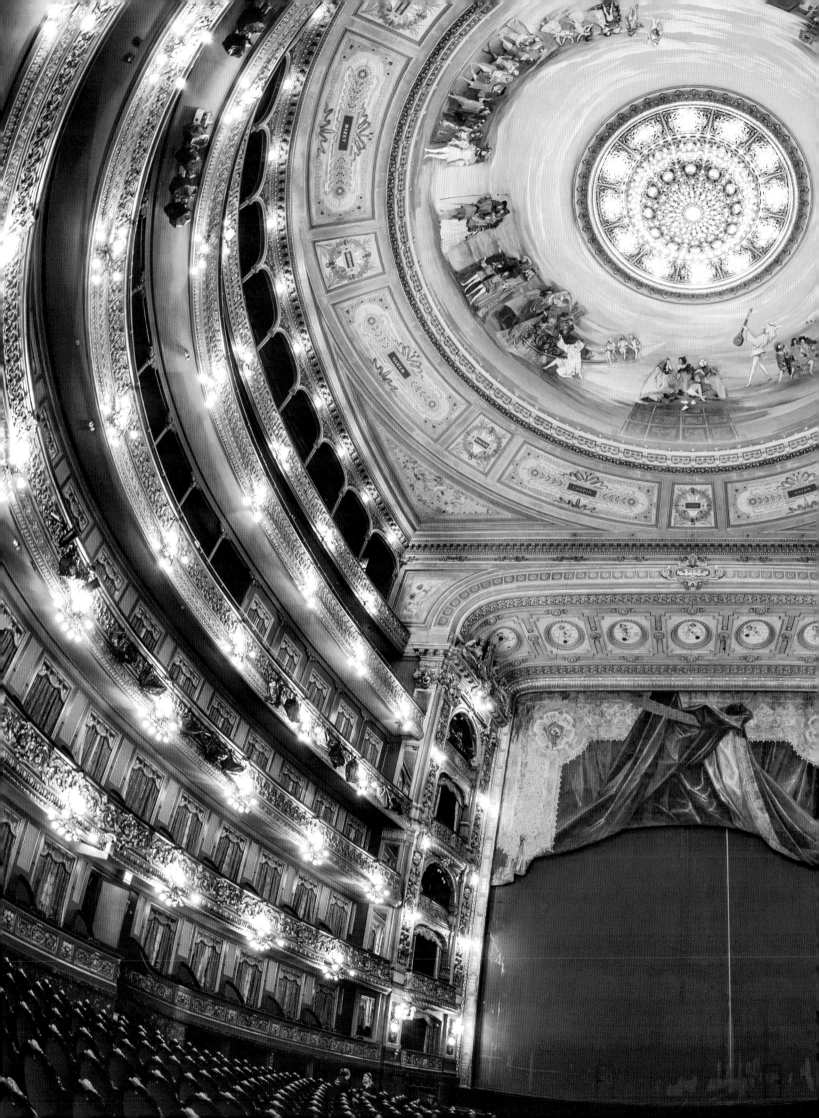

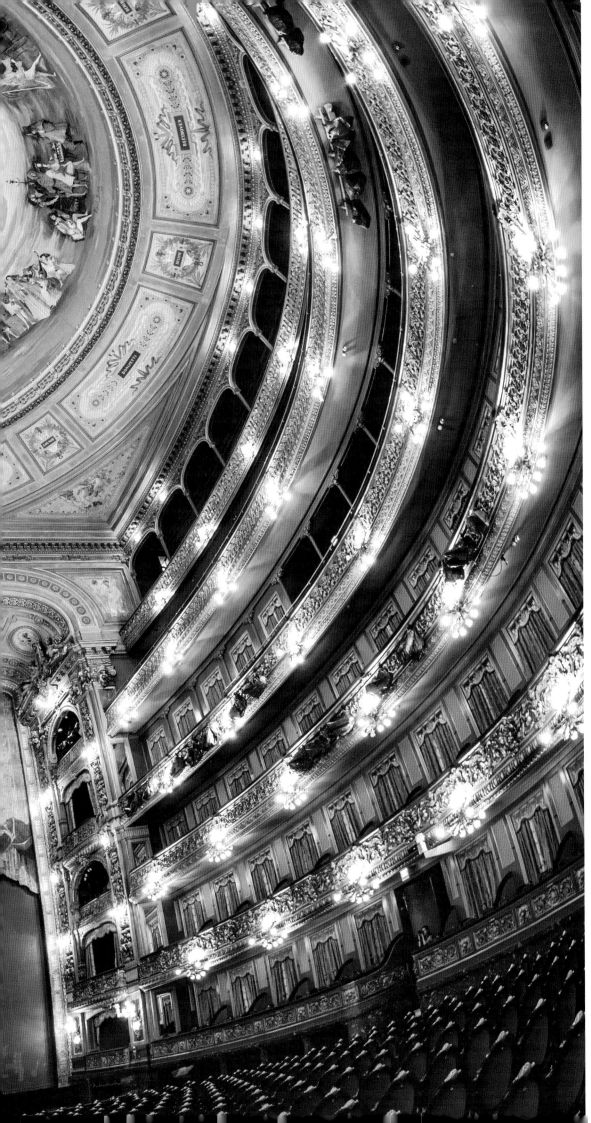

Teatro Colon, Buenos Aries, Argentina
The current building was inaugurated in 1908 and took 18 years to construct. Its foundation stone was placed in 1890, with the intention that the building would be finished in 1892, to mark four centuries since Christopher Columbus arrived in America. The theatre produces its shows from scratch, from workshops located in its basement.

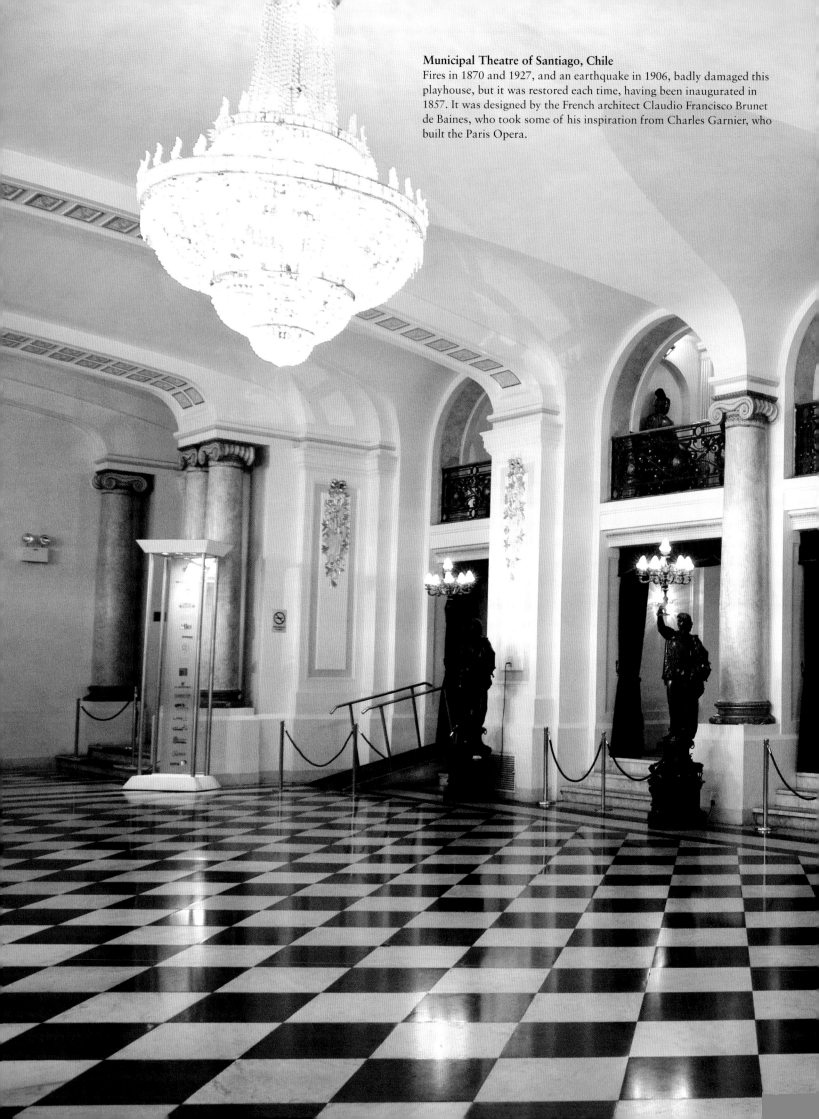

Municipal Theatre of Santiago, Chile
Fires in 1870 and 1927, and an earthquake in 1906, badly damaged this playhouse, but it was restored each time, having been inaugurated in 1857. It was designed by the French architect Claudio Francisco Brunet de Baines, who took some of his inspiration from Charles Garnier, who built the Paris Opera.

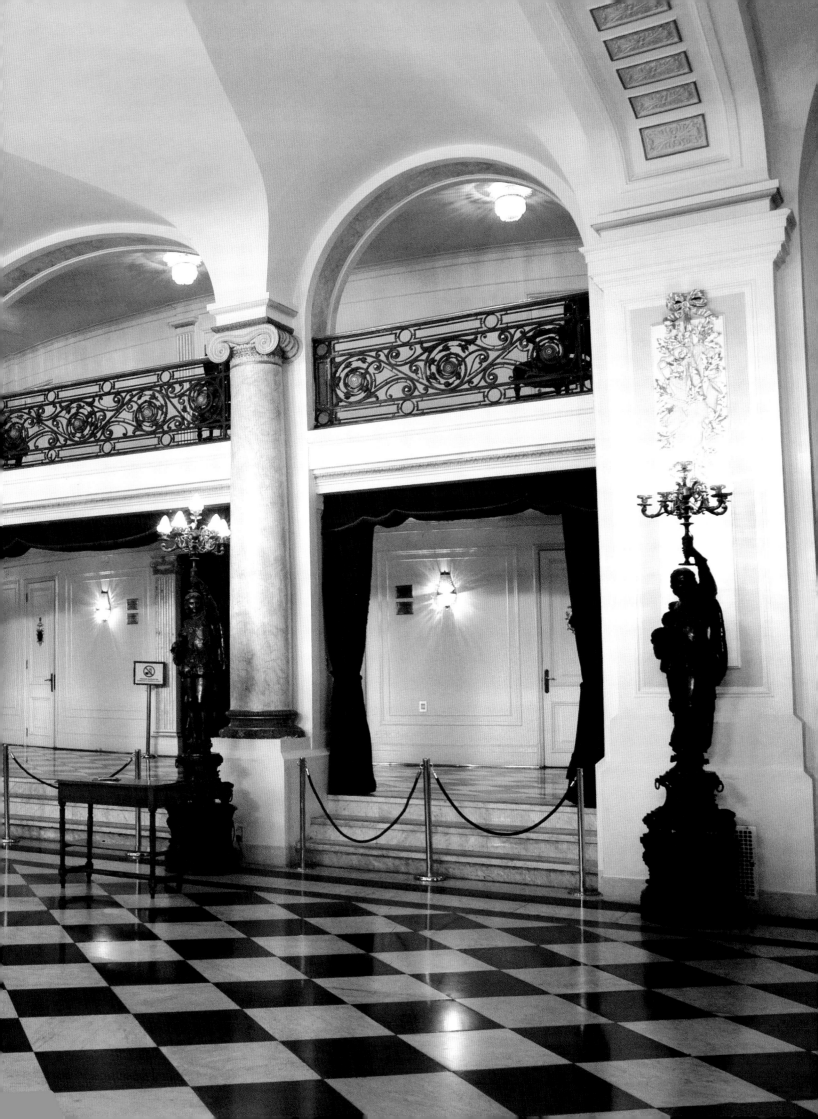

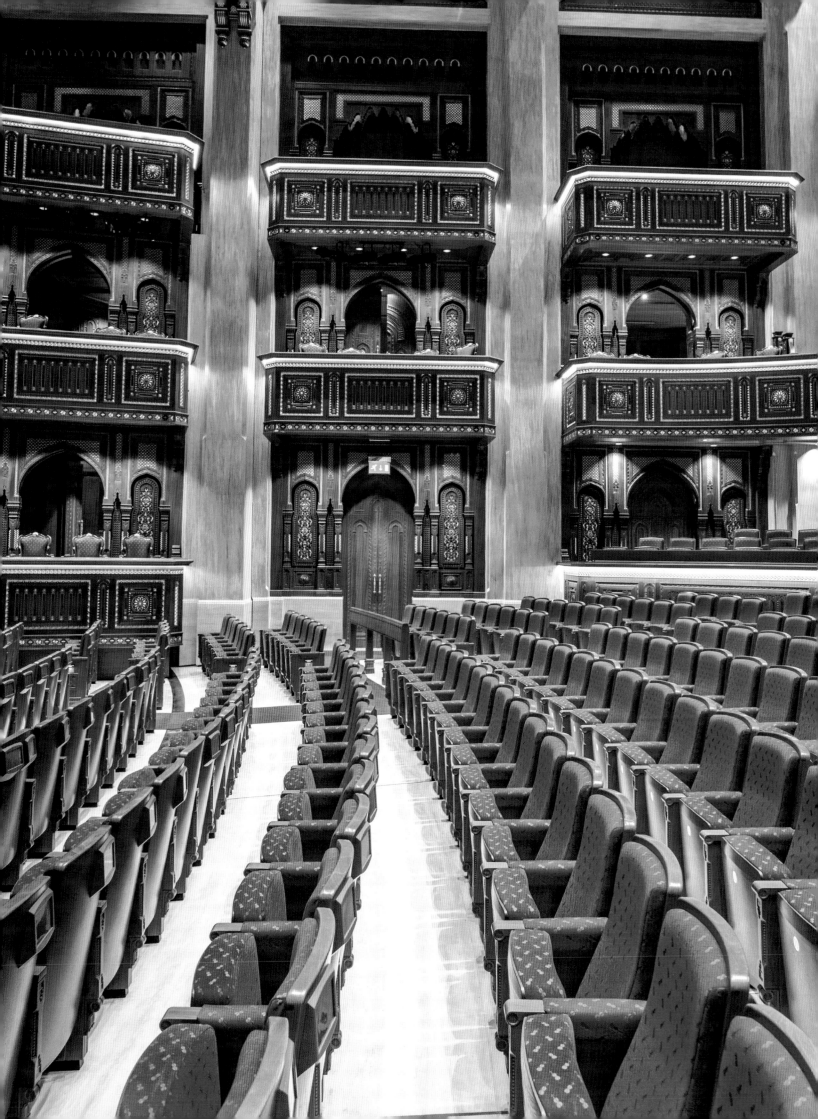

Africa and the Middle East

To some extent, the amazing theatres of Africa and the Middle East tell some of the story of these regions over the last 150 years. In the second half of the 19th century, European influence over Africa was approaching its height, for example with the building of the Suez Canal. With its inauguration came plans for Cairo's Opera House. But as the 20th century progressed, African nations' independent spirit grew stronger, and when the Alexandria Opera House opened, in 1921, it did so as Mohamed Ali Theatre, in honour of Egypt's early 19th-century ruler. In 1962 it was renamed Sayed Darwish Theatre, after the popular Egyptian composer.

At the other end of the continent, Soweto Theatre was spared by insurgents as the last bastions of white minority rule were removed, and at the end of the 20th century came influence from the Far East, with Japan paying for Cairo's new Opera House and China paying for Ghana's National Theatre.

This century has seen states on the Arabian Peninsula open grand theatres and opera houses of their own, as countries booming from oil and tourism in recent years make their own mark on the cultural world with statement buildings. But where the next amazing theatres in Africa and the Middle East emerge remains to be seen.

OPPOSITE AND OVERLEAF:
Royal Opera House Muscat, Oman
This was opened in 2011 with a performance of *Turandot* conducted by tenor Placido Domingo. Fellow tenor Andrea Bocelli, soprano Renee Fleming and cellist Yo Ma have also played there, as well as trumpeter Wynton Marsalis. The opera house complex contains landscaped gardens, retail outlets and luxury restaurants.

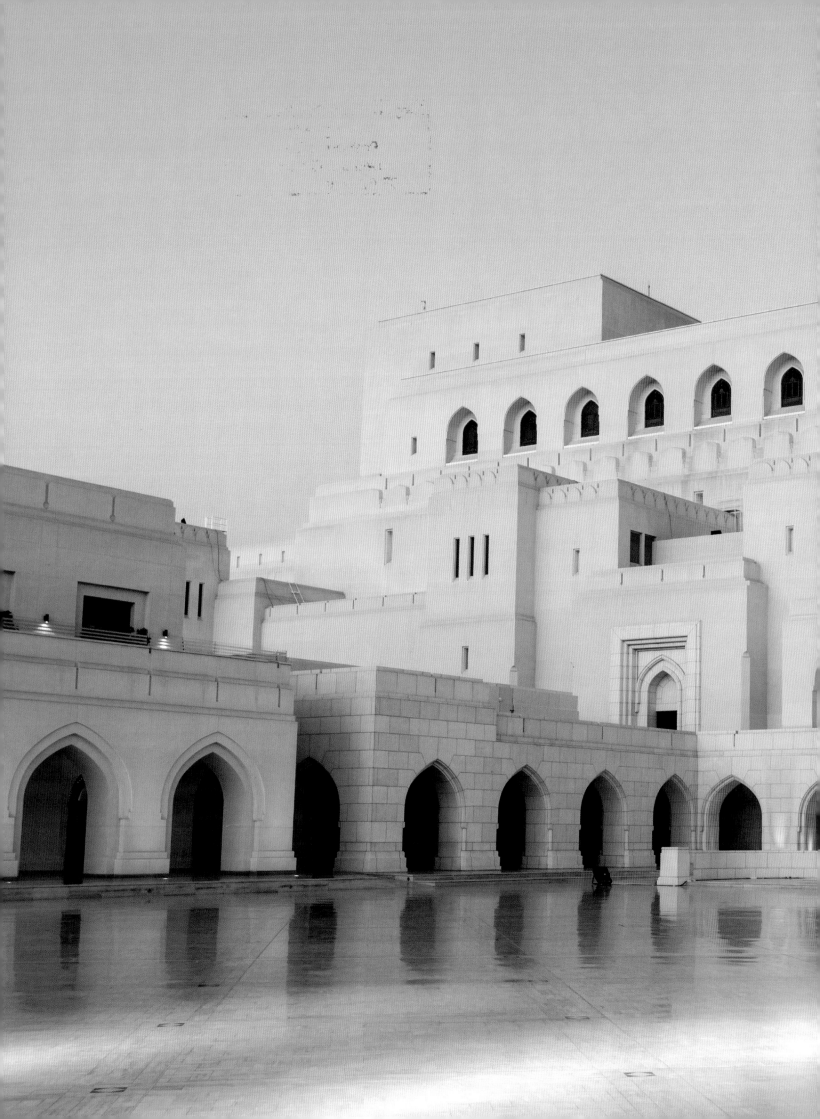

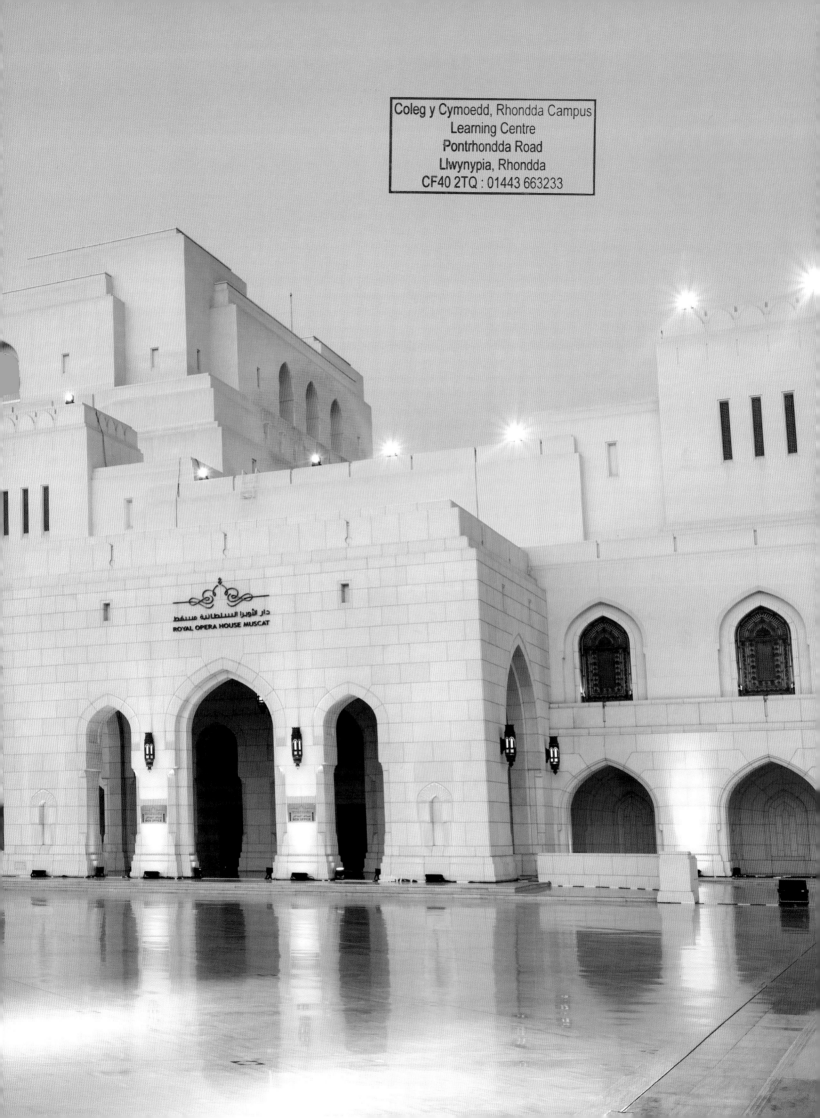

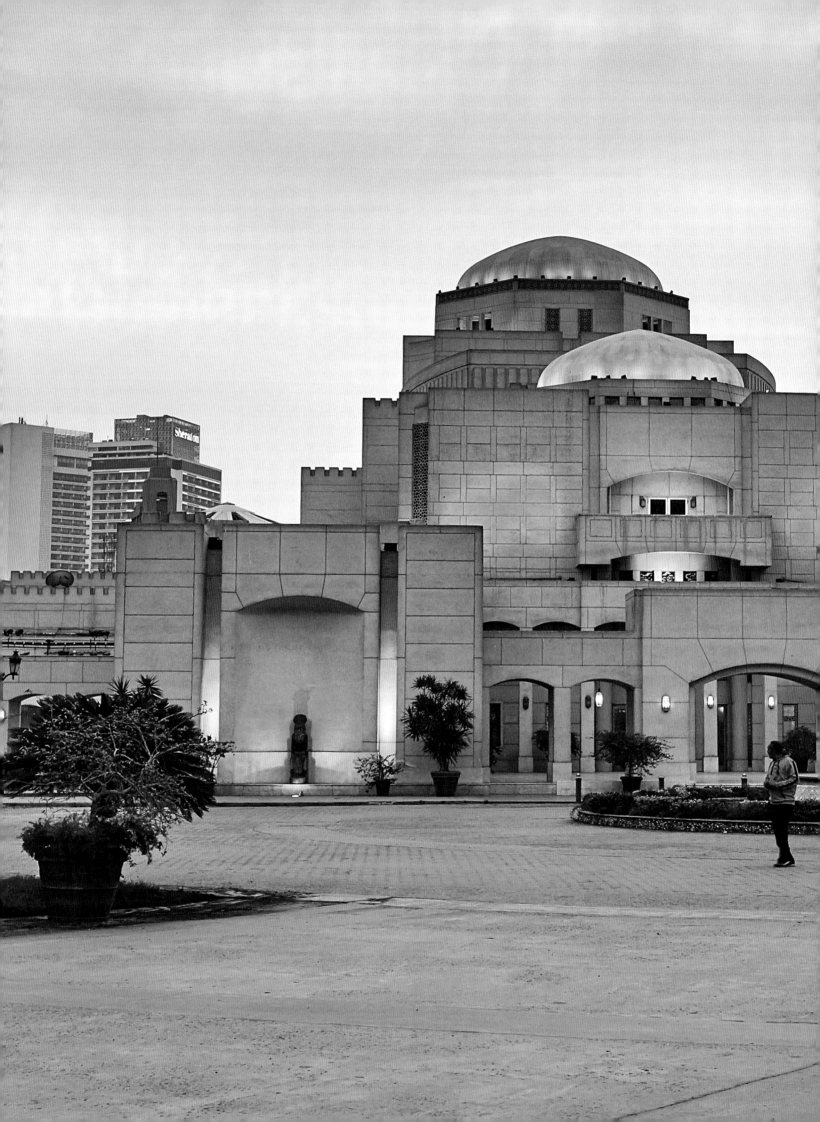

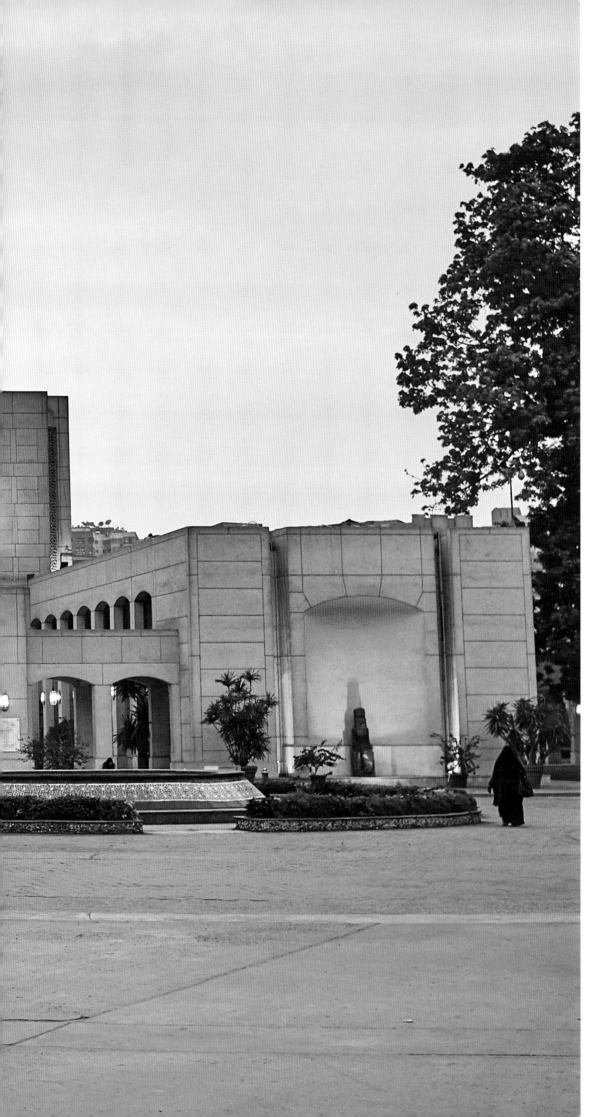

Cairo Opera House, Egypt
This building, inaugurated in 1988, was a gift to the country's people from Japan, in return for the visit to the Far East made by former President Hosni Mubarak in 1983. It replaced the Khedivial Opera House, for which instructions were given in 1869, to mark the inauguration of the Suez Canal. It burned down in 1971.

**Sayed Darwish Theatre,
Alexandria, Egypt**
Built in 1921 by French engineer
Georges Park, this playhouse was
originally named after 19th-
century Egyptian ruler Mohamed
Ali. In 1962 it was renamed after
Sayed Darwish, who was born
in Alexandria and was an early
20th-century Egyptian singer and
composer. Many consider him to
be the father of popular music in
the country.

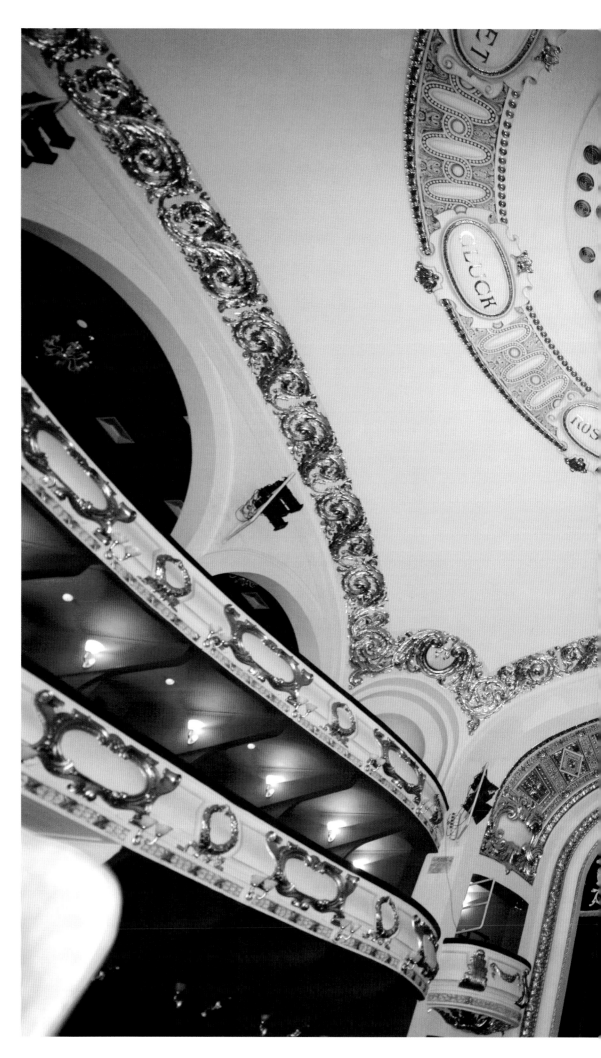

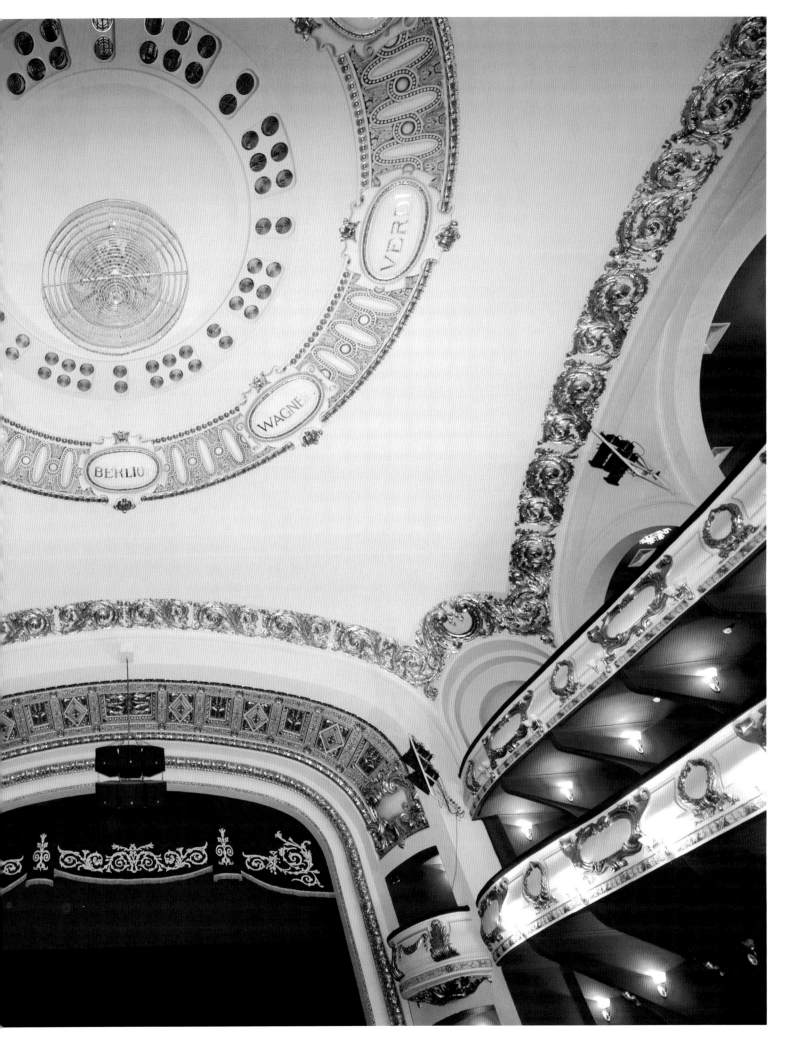

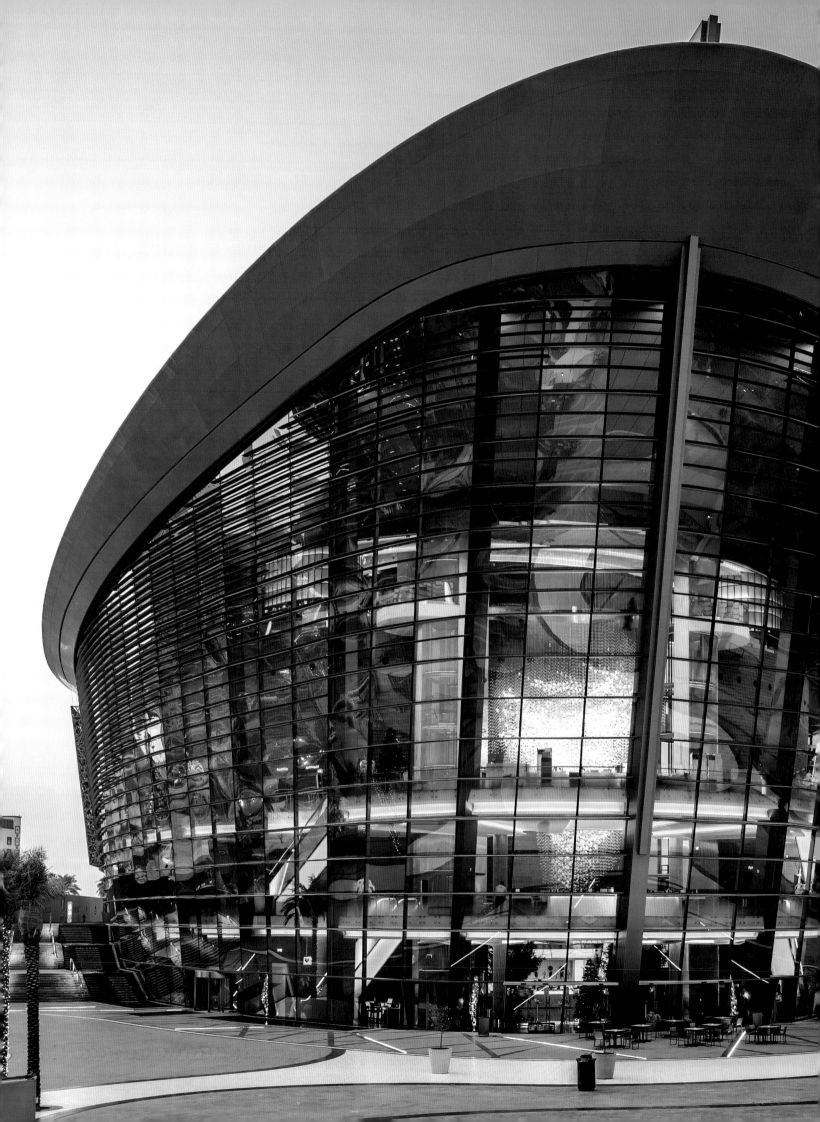

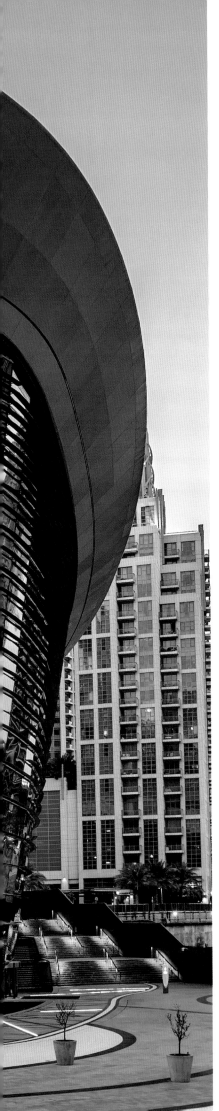

ALL PHOTOGRAPHS:
Dubai Opera, UAE
The 2016 building here is dhow-shaped, in a nod to the area's maritime past and, internally, it can transform from a theatre to a concert hall to a 'flat floor' event or banqueting space. Its rooftop restaurant has views over the Dubai Fountain and the Burj Khalifa. The auditorium can seat up to 2,000 people.

National Theatre of Ghana, Accra, Ghana

This structure was built by China in 1992 and offered as a gift to Ghana. It houses the National Dance Company, National Symphony Orchestra and the National Theatre Players. The three-tier water fountain that sits beneath the boat-like form – which cost $20 million (£15m) – also supplies the building's fire hydrants.

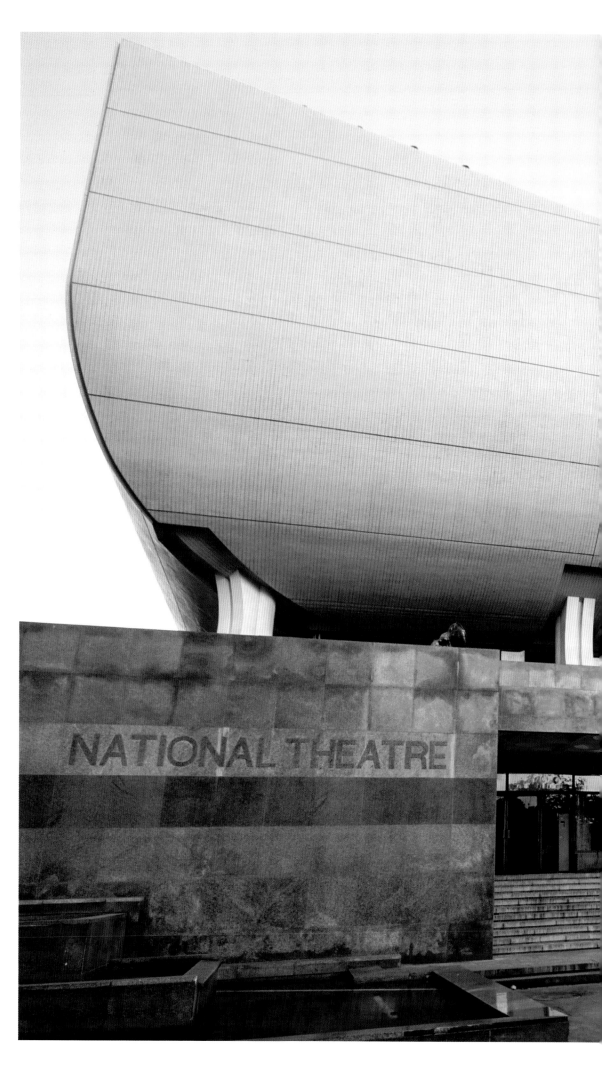

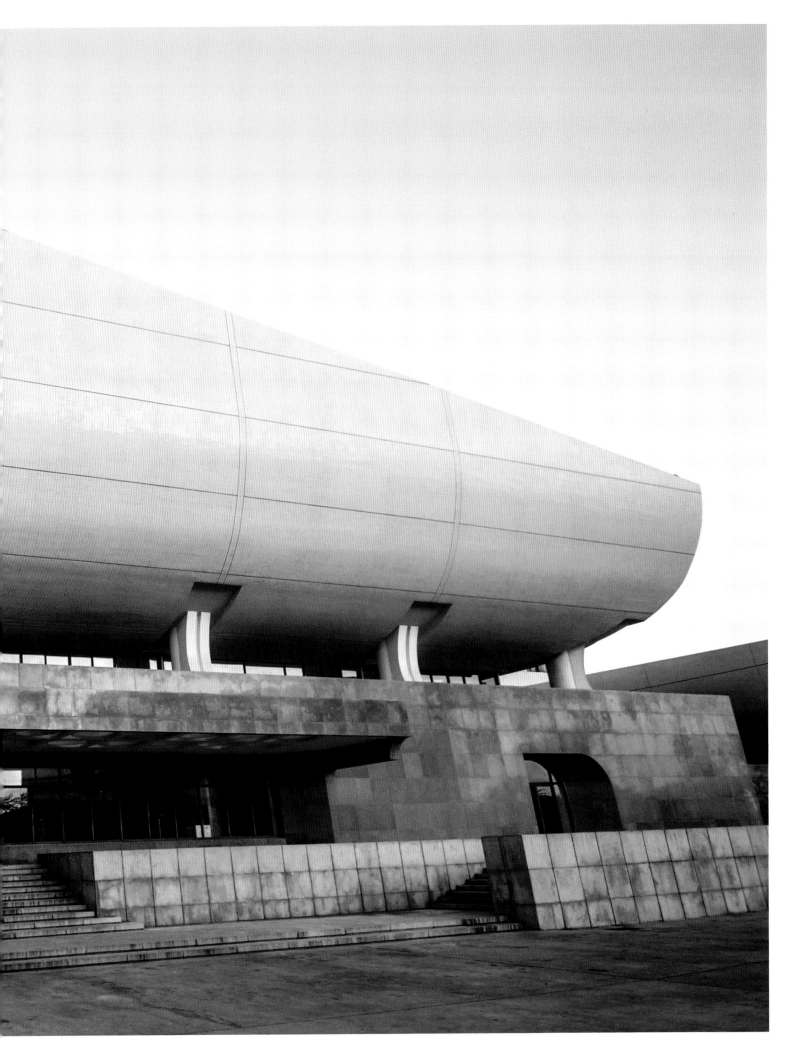

National Arts Theatre, Lagos, Nigeria

The exterior of this 1970s building is shaped like a military hat – it was started when Yakubu Gowon was head of state and finished when Olusegun Obasanjo was in power. Both were military rulers. Constructed by a Bulgarian company, it resembles the Palace of Culture and Sports in Varna, Bulgaria, completed in 1968.

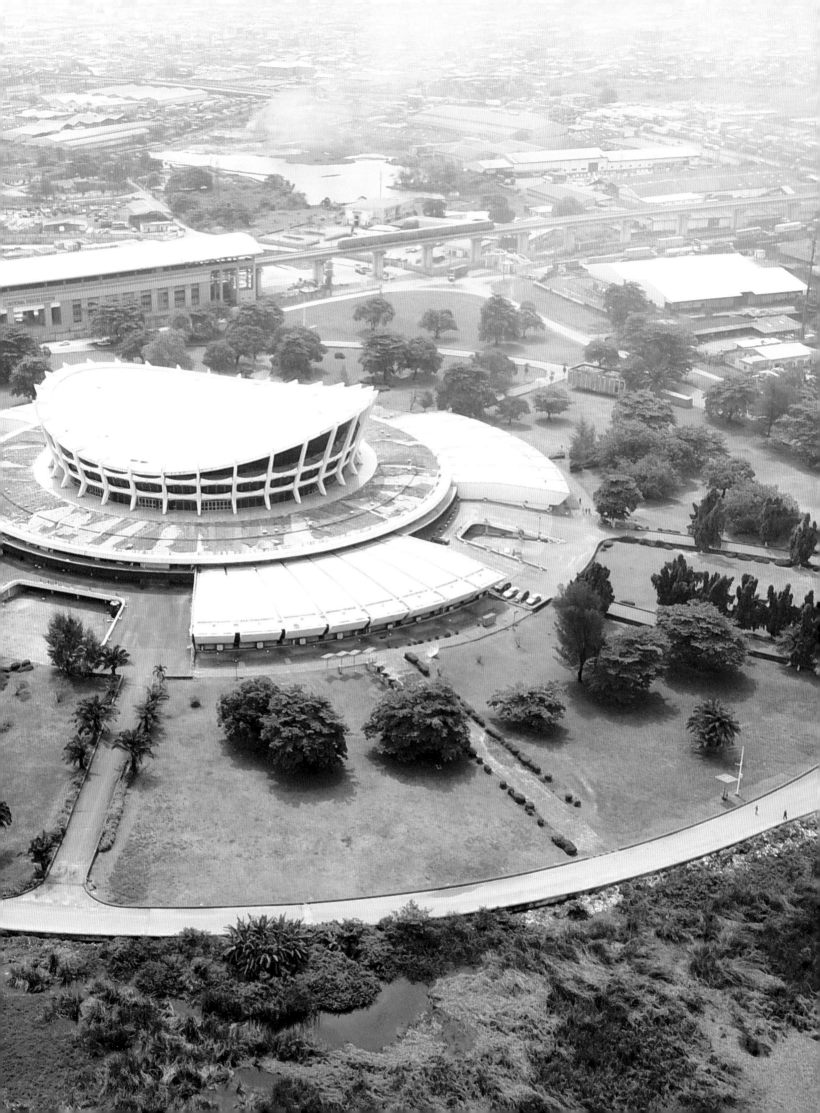

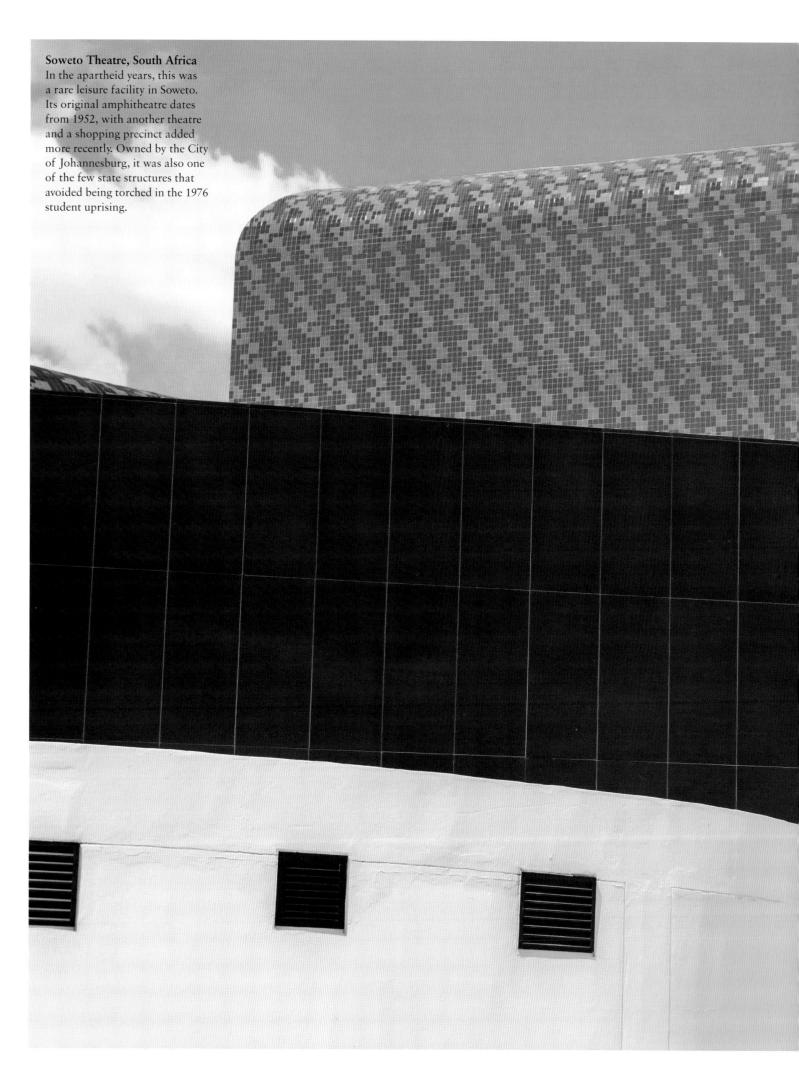

Soweto Theatre, South Africa
In the apartheid years, this was a rare leisure facility in Soweto. Its original amphitheatre dates from 1952, with another theatre and a shopping precinct added more recently. Owned by the City of Johannesburg, it was also one of the few state structures that avoided being torched in the 1976 student uprising.

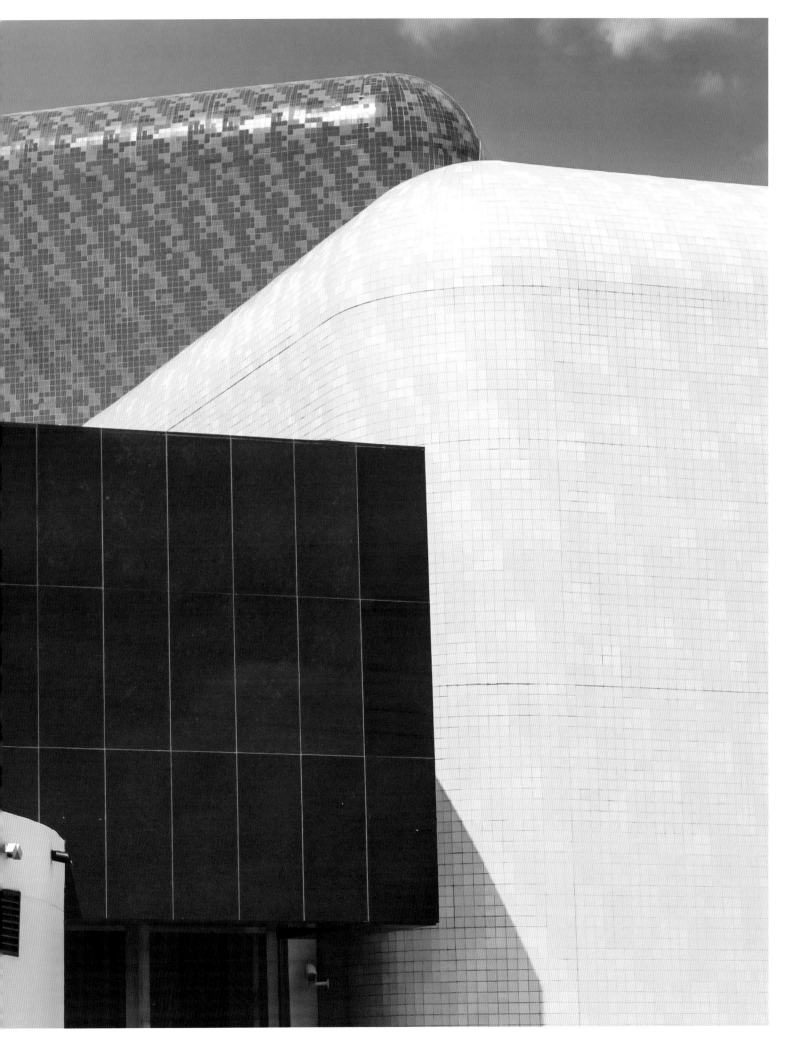

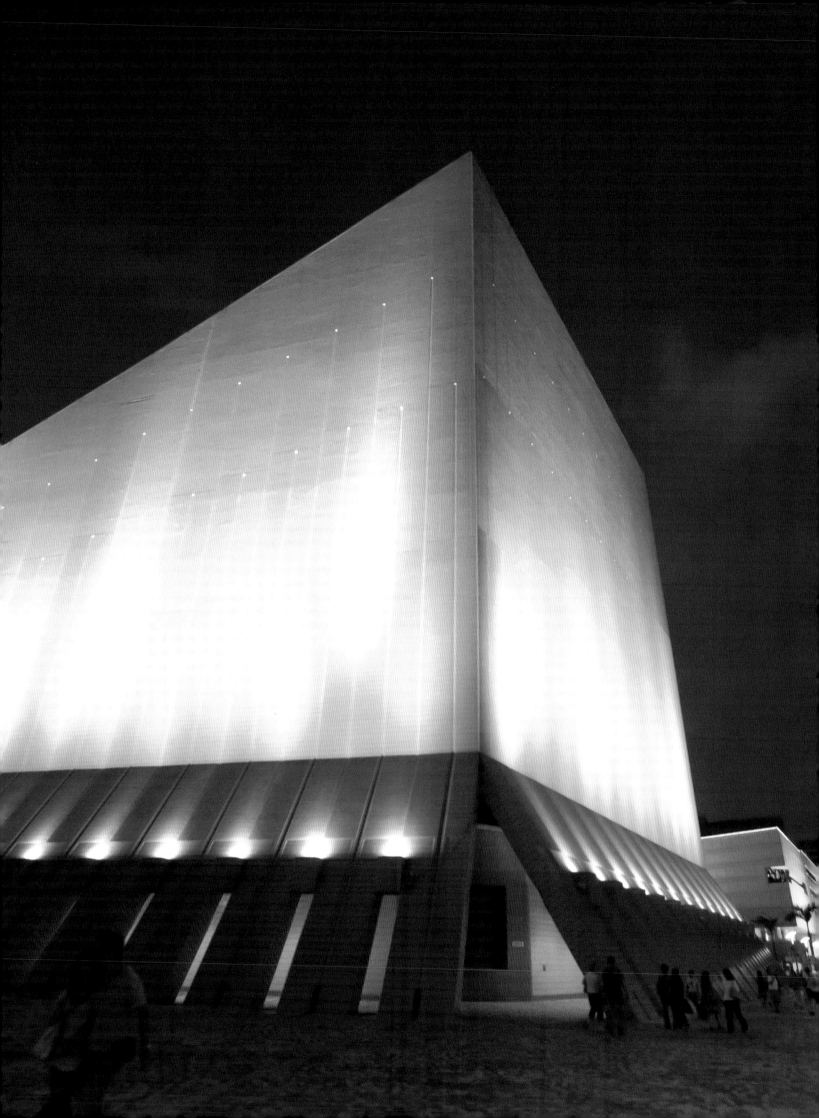

Asia and Australasia

This is where the most modern and cutting-edge theatres are being built today. Taking their cue from the iconic Syndey Opera House – one of the most recognisable buildings on the planet – the theatres that have being going up in recent years in Hong Kong, China and Singapore are nothing short of spectacular, both in size and in their futuristic designs.

But there is still plenty in the East that harks back to the past. The West Kowloon Bamboo Theatre promotes Cantonese culture in temporary structures made of wood that pop up every New Year, and the National Theatre of Taiwan recalls elements of Chinese palace architecture. The Hakata-Za in Japan was built in 1996 but puts on traditional *kabuki* shows (and qualifies as a 'super-*kabuki*' theatre, having a large enough stage to put on *Miss Saigon*, with its helicopter), while the Suehiro-tei Theatre in Tokyo stages comic *rakugo* shows. European colonial architecture of the region is displayed in the Municipal Theatre of Ho Chi Minh City in Vietnam, and in the Indonesian shadow puppet theatre in the Taman Sriwedari playhouse on Java.

Meanwhile, in Australia and New Zealand, the world of theatre is given the ultimate accolade – magnificent buildings that were once built as cinemas a century ago have now been converted for live performances.

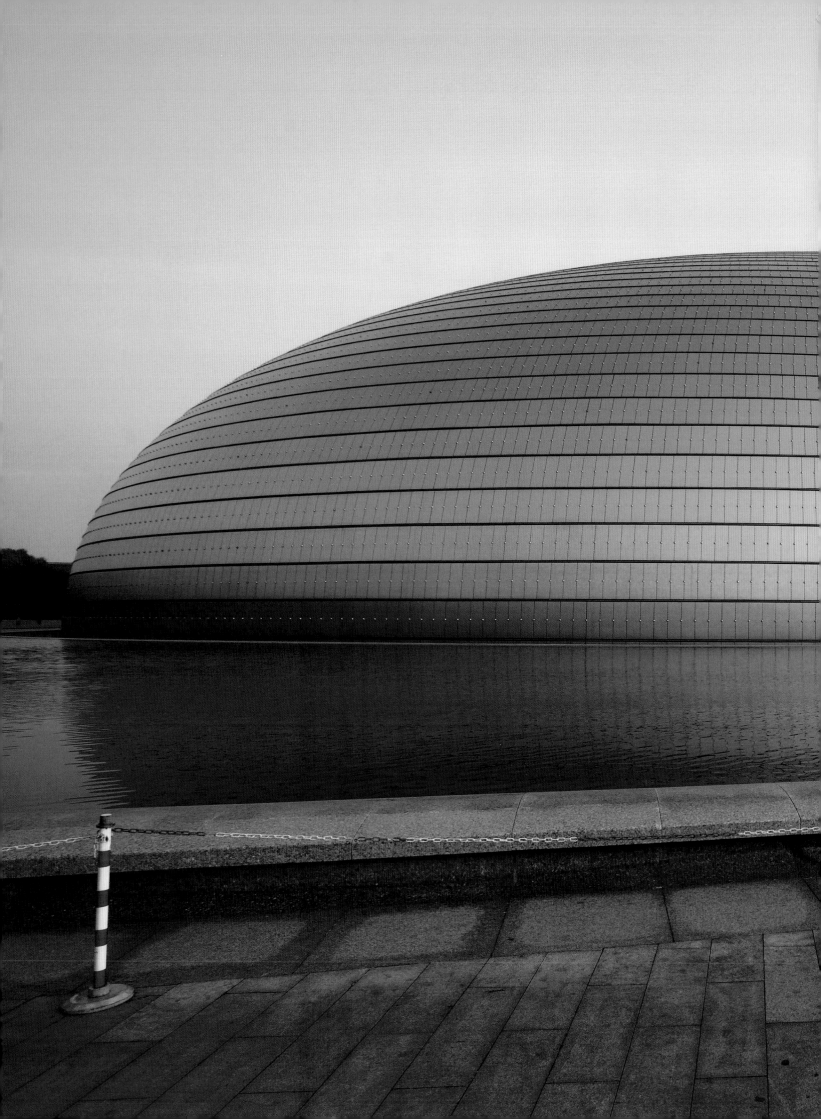

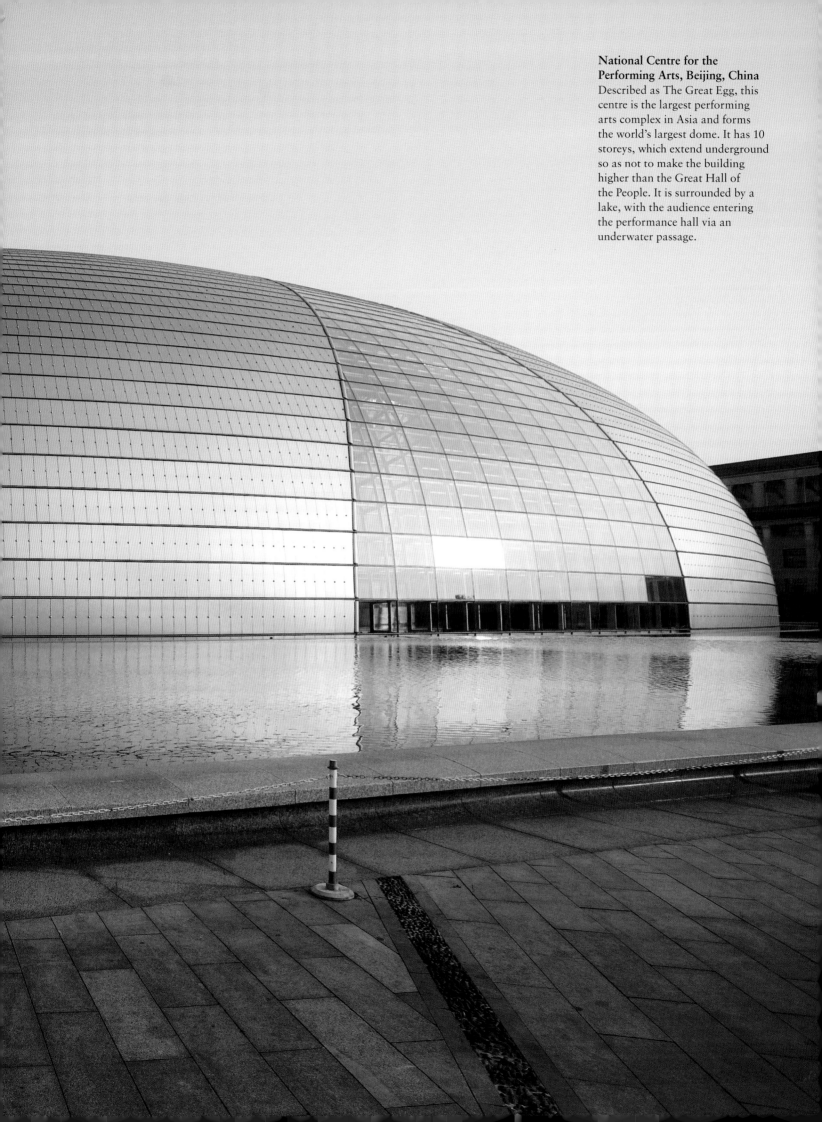

National Centre for the Performing Arts, Beijing, China
Described as The Great Egg, this centre is the largest performing arts complex in Asia and forms the world's largest dome. It has 10 storeys, which extend underground so as not to make the building higher than the Great Hall of the People. It is surrounded by a lake, with the audience entering the performance hall via an underwater passage.

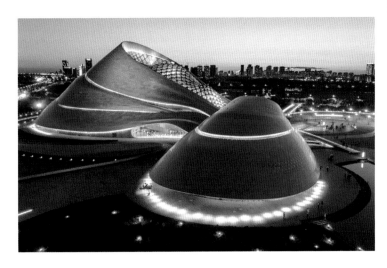

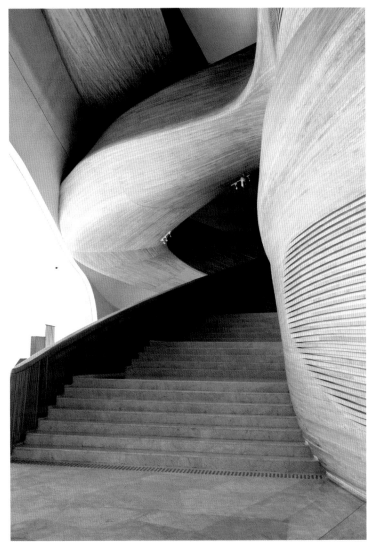

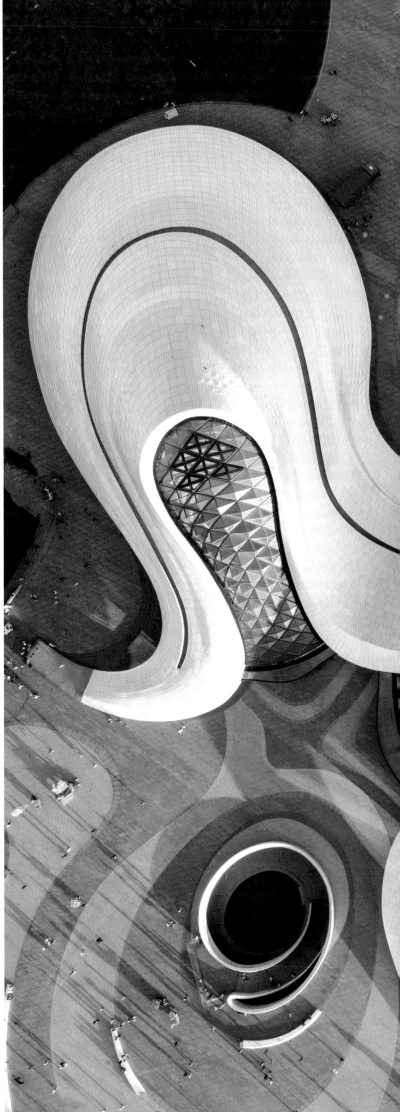

ALL PHOTOGRAPHS:
Harbin Grand Theatre, China
Clad entirely in aluminium panels, this venue is designed to appear to the naked eye as consisting of swoops and swirls. Harbin, in the northeast province of Heilongjiang, is a UNESCO-listed 'City of Music' and where China's first orchestra was established. The Grand Theare itself consists of several performance spaces.

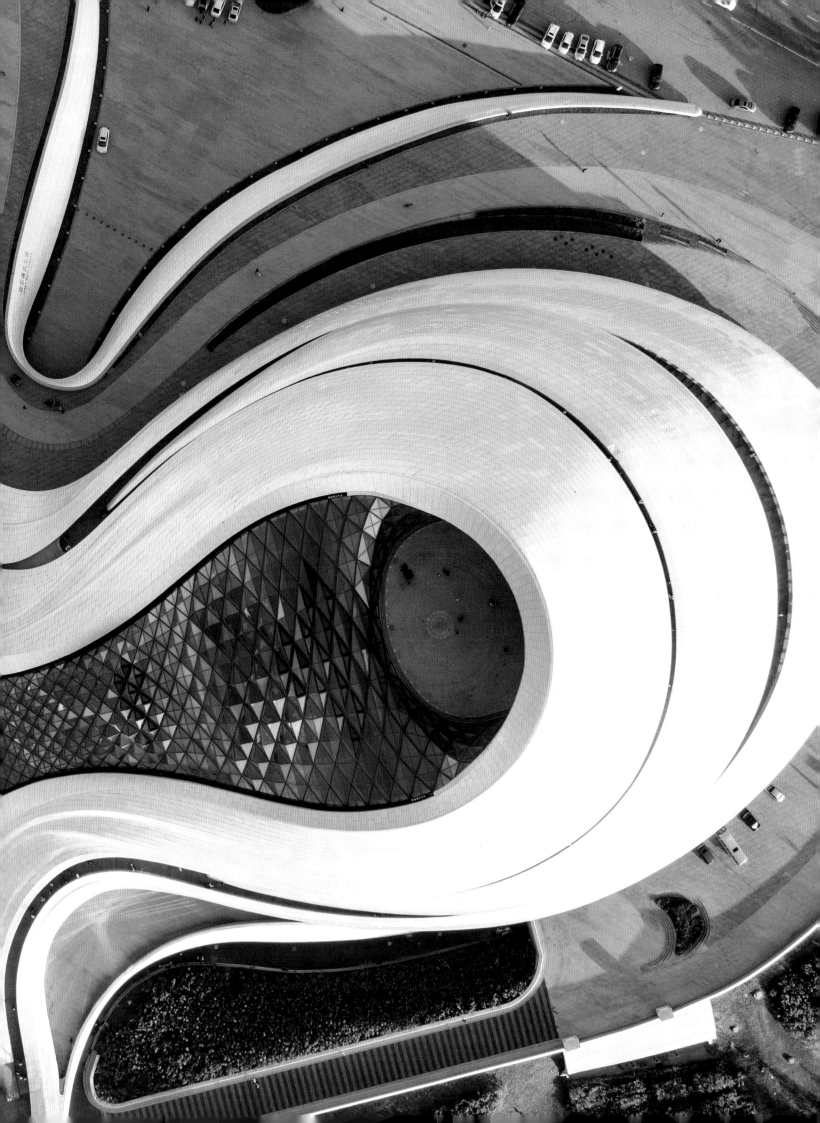

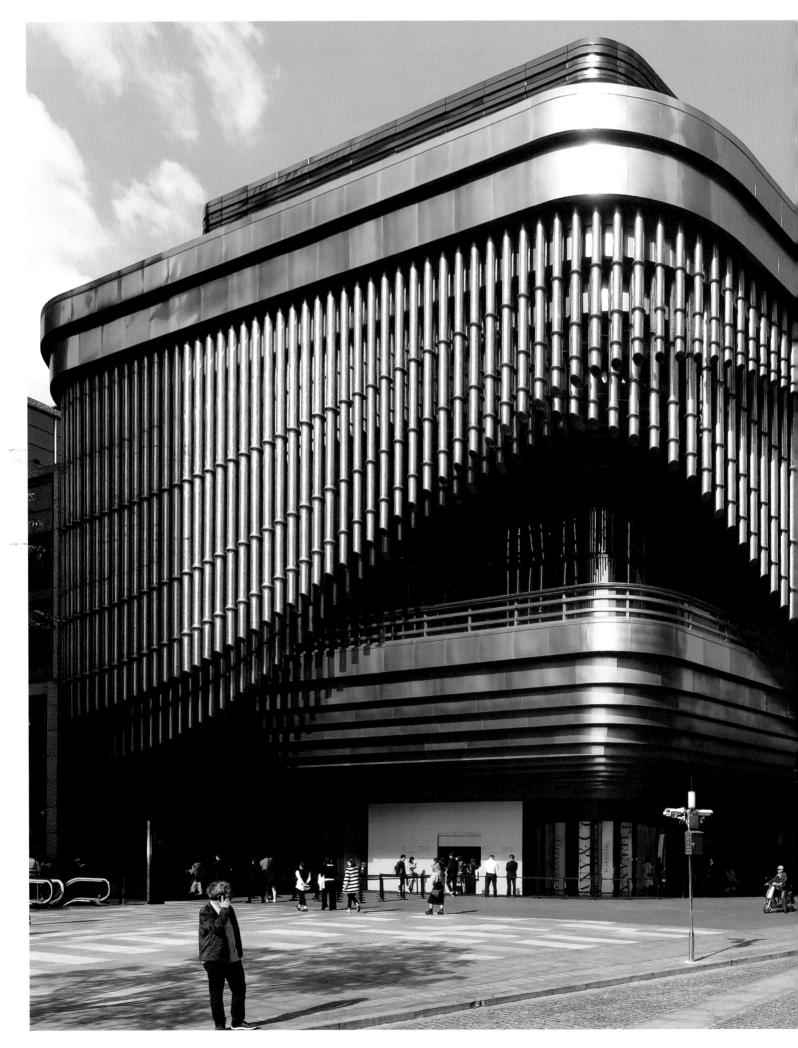

Fosun Foundation Arts Centre, Shanghai, China
Catering to various forms of expression, this institution in the Bund Finance Centre was designed by British firms Foster & Partners and Heatherwick Studio, with the visual highlight the golden, rotating bamboo curtain that hangs from the third floor. Heatherwick also designed the Cauldron for the Lonon 2012 Olympics.

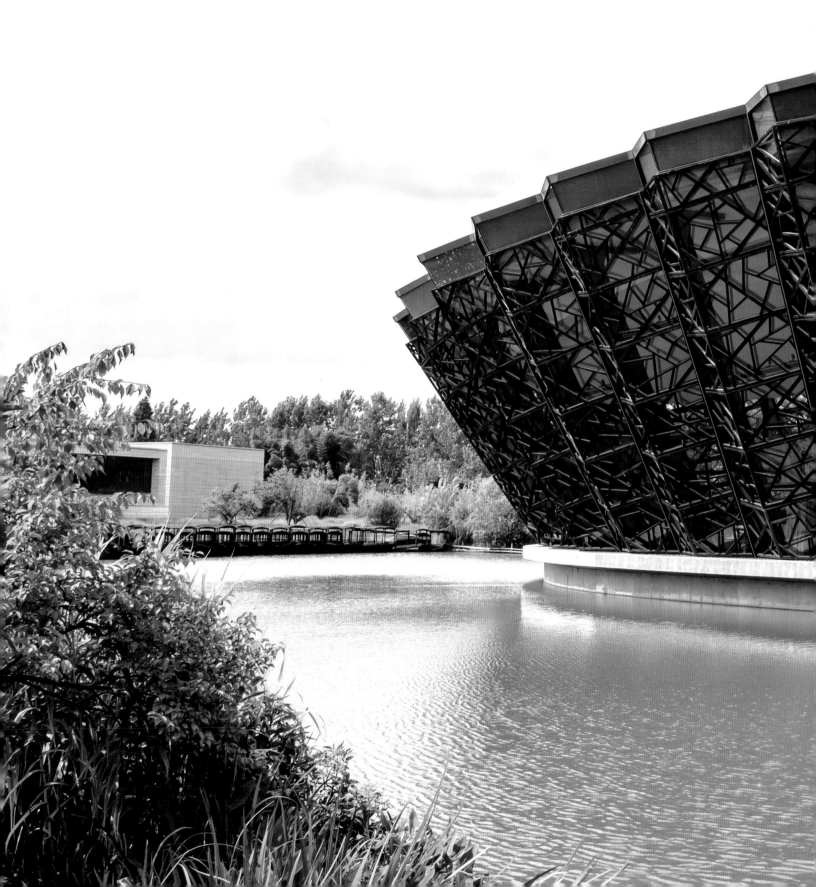

Wuzhen Theatre, Zhejiang, China
Visitors reach this venue from across either a stretch of water by wooden boat, or by foot across a bridge from an island. The centre has two stages, which sit back-to-back and interlock in a lotus shape. Wuzhen itself is a historic town near Shanghai and has an annual theatre festival.

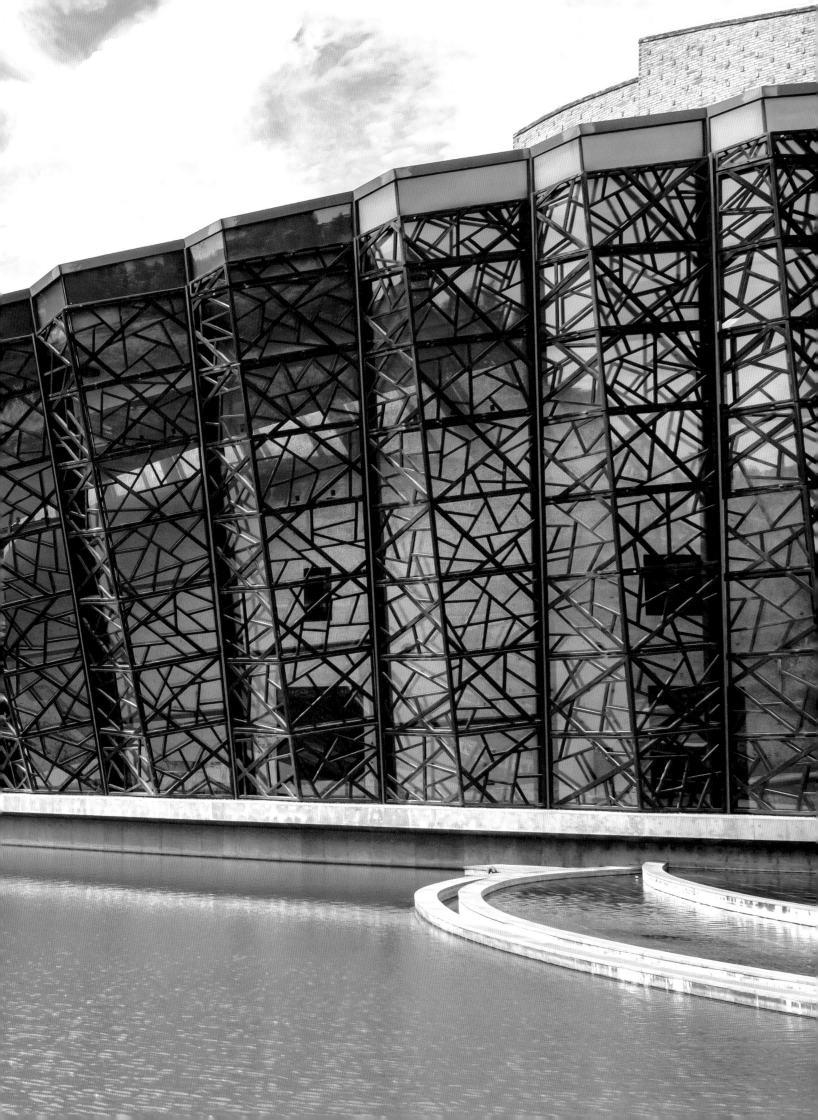

West Kowloon Bamboo Theatre, Hong Kong

Every New Year, one of these temporary structures is built and performances are put on that promote Cantonese culture. The first one, in 2012, was constructed using 10,000 bamboo stalks – 10 scaffolders created the arena in two weeks for an audience of 800 members.

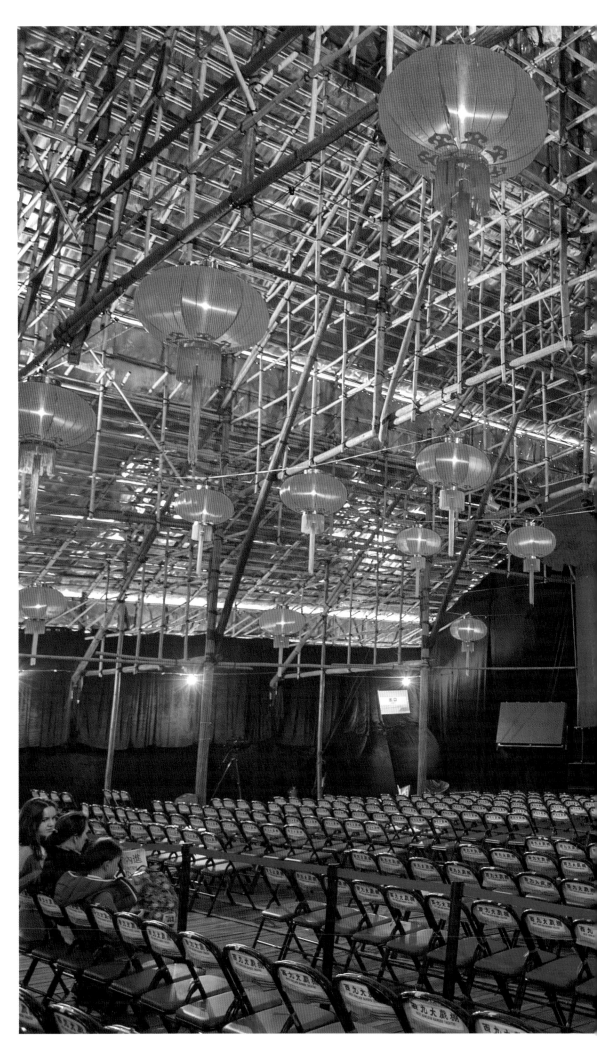

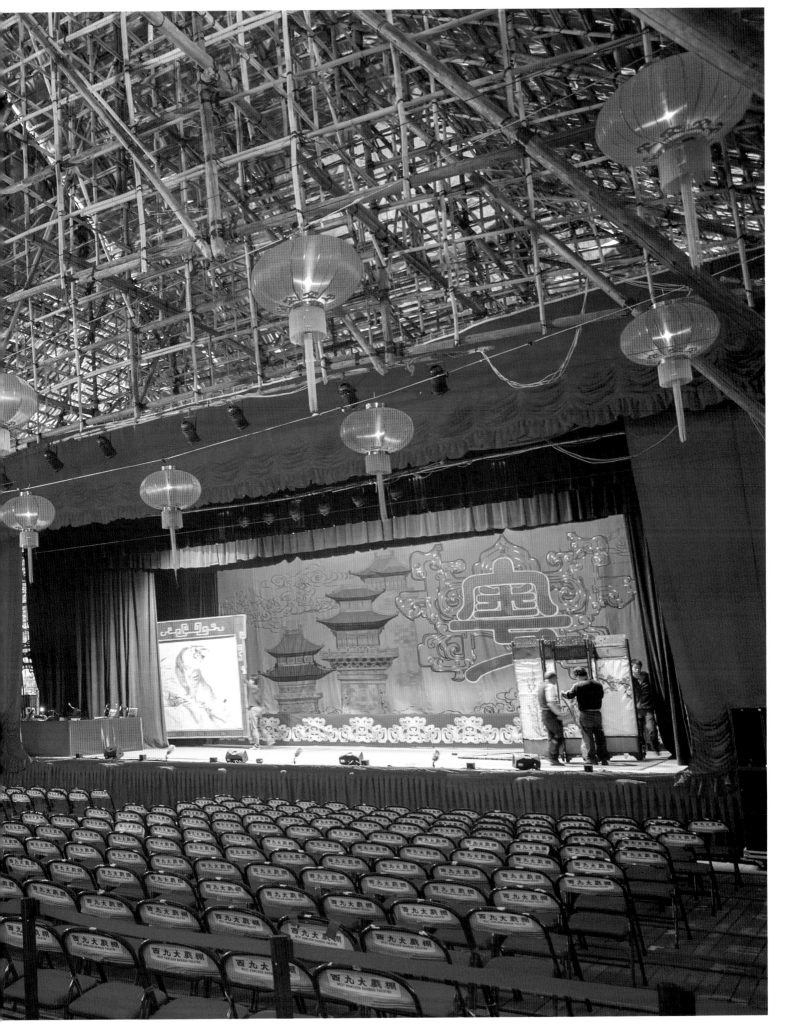

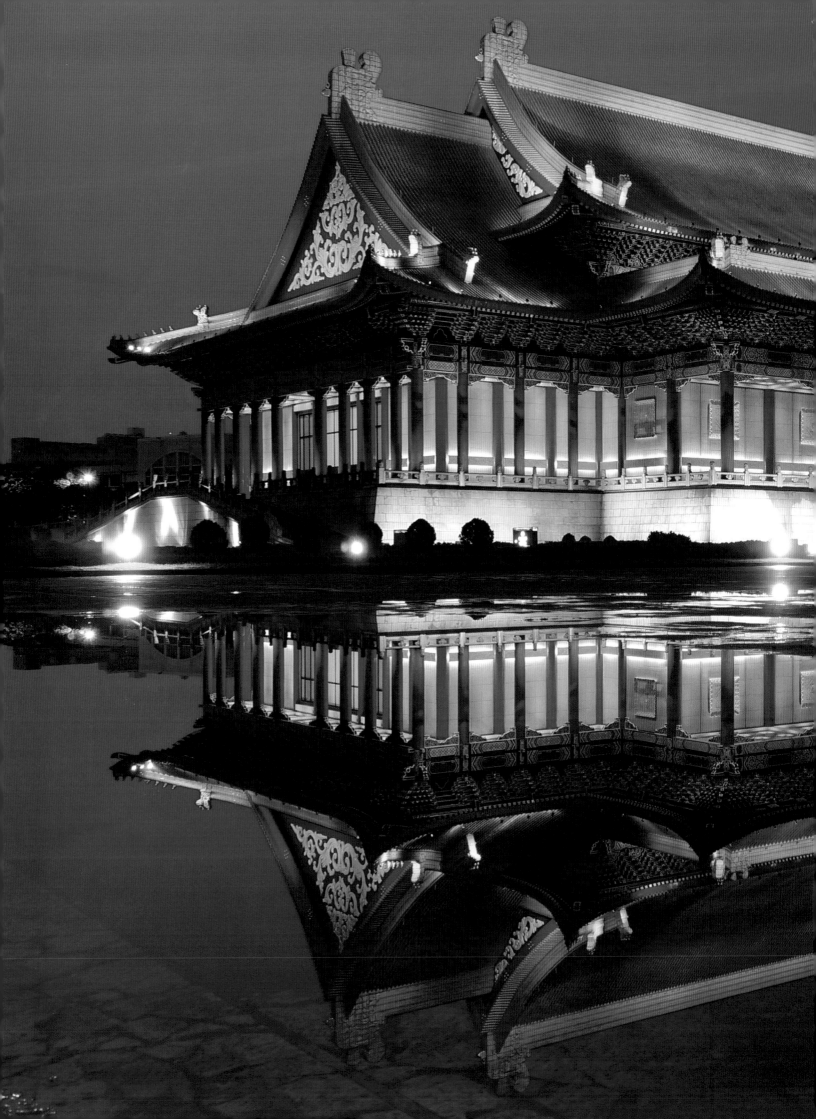

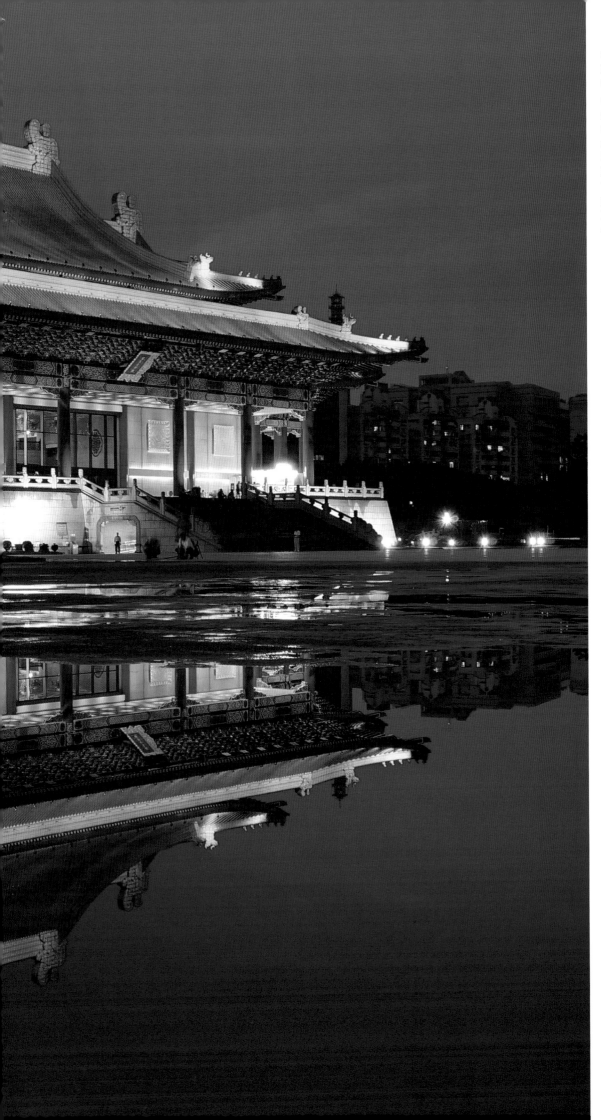

LEFT:

National Theatre, Taipei, Taiwan
Completed in 1987, this complex
recalls elements of Chinese
palace architecture. It contains
the National Theatre but also
the National Concert Hall. The
Kirov Ballet and Rudolf Nureyev
have performed at the National
Theatre, and the likes of Placido
Domingo, Jose Carreras and
Luciano Pavarotti have graced the
Concert Hall.

OVERLEAF:

Hakata-Za, Fukuoka, Japan
This 1996 venue is a multi-
purpose space that can put on
kabuki, musicals and mainstream
plays. It has a rotating stage and,
with the intention of staging
Miss Saigon, it can accommodate
a helicopter. Its high-tech design
means that it qualifies to be
called a 'super-*kabuki*'.

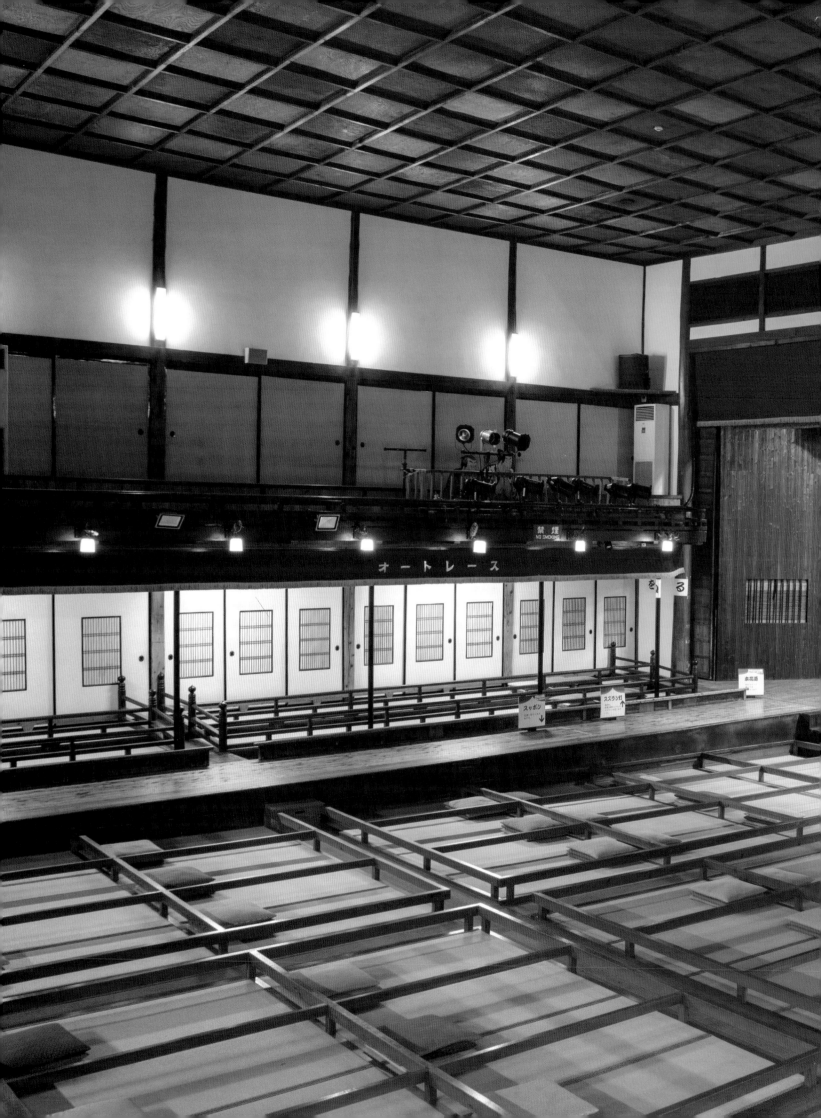

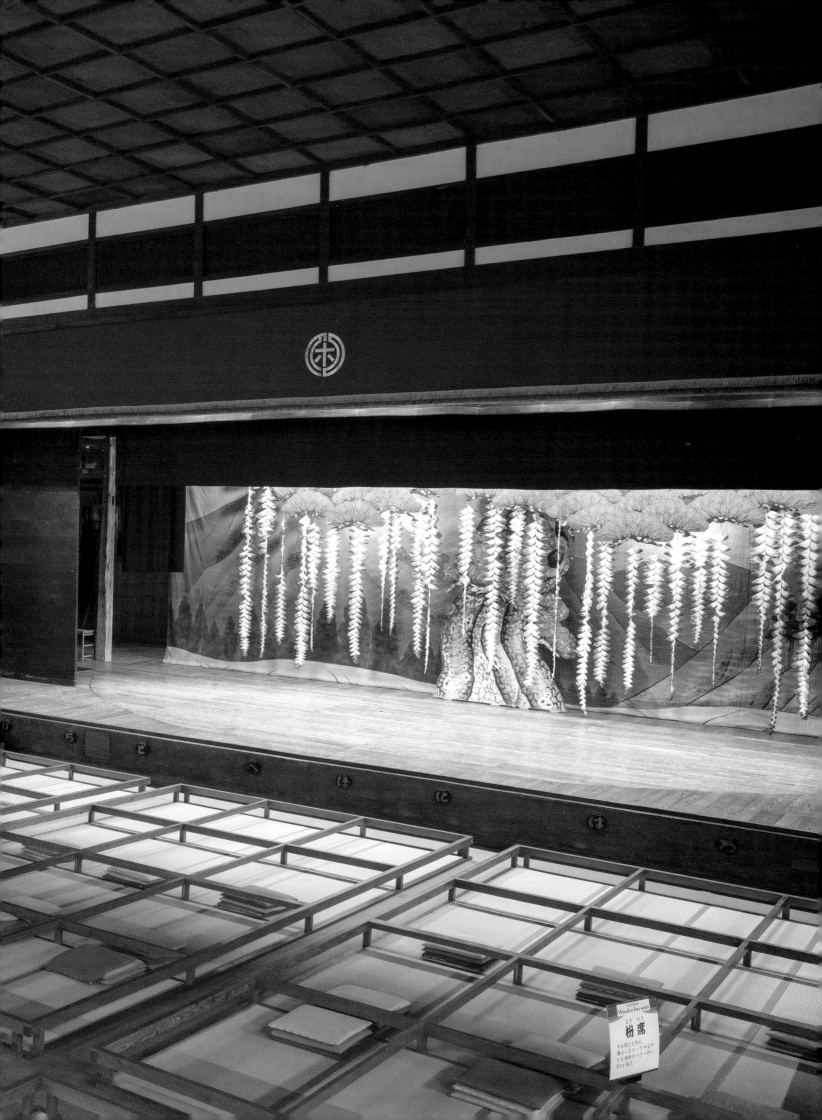

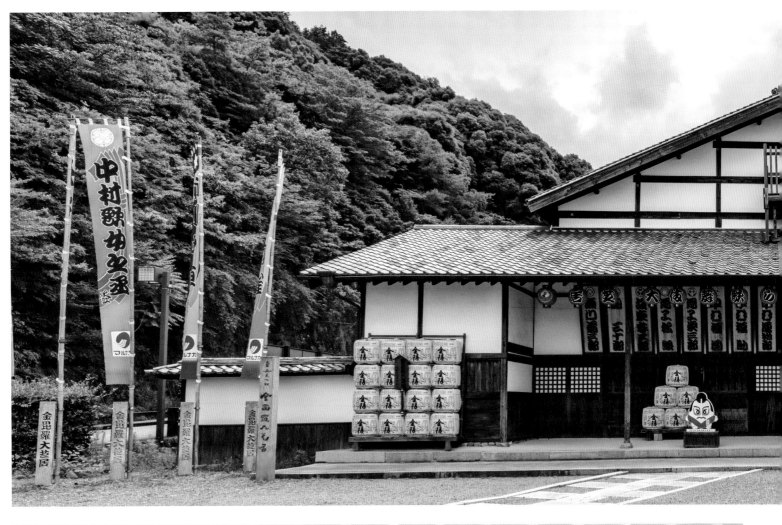

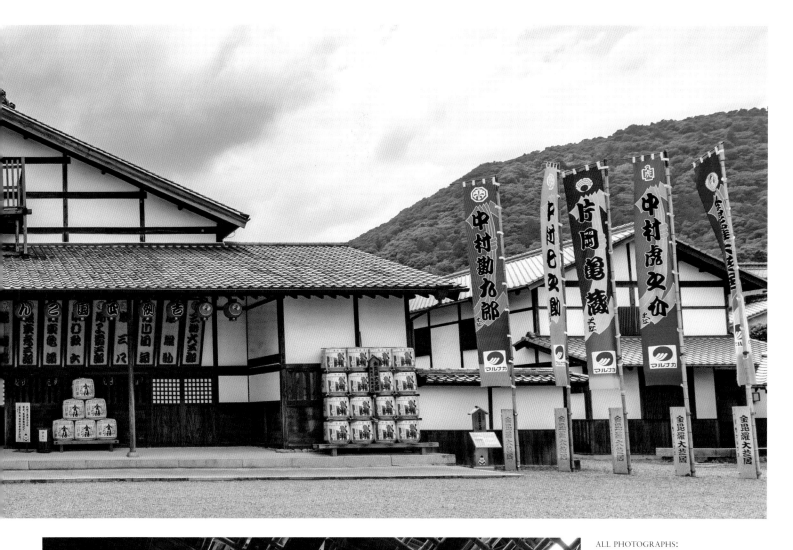

ALL PHOTOGRAPHS:

Konpira Grand Theatre, Kanamaruza, Shikoku, Japan
Constructed in 1835, this is the oldest *kabuki* venue in the country. In the 20th century it fell into disrepair and had a period as a cinema before it was restored – at a cost of more than $2 million (about £1.5 million) – reopening in 1976. But this new theatre is 200m (220yd) from the original location.

RIGHT AND OVERLEAF:

Kabuki-za Theatre, Ginza, Tokyo, Japan

There have been several of these playhouses here since the first one, built in the late 19th century. That burned down and was being rebuilt when the 1923 Great Kanto earthquake destroyed it. The subsequent building was razed to the ground in World War II and its replacement torn down for the latest version, unveiled in 2010.

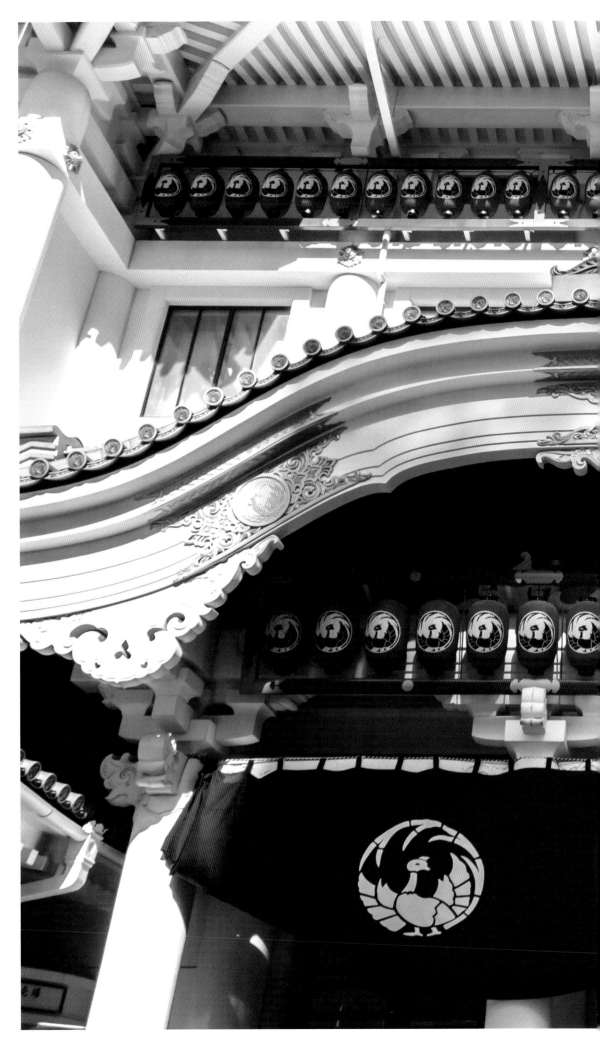

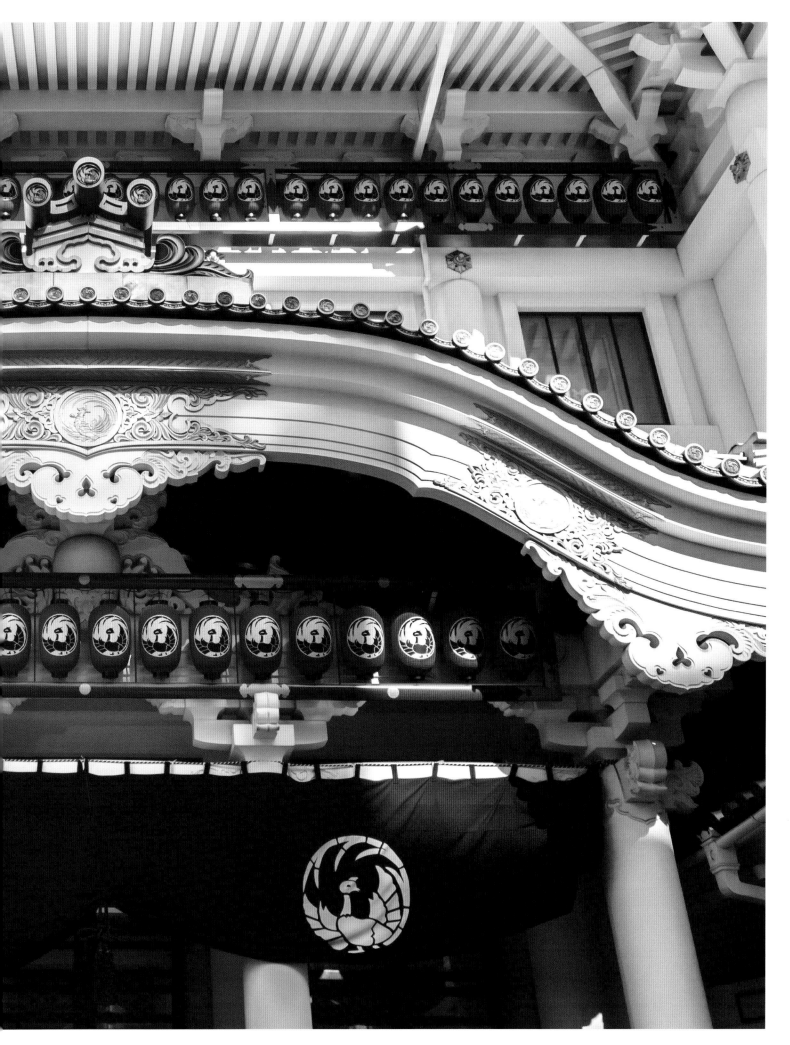

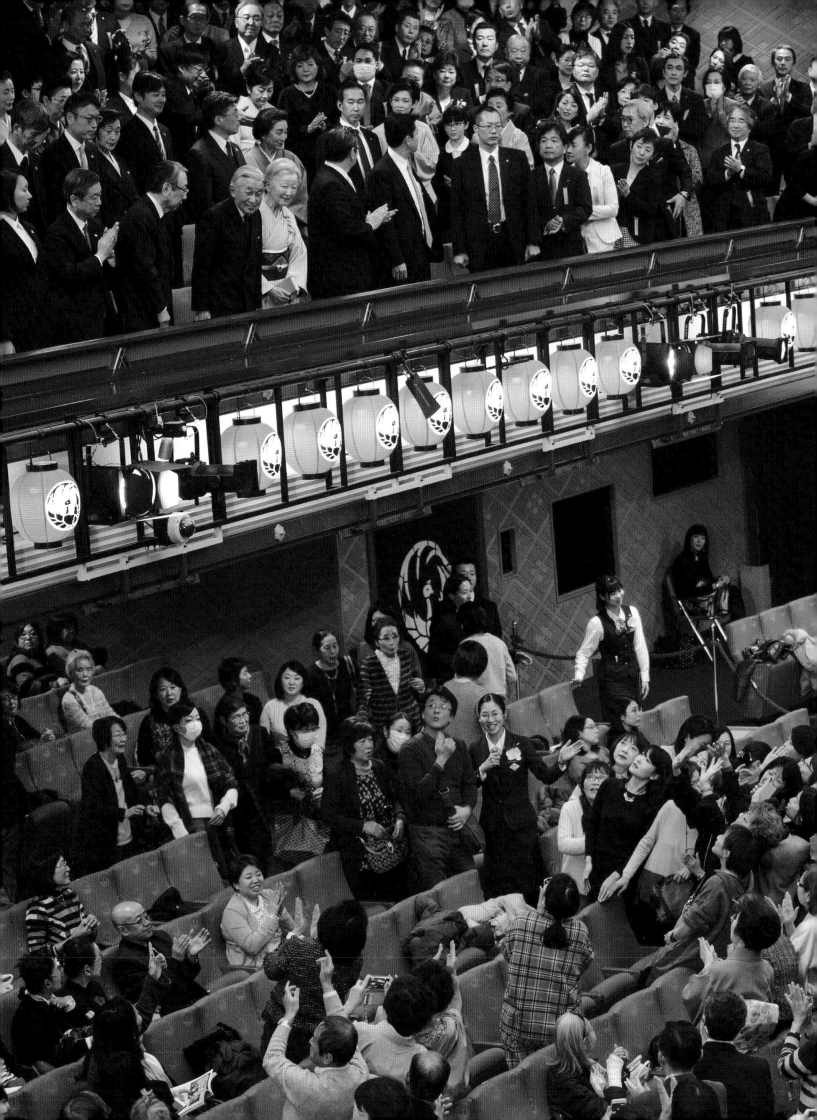

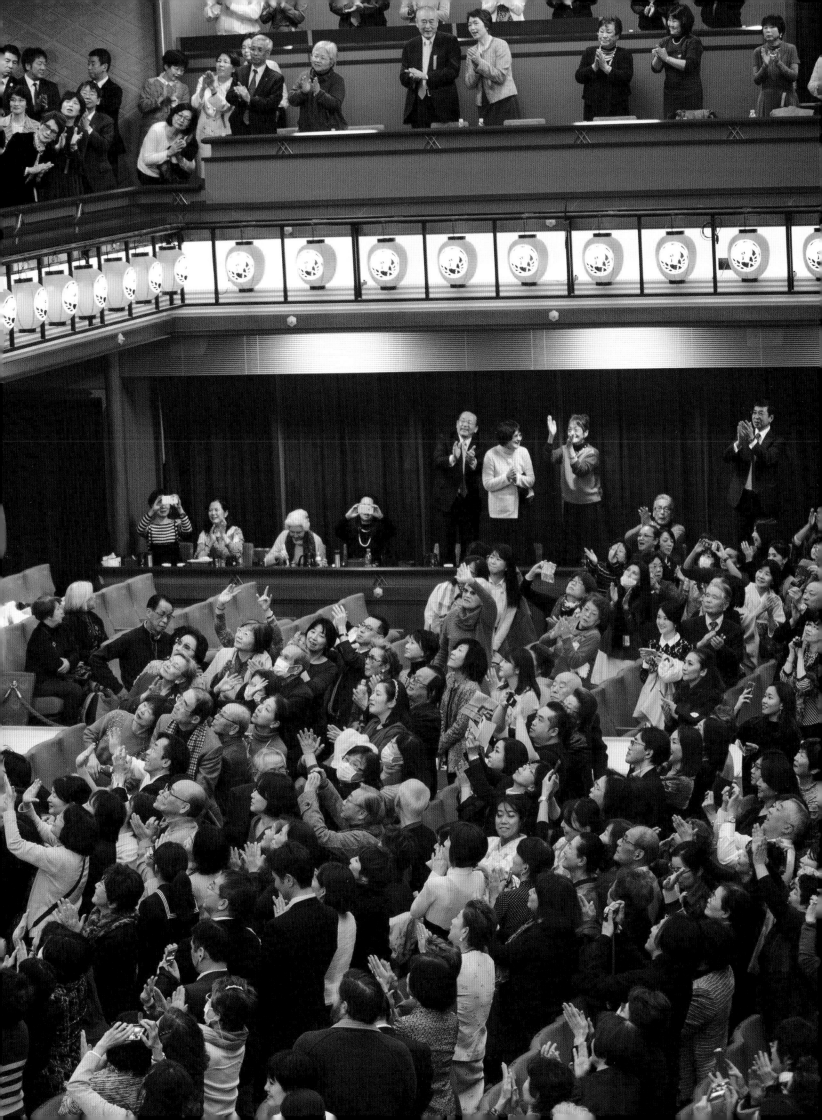

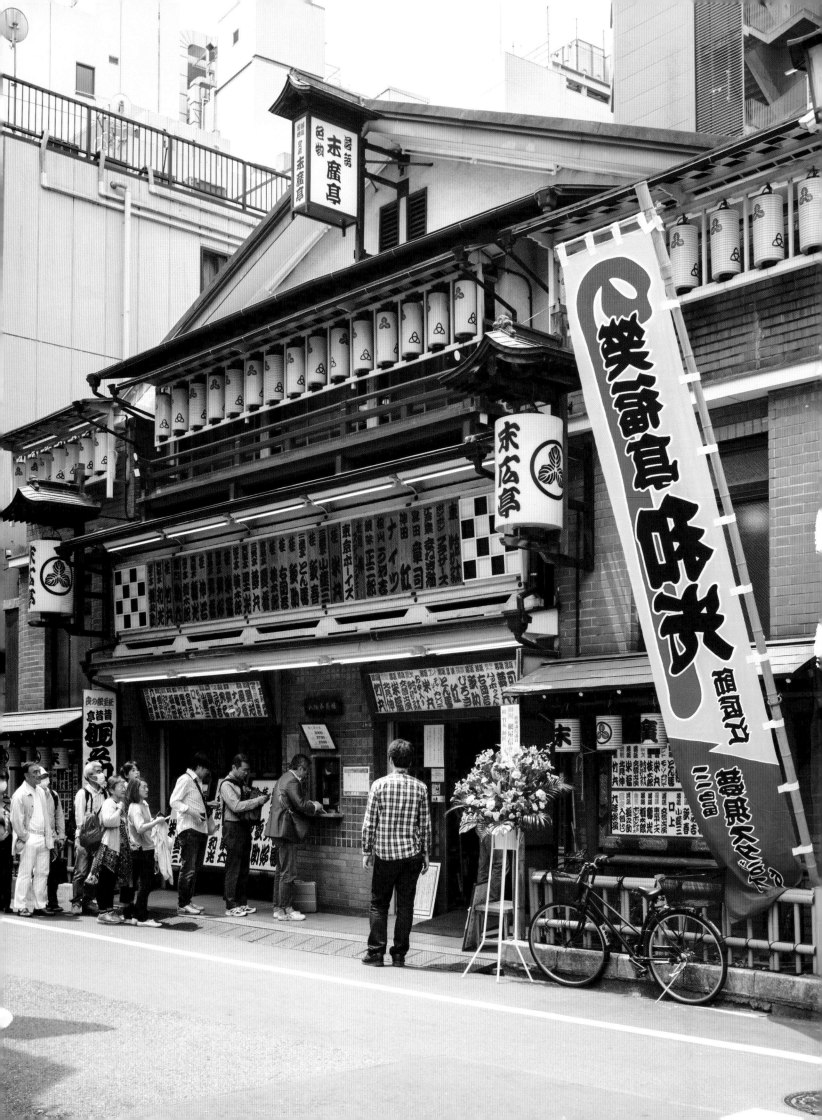

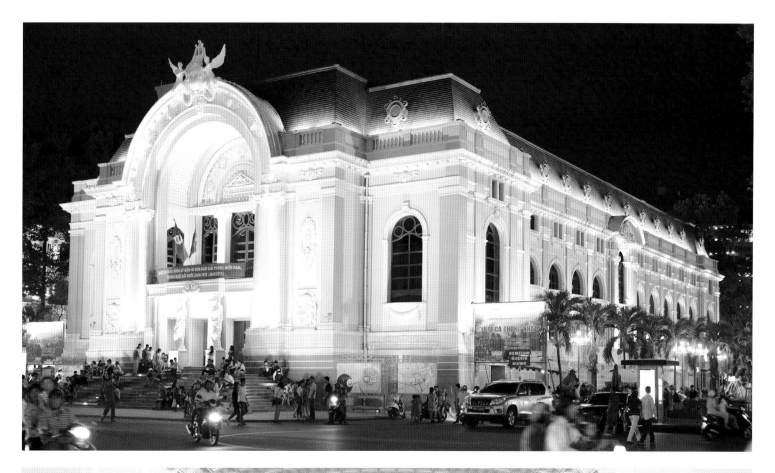

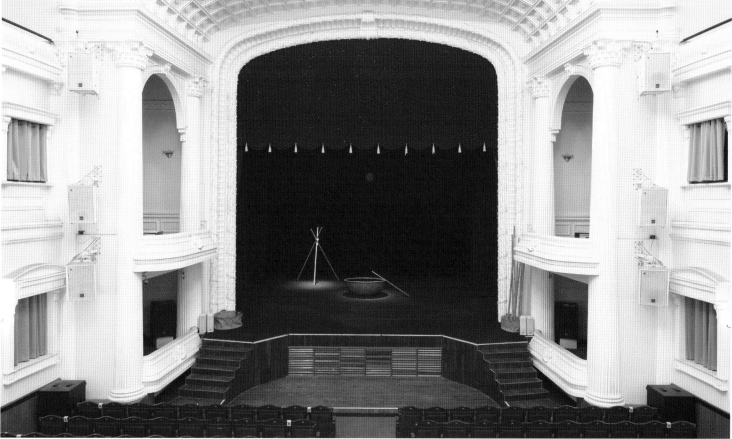

Suehiro-tei Theatre, Shinjuku, Tokyo, Japan
Built in 1946, this is a venue that puts on traditional *rakugo* (comic storytelling) shows, which are performed by a *rakugoka*, who wears a kimono and sits on a pillow. Shinjuku is a busy entertainment, retail and business district. Tokyo is specifically associated with *rakugo*, while double-act *manzai* comedy is associated with Osaka.

ABOVE TOP AND BOTTOM:

Municipal Theatre, Ho Chi Minh City, Vietnam
This is an example of French colonial architecture and was built in 1897 as the Opera de Saigon. After 1956 it was used as the Lower House of assembly for South Vietnam and was not used as a theatre again until 1975, then was restored 20 years later. The Municipal Theatre is a smaller counterpart of the Hanoi Opera House.

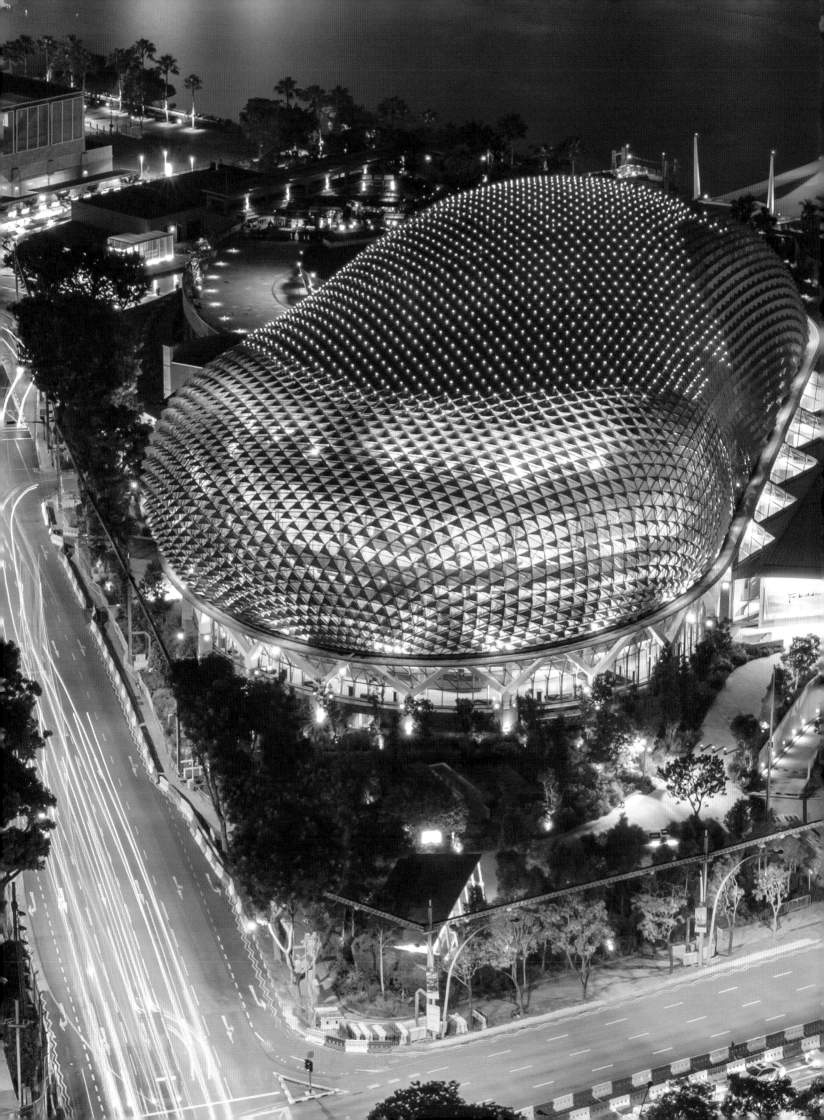

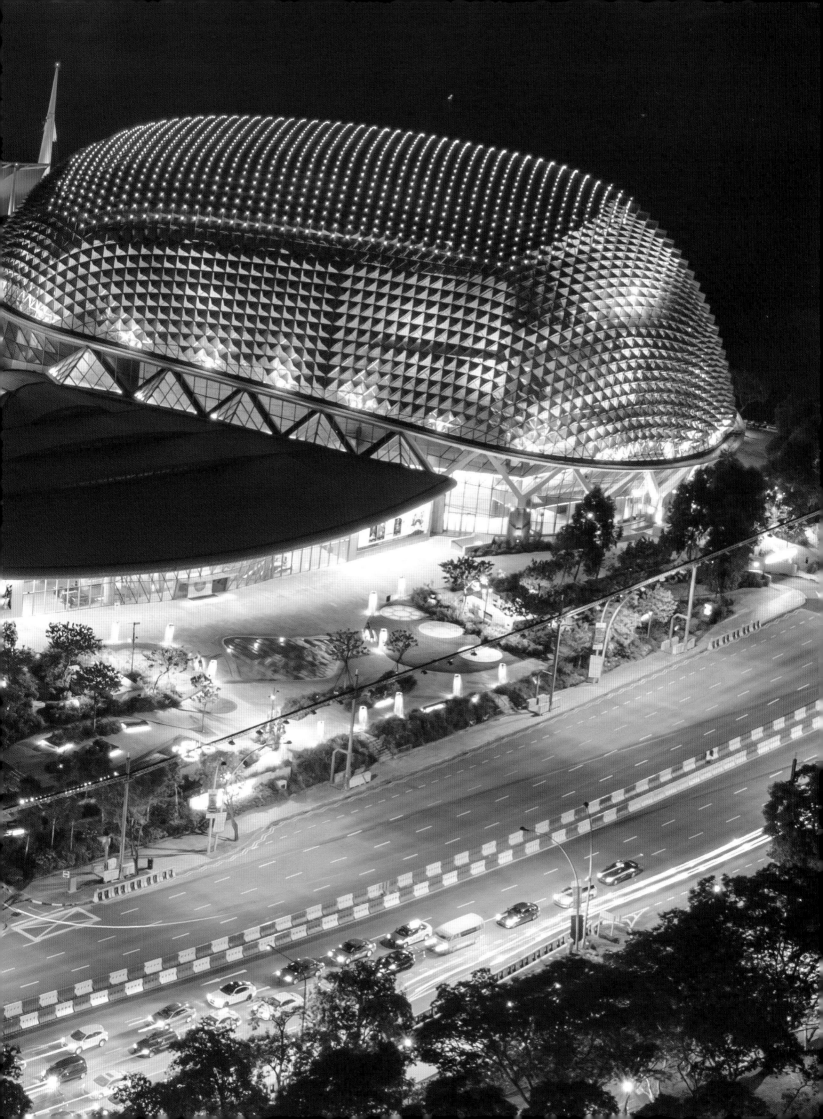

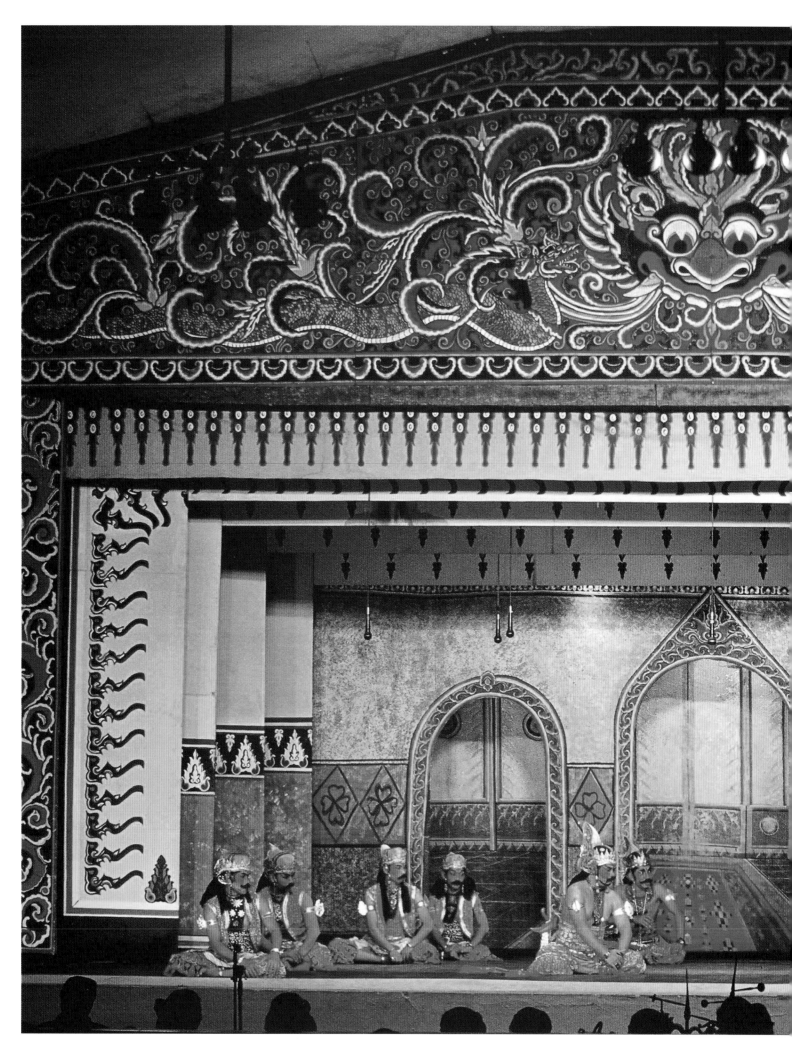

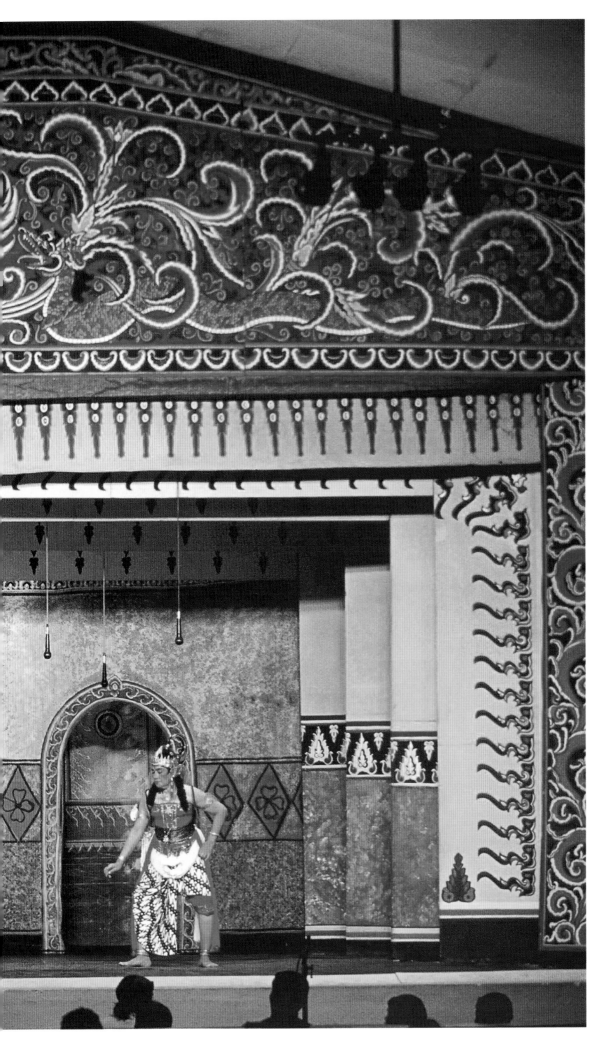

PREVIOUS PAGE:

Esplanade, Singapore
This arts centre – also known as
Theatres on the Bay – is made
up of two rounded glass domes,
which locals dub the 'durian'
as it resembles the spiky fruit
that is native to the area. The
space features the 1,600-seater
Concert Hall, where the Singapore
Symphony Orchestra regularly
performs. It opened in 2002,
having taken six years to build.

LEFT:

**Taman Sriwedari Theatre,
Surakarta, Java, Indonesia**
Storytelling using shadow puppets
has been popular in this area for
more than 1,000 years. Called
Wayang Kulit, the show is usually
accompanied by an Indonesian
gamelan orchestra. This theatre
specialises in it.

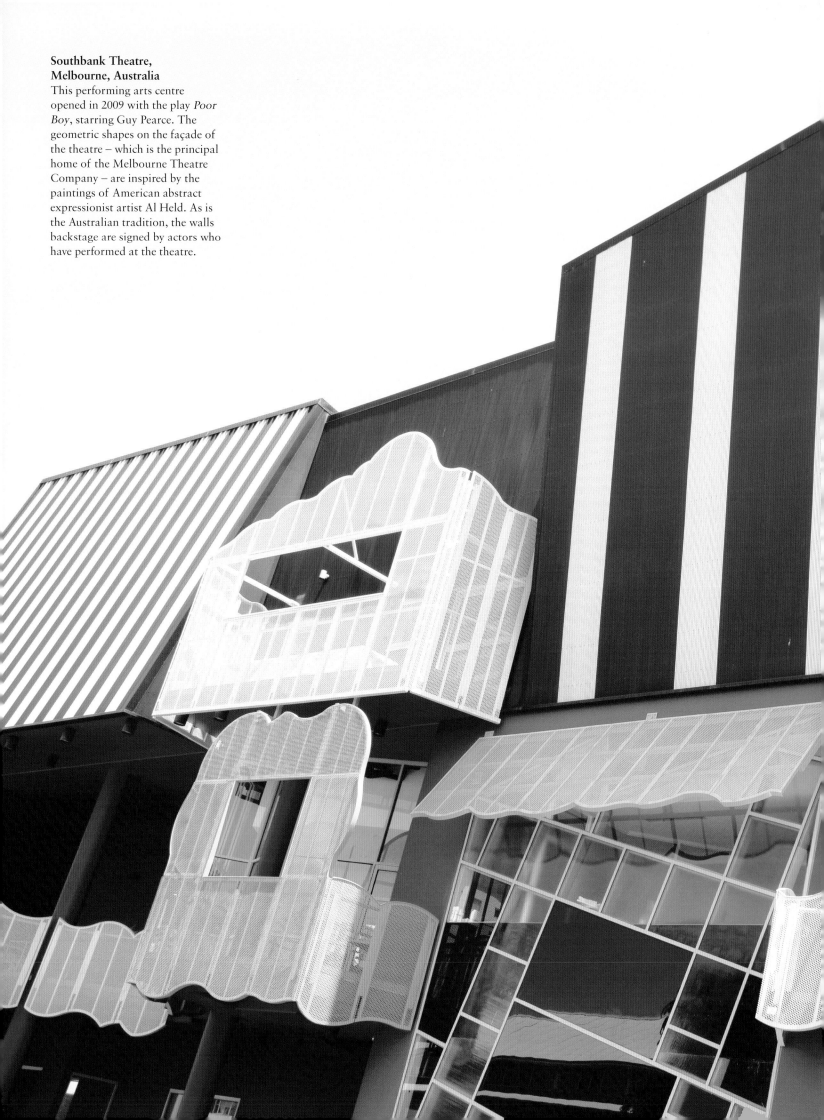

Southbank Theatre, Melbourne, Australia
This performing arts centre opened in 2009 with the play *Poor Boy*, starring Guy Pearce. The geometric shapes on the façade of the theatre – which is the principal home of the Melbourne Theatre Company – are inspired by the paintings of American abstract expressionist artist Al Held. As is the Australian tradition, the walls backstage are signed by actors who have performed at the theatre.

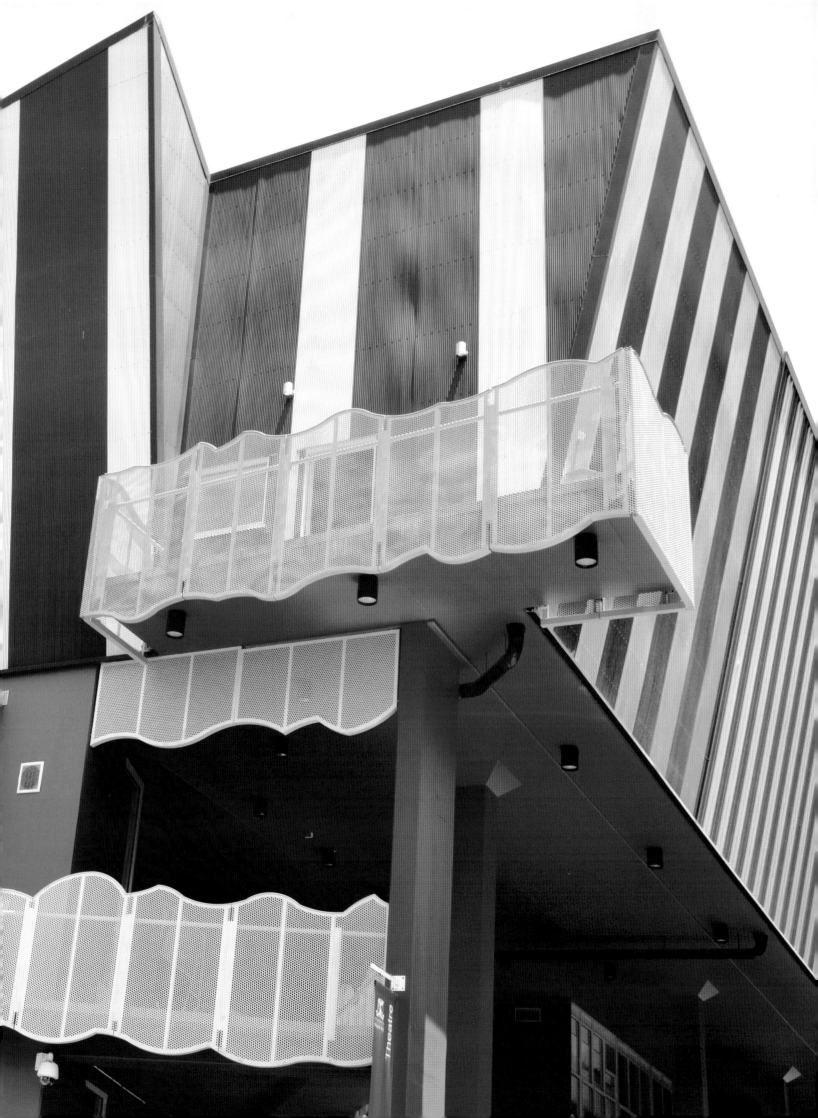

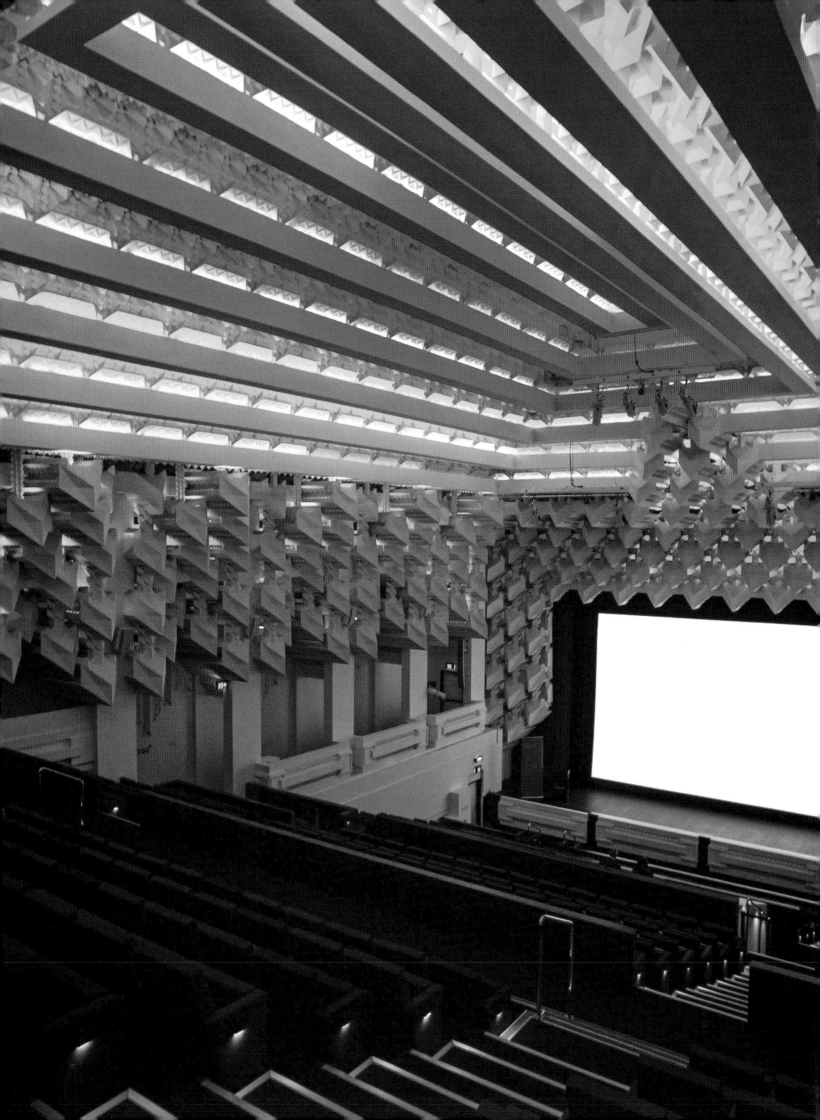

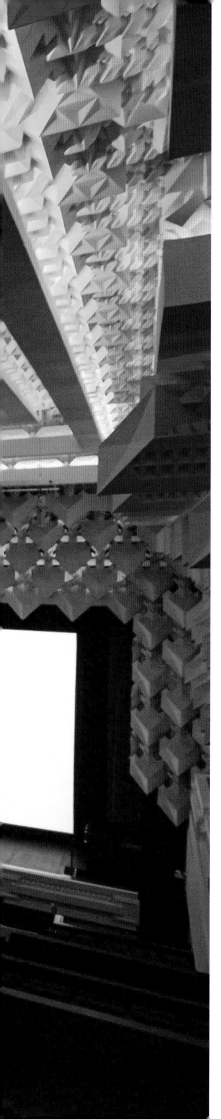

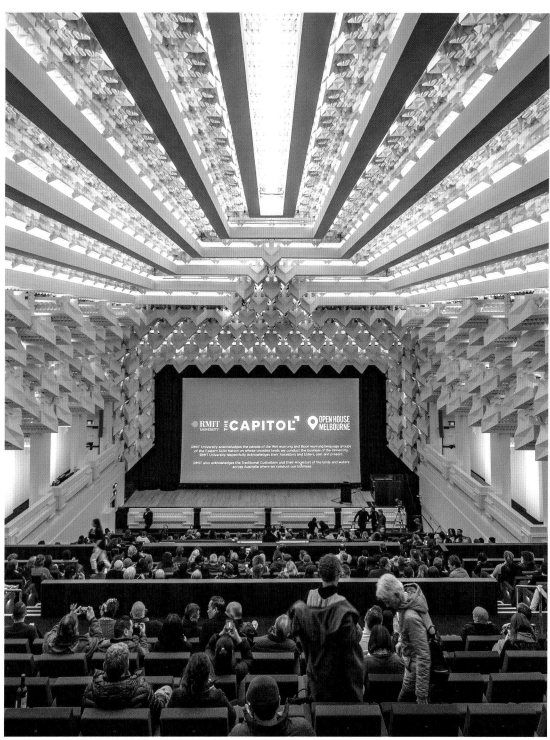

ALL PHOTOGRAPHS:

Capitol Theatre, Melbourne, Australia

This venue was originally built as a 'picture palace' in 1924 in the Chicago-Gothic style. Its ceiling was created with 33,000 plaster crystals lit by thousands of coloured lights and, during the silent-movie era, displays were choreographed to play in time with live orchestra scores accompanying the films. The venue now also hosts live theatre.

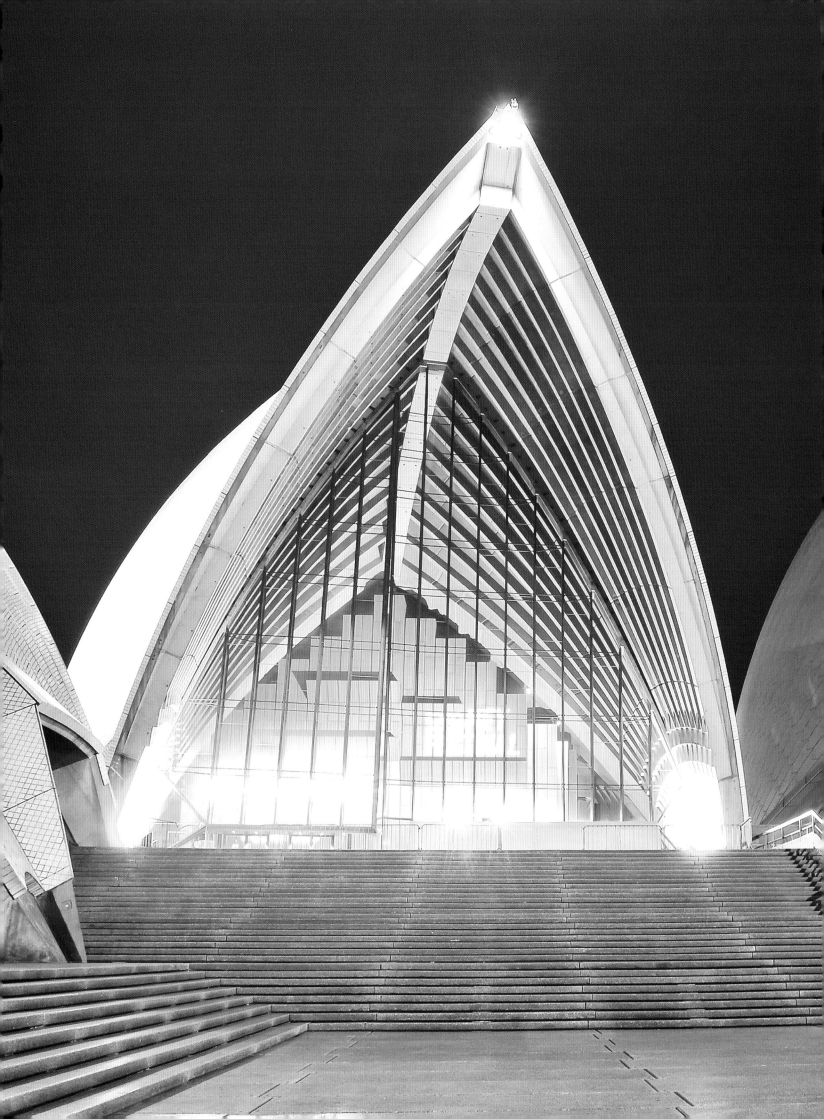

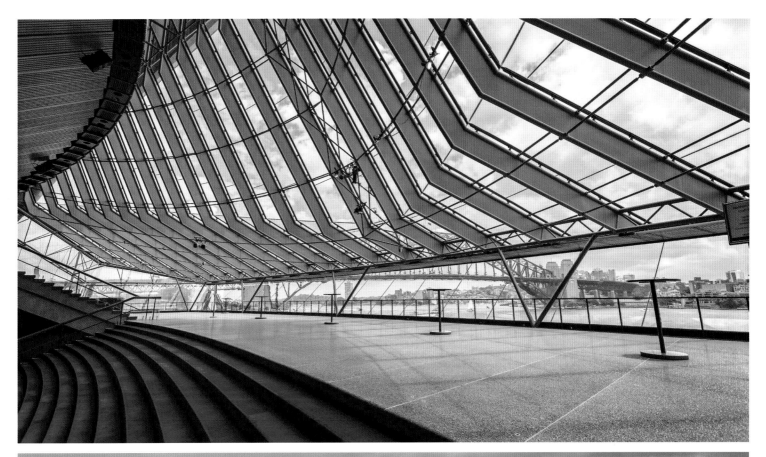

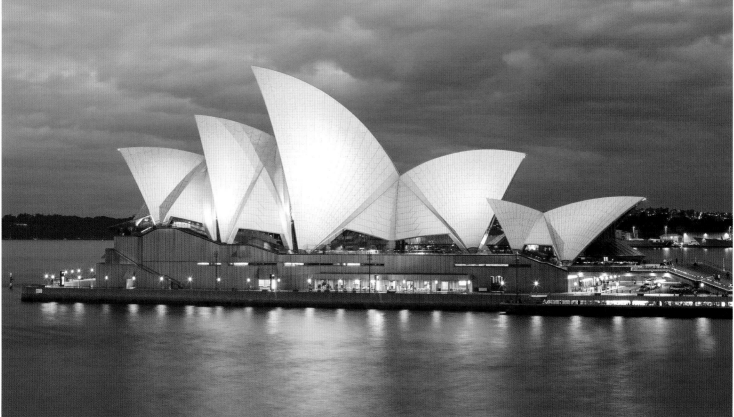

ALL PHOTOGRAPHS AND OVERLEAF:
Sydney Opera House, Australia
It is one of the most recognisable buildings in the world, but its architect,
Jorn Utzon, left Australia midway through construction, never to return
to see it completed, after the Dane fell out with the Minister for Public
Works, Davis Hughes. Construction had begun in 1959 and the house
was finally opened in 1973.

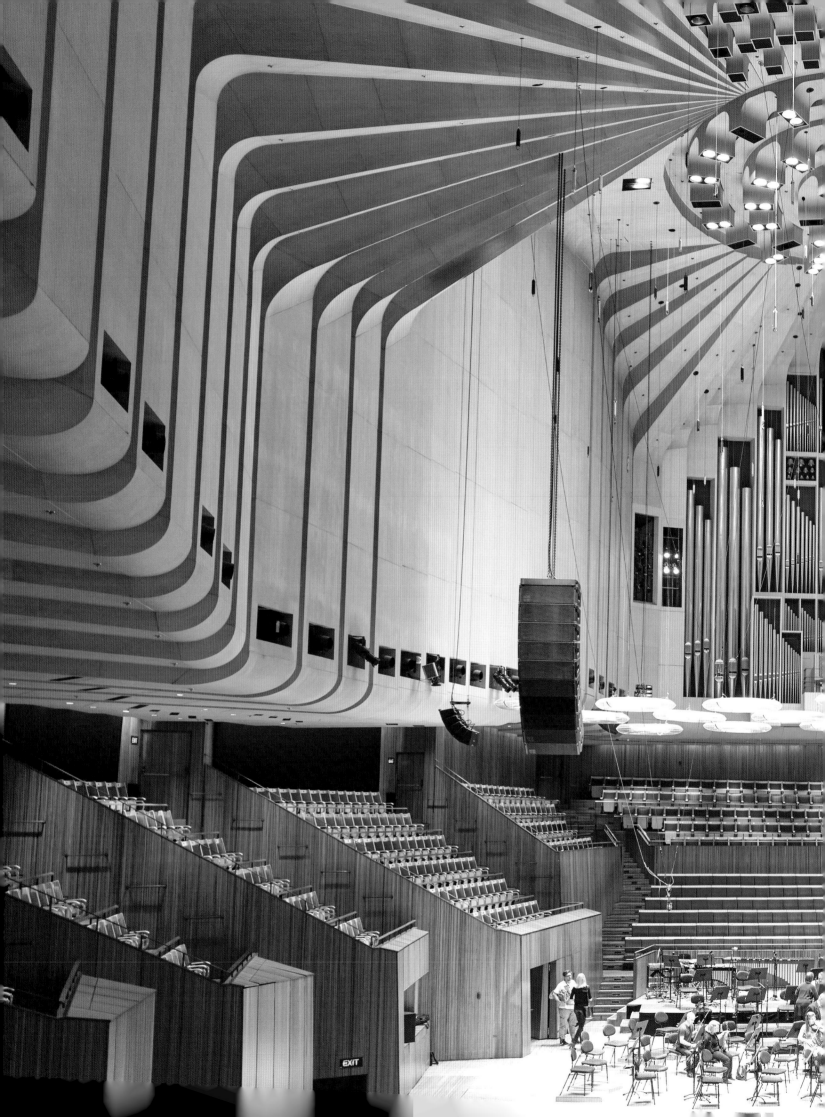

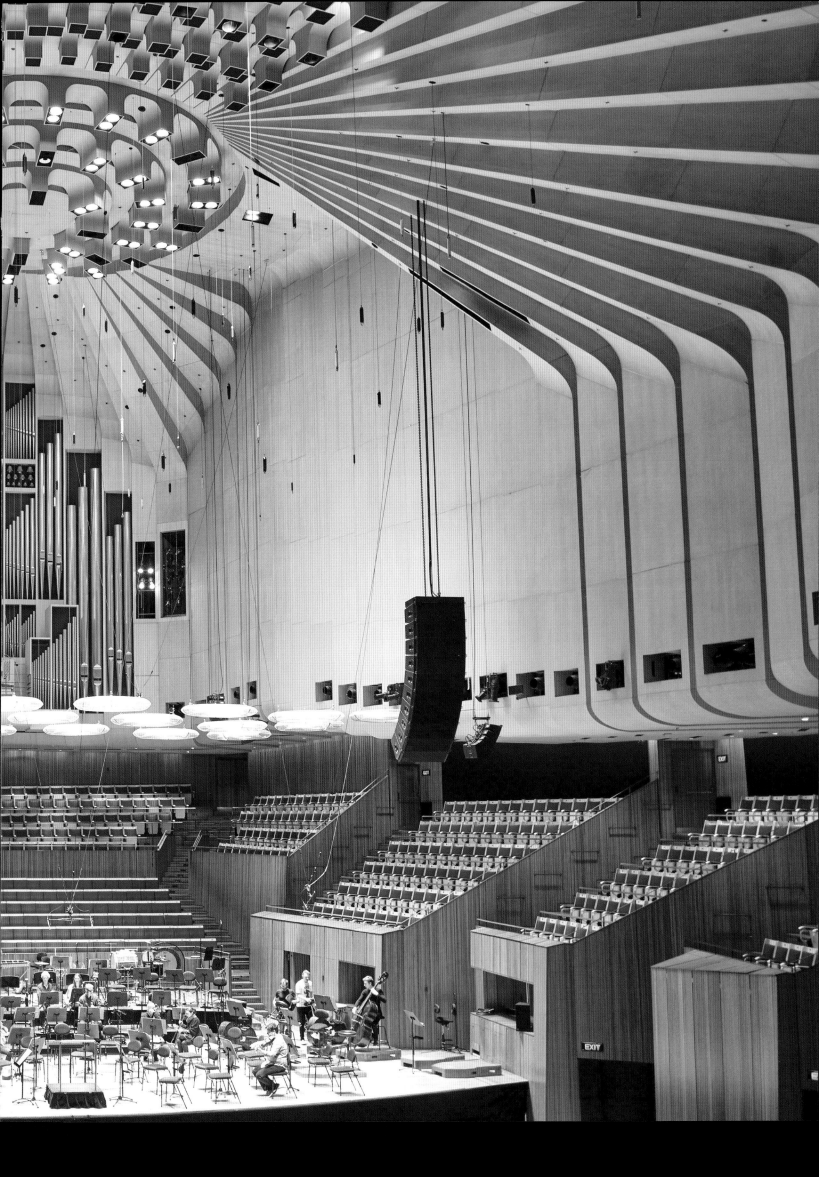

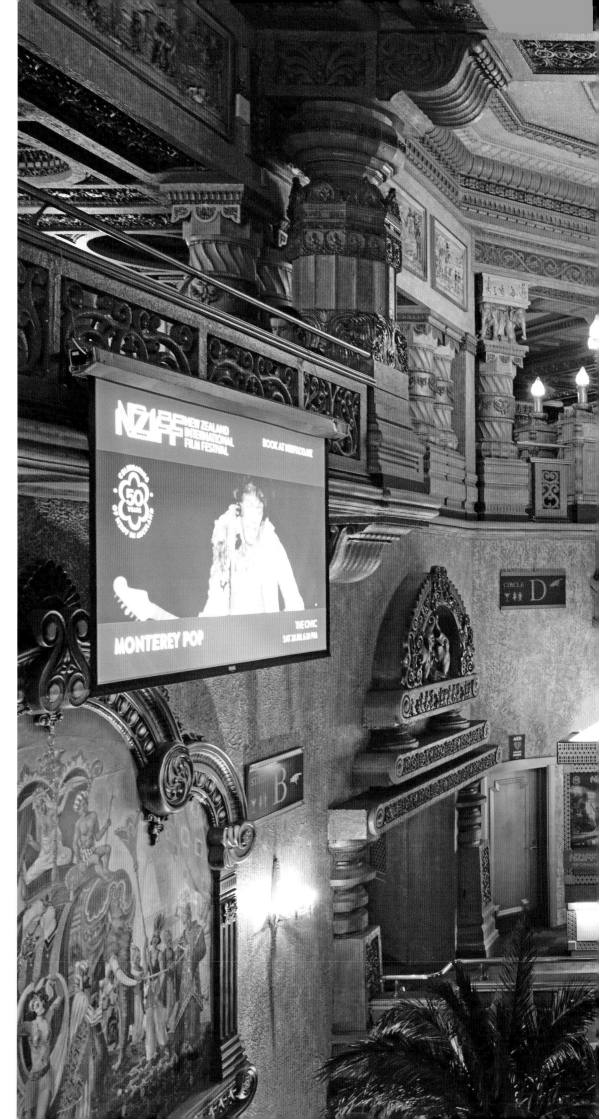

Auckland Civic Theatre, New Zealand

This was the first purpose-built cinema for 'talkies' in the country, built in 1929. Entrepreneur Thomas O'Brien chose an eastern theme for it, with minarets, turrets, spires and a dome in the auditorium, but the Great Depression bankrupted him. The Civic was restored in 1999 and now also presents theatre.

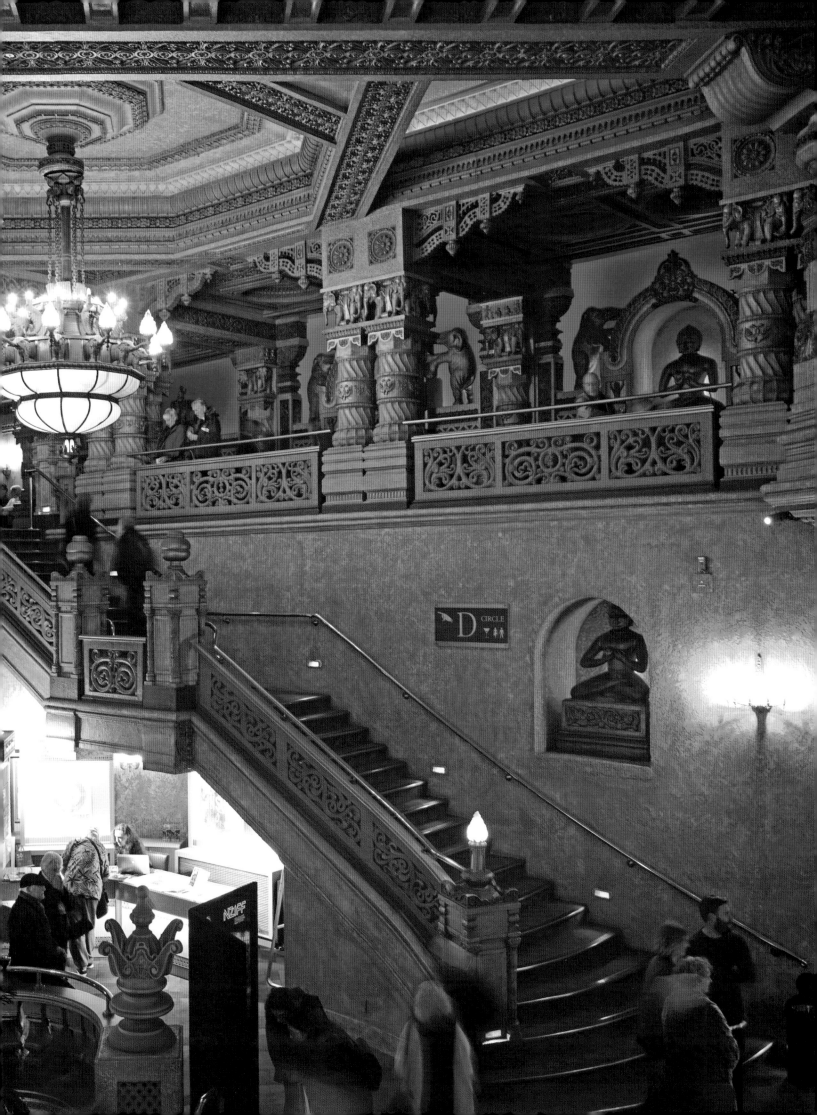

Picture Credits